Debra N. Mancoff

The Garden in Art

MERRELL

LONDON · NEW YORK

CONTENTS

INTRODUCTION

In the garden, nature is transformed to satisfy human needs. Since distant times, when settled communities first began to work the land, gardeners have carved out a space in the natural world. They cleared unwanted growth, tilled the soil, planted their seeds and reaped their crops. Over the years they began to enclose their fields, to protect their bounty from thieves, predators and invasive species. They invented methods to irrigate the land, supplementing the natural pattern of rainfall by controlling the flow of nearby water. And they learned to shape their lives to the rhythm of the seasons, cultivating the land through the warmer months and creating a surplus to see them through the winter.

Over the centuries the garden came to provide not only sustenance but also pleasure. It is not known when the first gardener chose to tend a plot to gratify the senses as well as nourish the body, but archaeologists speculate that by the middle of the second millennium BC, wealthy landowners in Egypt, the Middle East and east Asia were enjoying private gardens that were separate from their cultivated fields. To make that distinction, these landowners located such gardens close to their residences, enclosed them within walls, and planted them with flowering and fruit trees, fragrant herbs and climbing vines. Like the fields, these gardens provided a useful bounty: delicious fruits and nuts, grapes for making wine, and herbs for the production of medicines and cosmetics. Unlike the fields, however, these gardens were also sites for relaxation, and the plants grown in them did more than sustain the body. The fragrances of flowers and grasses scented the air. As fountains irrigated the garden, they cooled and refreshed the atmosphere and filled the enclosure with the soothing sound of running water. Above all, the arrangement of the plants – selected for colour, shape and proportion – delighted the eye.

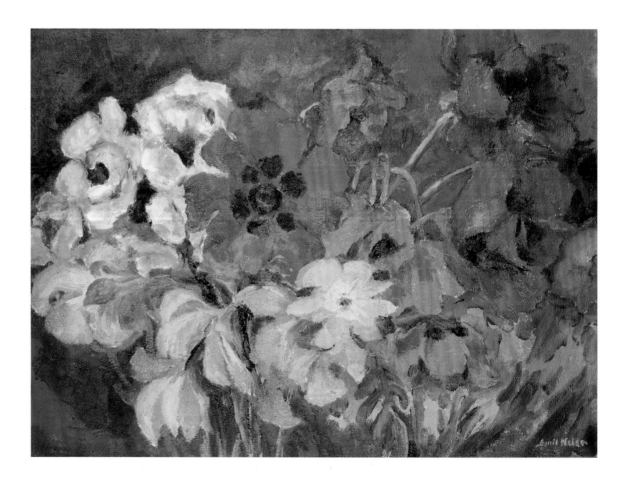

Emil Nolde
(1867–1956)
Üppiger Garten (Luxuriant Garden)
1945
Oil on canvas
74 × 101 cm (29⅛ × 39¾ in.)
Private collection

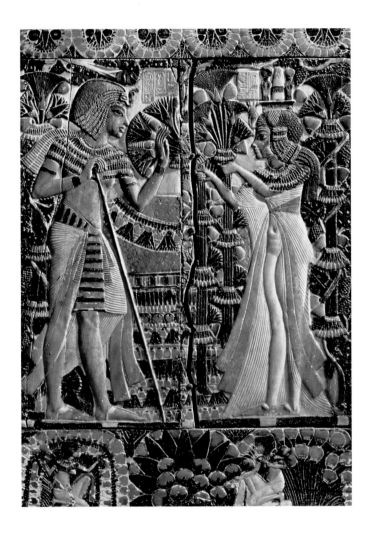

In gardens designed to please as well as provide, artifice enhanced nature, and the garden itself became a work of art.

Just as the gardener has explored and developed the aesthetic and sensuous possibilities of the garden, so artists have found gardens to be a rich and expressive motif for art. It will probably never be known when – or why – the first artist chose to make an image of a garden, but a universal reason can be found in the words of the German painter Emil Nolde (1867–1956). Nolde began to paint flowers early in his career, and would plant his own garden whenever he could. As can be seen in *Üppiger Garten* (Luxuriant Garden; opposite), his flower paintings featured the close observation of full-blown blossoms in vivid, unrestrained colour. Nolde painted this cluster of poppies and roses late in his career, but he recalled that it was the beauty of summer flowers at the height of the season that initially inspired him: 'The colors of the flowers attracted me irresistibly and at once I was painting.'[1] But Nolde also recognized in flowers something more poignant than sheer beauty; he equated the transience of that beauty with the brevity of human life. He wanted to capture the glory of flowers before they perished.

The ten chapters that follow explore the various motives behind the portrayal of the garden in art. Although the development of the art of the garden and the depiction of the garden in art are inextricably intertwined, here the selected themes reveal that a rendering of a garden often transcends the simple objective of representation. Art can preserve the image of gardens that have been lost or have changed over time; likewise, art can dissolve the garden wall, offering a glimpse into a privileged space. Drawing on the language of ideas and the context of culture, the image of a garden can be ripe with meaning. Artists sometimes create their own gardens, experimenting with colour using living arrangements before committing their discoveries to canvas. They can also create a garden out of ideas, giving form to a design that exists only in the realm of the imagination. Whether a reflection of the real world or a door opening on to a fanciful domain, the motif of the garden in art – like the garden itself – celebrates the deep and enduring bond between humanity and nature.

Although the archaeological evidence of gardening pre-dates surviving garden imagery by more than 7000 years, garden historians rely on art to reconstruct the plans and plantings of ancient gardens.[2] The oldest known image of a garden is an ancient Egyptian relief sculpture, dated to *c.* 3000 BC, that depicts an enclosed palm tree and a system of waterways. Also found in Egypt was a three-dimensional miniature model (*c.* 2000 BC) of a house portico with an enclosed garden featuring a pool and a variety of trees. By the fifteenth century BC, gardens appeared as a regular feature in Egyptian tomb paintings, and the high degree of naturalism – not only in terms of plant and flower species but also in terms of human activity – has helped scholars to gain a thorough understanding of ancient garden practices in the Lower Nile region.

In their original context, however, these images served a greater purpose than straightforward documentation. Almost without exception, ancient Egyptian garden imagery was associated with the elaborate tomb furnishings created to facilitate the passage of royal figures and important citizens to the afterlife. The painted-ivory coffer lid found in the tomb of Tutankhamun (left)

Egyptian School
Plaque from the lid of a coffer, from
the tomb of Tutankhamun

c. 1370–1352 BC
Painted ivory
Dimensions unknown
Egyptian National Museum, Cairo

Qiu Ying
(*c.* 1494 – *c.* 1552)
The Garden of the Wang Chuan Villa
(detail), after Wang Wei (699–759)

c. 16th century
Ink and colour on silk
Private collection

portrays the king and his wife in a garden. The queen hands the king bouquets of papyrus and lotus – symbols of the united kingdoms of the Nile – as well as a bunch of poppies. Then, as now, poppies were the source of opium, and in art they were associated with oblivion. This elaborate depiction, with its recognizable flowers, proclaims the belief that the king and his family will pass with ease into the afterlife, and will enjoy the pleasures of earthly existence, such as grape-laden vines, for all eternity.

The scholar's garden was a venerable motif in traditional Chinese landscape painting. A scroll by Qiu Ying (*c.* 1494 – *c.* 1552) depicting the Wang Chuan villa (below) offers a bird's-eye view of a real location: the retirement home of the renowned poet and painter Wang Wei (699–759), situated in the foothills of the Qinling Mountains. Tucked among the rolling hills and natural copses are small pavilions, rockeries and cultivated groves of trees. In accordance with the principles of Chinese garden design, the imposition of artificial features on the natural landscape can barely be discerned. The belief that a garden should 'look natural, though man-made' can be traced to the teachings attributed to the Chinese philosopher Laozi – compiled in the *Dao De Jing* (The Book of the Way and Its Power; *c.* fifth century BC) – which urged followers to submit to the ways of nature in order to find harmony in life.[3] The natural appearance of the Wang Chuan garden reflects these teachings.

Wang Wei lived during the Tang Dynasty (618–907), and his innovative landscape painting influenced the arts in China for centuries. But it was his poetry, as much as his garden, that inspired Qiu Ying of the Ming Dynasty (1368–1644) to create his beautiful vista of Wang's villa. Using analogy rather than description, Wang wrote a poem that evoked an imaginary journey through the undulating terrain of his garden. In an expert calligraphic hand, he

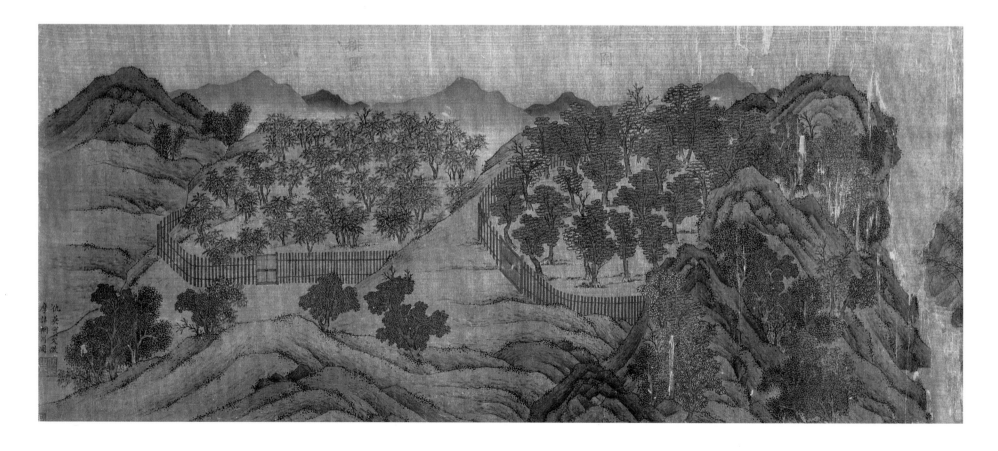

Lucas Cranach the Elder
(1472–1553)
Adam and Eve

1526
Oil on panel
117 × 80 cm (46 × 31½ in.)
The Courtauld Gallery, London

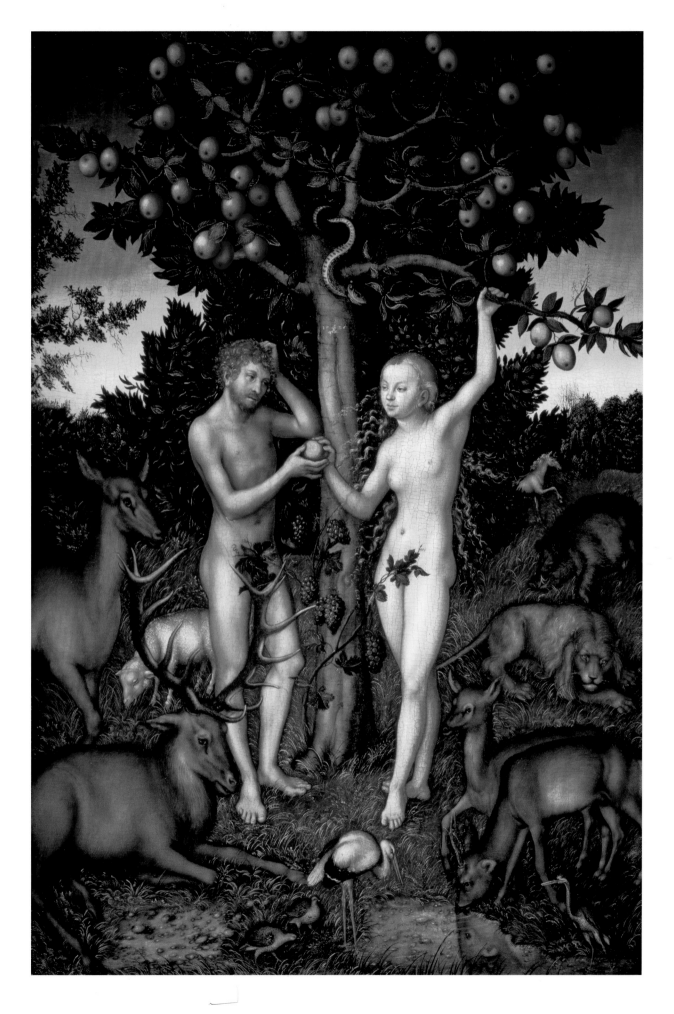

English School
Needlework picture
Early to mid-17th century
Satin silk ground embroidered with
coloured silks
27.5 × 42.5 cm (10⅞ × 16¾ in.)
Private collection

inscribed the poem on a silk scroll, which he also illustrated with an overview of his garden. In the generations that followed, such artists as Qiu Ying paid tribute to Wang's celebrated accomplishments in the four scholarly arts – poetry, calligraphy, painting and garden design – by creating in the traditional mode of landscape painting their own visions of the Wang Chuan villa, based as much on Wang's words as on his imagery.

Throughout history most cultures have envisioned an idyllic garden retreat where plants flourish, animals live in harmony, and nature – rather than human labour – provides sustenance. The origins of the word 'paradise' can be traced to the writings of the Greek historian Xenophon (*c.* 435–354 BC), who described the vast royal parks of the Persian kings as a *paradeisos*, or, in Persian, a *pairidaeza* (enclosure).[4] These spectacular pleasure gardens brought together flowering trees and plants, fountains and many species of exotic animals, all within a perfect yet natural domain. But the idea is far older than the name, and belief systems across the globe have distinct visions of paradise. The oldest known written description of such a place can be found in the Akkadian Epic of Gilgamesh (*c.* 1400 BC), in which the eponymous hero encounters golden trees and jewel-bearing plants in the Garden of the Gods. The ancient Greeks conceived of a sacred grove, where the nine muses danced for their father, Zeus; Zeus married Hera in another paradise garden, the Garden of the Hesperides, located at the edge of the world. Aztec pleasure gardens featured their own form of the *pairidaeza*, bringing together a diverse array of plants and animals in a single enclosure.

In Judaeo-Christian cultures the Garden of Eden is the prototype of paradise. Scholarly consensus dates the origin of the Creation story to the early years of the first millennium BC;

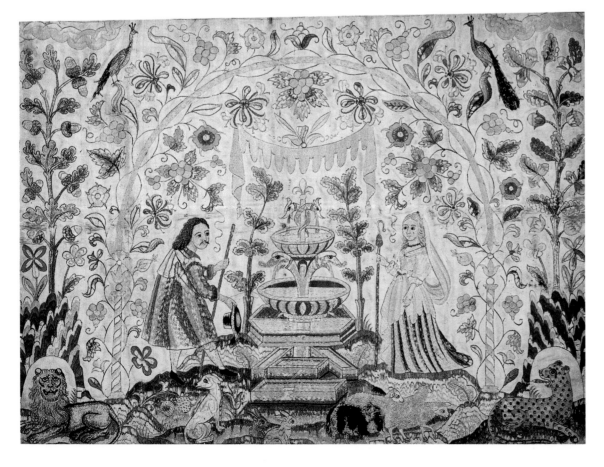

its roots and connections to similar tales in other cultures are undoubtedly older. After describing the creation of light, water, land and life, the book of Genesis states that 'God planted a garden in Eden … and there he put the man whom he had formed.' Everything required for life was provided within the garden: 'every tree that is pleasant to see and good for food' (2:8–9).[5] In the arts, the Garden of Eden is often a setting for the moral drama at the centre of Genesis. *Adam and Eve* (page 9) by Lucas Cranach the Elder (1472–1553) portrays the well-known scene of transgression; after eating the fruit of the Tree of Knowledge, Adam and Eve will be cast out of Eden. Cranach counterbalanced his warning of sin with the promise of redemption encoded in symbolic animals, such as the sheep, representing a devoted flock, and the antler-less roebuck, an emblem of the incarnated Christ as an innocent saviour at the mercy of humanity.

The Judaeo-Christian paradise garden also provided a metaphorical setting for marriage. The nameless man and woman in a seventeenth-century English embroidery

Netherlandish School
Garden scene from *Roman de la Rose*
(Harl. MS 4425 f.12v)

c. 1490 – *c.* 1500
Vellum
Dimensions unknown
The British Library, London

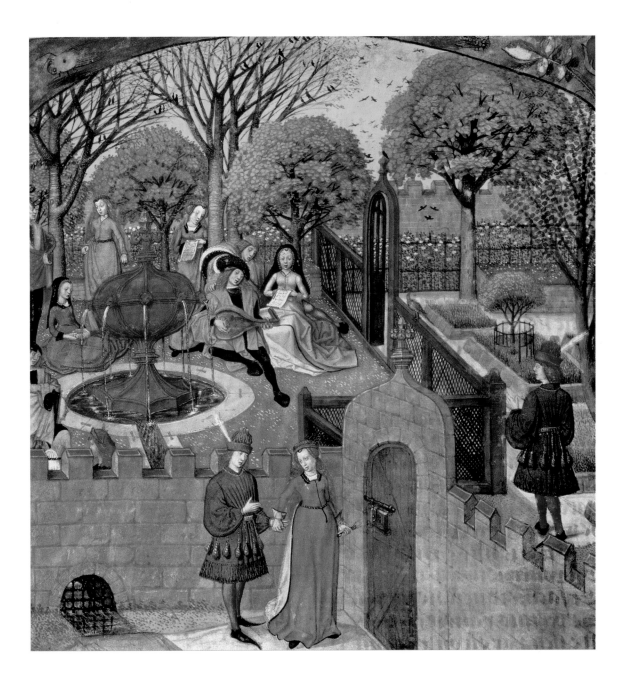

(opposite) stand in a luxuriant bower, surrounded by plants and animals of every description. Between them is a fountain similar to the 'garden fountain, a well of living water' described in a loving conversation between a bride and groom in the Song of Solomon (4:15). The arbour that arcs above the couple in the embroidery is twined with grapes and honeysuckle, matrimonial icons representing a bounteous life and a sweet union. These symbols suggest that the needlework was made as a wedding gift to wish the bride and groom the pleasures of paradise.

Images of paradise gardens record the garden-design elements of an artist's time, but, as artistic creations, they elevate the real to the ideal. An illumination of the garden scene from the medieval French poem the *Roman de la Rose* (above) allows the viewer to see behind the strong, defensive walls of an immaculately tended fifteenth-century pleasure garden, in which handsome men and comely women sit on a clipped lawn under the shade of well-trimmed trees. As in the English embroidery, the fountain recalls the enclosed garden in the Song of Solomon, but here the water streams down a channel and out into the wider world, simulating the river that flows

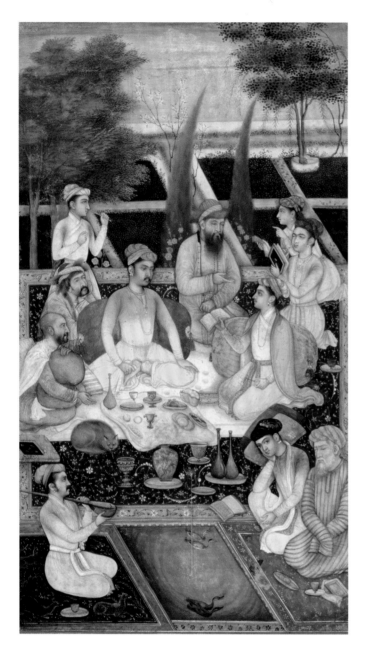

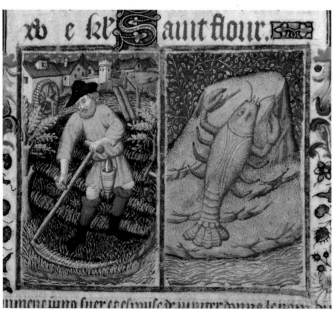

out of Eden. The rivers of paradise also influenced Persian garden design. The *chahar bagh* (four-fold garden) has roots in the innovative irrigation systems developed in ancient Persia. The garden's distinctive layout – centred on four water channels flowing in the direction of the main points of the compass from a central fountain – became standard during the Sassanian Era (224–651), although the basic design is likely much older. After the seventh century, with the rise of Islam, these channels came to represent the four rivers – of water, milk, honey and wine – that flowed out of paradise. A seventeenth-century illumination of two Indian princes seated on flower-patterned carpets (left, top) depicts secular pleasure, but is linked to a sacred idea: the magnificent garden, with its shade trees, cool waters and fragrant flowers, is a terrestrial microcosm of the gardens that will reward the faithful in the celestial paradise.

In the book of Genesis, after Adam breaks his oath to God, he is forced to provide food by his own toil: 'In the sweat of your face you shall eat bread' (3:19). But even in prelapsarian Eden he was bound to the land with an obligation of stewardship; an earlier passage states that 'God took the man and put him in the garden of Eden to till it and keep it' (2:15). In medieval Europe, labour on the land developed significance as a metaphor for a purposeful human life. When Ælfric of Eynsham, an eleventh-century English abbot, was asked to name the most essential human endeavour, he singled out agriculture, 'because the Ploughman feeds us all'.[6]

Such ideas took shape in the iconography of the Labours of the Months, medieval cycles of images depicting the rural activities associated with each month. Land workers had been featured in the art of many cultures of the ancient Middle East and Mediterranean, but the medieval schemes developed out of Roman imagery that allied seasonal activities with the calendar year. By the thirteenth century, the labours appeared as a subject in sculpture, stained glass and textiles, but they are most closely associated with the miniatures painted for books of hours, illuminated collections of daily and annual Christian prayers. In such books, each month is represented by a calendar page, and although the specific motifs are wide-ranging, two elements are standard: the astrological sign for the month, and the work activity associated with the season. A detail from the June page of the *Bedford Hours* (left, bottom) presents the first summer harvest paired with a crustacean representing a crab, the emblem for Cancer. While the accurate observation of manual labour in late medieval illustrations provides an authentic document of historic farm work, these luminous miniature paintings also portray an ideal world of flourishing fields and healthy farmers working in harmony with both nature and divine will. The Labours of the Months proved to be an enduring iconography, and over the centuries, as they shed their religious connections, they have become versatile symbols of the cycle of the seasons, reflecting changing times as well as persistent traditions.

The aristocratic circles of medieval Japan marked the changing seasons with flowers. *Hanami*, or flower-viewing festivals, began as a courtly diversion during the Nara period (710–794) and became an established practice in the Heian period (794–1185). Each spring, elegant men and women would gather in cherry groves to catch a glimpse of the ephemeral beauty of the *sakura* (cherry blossom). Poets celebrated the annual event in verse: 'Every spring / I make sure to look at them … I never weary of the sight.'[7] Over the years other festivals extended the viewing pleasure: wisteria in late spring, irises in the summer, *momiji* (red maple leaves) in the autumn.

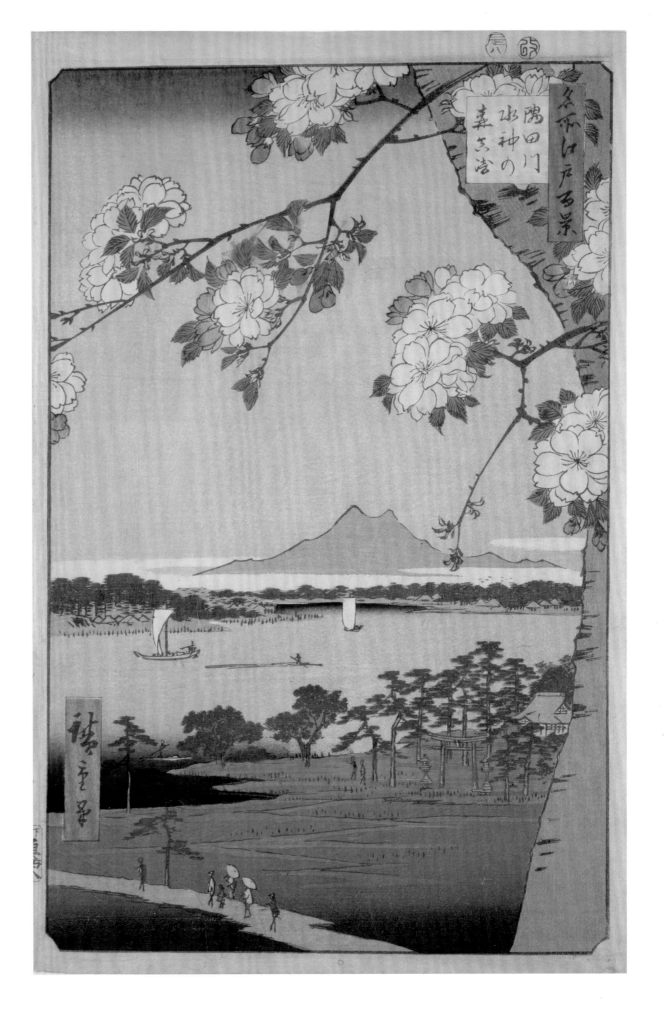

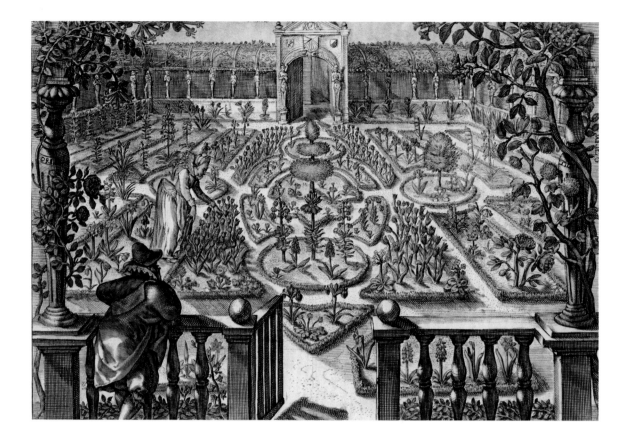

During the Edo period (1603–1868) the practice was adopted by the growing middle class, and by the nineteenth century tourist sites, with convenient transportation and tea houses for refreshment, brought diverse crowds to famous gardens. The master printmaker Utagawa Hiroshige (1797–1858) highlighted the most popular sites in his *One Hundred Famous Views of Edo*. His view of the Sumida River (page 13) features a *yaezakura*, a cherry hybrid with blossoms – often double – of more than five petals.[8]

The *Hortus Floridus* (Great Book of Flowers; 1614), part of which was engraved by Crispijn de Passe I (1564–1637), also used flowers to chart the seasons. As an innovator in botanical illustration, De Passe transformed the format of the traditional medical herbal book into a florilegium (a compendium of flowers). De Passe's engraved plates were individually hand-coloured, and each section of the book presents an array of seasonal plants – mostly flowering bulbs – as they would be seen growing in the soil. He also provided perspectives of seasonal gardens, as in *Spring Garden* (above). De Passe's meticulous observation provides a detailed record of a Dutch formal garden embellished with ornamental elements taken from Italian Renaissance garden design. Geometric beds with box borders feature spring bulbs – hyacinths, daffodils, tulips – in full flower. Raked gravel paths separate the beds, and perfectly clipped topiary punctuates the symmetrical composition. The whole garden is enclosed by a low wall crowned with caryatids; a barrel arbour covered with vines rises directly behind it. The architectural elements, such as the terrace in the foreground, suggest that this garden is attached to a grand house. The well-dressed man leaning on the balustrade can be assumed to be the owner, and his posture invites the viewer to look over his shoulder and admire the garden as proof of his wealth and social position.

Jacques-André Portail
(1695–1759)
*View of the Gardens and the Chateau
of Versailles from the Neptune Fountain*

c. 1742
Gouache on paper
52 × 73 cm (20½ × 28¾ in.)
Château de Versailles

The gardens of the royal chateau at Versailles remain the greatest example of the garden as a symbol of status. Shortly after attaining his majority, Louis XIV commissioned a grand renovation of the former hunting lodge, and the first building campaign (1662–68) laid out the grounds in a vast axial plan that imposed a new order on nature. Under the masterful direction of French landscape architect André Le Nôtre (1613–1700), broad avenues were cut through old copses, fully mature trees were moved from other sites to create ideal groves, and wide terraces were planted with impeccably manicured parterres and embellished with ornamental fountains. Designed to impress, the gardens at Versailles inspired French poet Jean de La Fontaine (1621–1695) to declare: 'So great a Number of beautiful gardens and sumptuous palaces are the glory of a Nation. Then what do not Foreigners say?'[9]

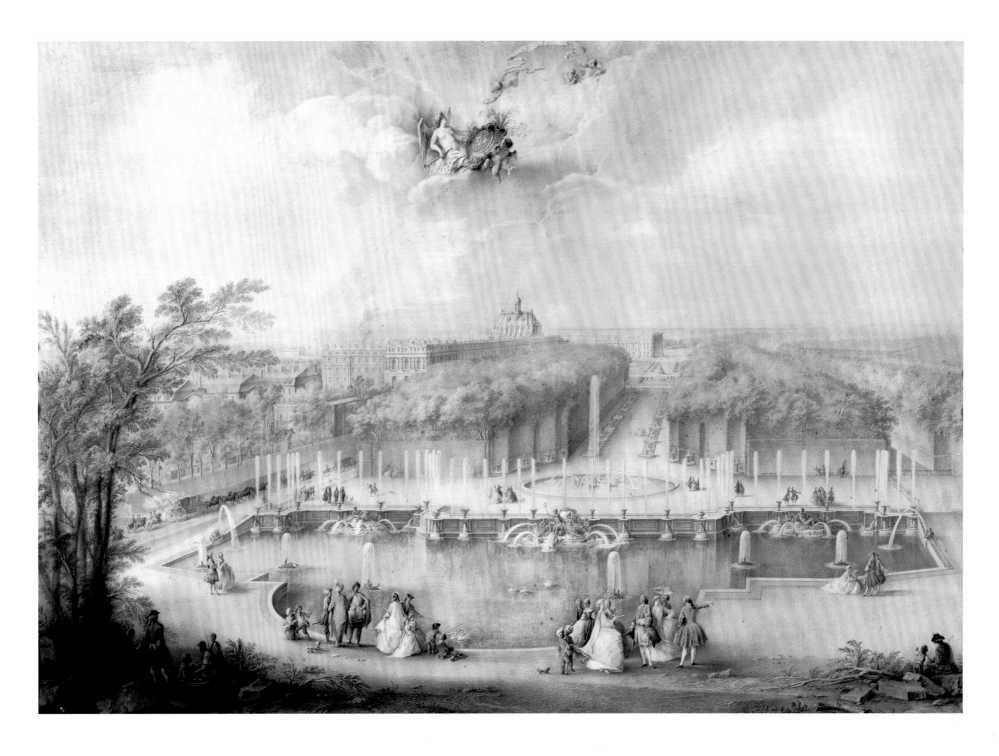

Le Nôtre designed the gardens to be seen from the private chambers of the upper storeys of the chateau, and this bird's-eye perspective proved to be the best visual device for conveying the grandeur of the gardens in art. Such views not only documented the stunning features of the most magnificent gardens in Europe, but also allowed the viewer to see the vista through the eyes of an elite patron or a privileged guest. One view (page 15), painted by Jacques-André Portail (1695–1759) during the reign of Louis XIV's heir and great-grandson, Louis XV, showcases the Neptune Fountain (1733–36). Beyond the water jets, a wide avenue flanked by walled-in woods extends towards the horizon. Like a stage manager, Portail arranged a company of figures in the foreground – stylish courtiers, exotically dressed emissaries and picturesque peasants partly hidden in the shadows – to enhance the theatrical atmosphere. There is even a figure of Fame in her airborne chariot; her trumpet is at hand, ready to herald the arrival of the king.

By the time of Louis XV's reign, British landscape architects, including Batty Langley (1696–1751), Lancelot 'Capability' Brown (1715–1783) and Humphry Repton (1752–1818), were rivalling French formalism with an approach to garden design that enhanced the contours of the land rather than subjecting them to an imposed geometrical order. In their books, as well as in their commissioned gardens, they advocated a softer, more naturalistic aesthetic, which featured curving paths, rolling hills and a controlled overgrowth that appeared to be the result of time rather than deliberate cultivation. Throughout Europe, gardens that were once meticulously manicured were encouraged – at least in sections – to grow wild, as seen in the romantic depiction of a small park in the grounds of the Villa d'Este in Tivoli (left) by Jean-Honoré Fragonard (1732–1806). A lush canopy of trees encloses a little grotto, making this quiet corner the perfect location for a lovers' tryst.

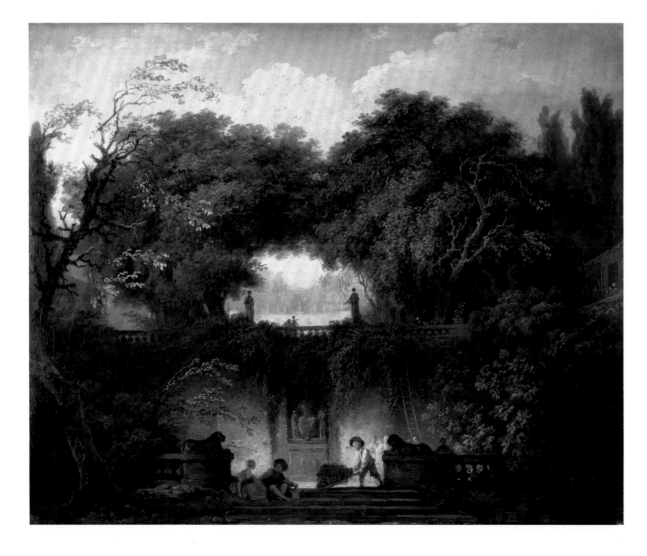

During the eighteenth century, aristocratic and elite estate owners began to give the public limited access to their grounds, and famous gardens became an essential feature of the European Grand Tour. Artists joined the growing ranks of tourists, and in addition to documenting notable sights, they sought to capture the sensation of being in a specific garden, as seen in *The Fountains of Versailles* (opposite) by J.M.W. Turner (1775–1851). Turner has obscured the grand design with clouds of atmospheric mist; rather than recording the view, he shares the intimate experience of a visitor's first-hand response to the garden.

The motto *Urbs in horto* (City in a Garden), commemorating the incorporation of the city of Chicago in 1837, reflects a growing trend on both

J.M.W. Turner
(1775–1851)
The Fountains at Versailles
1826–33
Watercolour on paper
14 × 19 cm (5½ × 7½ in.)
The British Museum, London

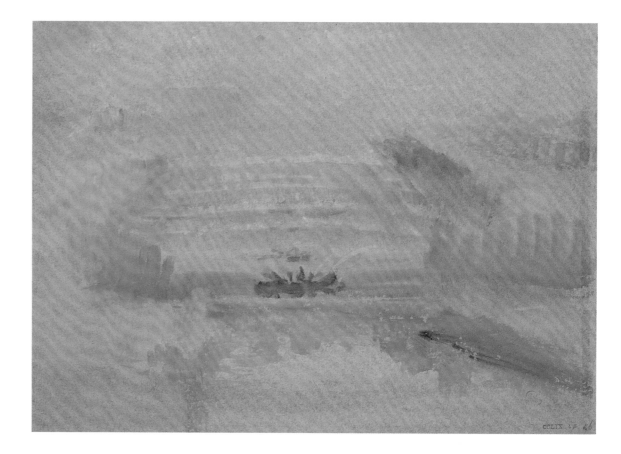

sides of the Atlantic during the nineteenth century. Throughout this period, gardens, parklands and zoos were built with civic funds to improve urban life. Royal domains, such as Kew Gardens in London, passed into the hands of the state, and large tracts of municipal property, such as New York's Central Park, were designated as open lands and developed for public recreation. The best example can be seen in Paris, where over the course of only a few decades the amount of public land increased almost a hundredfold.[10] Parks and gardens, a central feature of the grand renovation plan designed by Georges Eugène Haussmann under the agency of the Second Empire (1852–70), provided an open-air setting for modern, middle-class life. Parisians gathered in the Jardin des Tuileries for free concerts, met their fashionable friends in the Jardin du Luxembourg, and packed hampers for picnics in the Bois de Boulogne. Artists interested in capturing contemporary life took their easels out to the gardens to observe city dwellers of all walks of life and every generation enjoying their leisure in a public space (page 18).

Gardening at home also gained in popularity. During the nineteenth century light gardening and botanical study were regarded as decorous pursuits for middle-class women. Gardening tips were included in household and etiquette manuals, and such books as Jane Webb Loudon's *The Ladies' Companion to the Flower Garden* (1841) featured bouquet imagery, as well as botanical illustrations, in order to appeal to female readers. New technology, together with the repeal of the glass tax in England in 1845, allowed many homeowners to improve their property by adding a greenhouse or conservatory. More modest homes cultivated potted plants. During a trip to Paris, the Anglo-American horticultural writer Thomas Meehan (1826–1901) noted that the passion for plants had spread throughout the economic classes: 'The roofs, the windows, the backyards—wherever it is possible to stow away a flower, a flower is found.'[11] William Morris (1834–1896),

Félix Vallotton
(1865–1925)
The Luxembourg Gardens
1895
Oil on canvas
54 × 73 cm (21¼ × 28¾ in.)
Private collection

whose signature wallpaper and textile patterns were inspired by the flowers in his garden, promoted the integration of home and garden design. Such design movements as the Arts and Crafts Movement, the Aesthetic Movement and Art Nouveau explored the use of floral and plant motifs as a means of bringing the garden into the home, as seen in the full-blown poppies on a stained-glass lampshade by Tiffany Studios (opposite). In both garden design and home decor, favourite flowers ranged from such new imports as the Japanese iris and Chinese roses to such spectacular hybrids as multicoloured chrysanthemums, as well as more traditional blossoms, including lilies, poppies and sunflowers. Morris urged the return to such native plants as snowdrops and old roses; his advocacy paralleled the wild-flower movement in horticulture, launched by William Robinson's book *The Wild Garden* (1870).

The artists who embraced home gardening saw their gardens and conservatories as extensions of their studios. The conservatory of James Tissot (1836–1902) opened directly off his studio, and the lush, tropical plantings often appeared as a backdrop in his paintings (page 195). Few artists were more closely associated with gardens than the painters of the Impressionist circle.

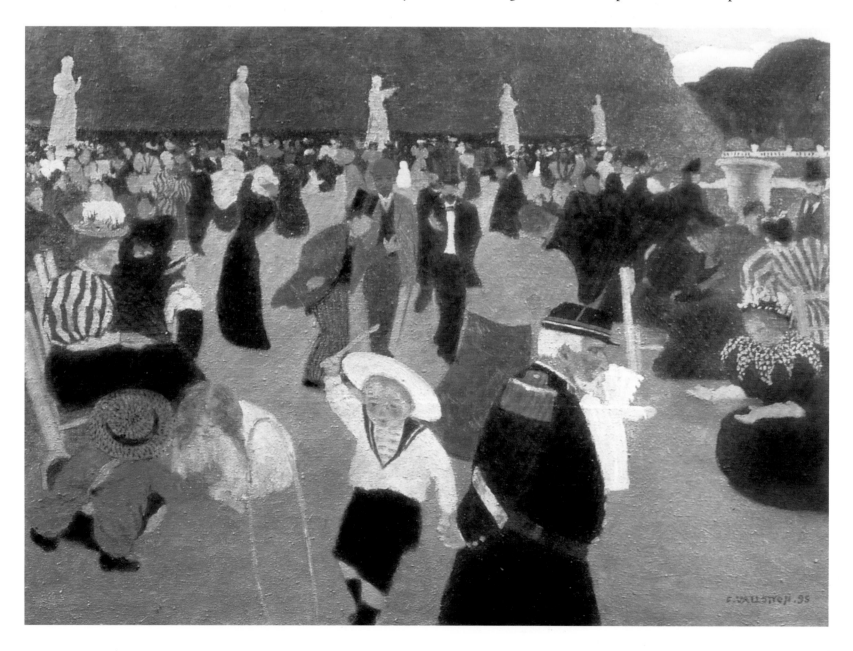

Tiffany Studios
Oriental Poppy floor lamp (detail)
1902
Leaded glass
Private collection

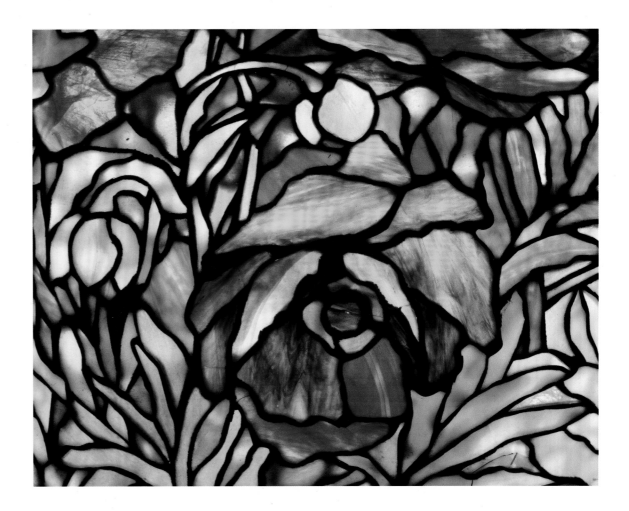

Claude Monet (1840–1926), for example, rented a villa in Ville d'Avray, at that time a small settlement to the west of Paris, in the summer of 1866. The villa's garden provided the setting for *Women in the Garden* (page 20), one of Monet's first large-scale experiments working outdoors in natural light. His first wife, Camille Doncieux, posed for each of the figures, but the painting is neither a portrait of Camille nor a record of the garden. Monet sought and captured the sensations of light, heat and fragrance: the pleasures of a garden on a warm summer's day. As the members of the Impressionist circle married, bought property and raised their families, they came to favour home gardens. The intimate subject of friends and family relaxing in the garden provided another motif of contemporary life, as seen in the work of Monet and Berthe Morisot (1841–1895). The most passionate gardeners in the circle – Monet and Gustave Caillebotte (1848–1894) – considered their gardens to be more than just an extension of the studio; to them, they were an extension of their art.

Gardens also provided a setting for sentimental vignettes, which were especially popular in the United Kingdom and the United States in the second half of the nineteenth century. The garden offered a range of symbolic references – floral lore and iconography – that added dimensions of meaning, particularly if the subject was love. Towards the end of the century, however, artists increasingly employed natural settings for visual effects, seeking to express sensory and emotional experience through light and colour rather than through narrative. *Girl and Laurel* (page 21), a depiction by Winslow Homer (1836–1910) of a country girl surrounded by blooming laurel, may evoke thoughts of rustic nostalgia, but Homer's prime interest was in the

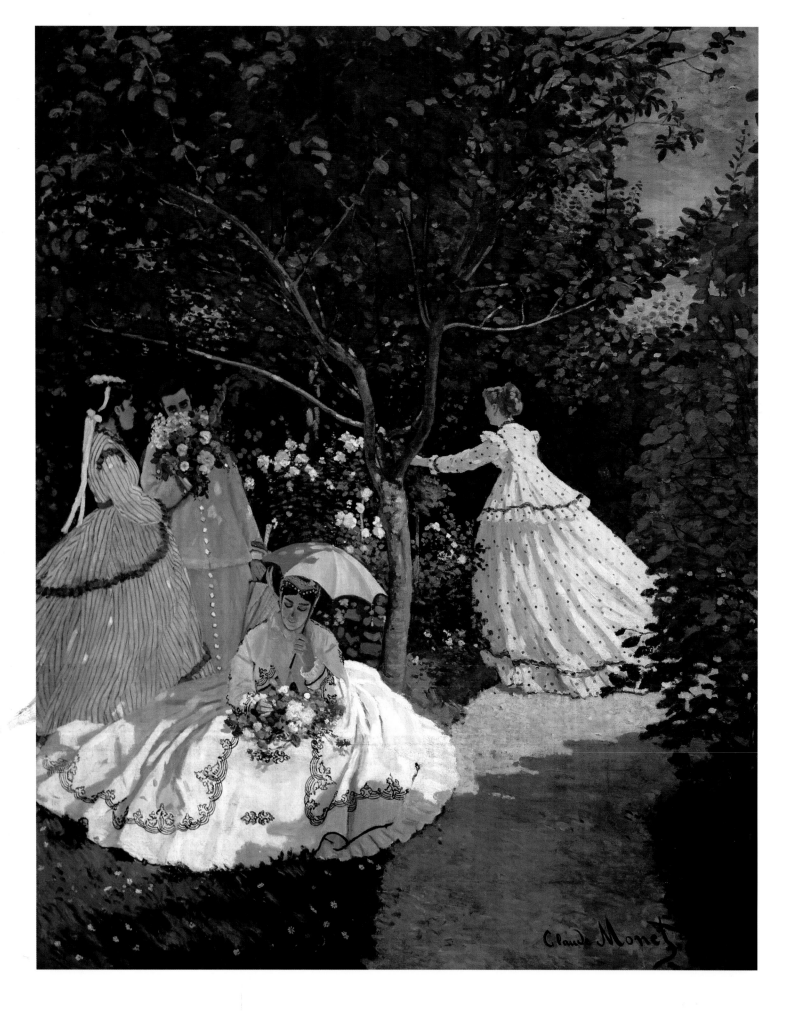

Claude Monet
(1840–1926)
Women in the Garden
1867
Oil on canvas
255 × 205 cm (100⅛ × 80¾ in.)
Musée d'Orsay, Paris

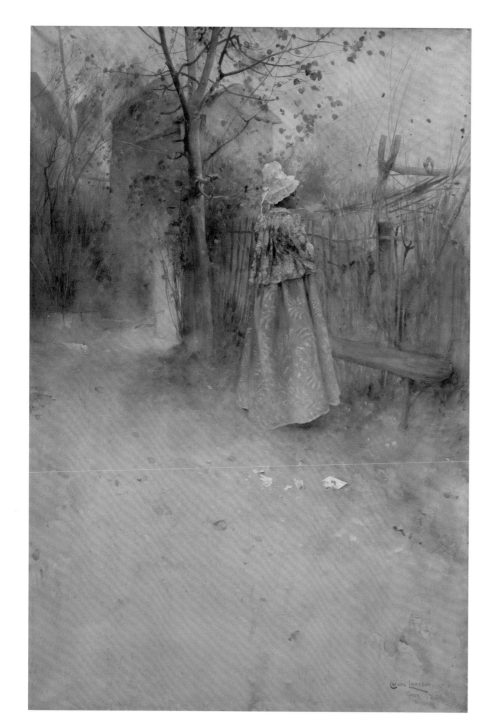

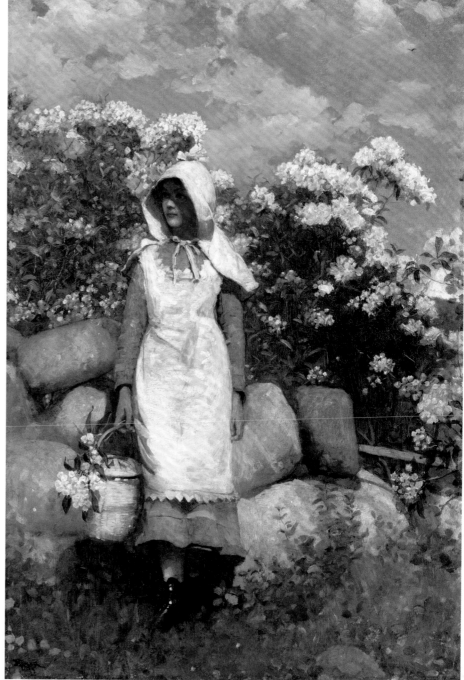

Carl Larsson
(1853–1919)
Autumn

1884
Watercolour on paper
92 × 60 cm (36¼ × 23⅝ in.)
Nationalmuseum, Stockholm

Winslow Homer
(1836–1910)
Girl and Laurel

1879
Oil on canvas
57.5 × 40 cm (22⅝ × 15¾ in.)
Detroit Institute of Arts

Paul Gauguin
(1848–1903)
Te Avae No Maria (Month of Mary)

1899
Oil on canvas
96 × 74.5 cm (37¾ × 29⅜ in.)
The State Hermitage Museum, St Petersburg

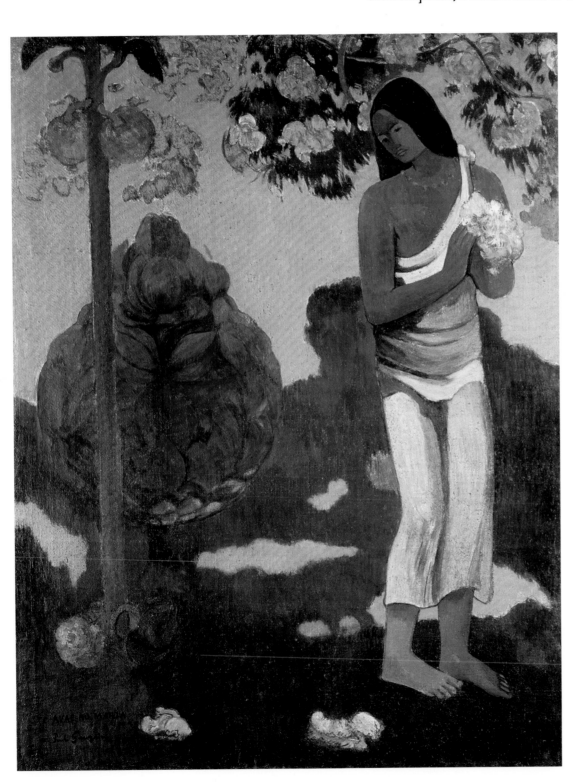

freshness of the air, the solidity of the rocks and the glorious colour of the blossoms under the sun. Likewise, *Autumn* (page 21) by Carl Larsson (1853–1919) – a watercolour of a solitary woman standing on dry, hardened ground beneath the nearly bare branches of a tree – has no associated story; rather, it is a study in mood and atmosphere. The cool, grey tones of Larsson's palette, as much as the woman's posture and the barren field, convey the chill of autumn.

The motif of the garden also provided a point of departure for artists' imaginations. During his second and final journey to the South Seas, Paul Gauguin (1848–1903) painted in the Marquesas, a remote chain of islands located to the north-east of Tahiti. The lush vegetation and abundant flowers he found there evoked a tropical paradise, but Gauguin constructed his exotic imagery (left) as much from memory, invention and fantasy as from his surroundings. Back in Europe, a new generation of painters, including Gustav Klimt (1862–1918), Paul Klee (1879–1940) and Nolde, would find the same creative release in local gardens, where the observation of nature opened the path to spiritual as well as pictorial discovery.

When master gardener Gertrude Jekyll (1843–1932) discussed plantings for a hardy flower border, she employed language that was as closely associated with painting as it was with gardening. She advised her followers to treat their flowers as pigments, and the border as a canvas. With careful attention to a 'distinct scheme of colour arrangement' and 'good harmonies', each section of the border would become 'a picture in itself' (opposite).[12] Jekyll's painterly considerations, as well as the way in which she composed her borders, reflected contemporary ideas in painting. Throughout history the two forms of expression – the garden, and the motif of the garden in art – have enjoyed a close and lively relationship, but each has dimensions that the other cannot simulate. No painting can ever fully convey the sensory effect of floral scent wafting through the air, the feel of rough bark or smooth petals, or the gentle sound of a trickling fountain. But a painting of a garden can take the viewer to another time or place, whether back in history, across the seas or into an artist's imagination. The pages that follow explore the many ways in which the garden in art can open doors to realms far beyond the confines of the garden itself.

Helen Allingham
(1848–1926)
A Bit of Autumn Border
n.d.
Mixed media on paper
20.5 × 15.8 cm (8⅛ × 6¼ in.)
Royal Watercolour Society, London

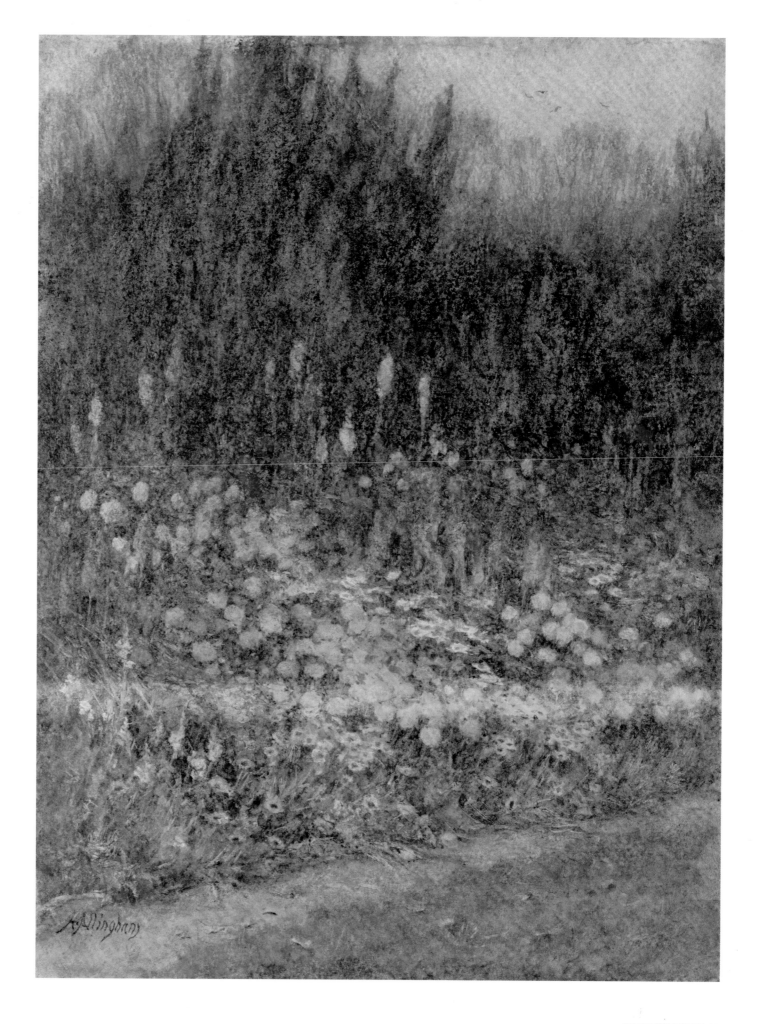

Through the Seasons

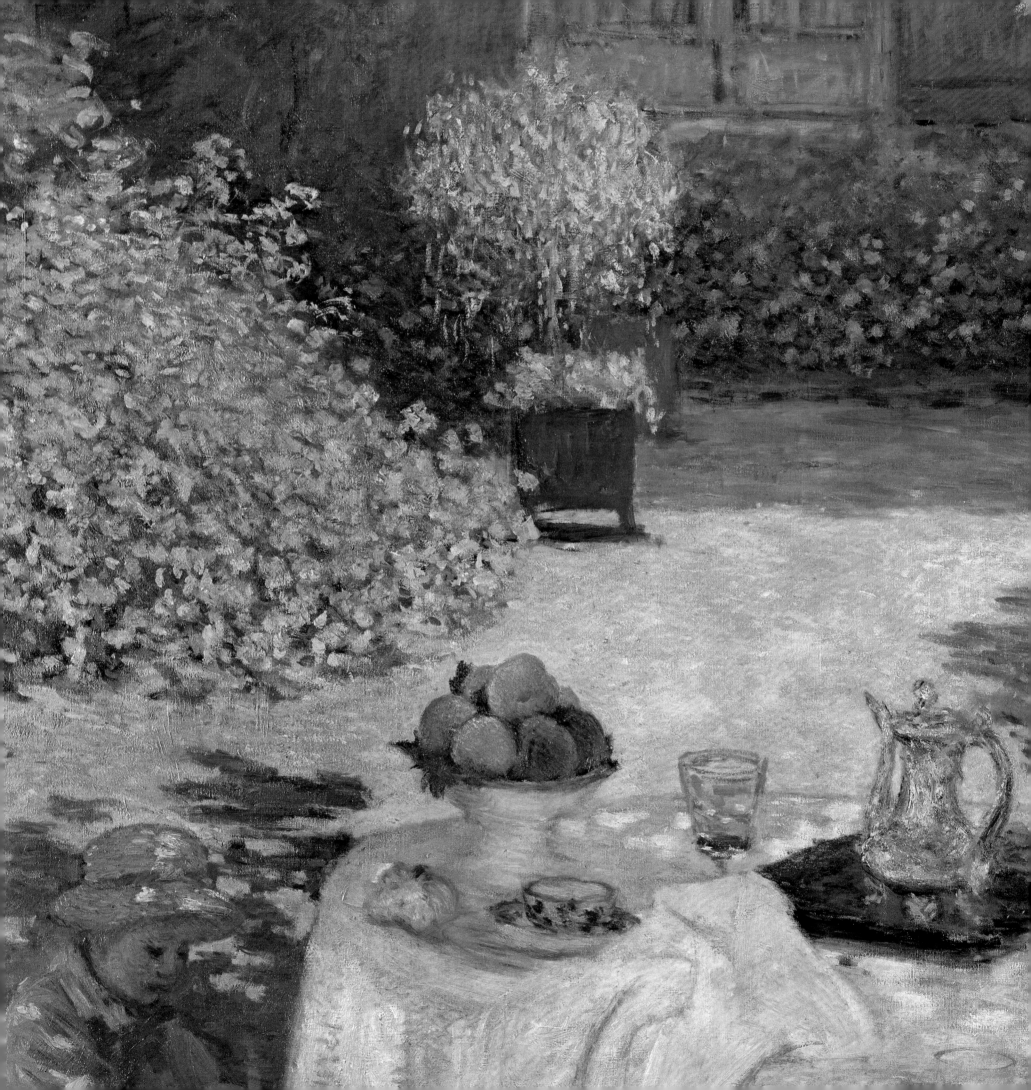

Late in October 1857, with a storm building in the north-east, American poet and essayist Henry David Thoreau (1817–1862) noted the signs of seasonal change in his journal. The river was rising, and as migratory birds were circling overhead, a few straggling sparrows huddled in nearby hedgerows. After years of studying the natural world, Thoreau recognized a profound connection between his own state of being and the annual cycle. What was once a series of observable phenomena had become 'simply and plainly … phases of my life'. Nature's rhythm set the pace for his own moods and perceptions, for, as he now realized, 'The seasons and all their changes are in me.'[1]

As a cultural theme, the innate connection between seasonal change and human experience finds its richest source of expression in the garden. In the ancient Mediterranean world, the bond was forged in the mythical courtship between Vertumnus, the Roman god of changing seasons, and Pomona, the Roman goddess of the orchards (opposite). At first she resisted his advances, but he won her heart eventually, establishing the ever-renewing cycle of burgeoning spring, verdant summer, bountiful autumn and dormant winter. Poets and artists personified the seasons in their verses and paintings. Such works range from Sandro Botticelli's timeless embodiment of spring in the form of an exquisite woman in a flower-sprigged gown (pages 30–31) to Mary Cassatt's portrait of a woman in autumn, wrapped in a heavy cloak and seated alone on a park bench surrounded by fallen leaves (page 39).

The enduring iconography of the Labours of the Months also had Classical roots, but found its most articulate form during the Middle Ages. By the late thirteenth century, books of hours merged the canonical year with the agricultural cycle, bringing together the activities of the sacred and secular worlds. Every season had its task: ploughing and planting in the spring, reaping the crops in the summer, clearing and harrowing the ground in the autumn (pages 29 and 38). Nature rewarded the mindful gardener with annual pleasures, such as a fragrant bower in spring, a lush grove in summer and an abundant harvest in autumn to nourish the household through winter.

At the very end of his journal entry, Thoreau assigns each season a colour: 'Spring is brown; summer, green; autumn, yellow; winter, white.'[2] But each season in the garden has more than a single hue; it has its own palette. In nineteenth-century Japan, tourists gathered to see the first pale plum blossoms in spring; likewise, they would travel to maple groves to see the last scarlet leaves of autumn. Such artists as the master printmaker Utagawa Hiroshige drew inspiration from these colourful yet fleeting displays (pages 28 and 37). In Europe, such painters as Vincent van Gogh and Claude Monet found their own seasonal language of flowers: sapphire-blue irises in late spring, vivid roses and geraniums in summer, the last golden radiance of sunflowers just before autumn (pages 32, 35 and 37). Winter, meanwhile, was more than simply white. Like Thoreau, Camille Pissarro closely observed distinctive seasonal phenomena; from a window high above the frost-covered Jardins des Tuileries in Paris, he saw that silver, mauve and violet – as well as white – were the colours of winter (page 41).

Hendrik van Balen I
(*c.* 1574–1632)
Vertumnus and Pomona
n.d.
Oil on canvas
105 × 131 cm (41⅜ × 51⅝ in.)
Musée de l'Hôtel Sandelin, Saint-Omer, France

Pomona, the Roman goddess of orchards, shunned the attentions of men. She tended her garden in contented solitude behind high stone walls, but Vertumnus, the Roman god of seasonal change, won her heart and hand through trickery. In Ovid's version of the tale, Vertumnus employed disguises in order to woo her – posing as a reaper, a herdsman and a hedger – but his ruse failed until he came to her as a kindly crone, singing praises of love. He convinced her that men and women, like plants in the garden, thrived in union, citing the example of the ivy and the elm: 'Had not the tree … wed the vine / Its only value would be its leaves.'[3]

Hendrik van Balen I depicts Vertumnus's triumph. The comely goddess – holding her attribute, a pruning knife – is so entranced by the crone's song that she allows the disguised suitor to embrace her while Cupid readies his bow. The monkey with the pomegranate, a fruit favoured by Venus, embodies erotic desire, but the peacocks honour Juno, the patron goddess of matrimony. The scene is framed by a rose trellis and a sturdy elm, twined with ivy. Like garden plants, Vertumnus and Pomona will flourish together, as the cycle of the seasons renews the abundance of the garden.

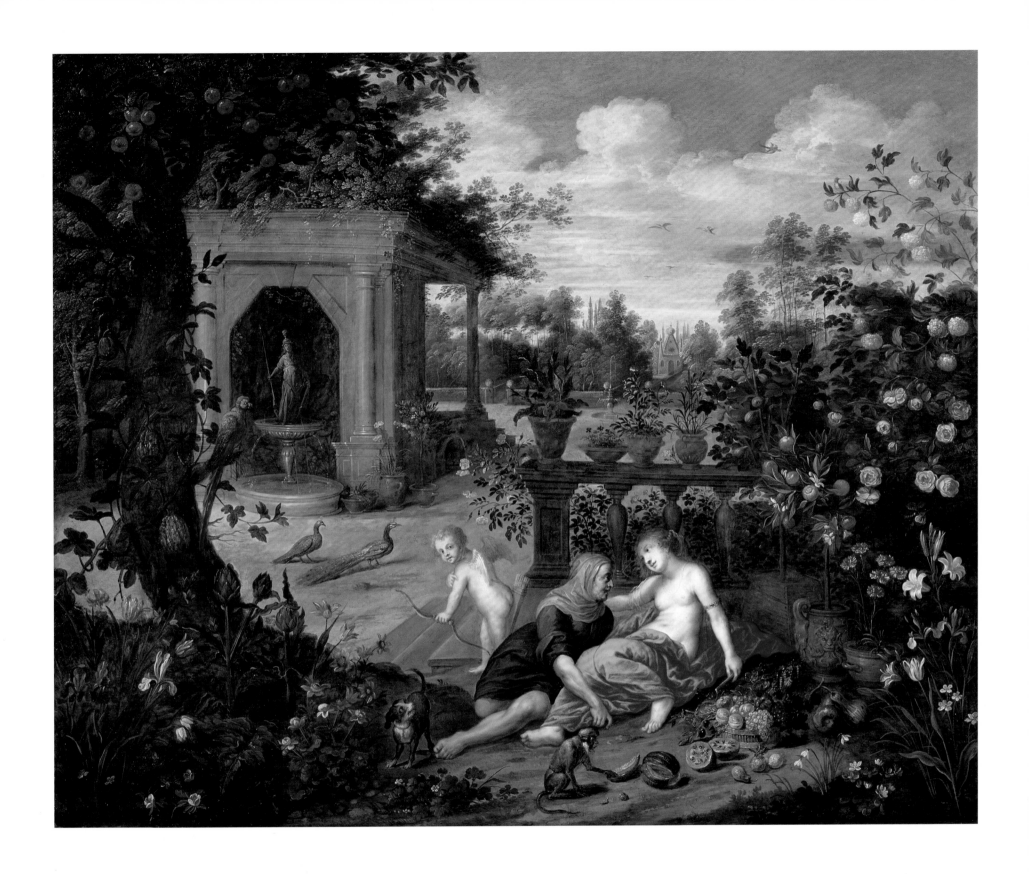

Utagawa Hiroshige
(1797–1858)
Plum Estate, Kameido, from
One Hundred Famous Views of Edo

1856–58
Colour woodblock print
Dimensions unknown
Galerie Janette Ostier, Paris

In Japanese floral lore, a blossoming plum
tree heralds the New Year. Together with the
pine and the bamboo, the plum tree is known
as one of the 'Three Friends of Winter' that
endure the season's cold, and although its
white flowers appear to be delicate, the tree
is an emblem of courage, for the buds must
push through the snow to bloom. The
opening flowers announce the coming of
spring, as celebrated in a haiku by the poet
Hattori Ransetsu (1654–1707): 'The warmth
grows by degrees; / One plum blossom after
another / blossom.'[4]

The particular plum tree featured in
Utagawa Hiroshige's woodblock print was
known as the 'Sleeping Dragon' (*Garyubai*),
a name inspired by its unusual growth
pattern. Branches from the original trunk
grew downwards into the soil, extended
underground and re-emerged as another
trunk bearing more branches and blossoms;
the tree's low-slung silhouette resembled
a mythical beast. Like the cycle of the
seasons, the famed tree embodied nature's
rejuvenating power, and its double blossoms
were renowned for their exquisite fragrance
as well as their bright colour. A guidebook
to Edo (modern-day Tokyo) describes the
blossoms as 'so white' that they 'drive off the
darkness'.[5] The centuries-old tree perished in
1910, in the aftermath of a great flood.

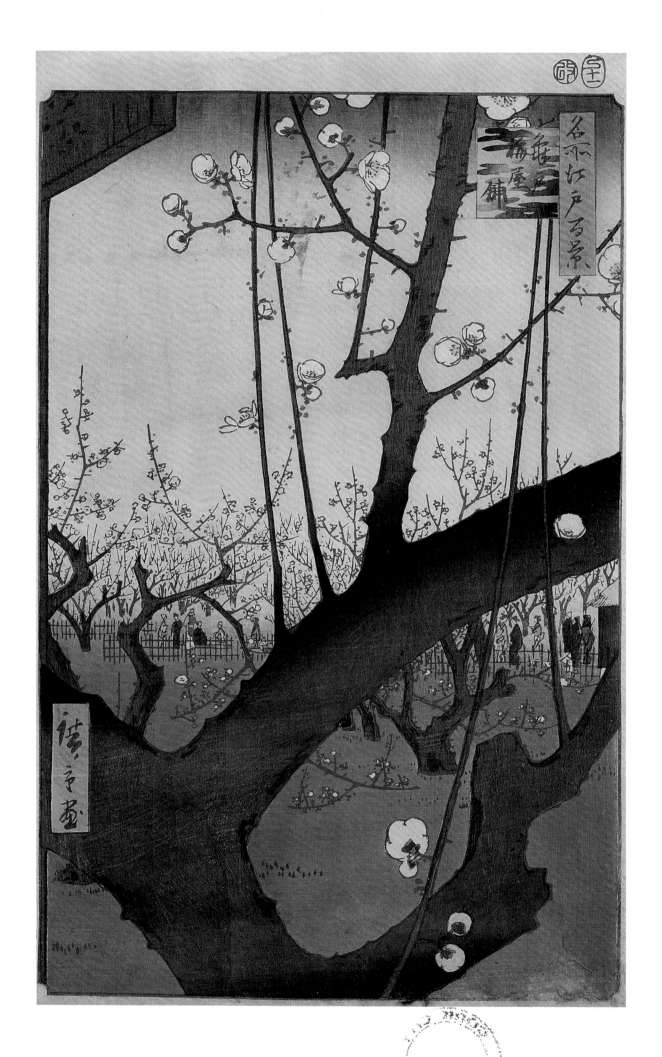

Limbourg brothers
(fl. 1400–16)
March, from *Les Très Riches*
Heures du duc de Berry
(MS 65/1284 f.3v)

c. 1411/13–16
Vellum
Dimensions unknown
Musée Condé, Chantilly, France

In the traditional scheme of the Labours of the Months, the work of the agricultural year begins in March. This magnificent illumination from *Les Très Riches Heures du duc de Berry* depicts the initial activities carried out in the cold spring air. As the ploughman in the foreground tills the soil behind his team of sturdy oxen, workers prune the vineyard's overgrowth, a shepherd watches his flock, and a man sifts seeds that have been stored in a sack. The countryside is as orderly as it is industrious, with each crop defined by low walls and cleared paths.

The Limbourg brothers – Pol, Jean and Herman – illuminated the aptly named *Très Riches Heures* for Charles V's brother Jean, duc de Berry; few books of hours match its scope and splendour. The calendar pages feature the duke's residences. Surrounded by fortified walls, the castle shown here is the Château de Lusignan, identified as such by the golden dragon sitting on top of one of the turrets; the little monument at the crossroads that divides the fields marks the region as Poitou. But daily life is as keenly observed as the handsome royal properties: note the patches on the elderly ploughman's tunic, and how his oxen strain to drag the plough through the hardened soil.

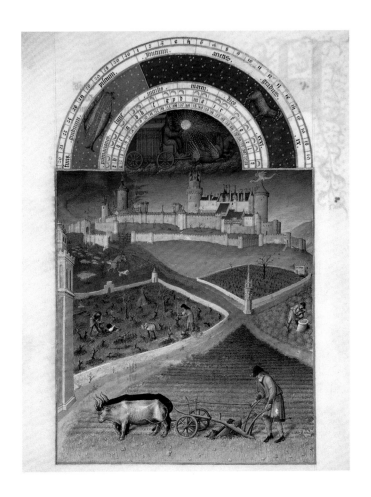

Workshop of Simon Bening
(c. 1483–1561)
April: Courting, from *The Golf*
Book (Add. MS 24098 f.21v)

c. 1540s
Vellum
Dimensions unknown
The British Library, London

Calendar pages of medieval books of hours often interspersed scenes of aristocratic leisure with those of agricultural labour. The April page in *The Golf Book* celebrates the onset of spring with a courting tableau in a castle garden. A strapping man in a fine, fur-lined surtout takes the hand of a demure woman in blue. They are both dressed in layered garments to guard against winter's lingering chill. But it is warm enough for the first wild flowers to be in bloom; a little child in yellow plucks them from the grass. To the left of the courting couple, on the other side of the bare lattice fence, a man in a yellow doublet trains a hawk; to their right, another couple lean over the fence to chat with a woman in the garden.

The Golf Book takes its name from an illumination of children playing a game of golf. Each calendar page features another game – in this case, one played with sticks and a cap – rendered in gold grisaille against a bright-blue background beneath the main illumination. But love is April's favoured pastime, and the detail in the upper left-hand corner of this page, of cranes building their nest atop a chimney, forecasts a good match between the man and his chosen lady.

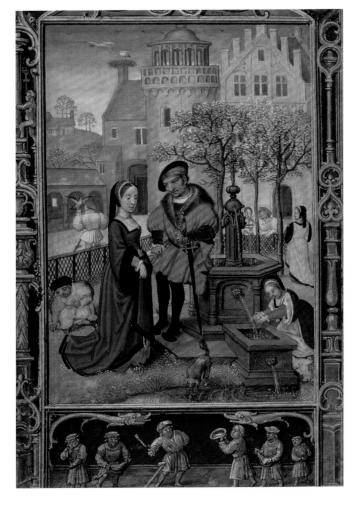

Sandro Botticelli
(1444/45–1510)
Primavera

c. 1482
Tempera on panel
203 × 314 cm (72⅞ × 123⅝ in.)
Galleria degli Uffizi, Florence

In Classical mythology, Zephyrus, the god
of the west wind, courted the nymph Chloris
with a domain of flowers, and they bore
a son, Carpus, whose name means 'fruit'.
In Botticelli's dazzling allegory of the arrival
of spring, we see Zephyrus fly in from the
right, his skin pale blue from the cold, and
his cheeks puffed round with the warming
wind. He embraces Chloris, who breathes
out flowers as she transforms into Flora,
the goddess of spring. The stately figure
of Venus presides over the transformation;
Cupid hovers above, aiming his arrows at
the dancing Graces. At the far left, Mercury
raises his *caduceus* (staff) to dispel any
lingering clouds.

 Botticelli's iconography seamlessly merges
the themes of love and the annual rebirth
of the natural world. The ancient Romans
welcomed spring with festivals of flower
tributes and dancing for Flora, also a fertility
goddess, and for Mercury, the god of the
shepherds. The setting, a bountiful apple
orchard, is Venus's realm, and more than
forty varieties of flowering plant common
to Tuscany bloom in the grassy meadow.
Originally installed outside the nuptial
chamber of Lorenzo di Pierfrancesco de'
Medici, the painting celebrates spring as the
season of love and life.

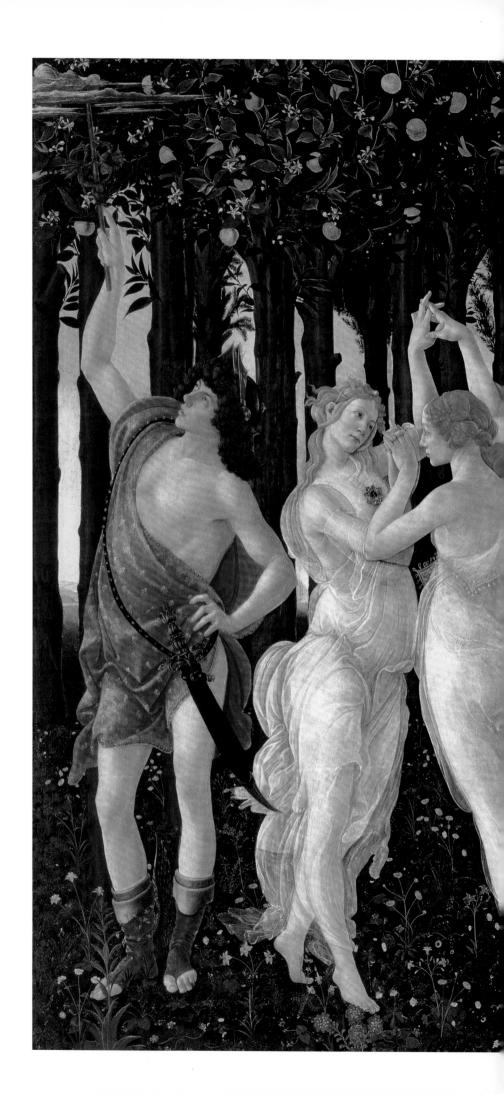

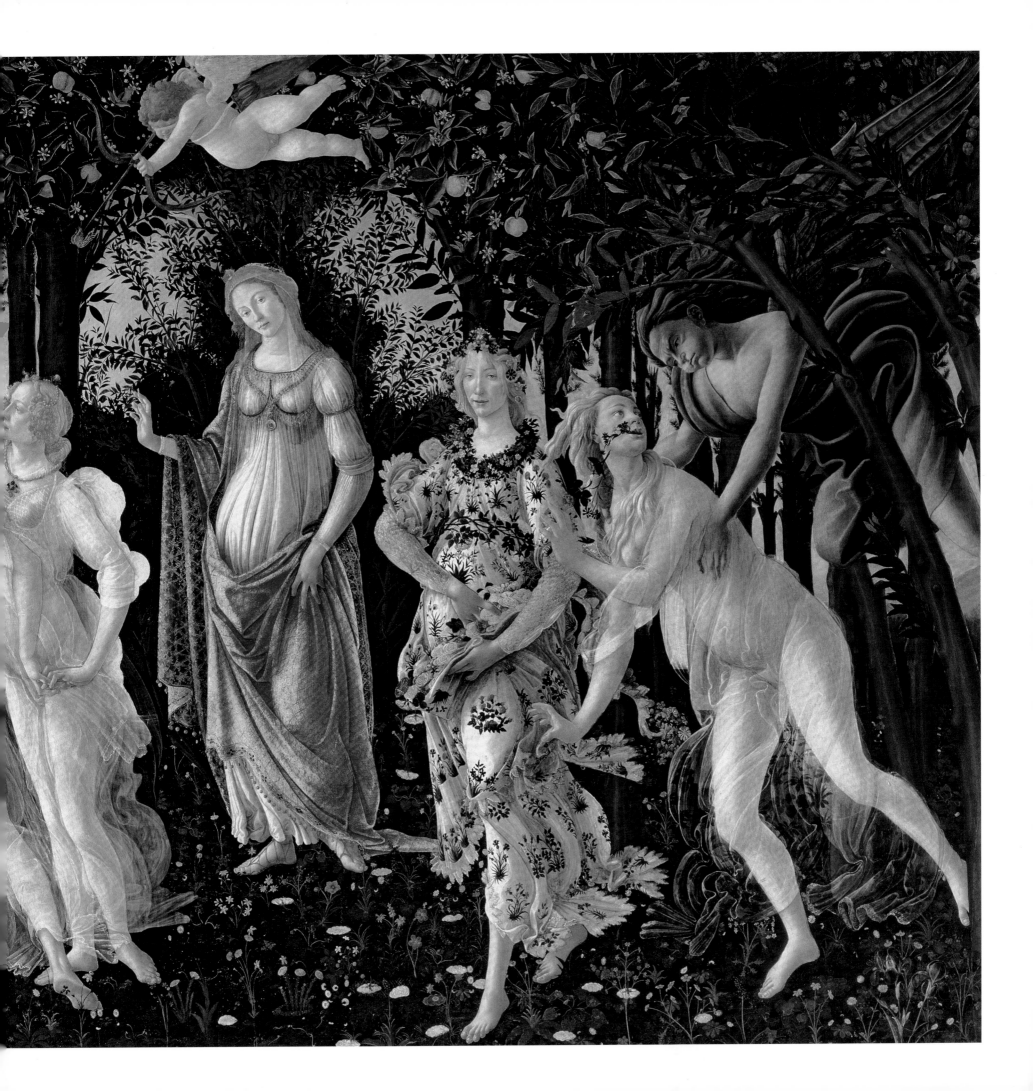

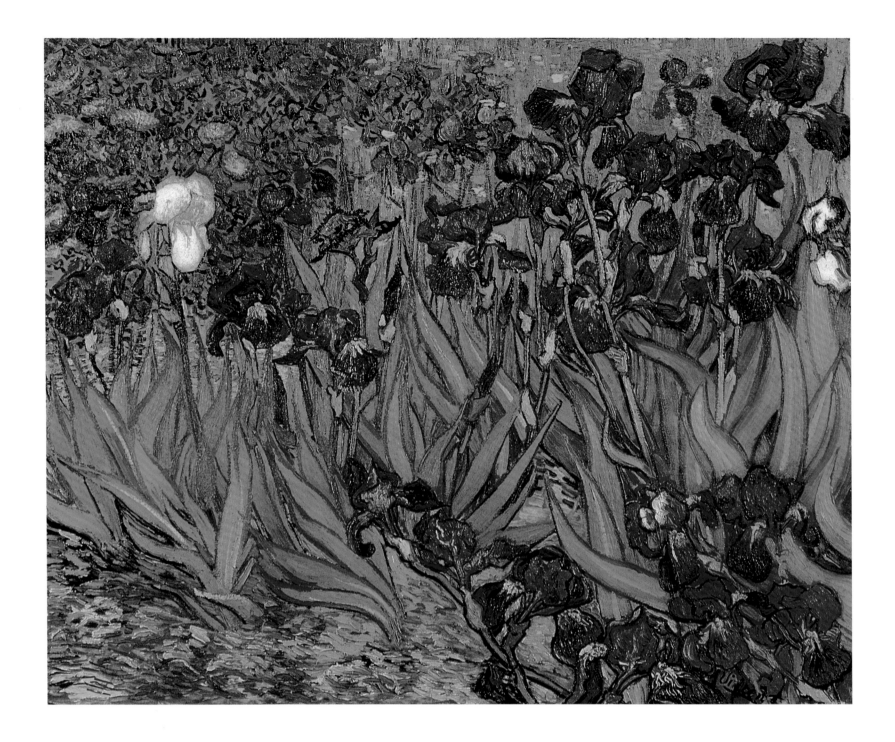

Vincent van Gogh
(1853–1890)
Irises

1889
Oil on canvas
71 × 93 cm (28 × 36⅝ in.)
The J. Paul Getty Museum, Los Angeles

Early in May 1889, after months of emotional turmoil, Van Gogh voluntarily sought treatment at the progressive psychiatric asylum Saint-Paul-de-Mausole in Saint-Rémy-de-Provence. His doctors recommended confinement to the hospital during the first month of his stay, and Van Gogh lamented to his brother Theo that he longed to paint outdoors because the bright hues of spring flowers would soon be replaced by the yellow of the wheatfield. Theo requested that his brother be given access to a ground-floor room with a view of the hospital's courtyard garden to use as

a studio. The garden had been neglected for years, but a dense patch of wild irises pushed up through the tangle of weeds and grasses. Van Gogh quickly set up his easel to capture the elusive moment of seasonal change in the form of one of his favourite flowers.

Throughout his troubled life Van Gogh found solace in nature's enduring cycle of change and renewal. With their sapphire blossoms, waving like standards on their tall stalks, the wild irises signalled the height of spring in Provence, and Van Gogh reassured his brother that capturing their fleeting beauty in paint helped to keep his melancholy at bay.

Vincent van Gogh
(1853–1890)
Wheatfield with Sheaves

1888
Oil on canvas
73 × 54 cm (28¾ × 21¼ in.)
Musée Rodin, Paris

To Van Gogh, the cultivated field, worked by the stalwart farmer, represented the ideal balance between human endeavour and nature. The yearly cycle of seasonal labour – tilling the soil, sowing the seed, reaping the harvest – gave meaning to life, and Van Gogh believed that painting these themes would likewise give meaning to his art. When he arrived in Arles in February 1888, he waited anxiously for the trees to blossom, an event that would signal the onset of spring. He followed the farmers into the fields and, in his own way, worked in unison with their labours; by June, the first grain was ready to be harvested.

In the traditional iconography of the Labours of the Months, threshing appeared twice: first in July, and then again in September or October. In the Mediterranean climate of Provence, the first crop of wheat came early in June, and Van Gogh boasted to his friend Émile Bernard that he painted throughout the day, without relief, in the burning sun of the open field: 'I enjoy it like a cicada.'[6] But *Wheatfield with Sheaves* captures the first morning light, which reflects off the wheat in a violet haze. The buildings of Arles, still engulfed in lingering pre-dawn shadows, loom in the distance.

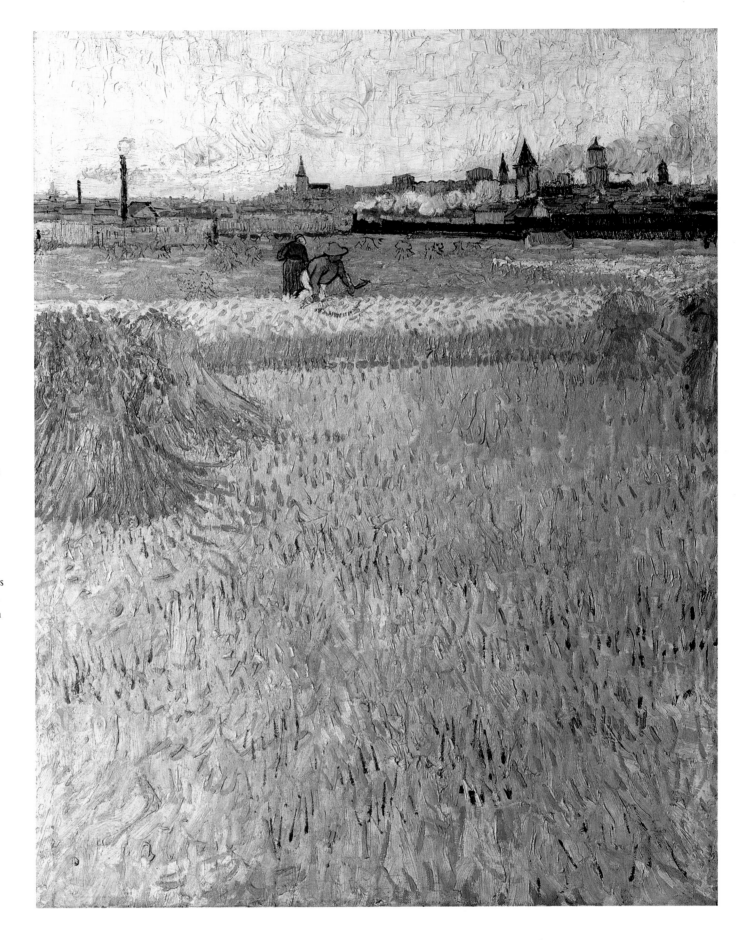

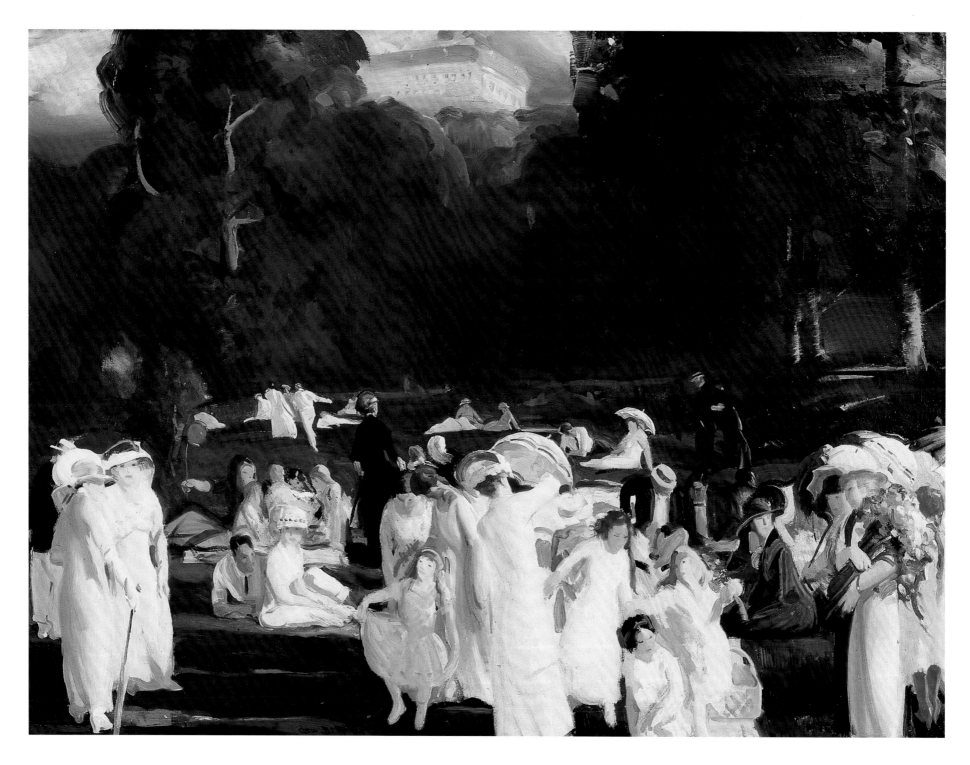

George Bellows
(1882–1925)
A Day in June

1913
Oil on canvas
106.6 × 122 cm (42 × 48 in.)
Detroit Institute of Arts

George Bellows moved to New York City in 1904. Walking the city's streets quickly became part of his daily routine, and whenever he could he spent time in Central Park. When he returned to his studio, he would transfer what he had seen to paper or canvas, preferring to work indoors rather than adopting the French practice of painting *en plein air*. Sometimes he summoned up impressions of earlier seasons, and in February 1912 he drew a black-and-white summer scene called *Luncheon in the Park*. The following year he expanded the idea into the painting *A Day in June*.

Working from memory, Bellows translated the sensations of heat and light into colour. The glare of the sun, blindingly bright on the white fabric of the women's dresses, conveys the feeling of the first hot day of summer. By contrast, the green sweep of the lawn, deepened by the shadows of the verdant trees, provides a sense of pleasurable relief. The crown of a high-rise building in the background, seen through a gap in the trees, identifies the locale as Central Park, an oasis of shade and space in the crowded city throughout the summer.

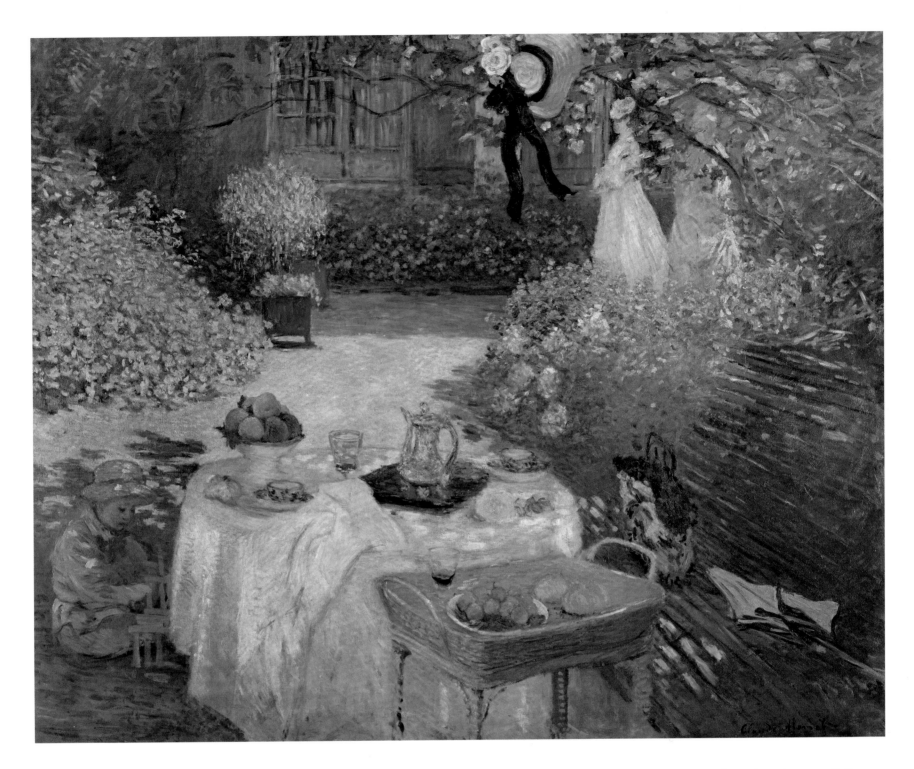

Claude Monet
(1840–1926)
*The Luncheon: Monet's Garden
at Argenteuil*

c. 1873
Oil on canvas
160 × 201 cm (63 × 79⅛ in.)
Musée d'Orsay, Paris

Beneath a canopy of leafy branches, a table and a wicker trolley bear the remains of a midday meal in the garden. Monet conveys this simple summertime pleasure through the suggestion of light, warmth and fragrance. The sun is high, but the trees cast cooling shadows. The roses, in full bloom, radiate the sensation of heat by means of vivid colour, and it is easy to imagine their heady bouquet mingling in the still air with the scent of ripe peaches and red wine. Two women stroll in the coolest reaches of the garden, while a small boy sitting in the shade by the side of the table plays with wooden blocks.

Monet knew these pleasures well. In 1872 he moved with his wife and young son to the suburb of Argenteuil, roughly 27 kilometres (17 miles) to the north-west of Paris. The house they rented had a large front garden, and during the warm months of the year family life moved outdoors. The summer paintings of 1873 and 1874 saw Monet introduce a new subject into his repertoire; portraying his own garden in full flower became the means by which he sought a productive harmony between his passion for nature, his artistic vision and personal contentment.

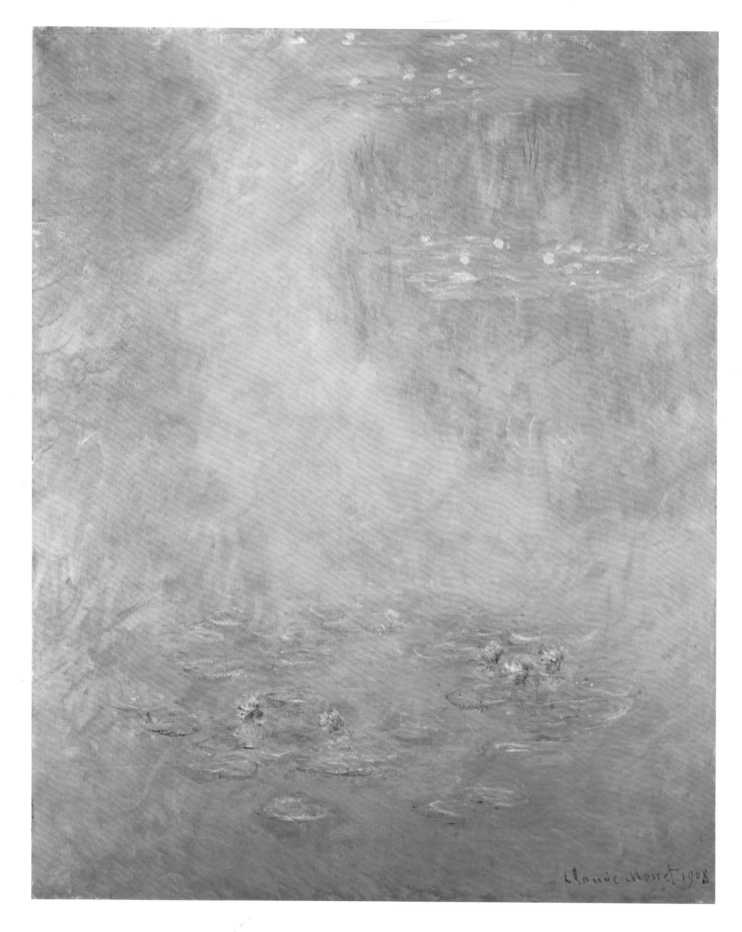

Claude Monet
(1840–1926)
Waterlilies

1908
Oil on canvas
100.7 × 81.3 cm (39⅝ × 32 in.)
National Museum Wales, Cardiff

During the first two decades of the twentieth century, the water garden at Monet's property in Giverny in northern France served as his summer studio. Every morning, at first light, he would set up his easel at the water's edge and begin to paint. As the sun reached its zenith, he would shelter under a large white umbrella so that he could continue to paint until mid-afternoon, when the lilies began to close. He often returned in the evening to study the subtle movements of the plants on the water's surface in the waning light.

Through close and constant observation, Monet translated atmospheric effects into light and colour, and the paintings of his *Nymphéas* series (1903–1909) convey the sensuous experience of high summer. Here, the hot noontime sun casts a shimmering glaze on the cool, blue water of the pond. The pink lilies are fully open, and their deep-green, raft-like leaves shine in the direct sunlight as they glide over the bright-green reflections of the leafy willow branches that hang overhead. These subtle variations of tone express the sultry qualities of moist, fragrant air and flickering light. When summer ended and the weather turned cold, Monet added finishing touches to these canvases in his studio, working indoors from memory.

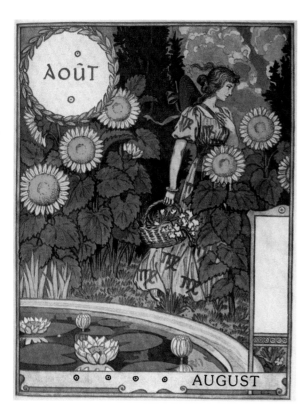

Eugène Grasset (1841–1917)
August, from *Calendrier de la Belle Jardinière*

1894–96
Lithograph on silk
20.3 × 15.5 cm (8 × 6⅛ in.)
Private collection

In northern climates the common sunflower grows quickly, and will bloom at any time between July and September. However, with its sun-like flower head of yellow ray florets encircling a darker mass of disc florets, it has long been associated with the peak of summer. In this illustration of August, designed as part of a calendar advertising the French department store La Belle Jardinière, Grasset continues the tradition. His tall, flamboyant sunflowers reign supreme in an overgrown, late summer garden.

Every plant is at its height, and every blossom in full flower. Grasset emphasizes the sunflowers' enormous flower heads, which crown lofty stalks mostly hidden behind a dense growth of foliage; the effect is that of a constellation of blazing suns. The open water lilies that float in the pool in the foreground echo the radiant form of the sunflowers, and the clarity of their reflections in the water suggests that the sun is at its peak, directly overhead. Playing on late summer's natural phenomena, Grasset captures the sultry sensation of heat and the extravagant display that signals the season's climax.

Utagawa Hiroshige (1797–1858)
Maple Trees at Mama, Tekona Shrine and Linked Bridge, from *One Hundred Famous Views of Edo*

1856–58
Colour woodblock print
Dimensions unknown
The British Library, London

The enduring Japanese tradition of *momijigari*, or the viewing of red maple leaves (*momiji*), can be traced back to the Heian period (794–1185), when courtly patrons gathered poets and musicians in a grove of maple trees to celebrate autumn. The crimson and russet hues were described as the herald of winter: once the leaves had changed colour, they would dry, tumble off the branches and scatter in the early winter showers.[7] Over the centuries the practice widened, drawing tourists to scenic sites to marvel at the annual display. Using the branches of a maple tree as a framing device, Utagawa Hiroshige portrays the precinct of the Tekona Shrine at Mama, roughly 16 kilometres (10 miles) to the east of Edo (Tokyo), as an ideal destination for enjoying the fleeting spectacle.

The famous shrine and the bridge mentioned in the print's title can be seen in the middle distance, but the huge leaves that cling to the branches of the tree offer the more compelling motif. Although the vivid orange and scarlet of the original hues have blackened over the years, the striking visual effect of the leaves is undiminished.[8] *Momiji* embody the implacable phenomenon of change, for as an anonymous poet reminds us, 'There is no autumn / That hasn't changed its colors.'[9]

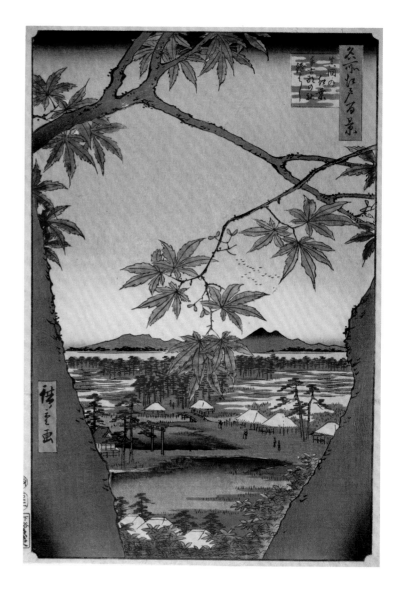

Alsace
September, from *The Labours of the Months*

1440–60
Wool and linen tapestry
Dimensions unknown
Victoria and Albert Museum, London

According to the iconography of the Labours of the Months, the onset of autumn brings the final harvest, but the harvest does not end the agricultural year. Once the final crop has been gathered, the field must be cleared and the ground prepared for the next planting. In this way, each year's work anticipates the next year's crop; the only way to enjoy abundance in the spring is to complete the seasonal tasks of autumn. This detail from a partial tapestry panel depicting the Labours of the Months – only July to December survive – shows harrowing and sowing as the labours to be done in September.

With its sturdy frame and strong teeth, the harrow breaks up any remaining clods of earth after the field has been cleared and ploughed. The sower follows in the harrower's wake, spreading the seeds of hardy plants that can survive the winter and sprout in early spring. These might include winter vegetables, fodder crops and such grains as oats and wheat. In this tapestry ensemble, the work of September is followed by one more harvest: in October, grapes are picked and pressed to make wine. In November the land lies dormant, and the farmer butchers an ox to provide a feast for his table in December.

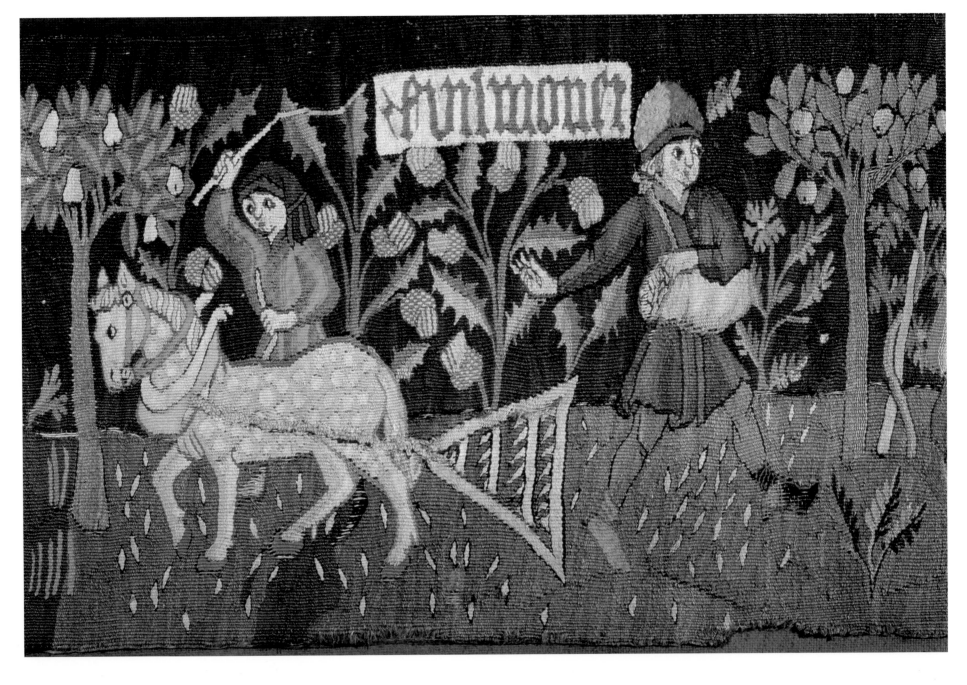

Mary Cassatt
(1844–1926)
Autumn

1880
Oil on canvas
93 × 65 cm (36⅝ × 25½ in.)
Musée du Petit Palais, Paris

Wrapped in a woollen cloak, the artist's
sister, Lydia Cassatt (1837–1882), sits
alone on a park bench. There is no mistaking
the season. Behind her, the trees shudder
in the wind as they shed their ochre leaves
and create a carpet of colour on the ground.
The thick strands of the cloak's fabric
augment the autumnal palette with hues of
orange, brown and scarlet. The bright green
of the bench heightens the visual effect by
recalling the vivid foliage and warmth of the
previous season.

Lydia had moved to Paris in 1875; three
years later she was diagnosed with Bright's
disease, and in 1882 she died from kidney
failure. Her pensive demeanour and pale
complexion in *Autumn* reflect her declining
health. But the elegiac mood of the painting
transcends mere biographical portraiture.
In 1879 Mary Cassatt had made her debut
as an independent artist at the fourth
Impressionist exhibition, and she shared
her new colleagues' fascination with the
expressive quality of colour under natural
light. It is her rich palette, rather than an
associated narrative, that gives the painting
its true poignancy. The burnished tones,
thickly brushed in pure pigment, evoke the
characteristics of the season: muted light,
shorter days, dropping temperatures and
chilly winds.

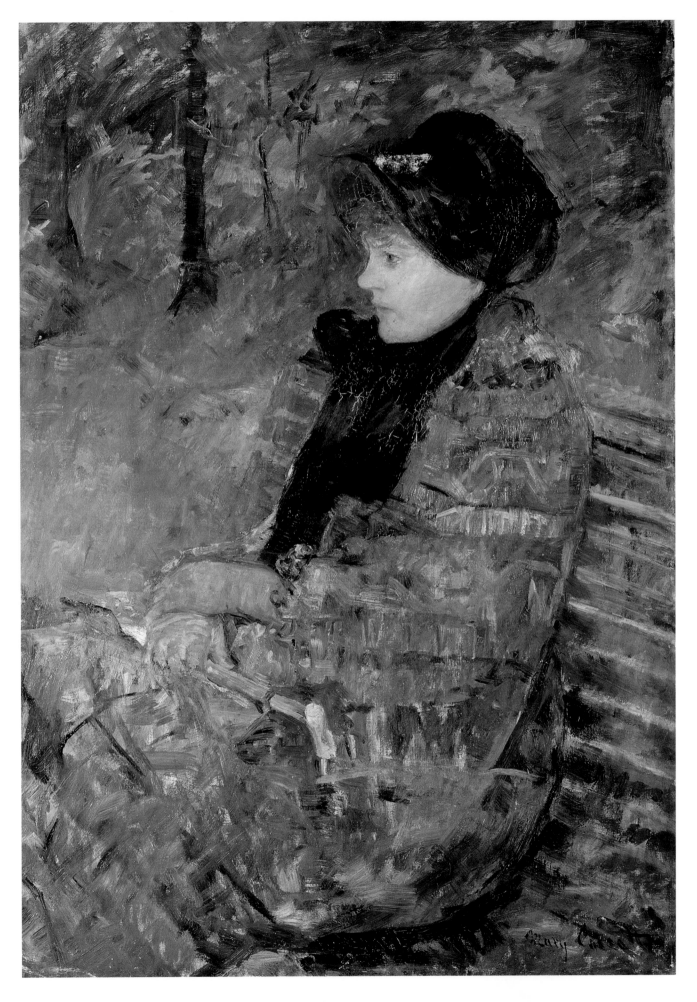

Samuel Palmer
(1805–1881)
The Harvest Moon

1833
Oil on paper laid on panel
22.2 × 27.6 cm (8¾ × 10⅞ in.)
Yale Center for British Art, Paul Mellon Collection,
New Haven, Connecticut

In the northern hemisphere, as the calendar year enters its final quarter the time between sunset and moonrise diminishes. In late September, the full moon appears larger, lower and brighter than in previous months, and in traditional European farming cultures its reflected radiance provided a few extra hours at the end of the working day in which to bring in the harvest before the first frost. As a result, the first full moon to occur after the autumnal equinox, which usually falls at the end of September, has long been called the harvest moon.

During his years in the village of Shoreham in north-west Kent (*c.* 1827–32),

Samuel Palmer sensed a spiritual power in the autumn skies. He wrote of watching 'the moon opening her golden eye', and of 'walking in brightness among innumerable islands of light'.[10] Although he painted this small watercolour after he had left Shoreham, his son Alfred described it as 'full of the Shoreham sentiment'.[11] Looming low in the sky, the harvest moon casts a pearly light over the gold and russet crops. Wraithlike in their white smocks, the labourers toil as they have done for countless generations; driven by nature's rhythm, they must work quickly to bring in the harvest under the waning illumination.

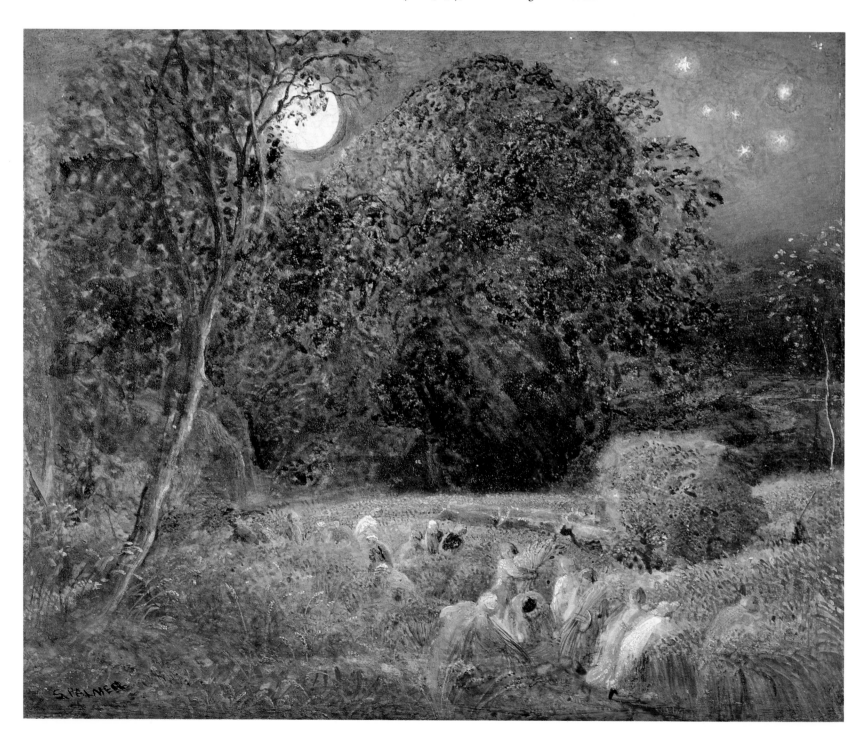

Camille Pissarro
(1830–1903)
White Frost, Jardin des Tuileries

1900
Oil on canvas
65 × 81 cm (25½ × 31⅞ in.)
Private collection

Camille Pissarro conveys the chilling beauty of a winter's day in the Jardin des Tuileries through colour. Silver-grey glazes the branches of the chestnut trees, and a pale-mauve haze mingles with opalescent clouds in overcast skies. Deep-blue shadows cloak the towering pavilion of the Louvre, while the distant buildings on the banks of the Seine are engulfed in a pale-violet mist. The gardens, filled with visitors during more temperate weather, are now empty. Only a few silhouettes of hunched, hurrying figures can be glimpsed on the gravel path.

Pissarro's decision to paint the gardens in winter was deliberate. Late in the previous year the artist had leased a flat on the rue de Rivoli overlooking the gardens, and he spent the season gazing out of the window while translating the effects of subdued light and cold air into colour on canvas. But his vista also highlights the elegant geometry of the garden, seen here in the gravel *allées* encircling a shallow *bassin*. This small detail of the vast design, created by André Le Nôtre in 1664, reveals that the garden was planned to be beautiful throughout the year, especially when seen from above.

Austrian School
The Winter Garden of Hofburg Palace, Vienna

1852
Colour lithograph
Dimensions unknown
Private collection

For centuries, gardeners were faced with the challenge of maintaining a warm environment in which to protect summer and non-native plants from harsh winter temperatures. The popularity of imported citrus trees led to the development in the sixteenth century of the *orangerie*, or 'orange house', made from timber and panes of glass. The addition of iron stoves followed, but, according to the English diarist and writer John Evelyn (1620–1706), their noxious fumes left plants 'sick, languorous and tainted'.[12] By the mid-nineteenth century, new technologies allowed garden designers to create climate-controlled structures capable of simulating a wide range of atmospheric environments. Cast-iron glasshouses,

crowned with domed roofs and heated with steam or hot water flowing through iron pipes, were elegant as well as practical, and the Winter Garden at the Hofburg Palace in Vienna became a cold-weather retreat in which fashionable visitors could relax among flourishing plants.

This mid-nineteenth-century view of the Winter Garden displays the advances of hothouse technology. The interior is flooded with light, which streams in through broad glass panes held in a cast-iron armature. Hidden heaters warm the trapped air to a temperature that will sustain Mediterranean evergreens and palms throughout not only a frigid winter but also a temperate summer.

Utagawa Kunisada
(1786–1864)
and
Utagawa Hiroshige II
(1829–1869)
Maids in a Snow-Covered Garden

1859
Colour woodblock print
Dimensions unknown
UCL Art Collections, London

A group of women – warmly dressed in layers of colourful kimono – have ventured into a garden covered with freshly fallen snow. Bright white against the dark-blue sky and the deep-blue water, the snow transforms the surrouding trees, shrubs and rose bushes into forms that are fantastic and new. In the centre of the group, two figures wield wooden shovels, tossing the snow aside as the women look on. The magnificently dressed woman in the foreground carries a tray heaped high with a pristine mound of snow; she glances quickly over her shoulder as she walks towards the little bridge that leads out of the garden.

This image combines two popular print motifs of the late Edo period (1603–1868) in Japan: seasonal change and beautiful women. *Ukiyo-e*, or 'prints of the floating world', often featured such ephemeral phenomena as fashion, celebrity and the changing spectacle of nature. The extravagant garments of the woman in the foreground are characteristic of *bijin-ga*, the pictures of female beauties collected by male patrons, and when seen against the field of white snow, her red *uchikake* (outer robe) expresses a seasonal greeting. In Japanese culture, the combination of red and white signals good fortune, a conventional wish for the start of a new year.

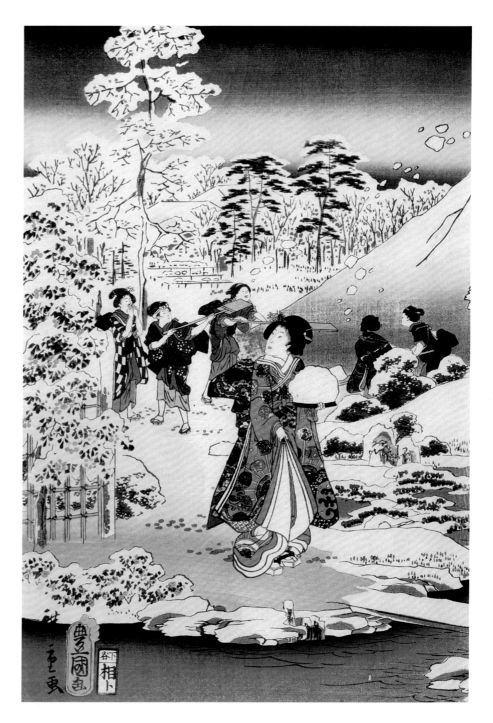

The Garden as Metaphor

According to the Epic of Gilgamesh, in the Garden of the Gods clusters of carnelian fruits dangle from vines, and lapis lazuli leaves grow on the trees. In the book of Genesis, God creates a garden filled with every form of flora and fauna, and then shapes a being in his own likeness and grants him dominion over it. The Qur'an reveals that a perfect garden – verdant with fruit and palm trees, shaded by pavilions and cooled by fountains – will reward the pious man for his service and faith. More than treasure or tribute, the gardens in these sacred books were seen as a gift from the divine to humanity. The origins of the word 'paradise' can be traced to the Persian word *pairidaeza*, or 'enclosure'. Garden historian Tom Turner speculates that the term originally referred to land set aside for the cultivation of fruit trees and the keeping of animals, but it quickly acquired symbolic associations.[1] A paradise garden provided a natural haven away from the dullness and demands of the everyday world. The significance attached to garden design quickly transferred to the visual arts, presenting artists with a metaphor that allowed them to evoke the wonders of the spiritual world in the guise of natural beauty. The *hortus conclusus*, or 'enclosed garden', is one of the most enduring garden metaphors in Western culture. It can be traced to a lyrical line in the Song of Solomon: 'A garden locked is my sister, my bride, / a garden locked, a fountain sealed' (4:12). The sealed garden represents fertility in its purest state; within the protected walls, plants bear flowers and trees bear fruit safe from violation or corruption. In the Middle Ages, the *hortus conclusus* was the domain of the Virgin Mary, and artists employed the metaphorical setting for scenes from the New Testament, such as the Annunciation (pages 50–51). But as a space apart, the garden also served as a place of introspection, as in the case of Christ's crisis of faith in the Garden of Gethsemane (page 53).

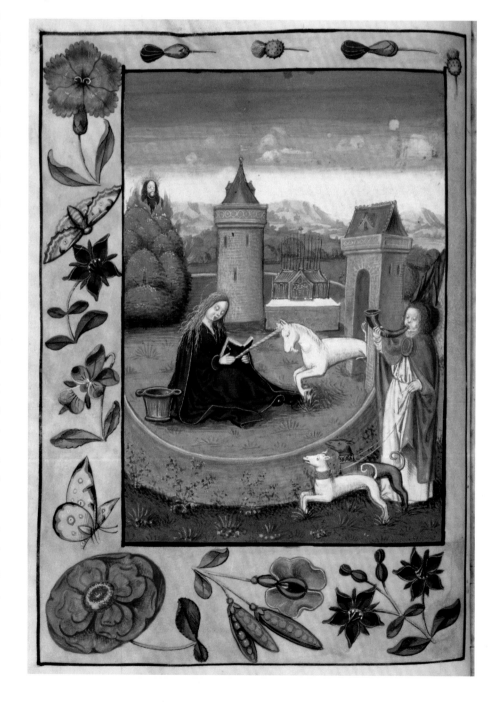

Sacred and secular references combine in garden iconography. The Mughal emperor Babur re-created the rivers of paradise in his four-fold design for palace gardens (page 52), while a Flemish image of the Annunciation employed a hunting legend to celebrate the Virgin's purity (right). Floral lore gave artists another lexicon of meaning: as long-standing symbols of abstract ideas, each individual rose, lily or violet added subtle depth to the visual narrative (pages 48 and 49). In the light of contemporary events, a flower's traditional meaning could transform the message of a painting, as seen in the title of Robert William Vonnoh's painting *Poppies* being changed to *In Flanders Field* in honour of fallen soldiers (page 60).

In the twentieth century the traditional iconography of the garden was augmented with new and personal inventions, as artists appropriated familiar forms to express difficult or ambiguous ideas – the inner experience, the relationship between sensation and memory, the morphology of life itself – that cannot easily be put into words. Metaphor transforms even conventional garden imagery into the medium of an esoteric message, allowing the artist to transcend prosaic language and speak directly through the senses to the spirit.

Flemish School
Annunciation, from MS McClean 99 f.11v

c. 1526
Vellum
16.8 × 12 cm (6⅝ × 4¾ in.)
The Fitzwilliam Museum, Cambridge

In this late medieval illumination, sacred and secular themes of chastity merge to announce the Immaculate Conception. Mary sits within the fortified walls of a *hortus conclusus*, a symbol of her inviolate virginity inspired by the phrase 'A garden locked' in the Song of Solomon (4:12). The shining bronze vessel and the burning bush – never consumed in its own eternal fire – further attest to her purity. The unicorn that has entered her protected space recalls a hunting legend in which only a virgin can tame the mythical beast. The Archangel Gabriel's horn and hounds extend the hunting metaphor; with a hardy blast, he proclaims that Mary has been chosen to bear a divine child by God, whose approving image appears in the burning bush.

In contrast to the plain green lawn within the *hortus conclusus*, the gold ornamental border of the page displays a symbolic garden. The blue starflowers presage the appearance of the guiding star in the eastern skies at the time of Christ's birth. The rose and the violet, here represented by a viola, were Mary's floral emblems. The carnation, in flower and bud, evoke Mary's tears and the nails of the Crucifixion, while the butterflies simulate souls released from their bodies at the time of salvation.

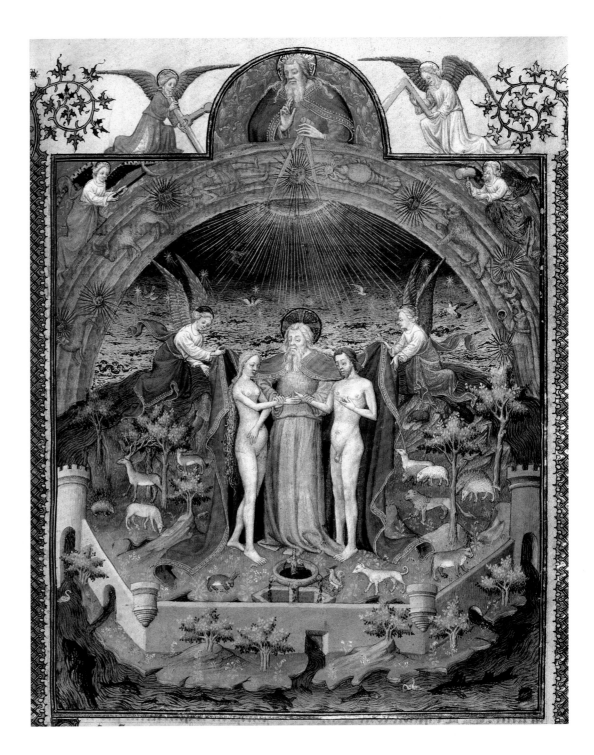

Jean Fouquet
(c. 1425 – *c.* 1478*)*
The Creation: God Introducing Adam and Eve, from *Antiquités judaïques* (MS Fr 247 f.3)

c. 1470
Vellum
21 × 17.8 cm (8¼ × 7 in.)
Bibliothèque Nationale de France, Paris

The book of Genesis records the divine creation of a perfect world over the course of six days. Each element of life – light, water, earth – was called into being, and then the world was made verdant and fertile with 'plants yielding seed, and fruit trees bearing fruit' (1:11). The creation of animals was followed by the creation of a man, and then by the creation of a woman, for 'It is not good that the man should be alone' (2:18). Jean Fouquet's elaborate, large-scale miniature presents the moment when God introduces Adam to Eve in this perfect world, the Garden of Eden.

With references to his own world, Fouquet transformed a spiritual idea into a charming vignette. The wall that surrounds Eden has the watchtowers of a defensive castle. Within, at God's feet, is a fountain, representing the river that flowed out of Eden and split into four branches to water the world. Fish swim in the waters, birds soar across 'the firmament of the heavens' and 'cattle and creeping things' roam the Earth (1:20, 24). The plants that flourish in Eden are 'pleasant to the sight and good for food' (2:9). As beautiful as they are innocent, Adam and Eve are portrayed as the natural inhabitants of this garden paradise.

Master of Oberrheinischer
Garden of Paradise

c. 1410–20
Mixed media on panel
26.3 × 33.4 cm (10⅛ × 13⅛ in.)
Städelsches Kunstinstitut, Frankfurt am Main

An anonymous master of the Upper Rhine created this small, exquisite painting to give a pious patron a glimpse of paradise. The setting is a contemporary pleasure garden – a grassy mead surrounded by a crenellated wall – in which birds perch and flowers bloom. The regal woman in blue is the Virgin Mary, and her central position indicates that this is her garden, a *hortus conclusus* that also serves as a metaphor for her purity. To her right, St Dorothy picks cherries – the fruit of paradise – while St Cecilia kneels before her, teaching the Christ Child to strum a psaltery. St George converses with the Archangel Michael; George's dragon lies dead and Michael's devil is docile. The woman in the

bottom left-hand corner of the painting, probably St Barbara, completes the metaphor by dipping a ladle into a basin that represents the well of living water in the splendid enclosed garden described in the Song of Solomon (4:12).[2]

With every flower in bloom, the beauty of this tranquil garden transcends the cycle of seasons. Mary's flowers – roses, lilies and violets – celebrate her exemplary womanhood, her chastity and her humility. The purple flag irises forecast her son's sacrifice; the periwinkle protects against evil. Like the cherries, the strawberries represent divine fruit. The bounty of this paradise is untainted by mortality.

Martin Schongauer
(c. 1435/50–1491)
Madonna of the Rose Bower

1473
Oil on panel
Height 200 cm (78¾ in.)
Église Saint-Martin, Colmar, France

Floral emblems gave meaning, as well as beauty, to medieval devotional imagery. During the later centuries of the Middle Ages, the rose was the favoured emblem for the Madonna, based on the belief that the roses in the Garden of Eden had no thorns. Through her kindness and chastity, Mary embodied the idea of the *rosa sine spina* (rose without thorns), and roses were used to honour her as a new incarnation of Eve, the original mother now cleansed of original sin.

The iconic theme of the Madonna of the Rose Bower, presenting Mary surrounded by a trellis adorned with climbing roses, expressed theological ideas in the form of familiar features of garden design. The term 'rosarium', designating a cycle of prayers in praise of Mary, was also used to describe a garden that featured roses. Martin Schongauer combined both meanings of the term in this altarpiece, commissioned for the church of Saint-Martin in Colmar, eastern France. He clothed Mary in red, rather than her conventional blue, drawing an analogy between his beautiful Madonna in her garden and her floral emblem. Parishioners would gather in front of the altarpiece to recite their prayers, one for each bead on their rosaries.

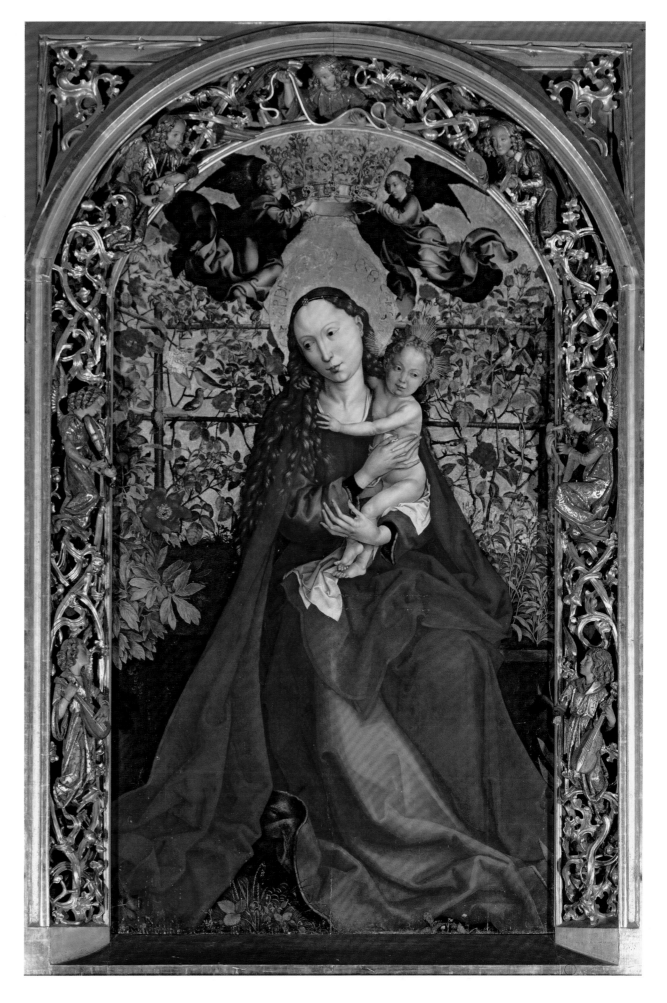

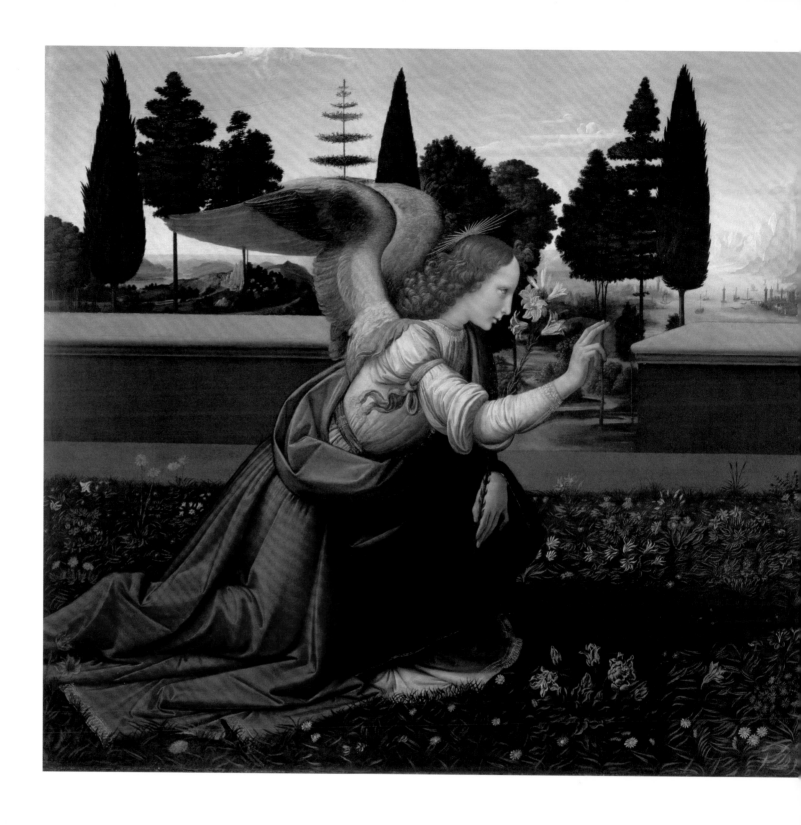

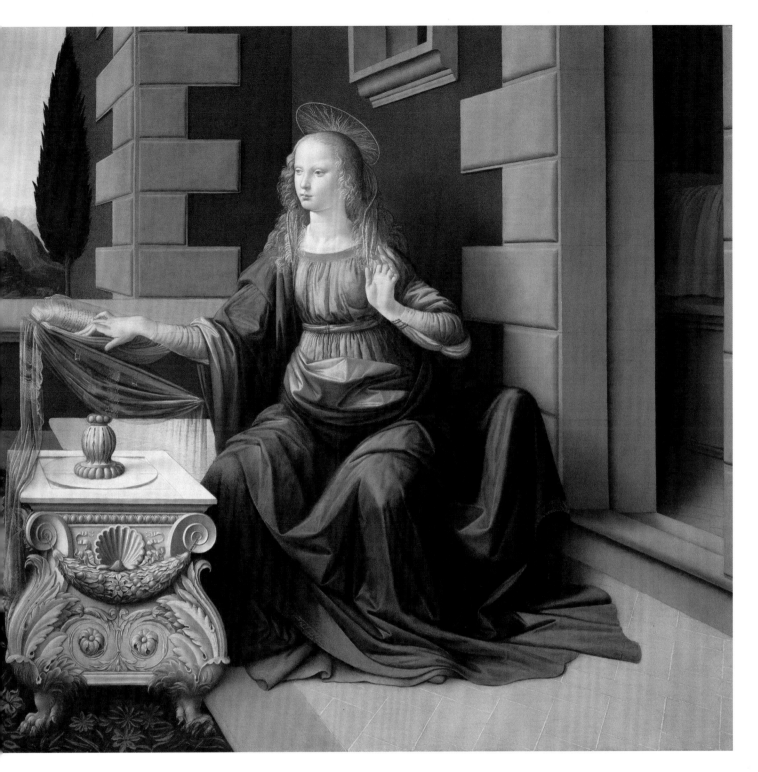

Leonardo da Vinci
(1452–1519)
Annunciation

1472–75
Tempera on panel
98 × 217 cm (38½ × 85⅜ in.)
Galleria degli Uffizi, Florence

As told in the Gospel according to Luke
(1:26–38), Gabriel travelled to Nazareth to
inform Mary that she had been chosen to bear
a divine child. Nothing more is mentioned
about the setting, but in Leonardo da Vinci's
day, Florentine artists typically staged the
Annunciation in a walled garden in reference
to the *hortus conclusus* described in the Song
of Solomon (4:12). Leonardo followed this
convention in *Annunciation*, one of his earliest
important commissions, which he painted for
the monastery of Monte Oliveto Maggiore
in Tuscany while he was still an assistant in
Andrea del Verrocchio's workshop. The
flowers that spangle the lawn – daisies, lilies,
violets and roses – have traditional
associations with Mary's virtues.

For Leonardo, painting an array of flowers
engaged not only iconographic considerations
but also scientific ones. Since childhood,
seeking to understand patterns of growth
through close observation, he had made
countless drawings of leaves, stems, blossoms
and seeds, and his methods anticipated those
adopted in the early practice of botanical
science. From the lilies in the foreground
of the painting to the cypress and topiarized
cedar trees in the distance, Leonardo's
accurate rendering of each flower and plant
locates the Annunciation in the world of
nature as well as in the realm of the spirit.

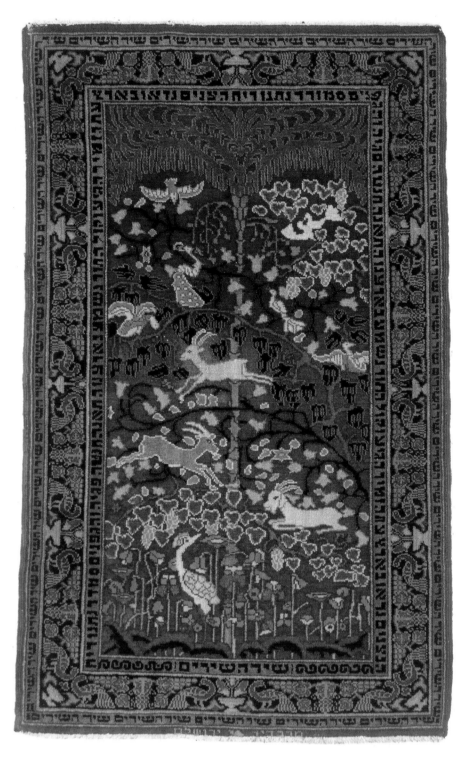

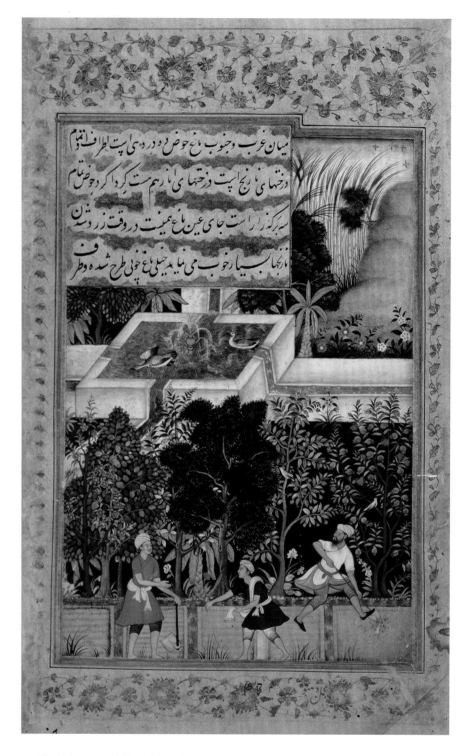

ABOVE

ABOVE

Jerusalem

The Song of Songs, Jewish
Marbadiah carpet

1920–21
Cotton and wool
156 × 98 cm (61⅜ × 38½ in.)
Private collection

The Song of Songs (also known as the
Song of Solomon), long attributed to King
Solomon of the tenth century BC, has been
interpreted as a multilayered allegory of mortal
and divine love. Current scholars believe
that it is more recent than Solomon's reign –
written some time between the fourth and third
centuries BC – and many now regard it as
a celebration of human desire between a
bridegroom and his bride. This modern carpet
testifies to the enduring power of the text's
intoxicating language, which praises beauty so
profound that it defies description and can be
expressed only through analogy.

The lush flora and lively fauna that
decorate the carpet illustrate the poem's
imaginative exchange between the bride
and groom. Comparing his lover to a stately
palm tree twined with grape vines, the groom
longs to 'lay hold of its branches' and caress
breasts that are 'like clusters of the vines'
(7:7–8). The bride describes herself as
'a rose of Sharon, a lily of the valley', and
her groom as 'an apple tree among the trees
of the wood' (2:1, 3). Such fragrant herbs
as henna, saffron, cinnamon and myrrh
(4:13–14) scent the air of this sensuous
earthly paradise.

Indian School
The Garden of Fidelity, from
Memoirs of Babur (Or. 3714)

c. 1590
Watercolour and ink on paper
Dimensions unknown
The British Library, London

The well-ordered, irrigated gardens of Samarkand (modern-day Uzbekistan) made a strong impression on the young Babur (1483–1530). A poet and a naturalist, as well as a valiant warrior and the founder of the Mughal Dynasty (1526–1707), Babur designed gardens for his capitals at Kabul and Agra, which he described in the journal he kept from the age of twelve until his death. At the end of the sixteenth century, Babur's grandson Akbar had the journal translated from Chagatai Turkish into Persian, and over the next few years, four magnificently illuminated copies of the *Memoirs of Babur* were produced in the imperial scriptorium in Lahore.

Babur mentions the Garden of Fidelity (Bagh-i Vafa) several times in his *Memoirs*, noting his pleasure in growing plantains and sugar cane, and that the orange trees were particularly beautiful when they were heavy with fruit. The garden's design was based on the traditional *chahar bagh*, or 'four-fold garden', characterized by four water channels that flow outwards from a central basin and define the beds of the garden. The channels watered the soil and cooled the air, but they also represented the four rivers of paradise flowing with water, milk, honey and wine, as described in the Qur'an.

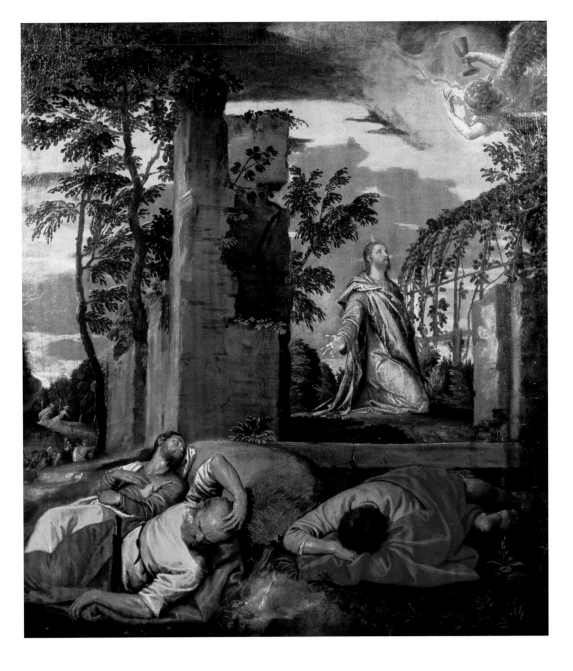

Paolo Veronese
(1528–1588)
The Agony in the Garden
n.d.
Media and dimensions unknown
Private collection

After the Last Supper, Christ and his disciples walked to the Garden of Gethsemane in the foothills of the Mount of Olives. Instructing the other disciples to wait at the gate, Christ entered the garden with Peter, John and James the Great. Once inside, however, he moved away from them, and confessed in an agonized prayer that he feared his impending sacrifice, imploring, 'Father, if thou art willing, remove this cup from me' (Luke 22:42). When he rose from prayer with new resolve, ready to submit to divine will, he found his disciples sleeping. He roused them, and journeyed on to face the coming trials that culminated in his crucifixion.

Paolo Veronese's vision of the Agony in the Garden presents all the narrative details described in the Gospel according to Luke. James, Peter and John slumber in the foreground, while the other disciples can be seen on the winding road outside the garden walls. Christ kneels within the walls, opening his arms to prayer. The grape arbour recalls the Eucharist, instituted just hours earlier at the Last Supper. The angel bearing the chalice also invokes the metaphorical sacrifice, but as he raises the golden cup towards heaven, he also confirms Christ's acceptance of his fate.

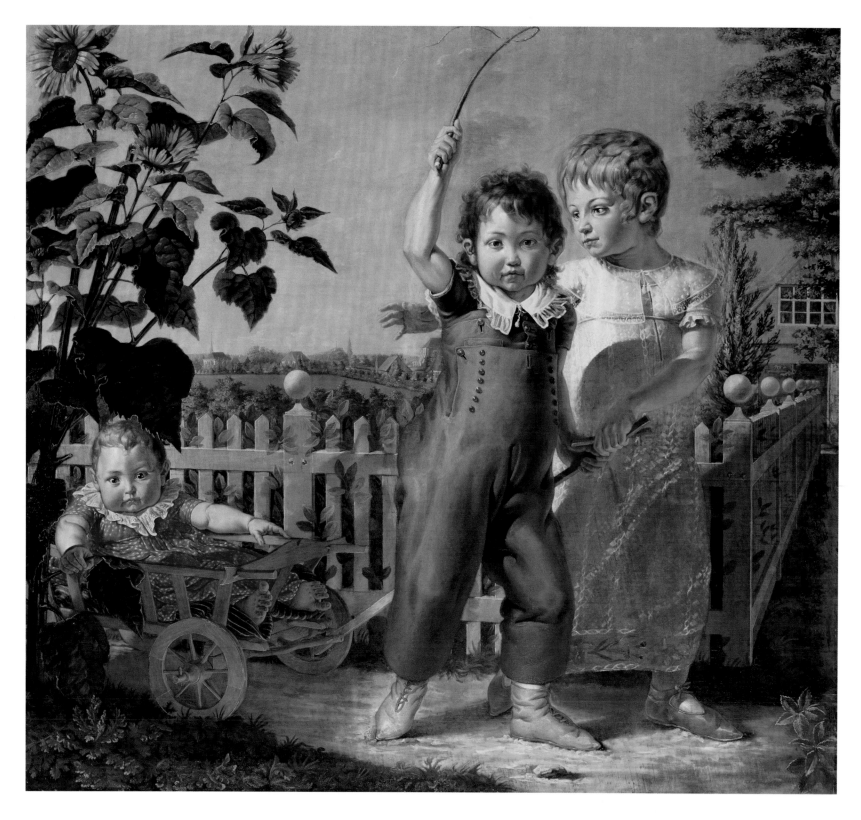

Philipp Otto Runge
(1777–1810)
The Hülsenbeck Children

1805–1806
Oil on canvas
131.5 × 143.5 cm (51¾ × 56½ in.)
Hamburger Kunsthalle, Hamburg

From an early age, Philipp Otto Runge possessed a profound reverence for nature. He regarded the physical world as the manifestation of celestial power, and he embraced art as a means of expressing his Christian pantheist perspective. Writing to his friend Ludwig Tieck, Runge described the harmony among 'all natural phenomena', asserting that every plant and flower 'harbours a certain human spirit, idea or feeling' that 'can only hail from Paradise itself'.[3] His portrait of the Hülsenbeck children seems to testify to his belief that a vibrant divine spark unified everything in nature.

Maria, August and Friedrich were the children of Friedrich August Hülsenbeck, the business partner of the artist's brother. Runge painted them playing just outside the garden gate of their suburban home in Eimsbüttel; the church spires of Hamburg can be seen in the distance. By using a low point of view, Runge gives the children a monumental quality, but also shows the viewer the world from their perspective. The towering sunflower, with its three nodding blooms, seems to possess the same organic strength as the children's taut, vital bodies. Both the flower and the children contain the divinely generated primal energy that Runge sensed in all aspects of the natural world.

James Tissot
(1836–1902)
Jesus Looking through a Lattice

1886–94
Opaque watercolour over graphite on grey
wove paper
14.4 × 17.6 cm (5⅝ × 6⅞ in.)
Brooklyn Museum, New York

After a career-long fascination with the subject of fashionable women, James Tissot turned to sacred themes. In 1885 he claimed that, while sketching in the church of Saint-Sulpice in Paris, he had had a vision of Christ consoling the poor. Within a decade he had completed a series of more than 360 watercolours narrating the life of Christ, and in 1896–97 he published the paintings in the form of an illustrated version of the New Testament, known as the 'Tissot Bible'. Tissot conceived *Jesus Looking through a Lattice* as an allegorical frontispiece, based on a passage from the Song of Solomon: 'Behold, he standeth behind our wall, he looketh forth at the shadows showing himself through the lattice' (2:9).

Almost completely hidden behind the lattice, Christ is a vigilant presence, and the grape-laden vines that cling to the rough-hewn wall recall his self-sacrifice through their association with the rite of the Eucharist. The sunflowers revive an old maxim of Christian piety that urged the devoted soul to turn to Christ's teaching in the way that the sunflower turns its blossom towards the sun. But the vigorous yellow blooms may also have had a personal significance; two decades earlier, Tissot had grown sunflowers in the garden behind his home in St John's Wood, north London.

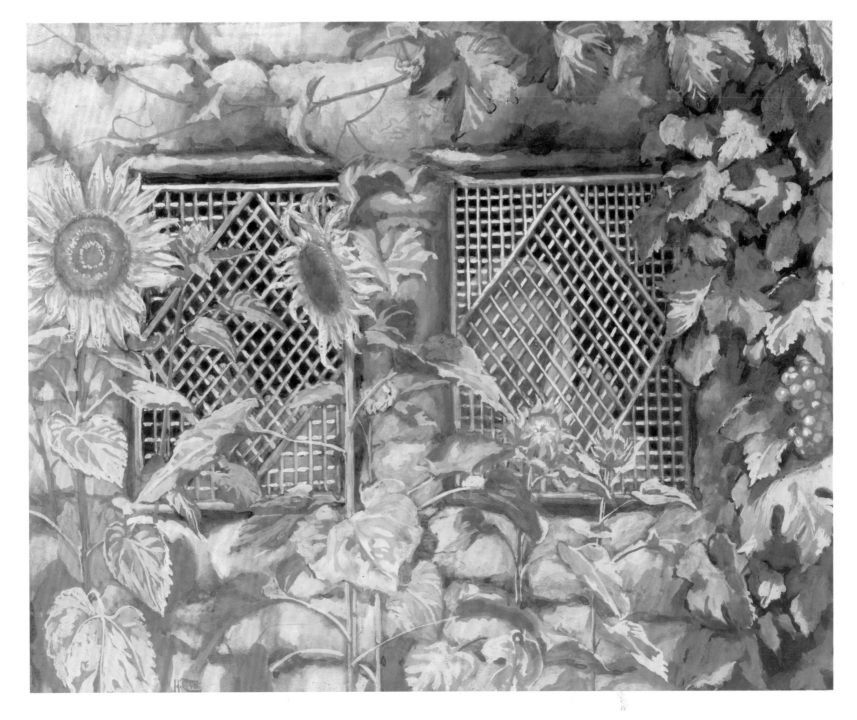

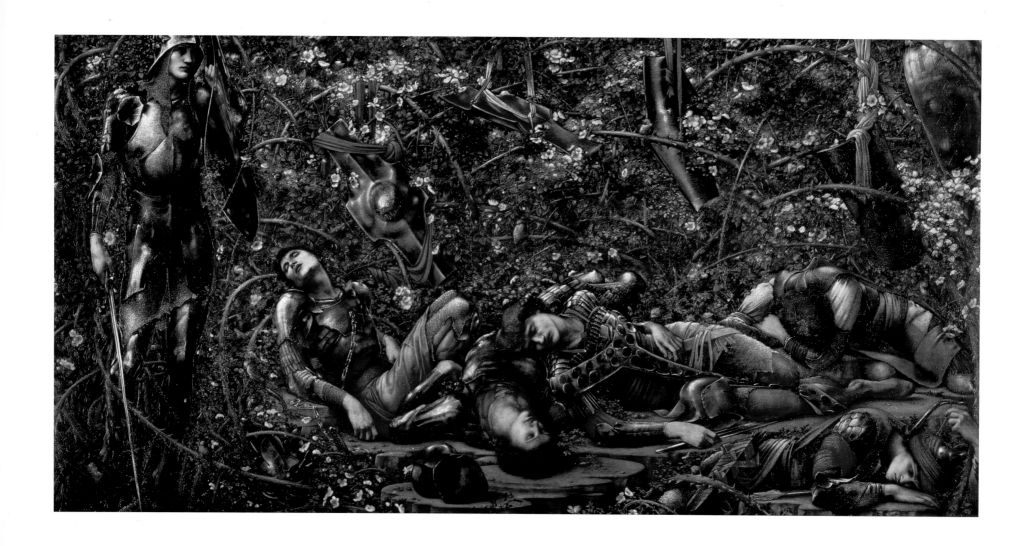

Edward Burne-Jones
(1833–1898)
The Briar Wood, from *The Briar Rose* series

c. 1874–84
Oil on canvas
121.9 × 248.9 cm (48 × 98 in.)

Faringdon Collection Trust, Buscot Park,
Oxfordshire, UK

In 1884 Edward Burne-Jones asked Lady Leighton Warren for a clipping from her garden, a large stem of briar rose, 'a hoary, aged monarch of the tangle, thick as a wrist and with long horrible spikes on it'.[4] For almost twenty years the painter had been fascinated by the tale of the Briar Rose, a variant of the Sleeping Beauty story, and now he wanted the stem in his studio to inspire him as he completed a set of four large-scale canvases that recounted the mysterious adventure of a knight in a castle overgrown with a twining thicket of briar rose.

In *The Briar Wood*, a tall, black-clad knight parts the tangled briar and gazes upon a group of young men lost in death-like sleep. Like the knight, they had come to the castle to break a century-long spell that had cast all who lived there into endless slumber, but they had all failed and succumbed to the curse. Now, the destined hero has arrived, and, with his shield raised to protect himself from the knife-sharp thorns, he summons his courage to cut his way through the blooming thicket, enter a rose-strewn chamber and rouse a sleeping princess with a kiss.

Edward Burne-Jones
(1833–1898)
The Rose Bower, from *The Briar Rose* series

c. 1886–90
Oil on canvas
121.9 × 248.9 cm (48 × 98 in.)
Faringdon Collection Trust, Buscot Park,
Oxfordshire, UK

In Victorian flower lore, the briar rose proclaims, 'I wound to heal'. To enjoy the fragrance of its beautiful blossoms, it is necessary to endure the tearing punctures of its formidable thorns. In the tale of the Briar Rose, the valiant knight seizes the challenge to cut away the brambles and 'smite the sleeping world awake'.[5] His own wounds are healed when he rouses the princess with a kiss. But Edward Burne-Jones chose to close his tale before the rescue, explaining, 'I want it to stop with the Princess asleep and tell no more.'[6]

There is no movement in the princess's chamber. Her supine position and white garments give her a ghostly appearance, like that of an effigy on a bier. The vigorous rose briar has begun to overtake the protecting curtain that divides the chamber from the rest of the castle, suggesting that the knight must act quickly, before it is too late. When the paintings were purchased by Alexander Henderson for the saloon in his country house, Buscot Park in Oxfordshire, Burne-Jones and William Morris created an installation to unify the ensemble – with gilded frames and additional panels – transporting the visitor, like the knight, to a magical garden where time stands still.

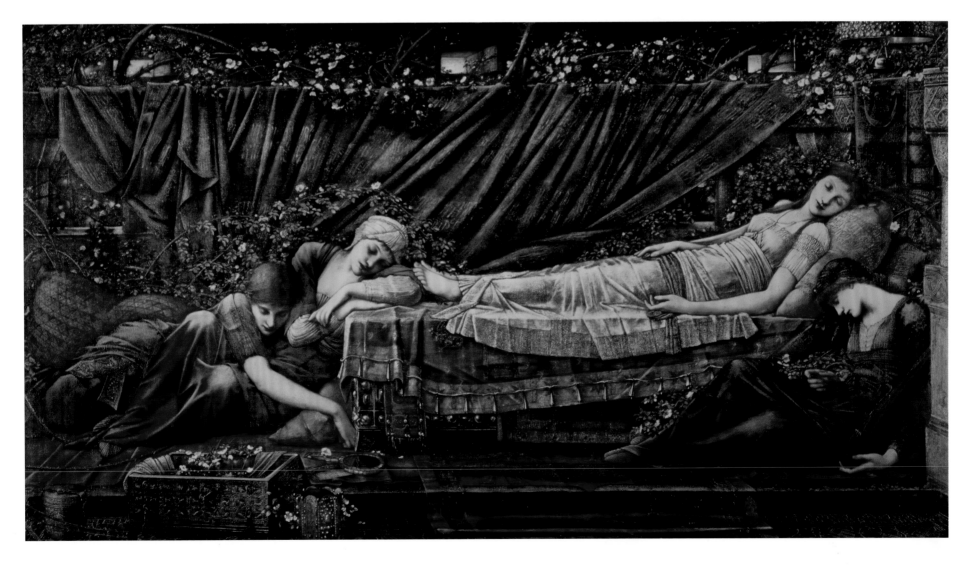

Chinese School
Chinese Ladies in a Garden

19th century
Watercolour and hair embroidery
Dimensions unknown
Allans of Duke Street, London

The literary genre of the 'Chinese beauty', or *shirin*, first appeared during the Han Dynasty (206 BC – AD 220). It developed out of the Confucian concept that regarded beauty as a sign of female virtue, but by the middle of the Tang Dynasty (618–907), beautiful women dressed in elaborate garments and paired with such natural life as butterflies, birds and flowers became a distinct category in poetry and painting known as 'palace beauties'.[7] They served to inspire a gentleman scholar to reflect on beauty and create his own response in poetry. Over the course of the Ming Dynasty (1368–1644), the term *meirin* came into use, indicating a fictional ideal woman engaged in solitary pursuits in the privacy of her room or garden.

This depiction of a *meirin*, dating from the last century of the Qing Dynasty (1644–1912), portrays an attractive young woman practising calligraphy in her garden while an attendant dresses her hair. Roses and peonies grow on the rock formation in the foreground, an auspicious sign of longevity and eternal spring. In common with the concept of the palace beauty, the technique of hair embroidery has its origins in the Tang Dynasty, but by the time this piece was created many of the erudite associations of both had faded.[8]

Hugo Simberg
(1873–1917)
The Garden of Death

1896
Watercolour and gouache on paper
16 × 17 cm (6¼ × 6¾ in.)
Ateneum Art Museum, Helsinki

Drawing on his profound interest in folklore and the supernatural, the Finnish painter Hugo Simberg reinterpreted the enduring iconography of mortality. In *The Garden of Death*, skeleton gardeners, cloaked in black like the Grim Reaper, are an eerily benign presence. They take joy in their work, smiling as they water their odd little plants and make bouquets out of ghostly white flowers. Rather than inspiring fear in the viewer, Simberg portrays the strangely charming skeletons as 'little helpers of death', in a garden he described as the dwelling for souls prior to the afterlife.[9]

As emissaries of death, the skeletons have a long and rich tradition in folklore, but the plants they tend here do not conform to common floral iconography, ranging from credible cactus plants to fantastic creations with spiralling stems and tress-like leaves. In 1902, having been commissioned to decorate the interior of the new cathedral in the city of Tampere, Simberg re-created this work in the form of a large-scale fresco for the north gallery. When the cathedral opened in 1907, the unconventional imagery unsettled congregants and critics alike. But, rather than challenging tradition, Simberg had sought to ease the trepidation that surrounds the idea of death through the iconic symbol of life: the garden.

Robert William Vonnoh
(1858–1933)
*In Flanders Field – Where Soldiers
Sleep and Poppies Grow*

c. 1890
Oil on canvas
142.3 × 246.1 cm (56 × 96⅞ in.)
Butler Institute of American Art, Youngstown, Ohio

After spending several summers in France, working outdoors to master the *plein-air* technique, American painter Robert William Vonnoh took up a subject made famous by Claude Monet. Corn poppies, growing wild in a tilled field, were common throughout northern France, and Vonnoh deftly captured the hazy effect of the hot summer sun shining on the translucent petals of the red blooms. He exhibited the work with the title *Coquelicots* (Poppies), and although the painting was praised in the press, he did not find a buyer for it until 1919. By then, the simple subject of a poppy field had acquired a commemorative association following the staggering loss of soldiers' lives during the First World War.

In 1915 a Canadian surgeon, Lieutenant Colonel John McCrae, serving with the First Field Artillery Brigade, witnessed the German invasion of Ypres, Belgium. Horrified by the carnage, he wrote the poem 'In Flanders Fields' to honour the countless youths who 'lived, felt dawn, saw sunset glow', but now were buried under 'the crosses row on row', beneath the fields where 'the poppies blow'.[10] In 1919 Vonnoh's painting of a mother and her children picking poppies was given its present title, linking it to the poignancy of McCrae's elegy.

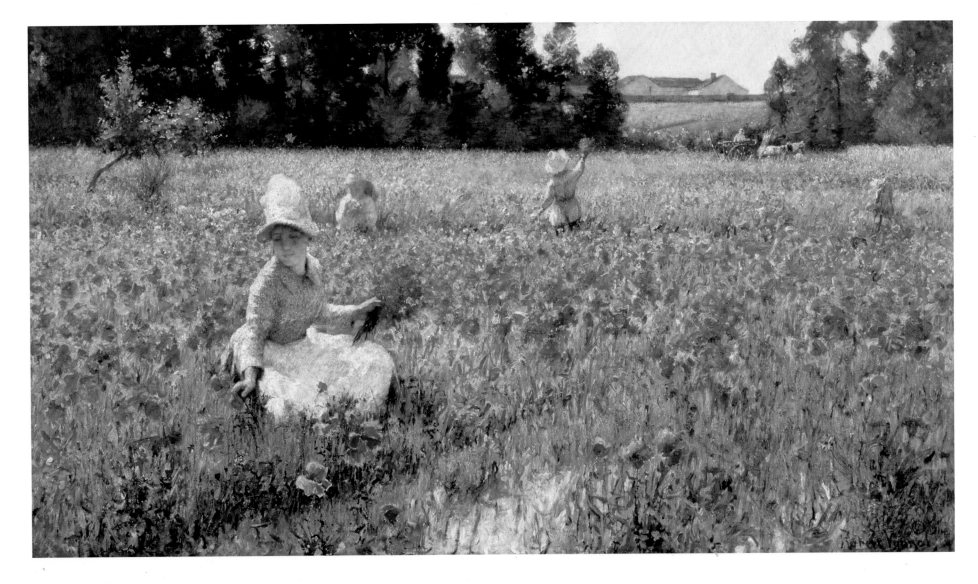

John William Waterhouse (1849–1917)
The Soul of the Rose

1908
Oil on canvas
88.3 × 59.1 cm (34¼ × 23¼ in.)
Private collection

At first glance, John William Waterhouse's depiction of a comely woman inhaling the fragrance of a blush-pink rose appears to centre on the analogy, often used in Victorian art, between a woman's beauty and that of a rose. The architecture suggests an Italian setting, but without indicating a specific location. Likewise, the woman's flowing robe and elaborately braided coiffure evoke an earlier time than that of Waterhouse's England, but without making a specific link to historical fashions. The ambiguity is deliberate, and, rather than narrative or analogy, Waterhouse relies on synaesthesia – with sight simulating scent – to create a mood of lingering reminiscence, powerfully suggestive but hard to define.

The title recalls a line from Alfred Tennyson's poem *Maud* (1855): 'And the soul of the rose went into my blood'.[11] The narrator speaks as he stands at a garden gate at dawn, longing for his love. He, too, experiences a rush of memory when surrounded by flowers, but Waterhouse's painting does not illustrate Tennyson's poem. Instead, it portrays the garden as a realm of the senses, where the angle of light on a leaf or the scent of a rose in full bloom can summon up memories and transport the visitor to another place and time.

Paul Klee
(1879–1940)
Magic Garden (Zaubergarten)

1926
Oil on plaster-filled wire mesh
52.9 × 44.9 cm (20⅞ × 17⅝ in.), framed
Peggy Guggenheim Collection, Venice

In 1926, when the Bauhaus relocated from
Weimar to Dessau, Paul Klee and his family
moved into one of the masters' houses,
designed for the teaching staff by Walter
Gropius. Klee took delight in his new
residence, where he could tend the garden,
and from which he could make regular visits
to nearby Wörlitz, an eighteenth-century
landscape garden with picturesque lakes and
islands. Klee's son Felix recalled that his
father was in his 'absolute element there',
given his strong attraction to landscape and
aquatic motifs.[12]

 Although *Magic Garden* was painted in
the year that Klee moved to Dessau, it should
not be regarded as a literal representation
of either his own garden or the scenic views
at Wörlitz. From an early age, Klee pursued
nature studies. He collected and identified
plant specimens, made pressed-plant collages
and built a herbarium. His interest in
morphology led him to develop theories
about art based on the analogous
development of living organisms, human
constructions and geometry. Rather than
being depictions of a specific place, such
paintings as *Magic Garden* display the parallels
and convergences that Klee saw between
these different types of form. Gardens served
as a departure point for artistic expression,
mediating between the known world and the
artist's imagination.

OPPOSITE

Gustav Klimt
(1862–1918)
Farm Garden with Sunflowers

c. 1906
Oil on canvas
110 × 110 cm (43¼ × 43¼ in.)
Österreichische Galerie Belvedere, Vienna

In a lecture on Gustav Klimt's painting given
in 1901, the Austrian playwright Hermann
Bahr (1863–1934) observed that, although
in the realm of the mundane 'a rosebush
is something quite specific', a philosophical
perspective opened the mind to the ideas
housed within the objects of the outer
world. The same was true for the inner
world, and he reflected that 'there is
something in the soul that is a rosebush'.[13]
As an accomplished allegorical painter,

Klimt mastered the art of suggestion,
shifting his viewer's perceptions from the
easy recognition of the familiar towards
more elusive meanings that were revelatory
of the inner world. In his garden paintings,
the sheer bounty of nature summons up
the mysterious force of life, embodying the
unknown and unknowable in the beauty
of the familiar.

 This unidentified garden was painted in
the vicinity of Litzlberg, a small village on

the Attersee near Salzburg where Klimt
summered between 1900 and 1907. The
bright, decorative patterns of full-blown
blossoms against densely massed stalks and
foliage recall the sumptuously jewelled
and embroidered garments that Klimt
depicted in his portraits and personifications
of the time. This aesthetic affinity, rather
than a deliberate representation, evokes
the bond between natural growth and
human experience.

Famous Gardens

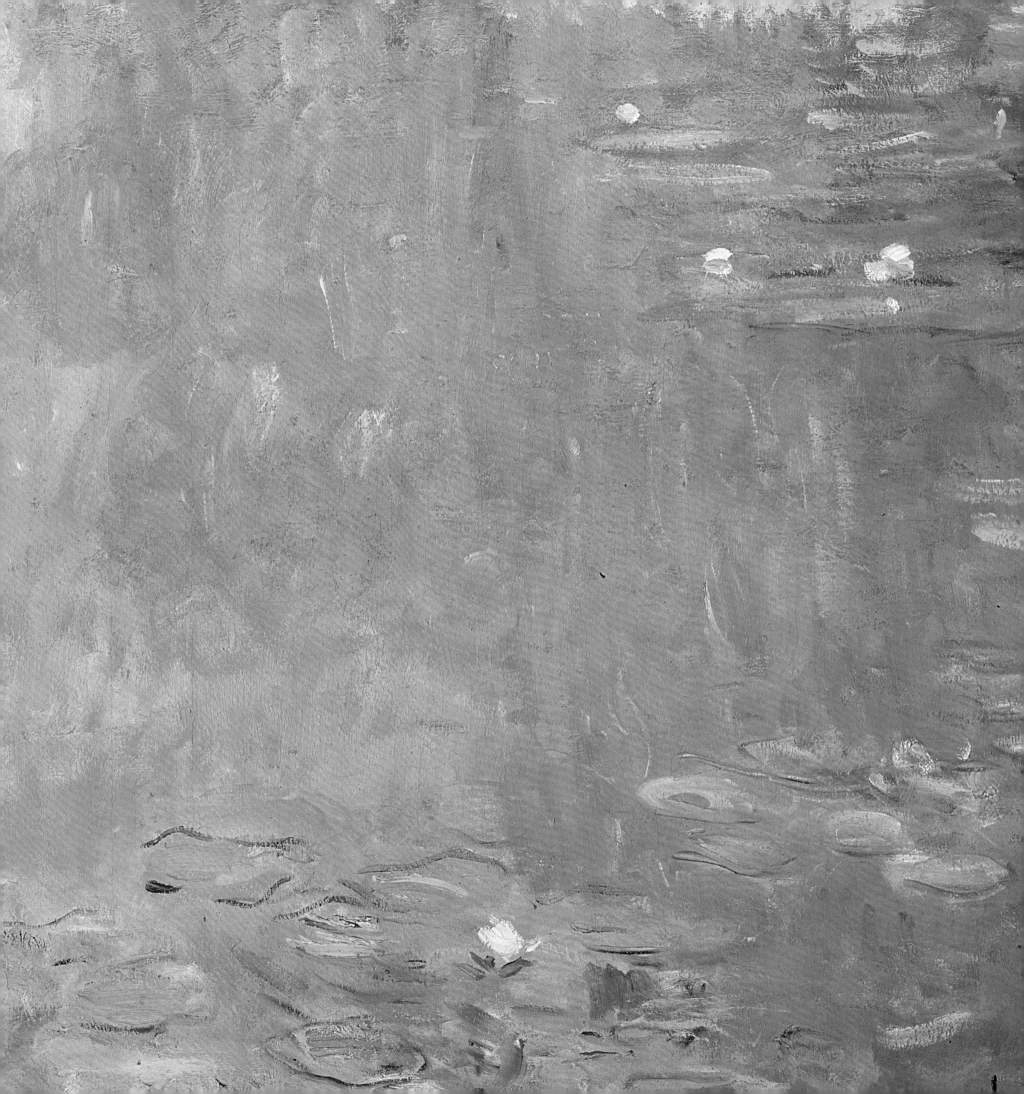

During the later years of his reign, Louis XIV wrote a guide to the magnificent gardens at his chateau. In *Manière de montrer les jardins de Versailles*, he instructed his privileged guests to pause before entering the gardens in order to 'contemplate the parterres, the *pièces d'eau*, and the Fontaines des Cabinet'.[1] More than simply drawing their attention to the special features of the exquisite vista, the king was commanding them to admire his power. The extensive plantings, the spectacular water displays, the *bosquets*, *palissades* and *allées* of mature trees – all stretched as far as the eye could see. The king had imposed order on nature, and the glory of his garden was testament to his fame.

The gardens at Versailles were a continuation of a venerable tradition. From the storied Hanging Gardens of Babylon to the heraldic designs created at Hampton Court Palace for Henry VIII, royal gardens had been conceived to impress visitors with the sovereign's wealth and power, as well as his taste. Envoys would return to their homelands with tales of horticultural wonders, and the gardens created to promote the fame of their owners would themselves become famous. Glorious descriptions of great gardens spread innovation in garden design, but they also inspired artists, who evoked the visual experience of the gardens in paintings that range from meticulous documentation to imaginative flights of fancy.

The bird's-eye view, as seen in a painting of the Summer Palace in Beijing (opposite) and Pierre Patel's perspective of Versailles (page 71), allows the viewer to observe and admire every distinctive element of a garden design, as well as grasp the unity of the grand plan. Paintings of celebrated gardens also bring viewers into privileged spaces. A two-page illumination grants us access to Emperor Babur's renowned Garden of Fidelity (pages 68 and 69); a diplomat and his entourage must wait outside the garden walls. The landscape garden, designed to unfold as a series of changing scenes as the visitor strolls along designated paths, can be depicted as a panorama or, as Richard Wilson chose to do at Kew (pages 78 and 79), as a series of perfect views, simulating the experience of stopping to contemplate a Chinese pagoda or a ruined arch.

The relationship between famous gardens and art is reciprocal. In the United Kingdom the vistas at Stourhead bring the Italian countryside to the county of Wiltshire via an intermediate source: the rolling contours and temple architecture were modelled on famed landscapes by French artist Claude Lorrain.[2] Paintings also allow us to look back in time at a garden view that no longer exists: the green vista of Stourhead before the magnolias and rhododendrons were planted (page 76); the overgrown grasses at the Taj Mahal (page 70); the simple arc of Monet's garden bridge without its wisteria canopy (page 83). Through art, we can also enter a famous garden that exists only in the imagination. Lewis Carroll's Alice had to dive down a rabbit hole and eat magic mushrooms to see the formidable domain of the Queen of Hearts, but we can join her at a safe remove by looking at John Tenniel's illustration (page 81).

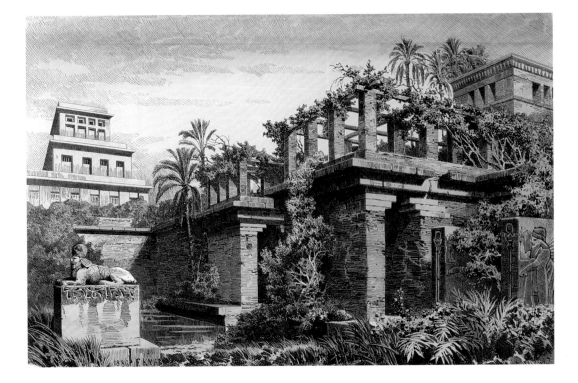

Ferdinand Knab
(1834–1902)
The Hanging Gardens of Babylon,
from the *Seven Wonders of the
Ancient World* series

1886
Colour lithograph
Dimensions unknown
Private collection

As founder and ruler of the New Babylonian Empire, Nebuchadnezzar (died 562 BC) vastly expanded the kingdom's existing territory. The earliest known references to the Hanging Gardens of Babylon post-date his reign by several centuries. Myths surround Nebuchadnezzar's motivation for building them: were they a peace offering, a declaration of his power or a gift to his wife, who longed for her home in Media? Although archaeological investigations at the site of one of his palaces have uncovered brick arches and a mechanism for carrying water, many scholars remain sceptical about the feasibility of raising water to the reputed height of the gardens.[3]

Ferdinand Knab's print of the long-vanished gardens appeared in an illustrated Munich journal, *Münchener Bilderbogen*, as part of a series titled *Seven Wonders of the Ancient World*. Many versions of the 'seven wonders' list had been produced since ancient times; by the medieval era, the Babylon site – the only garden on the list of contenders – was always included.[4] Knab's depiction of tall brick piers topped by plant-carrying stone beams may have been based on the one surviving description of the gardens recorded by Greek historian Diodorus Siculus in the first century BC. Today his account is generally discredited, but the image of leafy vines tumbling downwards from towering columns remains vivid in the popular imagination.

Tang Dai
(1673 – c. 1754)
and
Shen Yuan
(dates unknown)
View of the Summer Palace, from *Forty Views of Yuanming Yuan*

1747
Ink and watercolour on silk
64 × 65 cm (25¼ × 25⅝ in.)
Bibliothèque Nationale de France, Paris

In the mid-twelfth century, Emperor Hailingwang of the Jin Dynasty of northern China (1115–1234) moved his capital to present-day Beijing. There, he established an imperial resort on the north-west outskirts of the city, at the base of a looming hill. Over the centuries, as the ruling dynasties changed, the site remained a royal retreat. In 1750 the Qianlong Emperor of the Qing Dynasty (1644–1912) funded extensive renovations – creating what is now known as the Summer Palace – and renamed the site Qingyiyuan (Garden of Clear Ripples) after the large artificial lake at the foot of the hill.[5] During the final decades of the Qing Dynasty, the complex was destroyed twice: in the Anglo-French invasion of 1860, and in the Boxer Rebellion of 1900. In 1903 the Empress Dowager Cixi, who had renamed the site Yiheyuan (Garden of the Preservation of Harmony), restored it as her final residence.[6]

This painting captures the exquisite way in which the design of the Summer Palace balanced natural and man-made features. The most significant buildings were clustered at the base of the southern side of the hill. Many of them were orientated to provide a range of scenic views of the garden, including the willow trees growing along the shore of the gleaming lake.

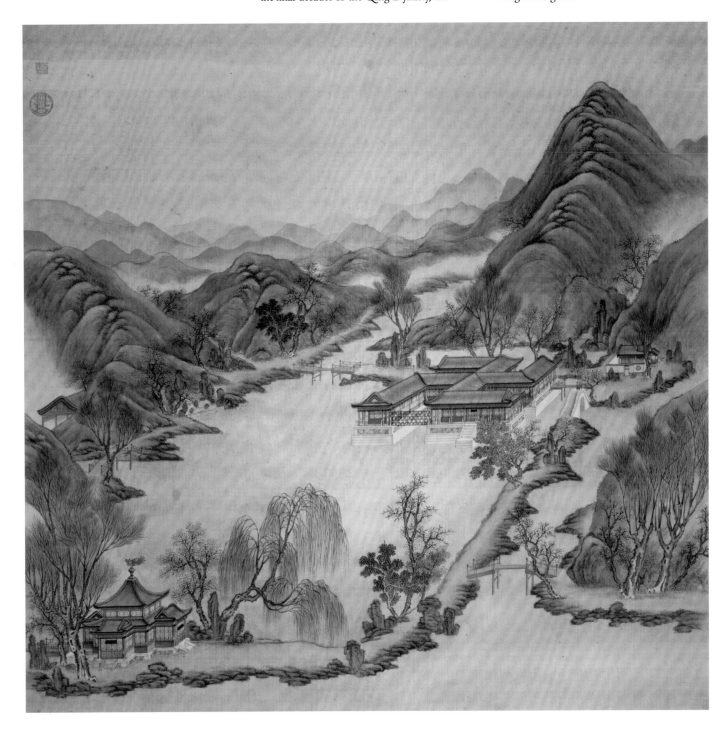

Mughal School
Babur Supervising the Laying-Out of the Garden of Fidelity (left-hand side of double-page composition)

c. 1590
Opaque watercolour and gold on paper
Dimensions unknown
Victoria and Albert Museum, London

The Mughal emperor Babur (1483–1530) was a man of many accomplishments. His noble ancestry linked him to Genghis Khan and Timur, and he founded the Mughal Dynasty (1526–1707) through valiant military campaigns and brilliant statecraft, extending his domain in central Asia to include much of India. Also a poet and a patron of the arts, Babur was fascinated by the natural world, a passion he expressed in innovative garden designs for the capitals he established throughout his realm. His favourite garden was the Garden of Fidelity (Bagh-i Vafa), which he built near Kabul around 1508.

This image represents the left-hand side of a double-page illumination created to illustrate a copy of Babur's journal (the right-hand side is shown opposite). The red sandstone walls identify the garden as the Bagh-i Vafa. Within the walls there are pomegranate and orange trees; Babur noted in his journal that the orange trees were 'a most beautiful sight' when the fruit acquired its vivid colour.[7] A workman stands on a raised garden bed, holding one end of a rope that is being used to lay out the straight lines of the garden. Outside the walls, an envoy and a battalion of horsemen gather at the gate, waiting for an audience with Babur.

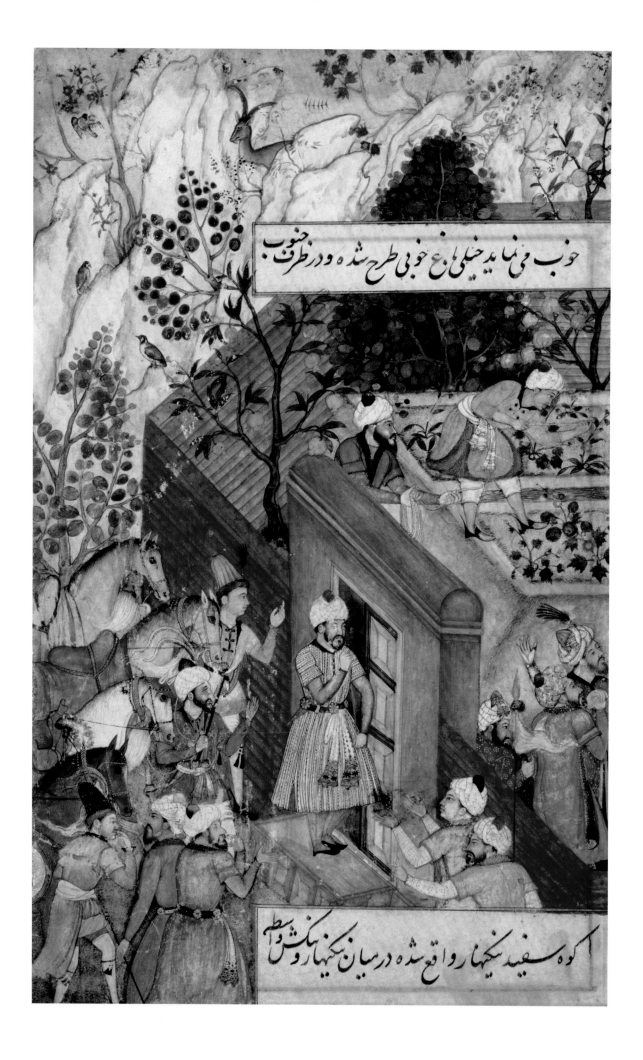

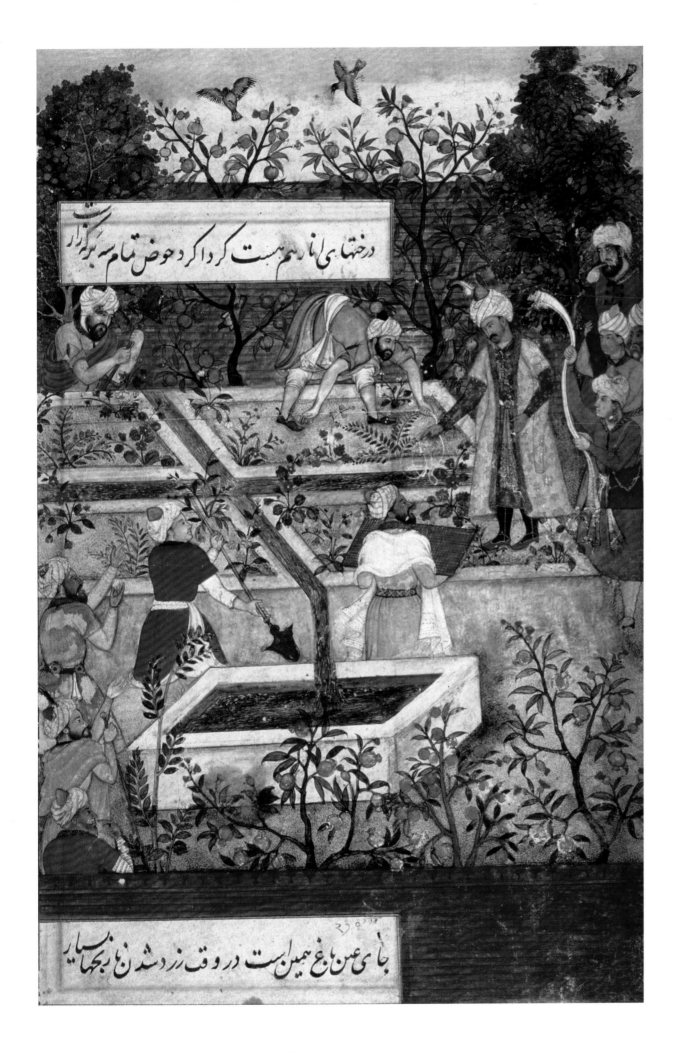

درختهای نارم مست کردا کرد و حوض تمام سه کرکزار

جای من باغ همین است در وقت زردشدن بر جهانبسیار

Mughal School
Babur Supervising the Laying-Out of the Garden of Fidelity (right-hand side of double-page composition)

c. 1590
Opaque watercolour and gold on paper
Dimensions unknown
Victoria and Albert Museum, London

In the right-hand side of the composition from Babur's journal (see opposite), Babur himself can be seen wearing a yellow robe over a red *jama*. He is crowned with a white turban, while a nearby manservant sports a white sash, an emblem of the emperor's sovereignty. With his architect in the foreground holding plans incised on a red tablet, Babur directs his workmen. Several stand ready with their gardening tools, but Babur is watching the man in green, who bends forward to secure the other end of the laying-out rope held by the workman in the left-hand side of the illumination. The positioning of the four water channels that divide the garden had to be precise, in accordance with the traditional elements of the Persian *chahar bagh* (four-fold garden), examples of which Babur had observed as a youth in Samarkand.

Babur's journal documents the active role he took in planning and tending the Bagh-i Vafa. One entry orders his gardeners to plant young trees, and to fill the borders of the garden with sweet-smelling herbs and brightly coloured flowers. Over the course of his reign Babur planted numerous gardens, but he always favoured the Bagh-i Vafa, with its abundant crop of oranges, lemons, pomegranates and plantains. As for Kabul, he claimed that if there were a place on Earth equal to its pleasant atmosphere, 'it is not known'.[8]

Sita Ram
(*fl.* 1810–22)
Garden of the Taj at Agra

c. 1815
Watercolour, gouache and graphite
on laid paper
40.6 × 56.2 cm (16 × 22⅛ in.)
Peabody Essex Museum, Salem, Massachusetts

Writing from Agra in 1663, the French traveller and physician François Bernier described exquisite new gardens built by the Mughal emperor Shah Jahan (1592–1666). There were broad 'garden allées' shaded by blooming fruit trees and cypress, and parterres so richly planted with roses and daffodils that they looked like flowering carpets.[9] The main feature of the complex was a magnificent white-marble mausoleum honouring Shah Jahan's favourite wife,

Mumtaz Mahal, who had died in childbirth in 1631. Through tremendous expense and effort involving the labour of 20,000 men and more than 1000 elephants, the Taj Mahal, or 'Crown of the Palace', was completed in less than two decades.

Sita Ram's early nineteenth-century view portrays the spectacular approach to the mausoleum. It is early morning, and the cypress trees cast shadows over a reflecting canal flanked by grass walkways and edged

with red sandstone. By this period the gardens had grown wild, but the traditional form of the *chahar bagh*, introduced into India by Shah Jahan's ancestor Babur, had survived. At the end of the century the Viceroy of India, Lord Curzon, replaced the flower beds with a green lawn clipped into geometric patterns. Today, scholars challenge the romantic myth of the grief-stricken husband's motives, but the Taj Mahal remains a favourite destination for lovers and newlyweds.[10]

Pierre Patel
(c. 1605–1676)
Perspective View of the Chateau, Gardens and Park of Versailles seen from the Avenue de Paris

1668
Oil on canvas
115 × 161 cm (45¼ × 63⅜ in.)
Château de Versailles

In the early seventeenth century the environs of Versailles became a favourite royal hunting ground. Rejecting the habit of his father, Henry IV, of staying in a village inn, Louis XIII constructed a lodge in 1623, and during the remaining two decades of his reign acquired tracts of land, built a palace and cultivated a garden. When Louis XIV assumed responsibility for governing France in 1661, he hired a team of brilliant artists and designers, including landscape architect André Le Nôtre (1613–1700), to transform the relatively modest retreat into a magnificent ensemble of architecture, gardens and woodlands, a suitably grand stage on which to act out the ambitious scope of his monarchy.

Pierre Patel's bird's-eye view, documenting the initial building campaign (1662–68), reveals the splendour of the plan. The grand central axis that leads from the village into a vast courtyard continues through the heart of the chateau, extending to the gardens, the park and, ultimately, the horizon. Elegant beds – the Parterre du Nord on the right and the Parterre de l'Amour on the left – flank the chateau. The groves of mature trees behind them were brought in from other royal estates. Every element conforms to the overarching formal aesthetic, embodying the king's own proclamation of absolute power: 'L'État, c'est moi.'

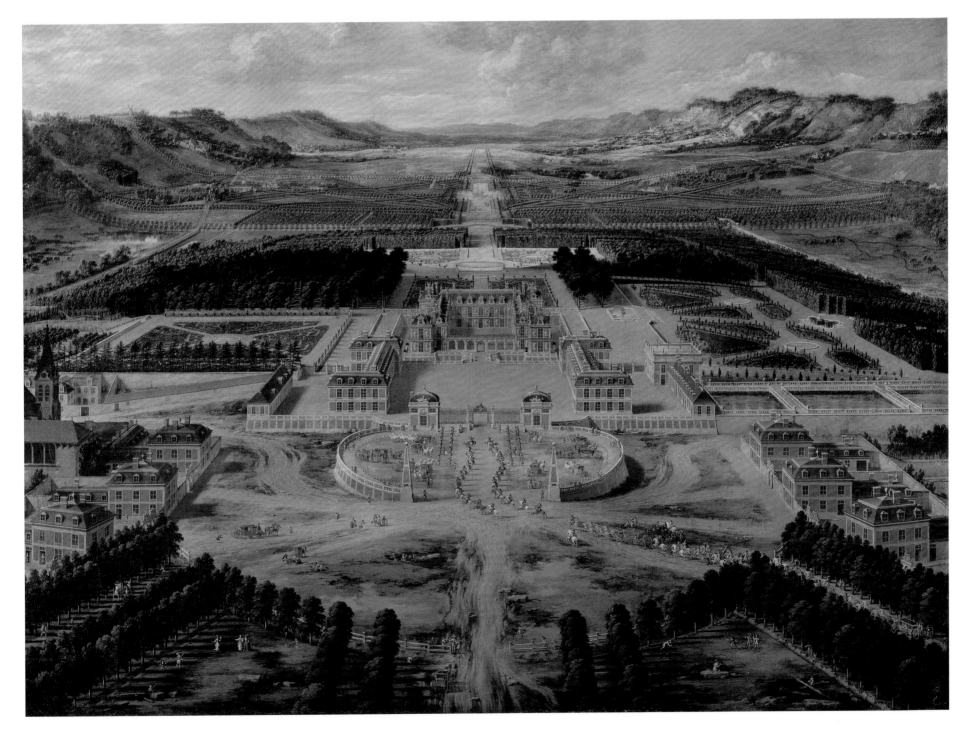

Jean-Baptiste Martin
(1659–1735) (attrib.)
The Orangerie at the Château de Versailles

c. 1700
Oil on canvas
115 × 165 cm (45¼ × 65 in.)
Château de Versailles

In 1686 the original orangery at Versailles, designed by Louis Le Vau in 1663, was replaced with a much grander structure by Jules Hardouin-Mansart. The new building was designed to house the growing collection of exotic trees, which included palm and pomegranate, as well as orange and other citrus varieties. Formality and grandeur informed every design decision made during the reign of Louis XIV, and the seamless integration of architecture and gardens achieved by the new orangery produced a visual setting of unprecedented splendour.

All the elements of the grand formal garden plan can be seen in this view. The arcade of the orangery provides an orderly backdrop for the manicured beds of the Parterre Bas. The circular patterns echo those of the round fountain pool, with its spouting water jet and the columnar pedestals for sculptures. During the summer, the trees, planted in distinctive square containers known as *caisses de Versailles*, were taken out of the orangery and arranged around the parterres. In the foreground, the artfully massed trees and clipped shrubs define paths that lead to the Cent Marches (One Hundred Steps) stairway and the elegant fountains of the Parterre du Midi. This processional plan directed visitors along those routes that would reveal the most impressive perspectives.

Hubert Robert
(1733–1808)
The Bosquet de la Grotte des Bains d'Apollo

1803
Oil on canvas
99 × 130 cm (39 × 51⅛ in.)
Musée Carnavalet, Paris

The term *bosquet* derives from the Italian word *boschetto*, or 'little wood'. It refers to a grouping of trees clipped to create a room-like space within a woodland. Such small-leafed trees as linden, hornbeam or hazelnut are preferred; properly tended, they provide a shady canopy and a private enclosure in gardens as public as Versailles. This site, in the northern woodland close to the chateau, was originally planned to feature two *bosquets*: the Salle des Bains de Diane, and, above it, the Marais (Marsh). Unfinished during Louis XIV's reign, the site was replanned for Louis XVI by Richard Mique in 1778 as a single *bosquet* in a natural style surrounding an artfully rugged grotto.

The sculptures in the painting date from the first design campaign. *The Horses of the Sun* (1666) by Gilles Guérin and *Apollo and His Nymphs* (1666–75) by François Girardon celebrated Louis XIV's identity as the 'Sun King', which linked him to Apollo and his daily task of pulling the sun across the sky in his chariot. In Mique's late eighteenth-century grotto, the repositioned sculptures strike a romantic note. The overgrown *bosquet* and the moss-covered rocks add the patina of antiquity, as if the sculptures date from the ancient world rather than from the era of Louis XVI's great-great-great-grandfather.

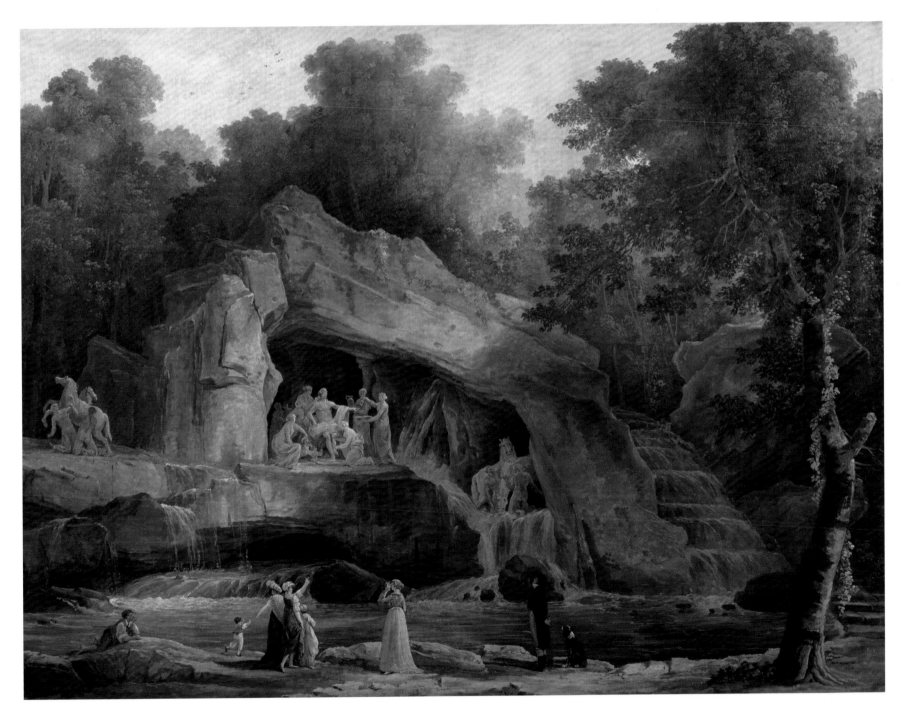

Claude-Louis Châtelet
(1753–1794)
The Hameau, Petit Trianon

1786
Watercolour
Dimensions unknown
Biblioteca Estense, Modena, Italy

In 1668 Louis XIV purchased the village of Trianon near Versailles, flattened all the existing structures, and cleared the grounds for palatial gardens. A century later his great-grandson and heir, Louis XV, added more gardens, a menagerie and an exquisite miniature palace – the Petit Trianon, designed by Ange-Jacques Gabriel – as a gift to his beloved mistress Jeanne Antoinette Poisson, the Marquise de Pompadour. She died before it was finished, however, and in 1770, when Marie Antoinette married Louis XV's grandson and heir, the Dauphin of France, the old king gave her the Petit Trianon and its charming gardens to use as her own private retreat.

In 1774, following the Dauphin's accession to the throne as Louis XVI,

Marie Antoinette added some new features to her retreat: an English-style garden with a flowering meadow and a collection of charming outbuildings. The Hameau (Hamlet), designed by Richard Mique in 1783 to resemble an old Norman village clustered around a lake, was approached through the English garden. Seen here are (from the left) the dairies and a dovecote; the large building on the right is the queen's house. Several cottages, ornamented with gardens containing hyacinths, wallflowers and geraniums, accommodated the queen's guests. Wearing faux-rustic garments, the queen and her entourage relaxed by pretending that they lived in the country and worked in the dairy and the garden.

Johannes Kip
(1653–1722)
after Leonard Knyff
(1650–1722)
The Royal Palace of Hampton Court, from *Survey of London*

1730
Coloured engraving
Dimensions unknown
Private collection

Henry VIII, the first royal resident at Hampton Court Palace, used the extensive gardens to proclaim his power. The overall design featured Tudor emblems, heraldic beasts and his family colours of green and white. A century later Charles I adopted the formal severity of European designs and stripped the garden of ornamentation. William III and Mary II had created a beautiful garden at their Dutch hunting lodge, Paleis Het Loo in Apeldoorn, and when they became the rulers of England in 1689 they transformed the gardens at Hampton Court.

This bird's-eye view shows the east parterre, or the Great Fountain Garden. French architect Daniel Marot (1661–1752),

who had supervised the gardens at Het Loo, created an elegant single-axis plan with a central fountain and flanking parterres. His style merged Dutch simplicity with French formality, and, like André Le Nôtre at Versailles, he designed the gardens to be seen from the palace windows above. He created his patterns using the cut-grass technique known as *parterre à l'angloise* (after English lawns) and scroll-work plantings of dwarf box against coloured gravel known as *parterres de broderie* (after their resemblance to embroidery). *Plate-bandes*, low lines of clipped evergreens on mounded beds, define the individual parterres. This innovative planting guaranteed year-round decorative beauty without the adornment of flowers.

Francis Nicholson
(1753–1844)
Stourhead

n.d.
Watercolour on paper
Dimensions unknown
Private collection

Henry Hoare II (1705–1785) had just
returned from a tour of Italy in 1741 when he
inherited his family's Wiltshire estate near the
River Stour. His father, a successful banker
who had purchased the property from its
ancestral owners in 1717, had commissioned
Scottish architect Colen Campbell to replace
the old house with a Palladian-style villa
(1720–24). With the help of English
architect Henry Flitcroft, the younger Hoare
transformed the extensive grounds into an
Arcadian Italianate setting with softly rolling
hills, rounded trees and shrubs, an artificial
lake created by damming the river, and
garden architecture in the Classical mode.

Hoare and Flitcroft composed their
vistas in emulation of the work of famed

seventeenth-century landscape painters
Claude Lorrain and Gaspard Dughet
(also known as Gaspard Poussin). Francis
Nicholson's view of the gardens, featuring
the Temple of Apollo on the left and the
Palladian Bridge and the Pantheon on
the right, offers a different perspective
from the series of charming ground-level
views that a stroller would see from the
footpath that rings the lake. The dense
growth of trees, especially surrounding the
Temple of Apollo, suggests that Nicholson
painted this view towards the beginning
of the nineteenth century, after the exotic
trees and laurels planted by Hoare's
grandson and heir, Richard, had begun
to mature.

Paolo Fumagalli
(19th century)
*Mount Vernon, Virginia, Home of
George Washington*

c. 1820
Coloured engraving
Dimensions unknown
Private collection

In 1761 George Washington (1732–1799) inherited a large estate near the Potomac River following the death of Anne Fairfax, his sister-in-law. Recently wed, he moved with his wife, Martha, into the small house at the centre of the property, and began to redevelop roughly 80 hectares (200 acres) of the 3240-hectare (8000-acre) site. Washington was a passionate amateur gardener, and whenever he was in residence at Mount Vernon he oversaw every detail of the gardens' upkeep. His views were shaped by contemporary English theories; a copy of Batty Langley's *New Principles of Gardening* (1728) could be found in his library.

A large plantation house, built around the original residence, was central to Washington's design. He positioned a brick-walled flower garden on the east side of the house – the new drawing-room had a view of the flowers – and a kitchen garden was dug on a lower terrace. Following Langley's advice, he used curving lines to create walks and the front driveway, softening the formality of the grand house. In 1783, after resigning his commission as commander-in-chief of the colonial army, Washington devoted all his time to the estate, surrounding the house with groves of young trees, including crab apple and pine taken from the far reaches of the estate, as well as catalpa, maple, hemlock and magnolia.

Richard Wilson
(1713/14–1782)
Kew Gardens: Ruined Arch

Early 1760s
Media and dimensions unknown
Private collection

During the early seventeenth century James I enjoyed hunting holidays in the grounds of Richmond Palace, a royal residence (no longer in existence) located to the south-west of London in a bend in the River Thames. Towards the end of the century Sir Henry Capel acquired nearby Kew estate, and his famed gardens brought even greater renown to this picturesque region of England. But the real connection between the royal household and garden patronage dates from the eighteenth century, when George II's wife, Queen Caroline, hired Charles Bridgeman to landscape the surrounding parkland in a naturalistic style, complete with garden follies designed by William Kent. The queen's daughter-in-law, Princess Augusta, continued the work, adding many more whimsical structures, including this ruined arch designed by William Chambers (1723–1796).

Richard Wilson's view is one of several of Kew Gardens and the river that he painted in the second half of the eighteenth century. By then, Chambers had built his best-known follies, including the Alhambra (1758), the Chinese Ting (1760), the Mosque (1761) and the Pagoda (1762). Chambers designed the Ruined Arch (1760) to look as though it had weathered the centuries, with a crumbling pediment and artful erosion ageing the newly built keystones and coffers. But it was not just a folly; it connected Kew Road to an enclosed pasture for grazing livestock.

Richard Wilson
(1713/14–1782)
Kew Gardens: The Pagoda and the Bridge

1762
Oil on canvas
47.5 × 73 cm (18¾ × 28¾ in.)
Yale Center for British Art, Paul Mellon Collection, New Haven, Connecticut

As a young man, William Chambers made several voyages to China, and in 1757 he earned public notice as the author of *Designs of Chinese Buildings, Furniture, Dresses, Machines and Utensils*. He came to Kew to work for Princess Augusta on the recommendation of John Stuart, the 3rd Earl of Bute (and, later, prime minister of Great Britain). Within the space of a few years, Chambers had designed a wide variety of structures for Kew, including the Temple of Pan (1758); a Chinese aviary (1760); the temples of Aeolus and Bellona (1760); the Orangery and Great Stove glasshouses (1761); the Temple of the Sun (1761); and the towering Pagoda (1762), ornamented with glittering dragons (now lost) and a gilded roof.

Chambers's eclectic world aesthetic was consistent with an interest in exotic plants established at Kew by Augusta's late husband, Frederick, Prince of Wales. *Hortus Kewensis* (1768), the first planting inventory of the gardens, listed species from every corner of the globe, including *Ginkgo biloba* from China, *Sophora japonica* (pagoda tree) from Japan and *Robinia pseudoacacia* (black locust) from North America. When Lancelot 'Capability' Brown was appointed master gardener at Hampton Court Palace in 1764, he imposed his trademark lawns and groves on Kew Gardens, but by then the botanical mission of Kew was already well established. Under the direction of Sir Joseph Banks (from 1784 to 1820), the Royal Botanic Gardens gained international fame.

Samuel Palmer
(1805–1881)
The Villa d'Este

1837
Watercolour on paper
27.3 × 37.5 cm (10¾ × 14¾ in.)
Victoria and Albert Museum, London

Samuel Palmer married in September 1837, and shortly afterwards he and his wife, Hannah, set off for Italy. With Rome as their base during a two-year sojourn, they explored the surrounding countryside. Palmer's favourite location was Tivoli, and in a letter to his father-in-law he proclaimed that 'The Villa d'Este is enchantment itself.'[11] Palmer made several drawings and watercolours there, including this view towards the town, with the Campagna and Rome in the distance. Hannah described the scene as follows: 'Villa itself through those wonderful trees looking like a palace of Heaven.'[12]

It may seem surprising that Palmer chose to feature the cypress and pine trees rather than the villa's famed waterworks. Cardinal Ippolito d'Este, the governor of Tivoli from 1550, acquired the estate that same year, and over the ensuing decades he and his descendants commissioned elegant terraced gardens with an astonishing range of water features, including fountains, basins, jets and cascades. During the eighteenth century, however, the gardens were badly neglected by their then-owners, the Habsburg dynasty, and by the time of the Palmers' visit the waterworks no longer functioned.[13] This hardly dampened Palmer's enthusiasm for the site, and even twenty years later he recalled that 'one might draw the cypresses in the Villa d'Este for a year and not exhaust them'.[14]

John Tenniel
(1820–1914)
The Queen has come! And isn't she angry, illustration from *Alice's Adventures in Wonderland* by Lewis Carroll

1865
Colour lithograph
Dimensions unknown
Private collection

After the strange events of the Mad Hatter's Tea Party, Alice's adventures in Wonderland take an even more curious turn. The next door that she opens reveals a passageway that leads to a beautiful garden with bright, blooming flowers and bubbling fountains. A towering rose tree graces the entry, and Alice watches in bewilderment as three gardeners busily paint its white blossoms red. As the gardeners explain to her that they had mistakenly planted the white tree rather than a red one, a grand procession enters the garden. It is the garden's mistress, the Queen of Hearts, and with a haughty glance at the gardeners trembling on the ground before her, she turns 'crimson with fury' and thunders, 'Off with their heads!'[15]

Oxford don Charles Lutwidge Dodgson (1832–1898) invented Alice's tale in 1862 to entertain the children of his friend Henry Liddell. It appeared in print three years later – under Dodgson's pen name, Lewis Carroll – and John Tenniel's imaginatively conceived illustrations became iconic. The artist heightened the absurdity of this particular scene by placing the bizarre royal entourage in a conventional setting. The prospect of a grand landscape garden – complete with a grove of trees, a dome-topped conservatory and a spouting fountain – can be seen beyond the wall, while a little bed of garden flowers blooms within bentwood fencing.

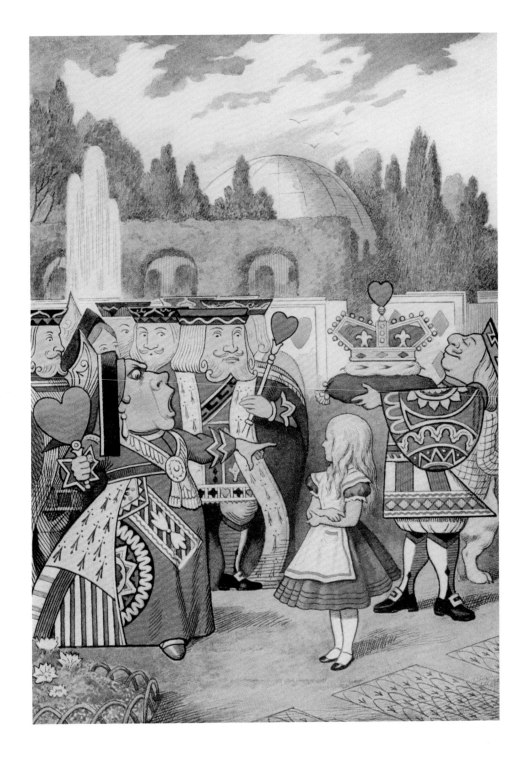

Claude Monet

(1840–1926)

Waterlilies at Giverny

1917
Oil on canvas
100 × 200 cm (39⅜ × 78¾ in.)
Musée des Beaux-Arts de Nantes, France

Visitors to Monet's home in Giverny often remarked that the taciturn artist was a warm and generous host. He took particular delight in escorting his favourite guests around his gardens, making certain that they saw the water garden before the lilies closed in the afternoon. Over the years he enlarged the water garden twice – first in 1901, and again in 1910 – adding winding footpaths, arched bridges, a trellis for climbing roses and a bench on which he could sit and contemplate the 'restful sight of those still waters'.[16]

As early as 1898 Monet imagined the motif of the water garden transposed to panels and installed in a circular room,[17]

but more than fifteen years passed before he began the project in earnest. Between 1914 and 1918 he painted boundless planes of water, brightened with open lilies and shimmering reflections, on huge canvas panels. He planned to give the panels to France to commemorate the end of the First World War. Although the twenty-two panels of the *Grandes Décorations* were not installed in the Musée de l'Orangerie until after his death – and he painted many more than the plan allowed – they simulate the serene experience that he shared with his guests, transporting the visitor from a Paris gallery to his garden.

Claude Monet
(1840–1926)
Waterlily Pond: Pink Harmony

1900
Oil on canvas
89.5 × 100 cm (35¼ × 39⅜ in.)
Musée d'Orsay, Paris

In February 1893 Monet purchased a small parcel of marshland across the road from his house in Giverny. The land contained a pond, which Monet planned to use as the central feature of a water garden. Fed by a stream called the Ru, the pond was stagnant, and Monet applied to the local prefect to reconfigure the stream bed so that it would flow out of, as well as into, the pond. His neighbours objected; they feared that the introduction of exotic plants would foul the Ru, which fed into the Epte River, the region's main tributary of the Seine. The local authorities dismissed the complaints as groundless, and granted Monet permission to re-route the Ru. Two years later he spanned the pond with a small green footbridge, which became the focal point for the *Japanese Bridge* series (1899–1900), the first complete series Monet painted in the water garden.

For each painting, Monet placed his easel at the edge of the pond. The bridge served as the one stable element in the composition; the water and its bounty of lilies undulated beneath it, while the fronds and grasses in the foreground and the drooping branches of the willows in the distance trembled with the slightest motion of the wind. When Monet exhibited thirteen works from the series in Paris in November 1900, critics compared them to scenes from Utagawa Hiroshige's *One Hundred Famous Views of Edo* (1856–58; see, for example, page 169). A year later he transformed the garden, tripling the surface area of the pond and crowning the bridge with a canopy.

Pleasure Gardens

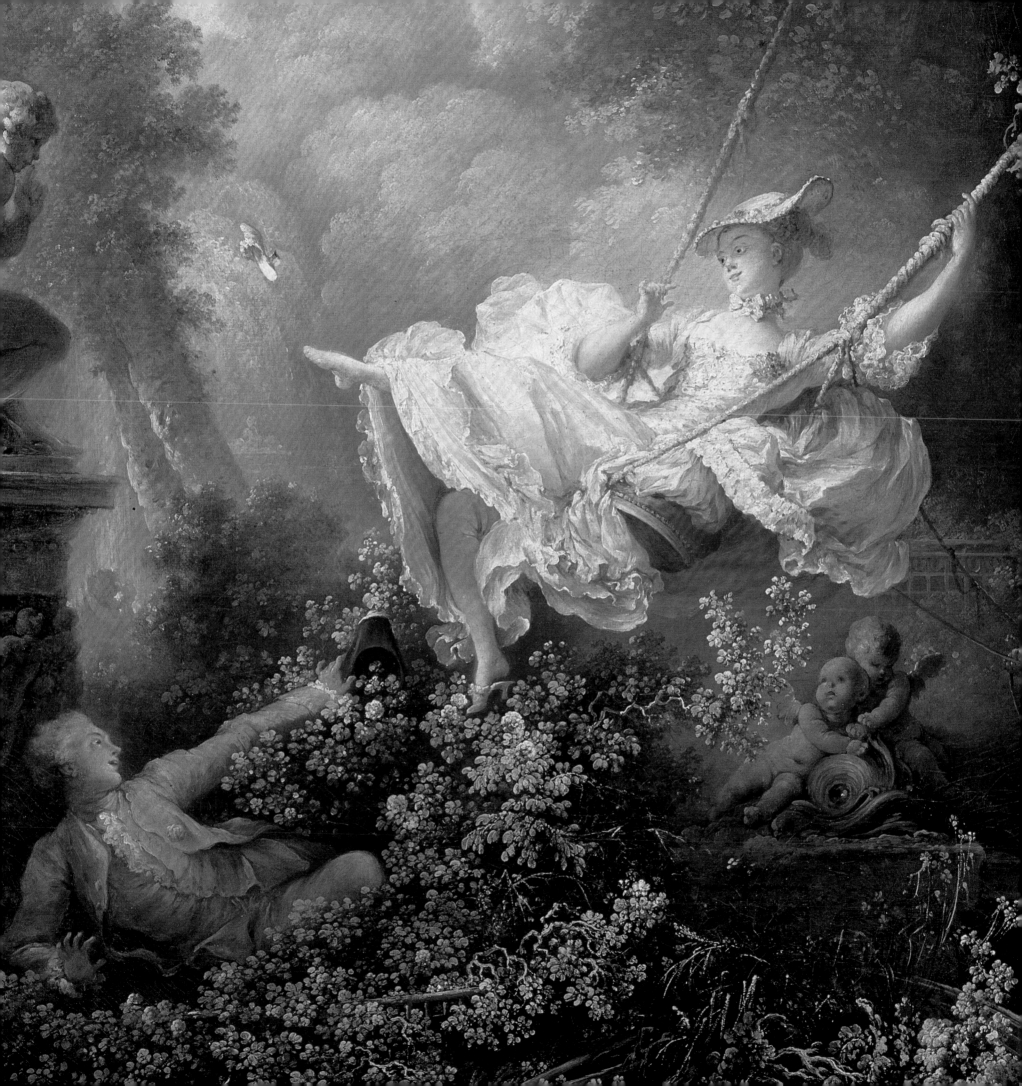

In *De Vegetabilibus et Plantis* (c. 1260), a landmark treatise on the natural sciences, the German philosopher and theologian Albertus Magnus urges his readers to design a special garden without regard to 'great utility or fruitfulness', in which every plant and tree appeals to the senses through scent and colour. He instructs the gardener to scatter such fragrant herbs as sage and rue in the grassy lawn, and to cultivate such brightly blooming flowers as columbine, roses and violets. Even trees should be chosen for their sweetness; he recommends bay and cypress. Albertus also suggests placing a bench in the centre, so that visitors 'may sit down to take their repose pleasurably when their senses need refreshment'.[1] With every feature chosen to delight the senses and soothe the spirit, the little garden would offer a haven from everyday concerns.

Pleasure gardens existed throughout the ancient world, as evidenced by depictions of such gardens in Egyptian tombs, on Chinese scrolls and on the walls of Roman villas. The images of pleasure gardens in the deluxe manuscripts of medieval Europe and the Middle East, however, represent a true visual parallel to the sensory experience that Albertus advocated in his treatise. Viewing a miniature painting of a pleasure garden offered a glimpse into a perfect miniature realm, a private garden safe within protecting walls or screened from sight by densely growing trees, where flowers bloomed in jewel-toned hues and garden furnishings were embellished with gold and silver. Little wonder, then, that illuminators chose such settings for scenes of intimate encounters, such as those in Loyset Liédet's *Garden of Love* (page 89) and the Persian *Two Lovers in a Flowering Orchard* (page 90).

As a setting, the pleasure garden could instruct as well as delight. Such flowers as violets, roses and lilies – emblems of the Virgin Mary – designate a feminine domain, and the noble lover in the tapestry *Offering of the Heart* (page 88) models gentlemanly behaviour as he enters the grassy mead to pledge his love to a lady. But sensory arousal can also lead to folly and sin, as portrayed by Hieronymus Bosch in his hallucinatory pleasure garden of 'earthly delights' (opposite). Under ideal circumstances, the setting matches the experience, as in the legend of the Spring Purification Festival hosted by the famed calligrapher Wang Xizhi at the Orchid Pavilion, where the intoxicating beauty of the flowers matched the inspired intoxication of the guests (page 96).

The most enduring use of the pleasure garden in art is as a setting for romantic love. French eighteenth-century painters staged coy flirtations, forbidden trysts and broken-hearted laments in leafy bowers (pages 92, 94 and 95). In the nineteenth century the garden became the stage for touching vignettes in which plants played the role of a chorus, commenting on desire, longing, disappointment and loss through the language of flowers (pages 99 and 102). The image of an intimate encounter in a place where the scents and colours of nature sharpen the senses, arouse emotions and stimulate delight transcended the boundaries of history, culture and class; when lovers met, the garden gave them privacy, pleasure and, at times, their hearts' desire.

Hieronymus Bosch
(c. 1450–1516)
The Garden of Earthly Delights
(central panel)
c. 1500–1505
Oil on panel
Triptych, 220 × 389 cm (86⅝ × 153⅛ in.) overall
Museo Nacional del Prado, Madrid

The central panel of Hieronymus Bosch's grand triptych features a bizarre panoramic landscape populated by slender little nudes, who cavort not only with one another but also with horses, pigs and creatures that defy any known classification. The scene teems with uninhibited activity: hordes of figures ride their beasts in a circular parade, immerse themselves in the shallow waters of streams and ponds, and couple without regard for either tenderness or decorum. Flanked by wings that depict the Garden of Eden on the left and the inferno of Hell on the right, Bosch's garden of 'earthly delights' appears to illustrate the irresistible force of carnal corruption that leads humanity to sin.

The precise message behind Bosch's iconography has confounded scholars for centuries. It has been variously interpreted as a thundering warning against human indulgence, a sermon on the fatal flaw of folly in human nature, and an alchemical parable that compares common humanity with base metal and the potential for salvation with spiritual gold.[2] A key to the disturbing pleasures of this garden may lie in the repeated motif of fruit, notably the giant strawberries. The sensual pleasures they provide – delicious taste and heady fragrance – are but momentary, and earthly pleasure, like life itself, is transient.

OPPOSITE, TOP

Loyset Liédet
(*c.* 1420–1479)
The Garden of Love, from
The Renaud de Montauban Cycle
(MS 5072 f.71v)

c. 1468–70
Vellum
Dimensions unknown
Bibliothèque de l'Arsenal, Paris

Medieval manuscript illuminations suggest that castle gardens provided the perfect setting for an intimate encounter. As seen here in Loyset Liédet's miniature painting, created for a cycle of tales based on a twelfth-century *chanson de geste* (song of heroic deeds), strong brick walls crowned with battlements and sturdy stone gates with massive wooden doors deter all intruders. The elegant couple sits on a lush green lawn as they share a decorous but ardent exchange. Like their surroundings, their dress and demeanour proclaim their aristocratic status; the little white greyhound resting nearby is an emblem of his master's chivalric virtues.

Favourite features of fifteenth-century garden design can be seen in Liédet's tableau. The U-shaped brick bench behind the lovers is covered with turf. It supports two ceramic planters: one holds a tiny rose trellis, the other a topiary tree clipped and trained into a triple estrade. A delicate basketwork fence defines the grassy enclosure, and a gravel walkway separates the fenced garden from its protective wall. The ornamental fountain alludes to the 'well of living water' described in the Song of Solomon (4:15). Conceived as a secular paradise, the medieval pleasure garden offered its elite occupants a refuge from commonplace concerns.

French School
Offering of the Heart

15th century
Arras tapestry
Dimensions unknown
Musée National du Moyen Age, Paris

The ideal of the courtly lover – keen in desire but decorous in behaviour – which first appeared in the troubadour songs and court entertainments of twelfth-century Provence, refined the concept of chivalric character in Europe. According to the code of *amour courtois*, or 'courtly love', the perfect knight was to be as gentle in the pursuit of love as he was fierce on the field of battle. By the fifteenth century, scenes of strapping men displaying devotion and deference to delicate women gained widespread popularity in all the secular arts, such as this tapestry featuring a man literally offering his heart to a lady.

A stand of trees in a flowery mead creates a secluded bower for the lovers' encounter. Dressed with aristocratic flair, the man enters the grove, holding out his beating heart. His white hound leaps towards the lady's beckoning hand, a gesture that bodes well for its master. Two rabbits symbolize carnal love, but the demure lady holds a vigilant falcon, an embodiment of the conquest of lust. Roses bloom in the foreground; as the floral emblems of both Venus and the Virgin Mary, they predict that this courtly lover will win his heart's desire.

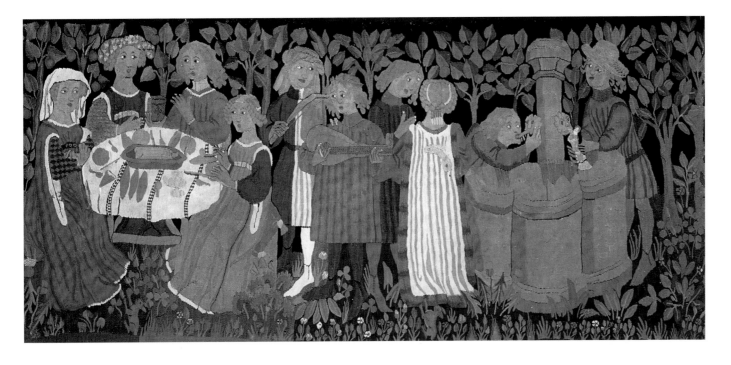

LEFT, BOTTOM

German School
Picture carpet depicting
a lovers' garden

c. 1450–60
Textile
66 × 142 cm (26 × 55⅞ in.)
Germanisches Nationalmuseum, Nuremberg

During the Middle Ages the cultivated
grounds of royal residences and grand estates
ranged from the enclosed garden within the
castle walls to the natural woods at the
furthest edge of the precinct. The so-called
'outer gardens' included sweeping meadows,
productive orchards and stands of select trees,
such as bay, olive and pine, planted in orderly
rows.[3] A pleasance, a tree-lined pleasure walk
ornamented with a fountain, was often part of
the outer gardens. In fine weather, it provided
a site for feasting, dancing and games.

This 'picture carpet', a tapestry made for
purely decorative purposes, depicts a festive
gathering in an outer garden. Screened from
view by a bountiful line of fruit trees in a
flowering meadow, well-dressed men and
women enjoy one another's company in the
open air. The couples on the left sit at a table
laden with food, while to the right of the
musicians a handsome man flirts with his
graceful companion. On the far right a man
in a short tunic stands at a fountain, filling
a vase with water for a freshly plucked rose.
The motif of the lovers' garden suggests that
the carpet was made as a wedding present or
for a woman's trousseau.

Persian School
Two Lovers in a Flowering Orchard
(MS C-860 f.41b)

16th century
Gouache on paper
Dimensions unknown
Institute of Oriental Studies, St Petersburg

During the Safavid Dynasty (1501–1732), royal scriptoria produced deluxe manuscripts of classical Persian poetry illuminated with sumptuous miniature paintings. Here, two lovers meet on the banks of a swiftly flowing stream. The tall tree between them is covered with clusters of roses, the ground is a carpet of blooming flowers, and dazzling autumnal leaves crown a white-barked tree. The lively figures, as well as the exquisite setting, reflect the sophisticated style of the early dynasty, when royal patronage was at its height and the naturalistic aesthetic of the illuminator Bizhad (*c.* 1450–1535/36) prevailed in influential workshops in Herat, Shiraz and Mashad.

For the privileged patron, an illuminated manuscript provided private pleasure. A small, elite audience would gather to listen to the reading of a work of the imagination, such as a tale of romance from the *Khamsa*, five narrative poems by the twelfth-century Persian poet Nizami. However, although the spoken words of the story would be shared, the viewing of the illumination offered a more intimate experience.[4] The illuminator's art transported each listener to secret pleasure gardens, where the beauty of nature heightened lovers' desires.

Indian School
A Couple Walking

18th century
Gouache on paper
Dimensions unknown
Musée Guimet, Paris

The elite gardens of the Mughal Dynasty
(1526–1707), like its refined tradition of
manuscript illumination, reflect a long legacy
of Persian cultural influence. Brought to
India by the dynasty's founding ruler, Babur,
the design of such gardens featured many
of the elements of an Islamic paradise
garden, including the distinctive layout of
the *chahar bagh* (four-fold garden), and water
flowing through channels and spouting
from fountains. Set within strong, protective
walls, the gardens provided their wealthy
male owners with havens in which they
could enjoy private meditation, the company
of their peers or, as seen here, the pleasure
of female companionship.

Surrounded by female attendants, a
couple saunters along a terrace flanked by
stone-bordered flower beds and a small
fountain. The lovers might end their stroll
by resting in the shade of the *chabutra*, the
pavilion located at the intersection of the
four avenues of the *chahar bagh*. The garden
would have been planted to appeal to the
senses: colourful carnations and narcissi
paired with fragrant jasmine and tuberose.
Running water freshened the air and
dispersed annoying insects, as well as creating
a soothing sound. But the lovers' senses
are otherwise engaged; they have eyes only
for each other.

Antoine Watteau
(1684–1721)
Mezzetin

c. 1718–20
Oil on canvas
55.2 × 43.2 cm (21¾ × 17 in.)
The Metropolitan Museum of Art, New York

Antoine Watteau debuted at the Académie
Française in 1717 with a subject so
innovative that the distinguished board
of professors created a new classification
to describe it. The *fête galante* presented
contemporary figures in open-air settings;
but in a departure from the atmosphere of
contentment associated with the enduring
love-garden motif, Watteau introduced
wistful elements of longing and loss. He also
blurred the line between the familiar and
the imaginary by freely mixing figures from
the theatre with elegant aristocrats.

 This melancholy fellow, singing to the
accompaniment of his own guitar, is a stock
character from the Italian theatre tradition
of *commedia dell'arte*. His costume – red-and-
grey-striped jacket and knee breeches, a soft
hat and rose-trimmed slippers – identifies
him as Mezzetin, the deceived lover or
disappointed husband.

 Here, taking refuge in an overgrown
bower, his lament falls on deaf ears; his only
companion is a stone statue of a woman,
and even she has her back turned in disdain.
The ivy that engulfs the left-hand side of
the bench heightens the poignant message;
it is the emblem of enduring love. By
transforming the pleasure garden into an
intimate stage for emotional expression,
Watteau influenced three generations of
eighteenth-century French painters.

Louis de Caullery
(c. 1580–1621)
In the Garden of Love
(The Five Senses)

1618
Oil on panel
51 × 43.8 cm (20⅛ × 17¼ in.)
Lobkowicz Collections, Nelahozeves Castle,
Czech Republic

Old and new traditions combine in Louis
de Caullery's lively depiction of a garden
party. During the Middle Ages, European
aristocracy cultivated private gardens to
stimulate the senses with vivid blooms,
trickling fountains and heady fragrances.
Safe behind walls, these gardens were also a
sanctuary for lovers; the sensuous atmosphere
– as well as the privacy – enhanced the
delight. In the seventeenth century Caullery
earned a reputation for painting elegant
images of upper-class entertainments. Here,
merging the medieval theme of the love
garden with contemporary fashions and
manners, Caullery explores a new subject,
known in The Netherlands as the
buitenpartijen.[5]

As Caullery's gallant men and modish
women tempt one another with wit and
beauty, they also satisfy the five senses. There
is food and wine for taste, lute music for
hearing. In the bottom left-hand corner of
the painting, a man and a woman admire
their reflections in a silver knife; in the
bottom right-hand corner, a woman inhales
the perfume of a rose. The kiss, between
a handsome youth and a lady in resplendent
red, is the most tender embodiment of touch.
Seated on a low wall in the distance, a man
directs his partner's attention to the garden
behind them. Even in such splendid
company, the garden entices lovers with
its promise of intimate delight.

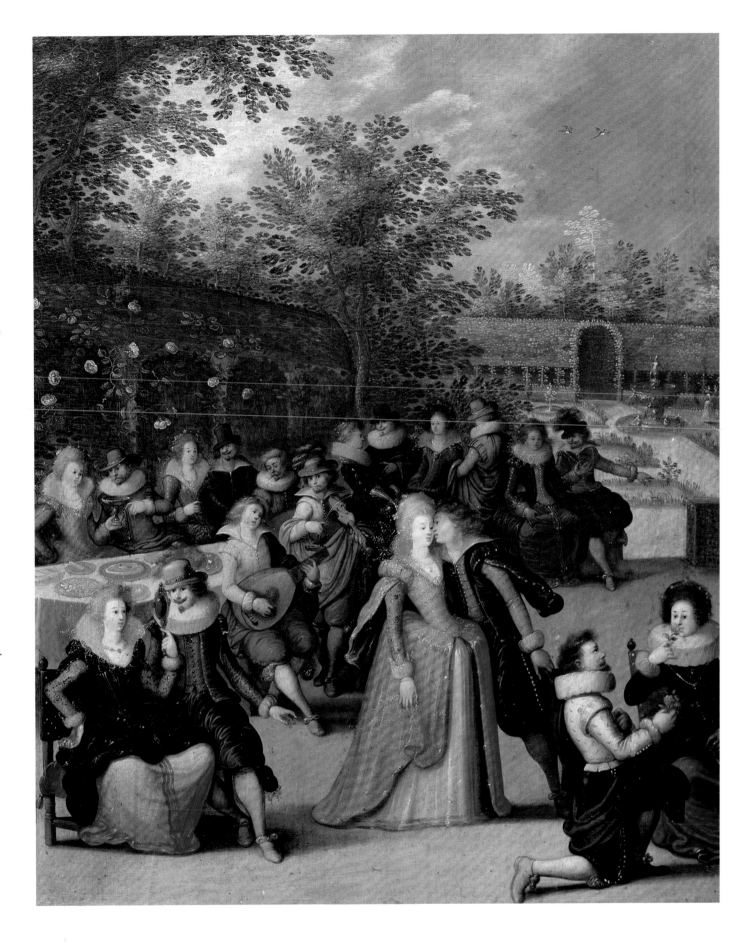

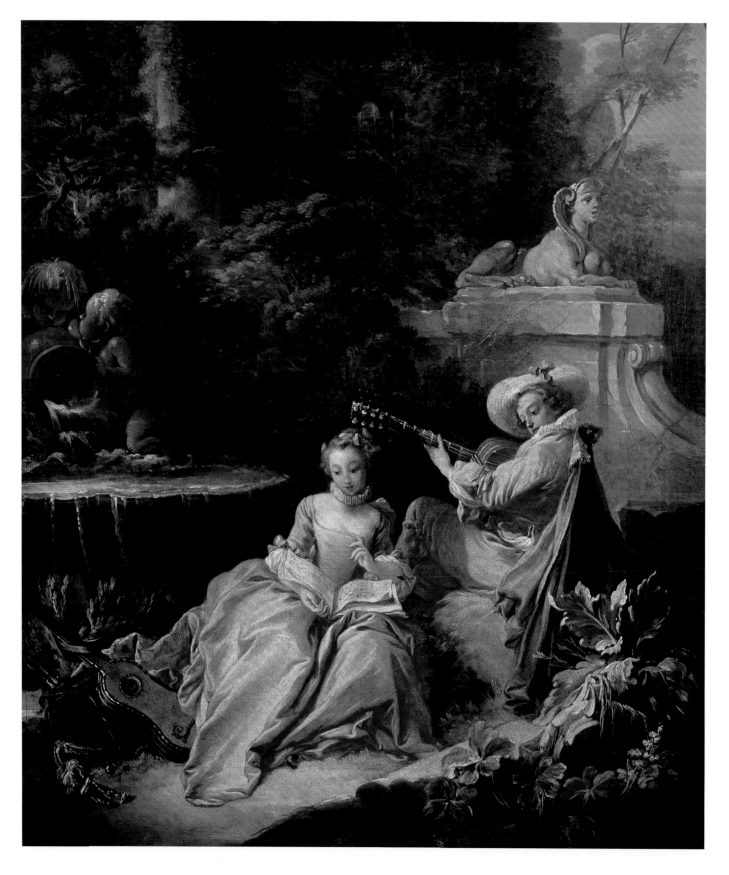

François Boucher
(1703–1770)
The Music Lesson

1749
Oil on canvas
65 × 57.9 cm (25⅝ × 22¾ in.)
Musée Cognacq-Jay, Paris

François Boucher lightened Watteau's pensive interpretation of the love garden (page 92) with suggestive flirtation. Here, the premise is a music lesson, with an attractive young woman singing and beating time while her good-looking companion strums a guitar. The bower setting is so verdant that it implies a return to natural overgrowth, while the presence of antique statuary and the abundant acanthus plant to the right of the couple evoke the timelessness of an Arcadian garden.

Unlike Watteau's indifferent stone lady, however, Boucher's statues encourage the lovers. To their right, two frisky putti tease each other as they pour water into an overflowing basin. The sphinx behind the lovers departs from its conventional role as a guardian to lift its head and join the woman in song. The tombstone among the acanthus recalls the Greek legend from the fifth century BC that tells of the young woman of Corinth who trained the thick, curled leaves of a plant to ornament her lover's grave. Boucher's seductive sentimentality appealed to the sophisticated tastes of the French aristocracy during the reign of Louis XV; the artist's scenes of light-hearted temptation were in perfect harmony with the new Rococo decorative style, and his paintings graced the private chambers of prominent patrons, including those of the king's mistress Jeanne Antoinette Poisson, Marquise de Pompadour.

Jean-Honoré Fragonard
(1732–1806)
The Swing

1767
Oil on canvas
81 × 64.2 cm (31⅞ × 25¼ in.)
The Wallace Collection, London

In his memoirs, eighteenth-century French
playwright and man about town Charles
Collé recalls a story told to him by Gabriel-
François Doyen, the esteemed history painter.
Doyen, it seems, had been approached by the
dashing young Baron de Saint-Julien with
a somewhat risqué commission. The baron
wanted his beautiful mistress to be portrayed
on a swing – with the ropes operated by a
bishop. Moreover, the baron requested that he
be positioned in the foreground – seen by his
mistress but hidden from the bishop – so that
'I would be able to see the legs of this lovely
girl'.[6] Doyen refused the commission, but
suggested the younger painter Jean-Honoré
Fragonard, who set the salacious subject in
a luxuriant bower. His arrangement of the
composition turns the viewer into a complicit
voyeur, a participant in a sophisticated
private joke.

With flushed cheeks, a woman dressed
in pink satin knowingly looks down as
she swings high above the rosebush in the
foreground. She kicks her legs to reveal lacy
petticoats and the tops of her silk stockings.
Hidden by the rosebush, the baron parts its
branches to gaze up in delight. Instead of a
bishop, an old servant – the abandoned rake
at the base of the rosebush suggests that he
is the gardener – works the ropes of the
swing. To heighten the intimate atmosphere,
Fragonard includes a replica of Étienne-
Maurice Falconet's *Menacing Cupid* (1757),
who raises his finger to his lips in a gesture
of complicity. In the overgrown bower the
lovers are free to indulge in a child's pastime
for sensual pleasure.

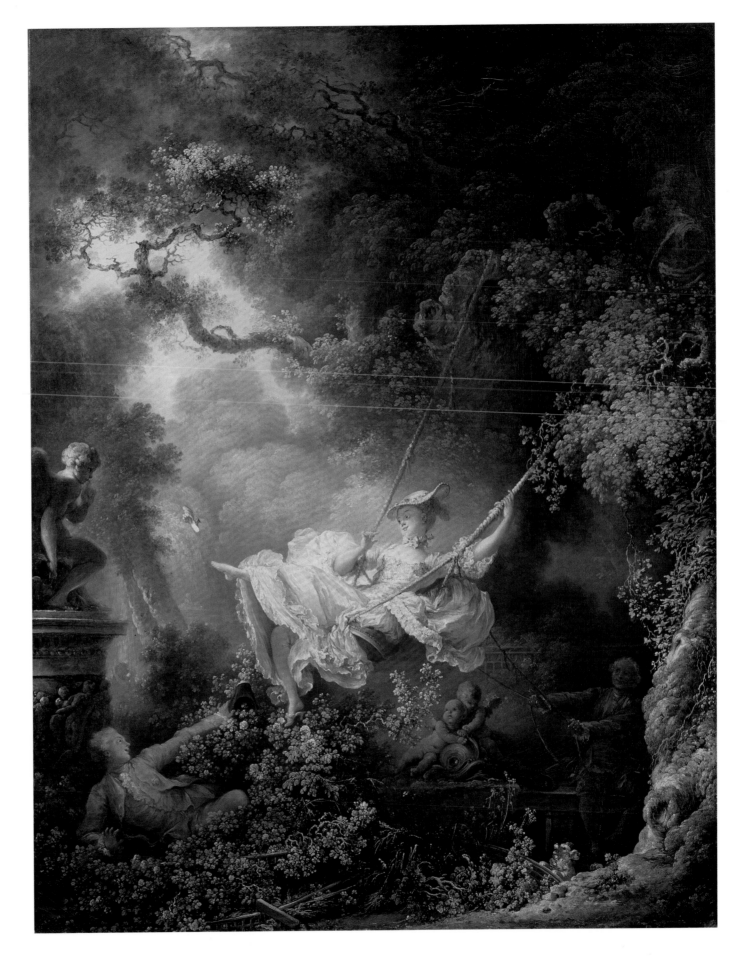

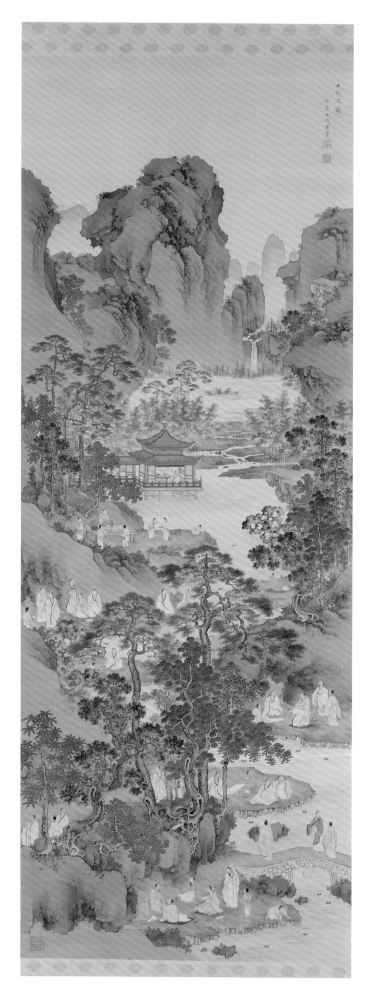

Nakabayashi Chikkei
(1816–1867)
Poetry Gathering at the Orchid Pavilion

n.d.
Ink, colour and gofun on silk
217.2 × 76.2 cm (85½ × 30 in.)
Indianapolis Museum of Art

In 353 the Chinese calligrapher Wang Xizhi (307–365) invited more than two dozen poet-scholars to join him at the Lanting (Orchid Pavilion) at the foot of Lanzhu Mountain for a Spring Purification Festival. To serve his guests, Wang floated cups of wine down a cool stream that flowed from the mountain, but required that each poet compose a poem before plucking his cup from the water. If a poet did not finish in time, he was required to drink a penalty cup. The water moved swiftly, and as the party grew more boisterous, the poets became more creative. At the end of the day Wang wrote the tribute *Lanting Xu* (Preface to the Poems Composed at the Orchid Pavilion), which is regarded as his greatest calligraphic creation.

The Japanese painter Nakabayashi Chikkei was affiliated with the Bunjinga school, a group of nineteenth-century gentleman painters who embraced the enduring Chinese-literati tradition of seeking beauty in nature. His interpretation of the famous gathering stresses the refinement of the poet-scholars rather than the happy intoxication that released their imaginations. Even today, calligraphers honour Wang's memory by gathering along the banks of the stream near the Lanting in spring.

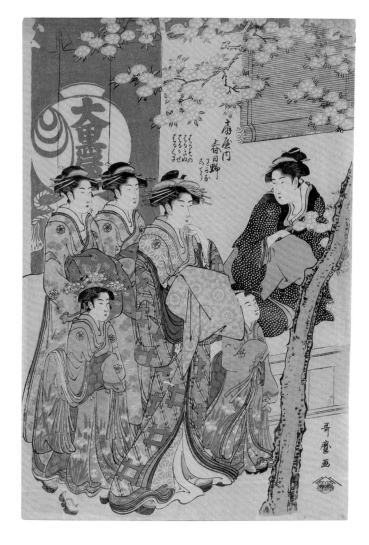

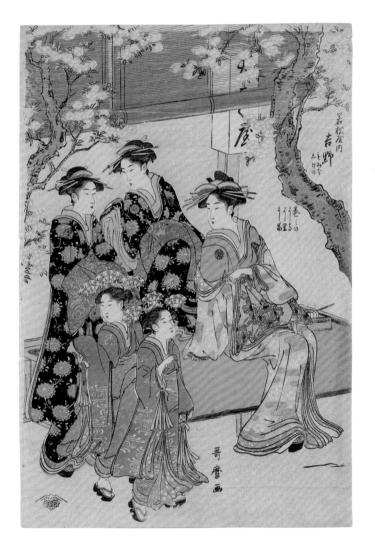

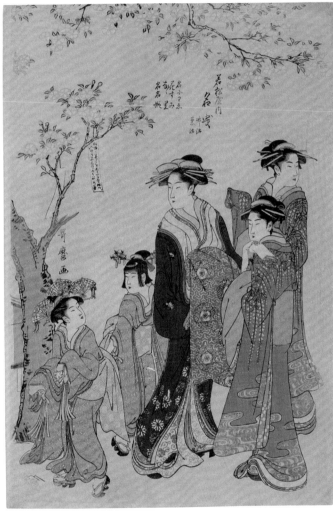

Kitagawa Utamaro
(1753–1806)
*Courtesans Strolling Beneath
Cherry Trees Before the
Daikokuya Teahouse*

c. 1789
Colour woodblock print on paper
Three panels, each 39.1 × 26.4 cm
(15⅜ × 10⅜ in.)
Brooklyn Museum, New York

Cherry blossoms were first cultivated in
Japan's imperial gardens during the early
years of the Heian period (794–1185). The
origins of the *hanami*, or flower-viewing
festival, can be traced to the same time, and
for centuries elegant parties of aristocrats
and poets assembled in cherry orchards each
spring to welcome the brief appearance of the
fragrant blooms. Their clustered pale-pink
petals evoke cloud formations, linking them
to the Buddhist precept that life's pleasures are
transient. In the mid-eighteenth century the
entrepreneurial brothel owners of Yoshiwara
(the pleasure district of Edo, modern-day
Tokyo) staged their own *hanami* by lining the
Nakano-chō (the main avenue) with potted
trees that were on the verge of blooming.
Once they had blossomed and had shed
their petals like falling snow, the trees were
removed and replaced by another attraction.

Here, Kitagawa Utamaro – famous for
his depictions of beautiful women – has
portrayed fashionable courtesans viewing
the cherry blossoms near the Daikokuya
Teahouse. Originally established on the
Nakano-chō, the teahouse perished in the
great Edo-period fire of 1787; this print may
celebrate its reopening in a new location.
The blossoms embody the spirit of *ukiyo* (the
floating world), urging pleasure-district
patrons to delight in beauty – floral or female
– before it fades.

Thomas Rowlandson
(1756/57–1827)
The Amorous Gardener
n.d.
Watercolour on paper
13 × 20 cm (5⅛ × 7⅞ in.)
Harris Museum and Art Gallery, Preston,
Lancashire, UK

With gentle humour, Thomas Rowlandson lampoons convention and class relationships by transforming the gardener into a seducer. Here, the potted plants and temporary seedling beds mark the season as spring, and the lord of the estate has come down to the vegetable garden to check on its progress. As he turns his back to totter up a little ladder and take a closer look, the manly gardener distracts his buxom – and much younger – wife. Their conversation seems to have veered away from the topic of horticulture, as indicated by the woman's reddened complexion and coy downward glance.

The gardener is as hardy as the vegetables he tends. His sleek work clothes show off his robust physique, and his high complexion and full head of hair proclaim his vigour. In contrast, the lord is aged and feeble: his emaciated frame is engulfed in the folds of his coat, his skinny legs are revealed by his old-fashioned breeches, and a wig covers his balding pate. His season has surely passed, but his wife's ample curves suggest that she is ripe for the picking. There is no doubt that she will succumb to the gardener's lusty appeal.

Arthur Hughes
(1832–1915)
The Long Engagement

1859
Oil on canvas
105.4 × 52.1 cm (41½ × 20½ in.)
Birmingham Museums and Art Gallery, UK

An oak tree shelters two lovers in a grove.
The woman gazes into the man's eyes as she
clasps his hand to her heart. He does not
return her gaze; instead, he looks upward,
as if to some future contentment. The title
of Arthur Hughes's painting helps to
explain the situation. The man is a curate,
and his salary is not enough to support a wife
and family. The poignancy of his situation
is summarized in the lines from Chaucer's
Troilus and Criseyde (written between 1381
and 1386) that Hughes inscribed on a label
attached to the back of the canvas: 'For how
might ever sweetness have been known / To
him that might never tastyd bitterness.'[7]

Hughes employs the symbolism of a
woodland setting to strike the same plangent
tone. The sturdy oak signifies endurance,
and the name 'Amy' carved into its bark
implies the curate's steadfast devotion. The
ivy that climbs the oak's trunk and covers
the inscription represents the woman's
unwavering fidelity. The wild roses and
ferns – respectively, simplicity and sincerity
in the language of flowers – convey nature's
abundance. But the vital beauty of the
verdant setting seems to mock the pale, ageing
lovers, and the mossy overgrowth at the base
of the oak, similar to that on a tombstone,
evokes the inevitable passage of time.

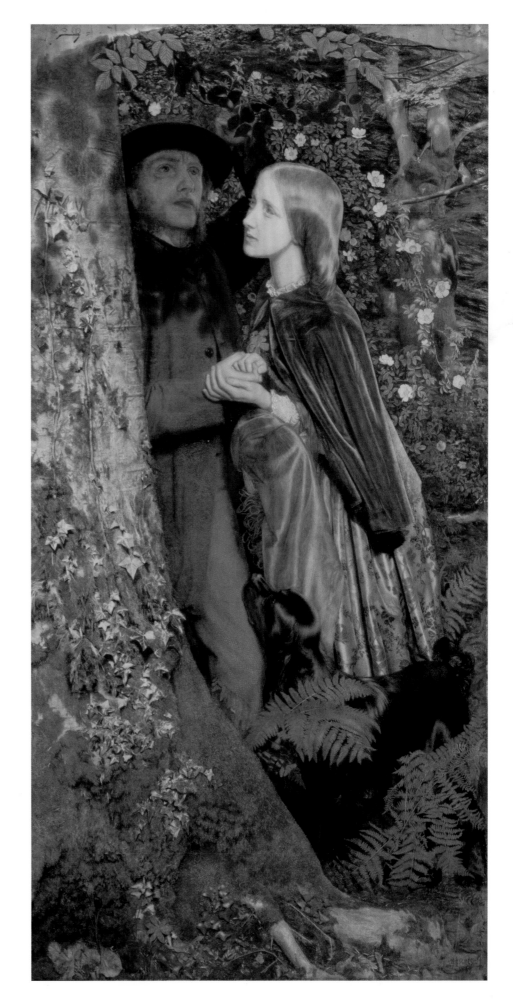

Jules Bastien-Lepage
(1848—1884)
Rural Love

1882
Oil on canvas
Dimensions unknown
The Pushkin State Museum of Fine Arts, Moscow

Jules Bastien-Lepage portrayed his lovers in a setting that mirrored the hard reality of working life in the French countryside towards the end of the nineteenth century. The vines that climb the trellis on the right-hand side of the painting produce vegetables rather than flowers. The fields, thick with foliage, evoke the hours of labour – weeding, thinning, picking – needed to keep them verdant. The gate at which the lovers meet is in need of repair: palings are missing and the stile is broken. However, it serves as a barrier in a moment of silence, suggesting that the man has just confessed his love, and is waiting for the woman to answer.

In the previous century the subject of rural courtship would have been treated as a pretty pastoral, perhaps by being staged in a bower and enacted by a handsome shepherd and a comely shepherdess engaging in suggestive flirtation. By contrast, as a naturalist painter who grew up on a farm, Bastien-Lepage observed life as it was lived in his day, and created his art from his observations. His couple is youthful, but their bodies are already thickened from the work they have done since childhood. Their guileless gestures seem as genuine as their rustic surroundings; the fields in which they labour nurture the bond between them.

Carl Heinrich Hoff
(1838–1890)
The Eavesdropper

1868
Oil on canvas
75 × 58.5 cm (29½ × 23 in.)
Hamburger Kunsthalle, Hamburg

Two young women, seated on a stone bench,
lean close to each other as they share the
contents of a single letter. Each holds a part
of the letter in her hand, and as the dark-
haired woman on the left continues to read,
the woman on the right looks on, seeming
eager for her companion to finish. By setting
this vignette in a garden grove, Carl Heinrich
Hoff indicates that the message is private,
and he guards the intimacy of the moment
with a luxuriant screen of ivy and climbing
roses that partially encloses the bench. Hidden
near the trees, however, the eavesdropper of
the title waits patiently, hoping to overhear the
ensuing conversation.

As a genre painter, Hoff plays with his
narrative by giving the viewer clues with
which to solve the puzzle of the story.
In the mid-nineteenth century pink roses
announced newly declared love, while
tenacious ivy signalled fidelity. The patient
spaniel in the foreground also has traditional
links with fidelity; bred to point and retrieve,
this Dutch Partridge Dog may indicate a
lover's pursuit of the lady he desires. Could
the abandoned shuttlecock and racket suggest
that the time for games is over, and that the
letter's author – now hiding behind the ivy –
has declared his love with honourable intent?

Edmund Blair Leighton
(1853–1922)
Off

1899
Oil on panel
32.7 × 24.8 cm (12⅞ × 9¼ in.)
Manchester Art Gallery, UK

A walk down the garden path can lead to disappointment as easily as it can lead to love. In *Off*, Edmund Blair Leighton employs the courtship cliché as a setting for a little melodrama. A lovely young woman in a muslin dress sits alone on the beam of a wooden bridge. Her posture – grasping the knee of her crossed leg – is as purposeful as it is defiant, but her pensive expression betrays her sorrow. Her erstwhile companion can be seen walking away from her; his steps appear to be measured, and his bowed head and hands clasped behind his back show that he too feels regret. But this is no lovers' spat with the promise of reconciliation. The rose bouquet abandoned at the end of the bridge indicates rejection.

Leighton earned his reputation in late Victorian England painting 'problem pictures', scenes that convey their narrative through suggestion rather than illustration, leaving the story unresolved. He expressed sentiments that were fully contemporary, but his use of historical costume – this scene is set in late eighteenth-century England – burnished his often commonplace scenes with romance. Here, he has transformed an ordinary garden path by the side of a river from a pleasant diversion for a courting couple into a stage for heartbreak.

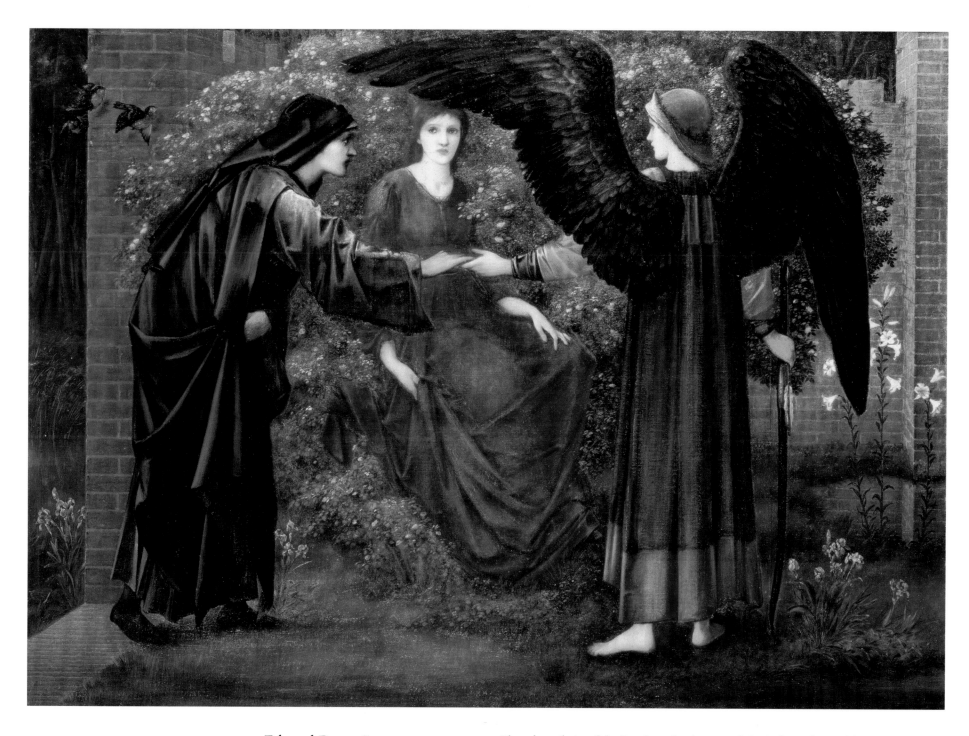

Edward Burne-Jones
(1833—1898)
Heart of the Rose

1889
Oil on canvas
96.5 × 129.5 cm (38 × 51 in.)
Roy Miles Fine Paintings, London

The ardent pilgrim of the French medieval poem *Roman de la Rose* attains his heart's desire in a garden of delight that exists outside the cares of the ordinary world. His quest began with a glimpse into Narcissus's fountain, in which he saw a perfect rosebud. It captured his heart, and with Love as his guide, he set out to win the heart of the Rose. Edward Burne-Jones portrays the Rose as a beautiful red-haired woman clothed in green. Her thorny throne is spangled with fragrant pink blossoms and protected by a brick wall topped with a battlement.

The first part of the poem, written by Guillaume de Lorris around 1240, celebrates courtly love.[8] Refinement and beauty thrive in the garden, and the pilgrim embodies a virtuous man, striving to adhere to courtly ideals. Burne-Jones knew the poem through Chaucer's English version (*c.* 1370), and the distance between his own world and that of medieval poets and pilgrims lends his interpretation the quality of a dream.[9] The flower blooming at Love's feet allies him with Iris, the messenger of the gods in Greek mythology, while the lily signifies the Rose's innocence. Through personification and floral iconography, Burne-Jones transforms the allegorical discourse into a magical tale in which an earnest lover finds ideal love in a perfect pleasure garden.

Working Gardens

Writing in 1811 to a friend who had just retired from professional life in order to oversee his farm, Thomas Jefferson (1743–1826) described himself as 'an old man' but 'a young gardener'.[1] In the strictest sense, this was hardly true. He had been an avid gardener since his youth, keeping records of his experiments and experiences from 1764 until 1824. When he left the presidency in 1809, he moved to his Virginia estate and took particular pride in growing new varieties of vegetable, which he served at his table. Although Jefferson's plantation labourers did most of the work, he took full responsibility for selecting the plantings and organizing crop rotations, and regularly tended the kitchen garden. While he regarded stewardship of the land as the central obligation of a citizen of his young country, he also took personal pleasure in cultivating a productive garden, declaring: 'No occupation is so delightful to me as the culture of the earth and no culture is comparable to that of the garden.'[2]

Through the ages, the arts have portrayed the working garden as a site of necessary but satisfying labour, with the bounty of the harvest as its natural reward. Depictions of prosperous farmlands appear in ancient Egyptian tombs, such as that of the skilled artisan Sennedjem (opposite), as recompense for a lifetime of service and loyalty. Medieval health manuals were illuminated with images of agricultural labour in which gardeners embodied the dual benefits of vigorous work and a sensible diet (page 108). A flourishing and well-planned garden was also used as evidence of cultural advancement, as seen in the images of the Americas circulated in Europe to encourage colonization (page 111).

Jefferson's concept of the gentleman farmer was only one of many potent identities linked to the working gardener. The book of Genesis explains that God placed the first human in the Garden of Eden 'to till it and keep it' (2:15), while medieval theological scholars noted a parallel between Christ's mission on Earth and the hard work of tilling the soil (page 110). A gardener's garments could disguise a king (page 112) or celebrate the worker whose knowledge and efforts guaranteed nourishment and pleasure (page 113). By the early modern era, economic wealth and common labour had shifted from the field to the factory, and the widening gulf between the garden and the table transformed the image of the working gardener into a romantic symbol of endurance and authenticity that countered the uncertainty of changing times (page 121).

More recently, the arts have reflected the ways in which this gulf might be bridged. The farmers' market, depicted as a cornucopia of fresh produce, can be seen as a modern, true-to-life equivalent of the bountiful displays featured in earlier, still-life painting (page 122). The city allotment – the urban counterpart to the rural potager – took on new meaning during twentieth-century wartime as a symbol of patriotic citizens doing their part on the home front. The working garden now serves as an alternative emblem of the good life (page 123), for, in the words of American writer and activist Wendell Berry, if 'one works with the body to feed the body', one reaps 'health, wholeness' as well as 'delight'.[3]

Egyptian School
Sennedjem and His Wife in the Fields Sowing and Tilling (detail), from the tomb of Sennedjem
19th Dynasty (*c.* 1319 – *c.* 1185 BC)
Wall painting
Deir el-Medina, Egypt

The modest scale of the family tomb in which this wall painting can be found, together with its location opposite the workers' village of Deir el-Medina near Thebes (modern-day Luxor), suggests that its owner had lowly origins. An inscription proclaims that Sennedjem was a 'Servant in the Place of Truth', a phrase used during the Nineteenth Dynasty to describe a skilled artisan working on the royal tombs in the nearby Valley of the Kings.[4] When archaeologists excavated the tomb in 1886, they found a perfectly preserved cycle of paintings that traced the journey of Sennedjem and his wife, Iyneferty, into the afterlife.

This image appears among the culminating scenes on the east wall of the tomb. Sennedjem's good service in life is rewarded with rich land and ample crops to sustain his family for all eternity. In the upper register, he ploughs the soil with a team of fine oxen; Iyneferty follows him, sowing seed. In the lower register, date palms and fig trees, heavy with fruit, thrive on the banks of a swiftly flowing irrigation canal. Every detail of this scene reflects agricultural practice along the Nile during Sennedjem's lifetime, but the pristine white festival clothes worn by him and his wife indicate that they are no longer among the living in the mortal working world.

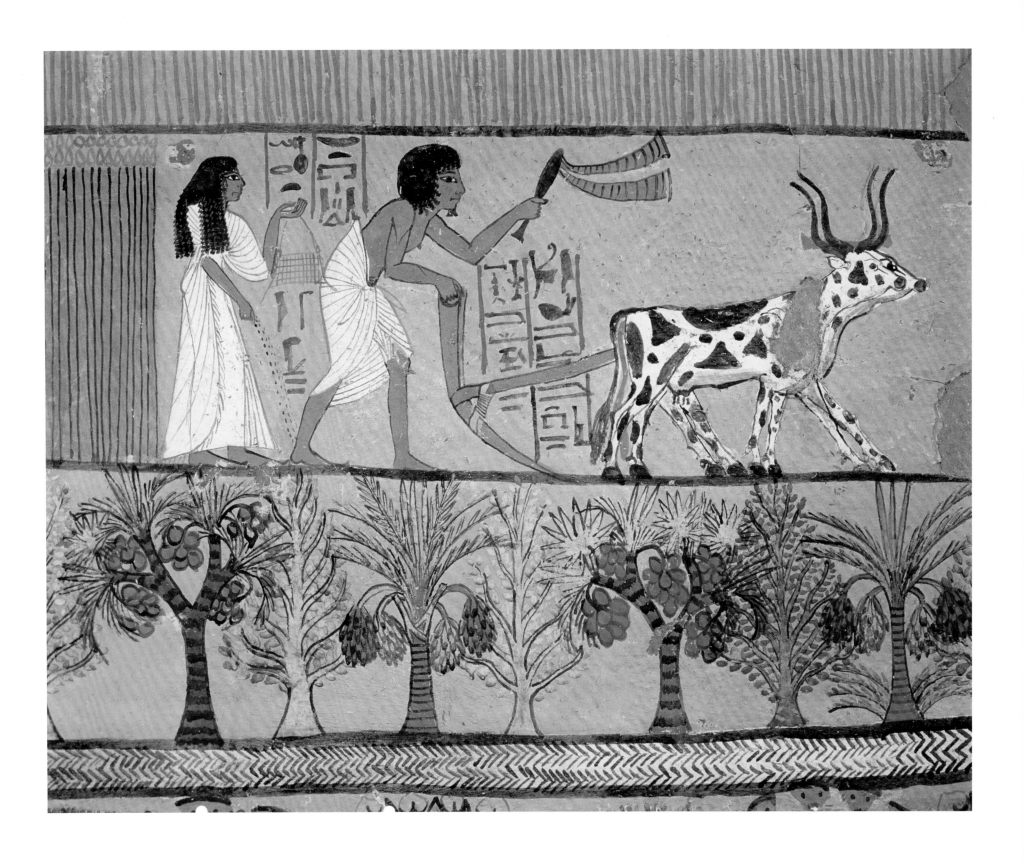

Italian School
Harvesting Spinach, from
*Tacuinum Sanitatis Codex
Vindobonensis* (Nova 2644 f.27r)

14th century
Vellum
Dimensions unknown
Österreichische Nationalbibliothek, Vienna

During the eleventh century, in Baghdad,
the Iraqi Christian physician Ibn Butlan
(died *c.* 1038) wrote a medical treatise for
a lay audience. In the *Taqwim al-Sihhah*
(Maintenance of Health), Ibn Butlan links
physical health to equilibrium, advising his
readers to balance all their activities – work
with rest, wakefulness with sleep – and to eat
and drink in moderation. Fresh air was as
important to him as vigorous work and
nourishing food, and he urged his readers
to enjoy life outdoors in every season. His
sensible and enduring instructions circulated
throughout the Middle East and into Europe,
and in the thirteenth century the *Taqwim al-
Sihhah* was translated into Latin in Palermo.

This miniature painting of an old woman
happily carrying her harvest of spinach out
of the garden and, presumably, into her
kitchen appears in one of the four known
illustrated Latin manuscripts of the treatise,
the fourteenth-century *Tacuinum Sanitatis*.
Many of the illuminations include captions
that list the nutritional and medicinal
qualities of the featured plant, as well as tips
for cooking. Spinach, for example, relieves
chest coughs and is particularly good for
young people. It tastes best when cooked in
salted water, but the reader is cautioned that
it occasionally disturbs digestion.

Jacob Grimmer
(1525/26 – c. 1590)
Spring

n.d.
Oil on canvas
Dimensions unknown
Palais des Beaux-Arts de Lille

The European motif of seasonal work
has its origins in the medieval iconography
of the Labours of the Months. In 1565
Pieter Bruegel the Elder (*c.* 1525/30–1569)
produced designs for a series of engravings
that updated the traditional depiction of the
labours with lively, naturalistic figures and
closely observed details. Jacob Grimmer
reinterpreted the *Spring* engraving in paint,
providing an accurate account of the
agricultural labours of the season.

Grimmer's garden is a hive of activity,
consolidating tasks that would span the
period from the first spring thaw to the start
of summer. The foreground features an
enclosed pleasure garden, where men and
women workers prepare soil in parterres for
sowing and transplanting. On the right, two
men begin to drape an ornamental pergola
with vines. Outside the garden, workers are
shearing sheep; behind them, a dovecote can
be seen through the budding tree branches.
In the centre, near the entrance to the pergola,
two women confer with an old man dressed
in a smock, apron and leggings. He doffs his
hat in a gesture of deference. The women's
elegant and immaculate garments identify
them as the mistresses of the estate, and in
the course of their inspection they are giving
their orders to the head gardener.

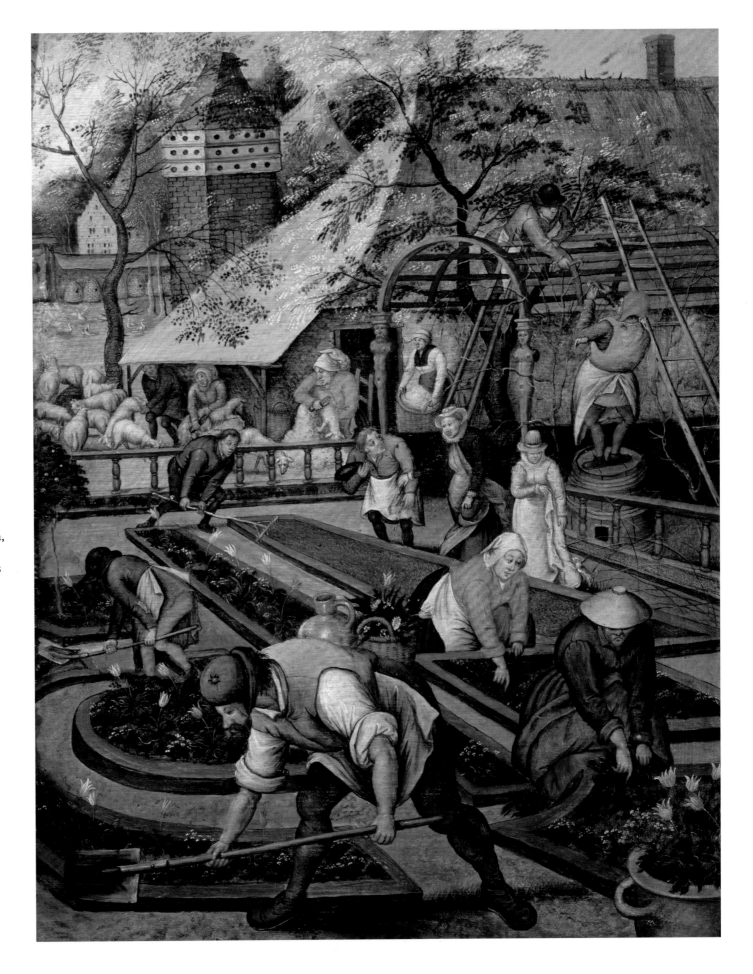

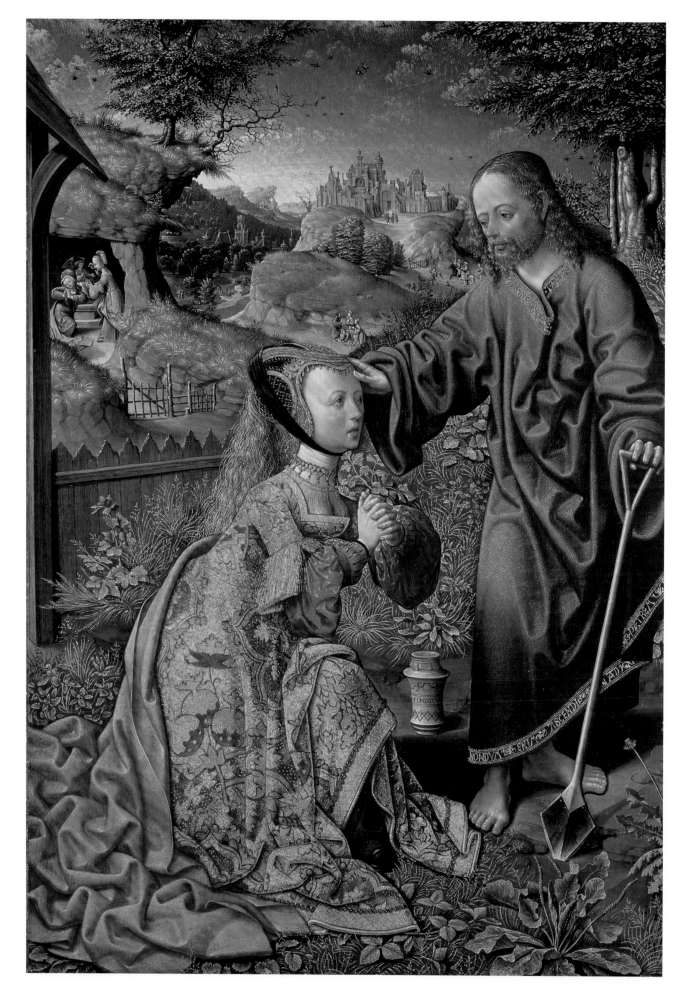

Jacob Cornelisz. van Oostsanen
(1472/77–1533)
Christ as a Gardener
1507
Oil on panel
54.5 × 38.8 cm (21½ × 15¼ in.)
Museum Schloss Wilhelmshöhe, Gemäldegalerie
Alte Meister, Kassel, Germany

After Christ's crucifixion, Mary Magdalene discovered that his tomb was empty. As she knelt and wept, a man approached. At first, she mistook him for a gardener, but when he called her name she recognized him as Christ. In the Gospel of John (20:1–18), the mistaken identity is a minor detail in the encounter, which culminates in Christ instructing Mary not to touch him (*noli me tangere*) for he has not risen. But Jacob Cornelisz. van Oostsanen enhances the association between Christ and cultivation by setting the scene in a vegetable garden and equipping Christ with a spade.

Other biblical references, as well as theological interpretation, add to the analogy between Christ's earthly mission and garden labour. In the book of Genesis, Adam's purpose in the Garden of Eden is to 'till it and keep it', but when he eats of the forbidden fruit, his fate is to produce his own food through hard toil in the fields (2:17; 3:18). The English mystic Julian of Norwich (*c.* 1342 – *c.* 1413) made a connection between Christ's task and that of Adam, envisioning the Lord sending Christ forth to work the soil, with 'greatest labour and hardest travail', to produce a bounteous crop that would please the Almighty.[5] Just as the gardener's labour feeds the body, so Christ's teachings fed the soul.

Theodore de Bry
(1528–1598), after John White
(*fl.* 1585–93)
The Village of Secoton, from
Admiranda Narratio …

c. 1588
Coloured engraving
Dimensions unknown
Service Historique de la Marine, Vincennes, France

As a member of the expeditionary party
that sailed from England to the New
World in 1585 to explore the possibility of
colonizing the North American coastline,
John White was well served by his artistic
skills. Aided by the surveyor Thomas
Harriot, he travelled the environs of Roanoke
Island (in present-day North Carolina)
making watercolour sketches of native flora
and fauna, as well as of the culture and
practices of the indigenous Algonquin-
speaking people. His subjects included a
settlement that the native population called
Secoton, and White drew an overview of its
orderly plan: a broad central thoroughfare
flanked by bark-and-reed dwellings and spare
but well-tended vegetable plots separated by
rows of corn.

Five years later, at his printing house
in Frankfurt am Main, engraver Theodore
de Bry reproduced White's sketches for
publication. Written by Harriot, *A Briefe
and True Report of the New Found Land of
Virginia* (1590) featured a selection of White's
images, which Bry had improved with
heightened colour and new details. To make
the settlement more attractive to his audience,
Bry made Secoton look like a European
rural village; he enlarged the dwellings,
increased the number and abundance of the
plots, and added a circular flower bed with
an adjacent stand of vigorous sunflowers.

Abd al-Hakim Multani
(fl. 1680s)
Khavar, Disguised as a Gardener, Being Threatened by Mir Sayyaf (detail), from Khavarannama
(Add. 19766 f.81a)

1686
Opaque watercolour on paper
The British Library, London

The Persian poem *Khavarannama*, written by Muhammad ibn Husam around 1426–27, is a martial saga that recounts the fierce exploits of Ali, the son-in-law of the Prophet Muhammad, and his companions Malik and Abu'l-Mihjan. This miniature, from an ensemble of 157 illuminations painted in the seventeenth century in the Punjab, is one of several scenes featuring Ali's companions confronting King Khavar.[6] Here, mistaken for a gardener, Khavar is threatened by Mir Sayyaf on behalf of Ali.

Dressed in a simple, floral-patterned *jama*, worn over striped trousers, Khavar reveals no trace of his royal identity, and is easily mistaken for one of his gardeners. In contrast, Mir Sayyaf wears a turban and the high leather boots of a horseman; Khavar's feet are bare. Mir Sayyaf is heavily armed with a quiver of arrows and a large sword, which he brandishes in a menacing gesture, while Khavar does not even possess the tools associated with his disguise, such as a rake, a hoe or a shovel. This scene of confrontation takes place in an idyllic setting, with a flowing river in the foreground and a flourishing grove of willow, cypress and pomegranate trees behind the two adversaries.

Martin Engelbrecht
(1684–1756)
A Gardener

c. 1735
Coloured engraving
Dimensions unknown
Bibliothèque des Arts Décoratifs, Paris

This fanciful figure of a gardener – nattily dressed, with a swag of fruit and foliage encircling his waist – is from a suite of engravings of a type known as the 'physiognomy of the trades'. Engraver Martin Engelbrecht owned a printing shop in Augsburg, southern Germany, where he gained a reputation for producing such novelties as miniature theatres featuring engraved, hand-coloured sheets of scenery and figures designed to create a three-dimensional effect. The trades series came out of an older visual tradition, the medieval *danse macabre*, in which people of all stations were presented as equally mortal. By the early eighteenth century the focus had shifted from impending death to life's labours, and the spirit was more playful, with artists depicting each worker as a proud embodiment of his or her trade.

Of the land workers included in Engelbrecht's *Assemblage Nouveau des Manouvries Habilles*, the gardener is the most elegant. He wears a velvet hat festooned with leaves, and a rose in his lapel. While the peasant in the series appears before a field of wheat, the gardener presides over a well-tended topiary grove; and although some of their trade tools are the same, the gardener's special attributes are his shears and his gleaming watering can.

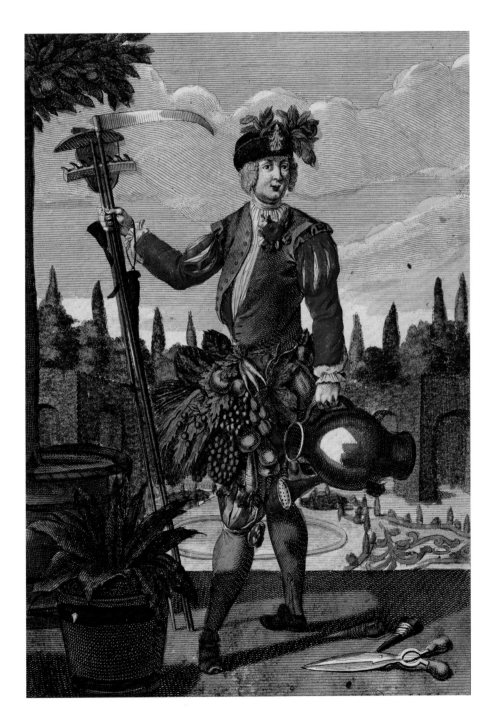

Thomas Gainsborough
(1727–1788)
Mr and Mrs Andrews

c. 1750
Oil on canvas
69.8 × 119.4 cm (27½ × 47 in.)
The National Gallery, London

On the death of his father in 1735, Robert Andrews inherited the Auberies, a large parcel of land located near Sudbury in Suffolk; fifteen years later, the death of his father-in-law doubled his holdings. Andrews developed the estate as a modern concern, employing the latest in farming technology. His sheep grazed in a commodious enclosure, and his cattle roamed among the trees of his oak plantation. Rather than sowing crops by hand, as was traditional, Andrews's farm workers used a seed drill, evidenced by the regular furrows of the harvested cornfield seen on the right-hand side of Thomas Gainsborough's painting.

As well as depicting the efficient result of recent agricultural technology, Gainsborough's portrait establishes Andrews's status and identity. His gun – proof of sufficient wealth to possess a gun licence – indicates his gentlemanly interest in hunting.[7] His wife, the former Frances Carter, wears a stylish blue satin gown and poses on an elegant wrought-iron bench. The couple had married in 1748, but rather than being a wedding portrait, this is a representation of their position in life: genteel young landowners presiding over an 'improved' estate. The unpainted spot in Mrs Andrews's lap has been much debated; Gainsborough may have left it open in order to include the couple's first-born child.

Humphry Repton
(1752–1818)
Forcing Garden in Winter, from
*Fragments on the Theory and
Practice of Landscape Gardening*

1816
Coloured engraving
Approx. 10.2 × 15.2 cm (4 × 6 in.)
The Stapleton Collection, London

In his writings on gardens, Humphry Repton lamented the brevity of the growing season in England. In the 'precarious climate' of his homeland, winter lasted from November to May, and during the cold months 'open gardens are bleak, unsheltered, dreary fields'.[8] He proposed that garden designers remedy this by building a series of structures, based on the latest improvements in greenhouse technology, that would provide an ideal environment for 'forcing' plants during the winter. This rendering, showing a proposal for Woburn Abbey in Bedfordshire, presents an ensemble of connected buildings designed to keep delicate species and tender shoots safe, even after heavy snow.[9]

The greenhouses in Repton's illustration feature glass roofs. This innovation appeared in the 1790s, but in the following decades the use of cast-iron mullions, instead of timber strips or overlapping plates of glass, provided greater protection against moisture seepage and drafts. A stove within, indicated here by the smoke rising from the chimney, maintained the temperature. This rendering also illustrates Repton's use of a series of greenhouses, connected to the main house by a conservatory, to create a sheltered walkway, a warm, enclosed corridor intended to simulate 'the comforts of a garden' despite winter's chill.[10]

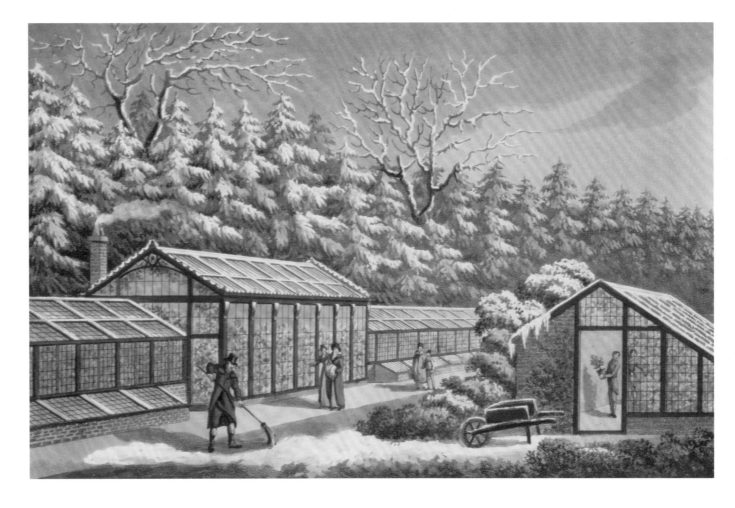

Isidore Verheyden
(1846–1905)
Jardin Potager

n.d.
Media and dimensions unknown
Private collection

The term 'potager', used to describe a kitchen garden, has humble origins. It derives from the French word *potage*, or 'soup', referring to a simple, simmered mix of available produce. In 1699 John Evelyn praised the kitchen garden as 'Welcome and Agreeable', declaring, 'I content myself with a Humble Cottage and a Simple Potagere.'[11] By Evelyn's day, however, the term had taken on an ornamental dimension. The elegantly devised potager at the Château de Villandry near Tours and the Potager du Roi at Versailles, for example, featured trimmed and trained vegetable beds, embellished with herbs and edible flowers. Other estates followed this model, masking the garden's practicality in a decorative design.

For the modest farming family, however, the humble meaning of the term endured. Isidore Verheyden, a naturalist landscape painter, sought his subjects in the rural regions of Belgium. He presents the purest understanding of a potager; cabbages and root vegetables are grown within easy reach of the kitchen adjacent to where the cows graze. Irish garden expert William Robinson (1838–1935) despaired that farmers' cottage gardens in Belgium were 'shocking in their baldness and ugliness'.[12] But Verheyden saw a rustic simplicity in his subject, inherent in the essential function of a kitchen garden: to provide food for the gardener's table.

Gustave Caillebotte
(1848–1894)
The Gardeners

1875/77
Oil on canvas
90 × 117 cm (35⅜ × 46 in.)
Private collection

In 1860 Gustave Caillebotte's father purchased property in Yerres, at that time a small village located about 19 kilometres (12 miles) to the south-east of Paris. For the next eighteen years the family summered there, enjoying the commodious house and expansive grounds, which included a vast lawn ornamented with mounded flower beds (*massifs*) and a wooded park that ran alongside a river. There was also a large kitchen garden, framed by a series of espaliered peach trees planted inside the garden's walls. Hired gardeners tended the plots that produced the summer fruits and vegetables for the affluent family's table.

Caillebotte depicts the gardeners wearing traditional blue aprons and imported panama hats. They work barefoot, to avoid trampling down the furrows. The gardener in the foreground waters beans with two brand new zinc watering cans; his partner carries copper versions. Behind them is a neat row of melon plants underneath glass market-garden cloches, which were used for germination and cuttings, as well as to protect the delicate luxuries grown for the household. An inventory taken after the death of Caillebotte's father in 1874 lists one hundred such cloches, together with six zinc watering cans, four copper cans and two wheelbarrows. Caillebotte and his brother maintained the property until their mother's death in 1878.

Sir James Guthrie
(1859–1930)
A Hind's Daughter

1883
Oil on canvas
91.5 × 76.2 cm (36 × 30 in.)
National Gallery of Scotland, Edinburgh

Sir James Guthrie painted the subject of
A Hind's Daughter on the farm worked by her
father, a smallholding just outside the village
of Cockburnspath in the Scottish Borders
near Berwick-upon-Tweed. A naturalist
painter, influenced by the work of Jean-
François Millet and Jules Bastien-Lepage
(page 100), Guthrie had taken up residence
in the rural outpost in 1883. Unlike many
of his fellow *plein-air* painters, however, he
stayed there during the hard winter, in the
conviction that it was the only way in which
he could gain genuine insight into village life.

There is nothing sentimental about his
portrayal of agricultural labour. A young
girl, yet to reach adolescence, is doing
woman's work. She stands in a cabbage field,
with her knife in one hand and a freshly cut
head in the other. It appears as though she
has paused for just a moment to confront the
viewer with a frank but wary gaze. The
number of cabbages – enough to feed a
family, but not to make a profit at the market
– reveals that this is the garden of a poor
household. Yet in his forthright depiction
of subsistence farming, Guthrie finds beauty
in the dignity of the young girl, and in the
flickering play of light on the dry ground,
on the thick leaves and on the coarse weave
of her garments.

Vincent van Gogh
(1853–1890)
Le Moulin de Blute-Fin, Montmartre

1886
Oil on canvas
45.4 × 37.5 cm (17⅞ × 14¾ in.)
Kelvingrove Art Gallery and Museum, Glasgow

After several years of painting in rural regions in The Netherlands and Belgium, Van Gogh moved to Paris in the spring of 1886 to live with his brother Theo, an art dealer, in Montmartre. Defined by the steep rise of the Butte Montmartre, the district lies in the northern suburbs of Paris. For centuries Montmartre had hosted a loose community of small cottages and farm plots, but the character of the district changed after it was officially incorporated into the city of Paris in 1860. Light industry crowded out many of the little farms, while the city's poor, displaced by urban renewal, came in search of cheap housing. Low rents also attracted artists and entertainers, whose presence brought a veneer of urban sophistication to the formerly rural outpost.

During the summer, Van Gogh liked to hike up the rise to paint among the cottages and their surrounding allotments. Here, he has focused on the Moulin de Blute-Fin, one of three surviving windmills. The ramshackle garden sheds and tangled plots betray the waning of the district as a farming community. A pavement cafe had opened near the windmill's base, and an observation tower, seen here to the right of the windmill, had been erected for tourists.

Eugène Grasset (1841–1917)
January, from *Calendrier de la Belle Jardinière*

1894–96
Chromolithograph
20.3 × 15.5 cm (8 × 6⅛ in.)
Private collection

In the medieval tradition of the Labours of the Months, January is the time to stay indoors. Calendar pages in books of hours sometimes featured preparations for a New Year's feast, but more commonly depicted workers either stoking the fire in their master's dwelling or trying to warm themselves by a cottage hearth. More than half a millennium later, Eugène Grasset revived the iconography for commercial purposes, but with a number of significant changes. In his portrayal of the first month of the year, he presents a determined young woman, bundled up against the cold, clearing away the hardened snow in a formal garden.

Grasset designed his calendar pages as a promotional gift for customers of the Parisian department store La Belle Jardinière. Playing on the name of the establishment, he depicted garden settings and beautiful female gardeners, all of whom are dressed simply but stylishly in garments made from the kinds of colourful fabric that were available at the store. The gardens feature manicured paths, decorative beds and – in the warmer months – a bounty of flowers. Even in January, despite the bare branches of the trees and the ice-covered fountain, there is a promise of the coming floral display, as suggested by the bright-red berries on the holly bush in the foreground and the orangery in the distance.

Kate Greenaway (1846–1901)
Mary, Mary, Quite Contrary, from *The April Baby's Book of Tunes*

1900
Colour lithograph
Dimensions unknown
Private collection

Folklorists speculate that the innocent-sounding nursery rhyme of the title of this work has its origins in the sixteenth-century persecution of Protestants under Mary I (also known as 'Bloody Mary'). If one links the 'silver bells' with the church, the 'cockleshells' with pilgrims and the 'pretty maids' with nuns, the rhyme can be read as a call to Catholicism. By the mid-eighteenth century it had shed any political associations, and in the decades that followed – as child-rearing specialists deemed gardening to be an invigorating and educational activity – it inspired such charming and playful images as Kate Greenaway's illustration.

Mary, Mary, Quite Contrary was one of sixteen illustrations created by Greenaway for *The April Baby's Book of Tunes* (1900), Mary Beauchamp Russell's children's book in which a mother explains the origins of nursery rhymes to her daughters. Mary, it seems, shunned convention, and dug up her garden of daisies and roses to plant oddities where 'other people have hollyhocks'.[13] Neighbours flocked to peek over the hedge and laugh at the peculiar garden. However, Greenaway's illustration appears to celebrate an industrious young woman, armed with a watering can and a rake, and to contrast her with the girls playing in the background. Her cockleshells, meanwhile, provide a pretty edging for a bed of tulips and lily of the valley, with their distinctive bell-like blossoms.

John William Waterhouse (1849–1917)
The Orange Gatherers

1889–90
Oil on canvas
118 × 82 cm (46½ × 32¼ in.)
Private collection

At the end of the 1880s, John William Waterhouse began to make regular visits to Capri, and during an extended stay that ended in 1890 he painted genre scenes featuring local children in the lush landscape. Here, the motif is gathering oranges in an overgrown garden grove. The trees, clustered against a staircase wall, are heavy with fruit, and the absence of a ladder suggests that rather than climbing up and plucking the oranges from the branches, the girls have been collecting those that have fallen to the ground. The older girls fill and carry baskets, while the youngest, sitting on a blanket and surrounded by the growing pile of freshly gathered fruit, holds a pilfered orange close to her chest.

Through the use of burnished and sunlit colour, as well as deft brushstrokes, Waterhouse conveys the sultry, perfumed air and flickering light of a Mediterranean garden. Rather than being a depiction of actual labour, the girls' activities are a picturesque device within a painting of pure sensation. In common with the work of his contemporaries Sir George Clausen and Jules Bastien-Lepage (page 100), Waterhouse's painting presents a nostalgic image of a working garden intended to appeal to urban patrons in London and Paris.

Raoul Vion
(dates unknown)
Poster advertising
horticultural products

20th century
Colour lithograph
Dimensions unknown
Private collection

The French writer Émile Zola (1840–1902)
set his novel *Le Ventre de Paris* (The Belly of
Paris; 1873) in Les Halles, a vast (and now
demolished) network of food stalls in the
1st arrondissement of Paris. Since the
twelfth century the location had served as a
centralized food market where farmers could
set up stalls and sell their wares. Zola's
narrative highlights the polarities of modern
life: the city and the country, the bourgeoisie
and the labouring classes, the fat and the thin.
Above all, it is a celebration of fresh food,
including the produce grown in the country
to feed the urban appetite.

Similarly, Raoul Vion's poster promotes
freshly picked produce. From an overflowing
wheelbarrow, the grocer selects a ripe melon
for his chic customer, whose arms are filled
with cut flowers. In the foreground are piles
of potatoes, emptied flowerpots and baskets
of fruit. Rather than use Les Halles as
a backdrop, Vion has set his scene in a
manicured park, complete with winding
paths and well-tended *massifs* (see page 117).
This display of rural bounty in an urban
setting reminds the viewer of the essential
connection between city markets and
country farms. The desire to preserve that
connection is a contemporary concern, as
seen in the popularity among today's urban
consumers of farmers' markets, produce
co-operatives and the 'locavore' movement,
members of which endeavour to eat only
locally produced food.

Linda Benton
(dates unknown)
Allotments and Dahlias
n.d.
Media and dimensions unknown
Private collection

Community farming on common land was a key feature of life in Anglo-Saxon Britain, but the Norman invasion of 1066 established the practice of feudal enclosure. In the years that followed, the poor were sometimes provided with land on which to grow food and graze animals, but the Enclosure Acts of the late eighteenth and early nineteenth centuries put most of the nation's farmlands into private hands. Concern for small landholders and the landless poor led to the Allotment Act of 1887, which required local authorities to provide gardening plots to meet the demands of their constituency. Additional legislation in 1907 and 1908 produced the now-familiar allotment: a small parcel of land, usually 10 rods (253 square metres/2723 square feet) in size, rented to and cultivated by an individual citizen.

In the twentieth century, allotment gardening was promoted as part of the patriotic endeavour to counter food shortages, as in the 'Dig for Victory' campaign of the Second World War. Today the increased desire for organic and locally grown produce has raised the demand for allotments – notably among a younger, urban population – and Linda Benton's view reveals that contemporary allotments feature flowers as well as vegetables, combining beauty and practicality in one compact garden.

Behind the Garden Wall

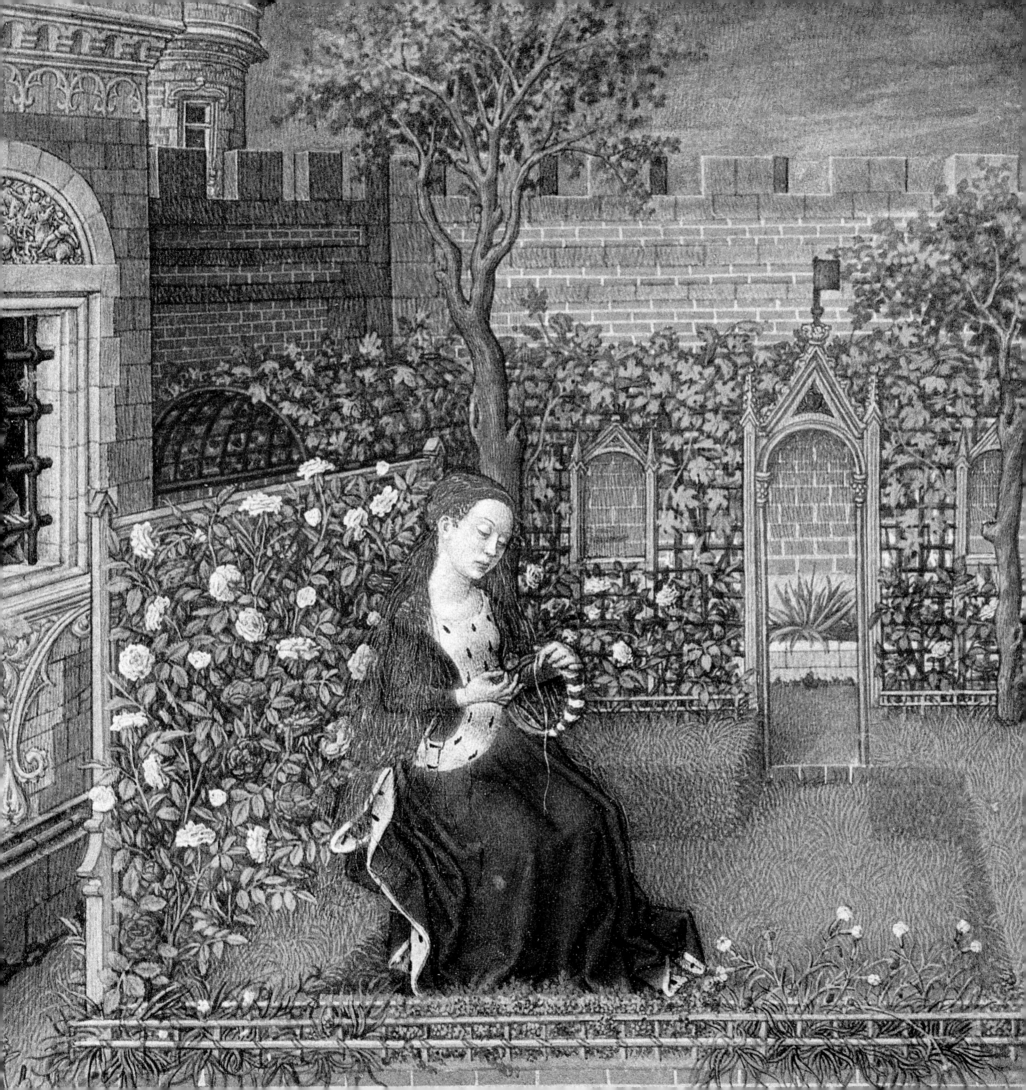

Mary Lennox, the main character in Frances Hodgson Burnett's beloved children's tale *The Secret Garden* (1911), arrives at Misselthwaite Manor in a sorry state. Orphaned after a privileged but love-starved upbringing in India, Mary is sallow, sullen and disagreeable. At first she indulges in self-pity at being stranded among strangers at her uncle's gloomy estate on the Yorkshire moors, but soon the sprawling manor piques her curiosity, rousing her to search the grounds to discover its secrets. More than anything, she wants to know what is hidden behind an ivy-covered wall with a locked door that no one has entered for ten years. One day she finds a buried key, and soon she summons the courage to draw back the ivy, fit the key in the lock, turn it and push open the creaking door. There, she finds an overgrown garden, 'the sweetest most mysterious-looking place anyone could imagine', and behind its walls she learns secrets that will transform her life.[1]

Throughout gardening history, the garden wall has done more than demarcate the boundary of the garden. It has provided security from predators, privacy from the public and an escape from the outside world. For example, in a twelfth-century account of life at Clairvaux Abbey in north-eastern France, the writer observed that the garden behind the abbey provided a haven for the monks, who could walk, rest or meditate 'within the wall of the cloister'.[2] Both barrier and gateway, the garden wall created a world within a world, and its presence decreed that passage from one to the other was restricted. Art offered a way to peer over the wall and into the garden, and often it was the only means by which the viewer was able to access a realm that could not be entered in ordinary existence.

In art, the garden wall has often separated the everyday world from paradise. Medieval Christian illuminators, such as those in the Boucicaut Master's workshop, depicted the Garden of Eden within a walled enclosure (page 129), even though a wall is not mentioned in the description of the garden in Genesis. Chinese painters and poets described sealed gardens that could be entered only through artistic imagination (page 132). Behind the garden wall, scholars conferred (pages 132–33), ladies passed the time (pages 129 and 130) and lovers held clandestine meetings (pages 137 and 138). Only art allowed the viewer to observe the scene within.

The wall itself could be of brick or stone, but it could also be defined by natural elements, such as the grove of trees and the flowing stream that enclose a bower in a Rajasthani miniature (page 131). New technology produced garden walls of glass, which permitted sunlight to enter and warm the air in order to sustain a tropical paradise in any climate. In scenes of courtship, the wall could divide lovers, while an open gate could fulfil their fondest dreams. No matter what lies behind garden walls – pleasure, pain, fantasy or destiny – the urge to look is hard to resist. Like Mary Lennox, the artist holds the key that opens the door to a wondrous world of imagination, insight and self-discovery.

John Anster Fitzgerald
(1823–1906)
The Death of Cock Robin
n.d.
Oil on canvas
Dimensions unknown
Maas Gallery, London

During the first half of Queen Victoria's long reign (1837–1901), the stolid citizens of the United Kingdom indulged a surprising passion: the subject of fairies. In particular, images of fairies – in paintings, in book illustration and even in theatre design – never enjoyed a greater popularity. These charming and sometimes provocative images stirred memories of childhood, and gave the viewer a brief escape from quotidian routine and the increasingly grinding pace of modern, industrialized life. With subjects ranging from scenes based on Shakespeare's plays to the characters in nursery rhymes, fairy paintings always featured a natural setting, suggesting a mysterious woodland or a neglected corner of the garden.

The origin of the nursery rhyme 'Who Killed Cock Robin' is obscure, but by the middle of the eighteenth century a standard version had appeared in such anthologies as *Tommy Thumb's Pretty Song Book* (c. 1774). Rather than illustrating the chorus of birds that confess to the murder and plan the funeral, John Anster Fitzgerald created a gathering of fairy mourners. The naturalistic leaves and common garden flowers, such as the stunning morning-glory blossom, reveal that the artist relied on close observation of the real world to paint a supernatural fantasy.

Stephan Lochner
(*c.* 1405–1451)
Virgin of the Rose Bower

1430–35
Oil on panel
50.5 × 40 cm (19⅞ × 15¾ in.)
Wallraf-Richartz-Museum & Fondation Corboud,
Cologne

In the Song of Solomon the ardent lover compares his beloved to 'A garden locked … a fountain sealed' (4:12). Medieval theologians interpreted the passage as a reference to Christ's virgin mother, and by the thirteenth century cloistered communities had given form to the analogy in the shape of enclosed gardens dedicated to Mary. The walled *hortus conclusus* offered a spiritual retreat, a place to soothe the soul and turn the mind to meditation. Its mystic meaning, as well as its meditative purpose, also inspired the subject of the Virgin in a rose bower.

Stephan Lochner's Madonna sits on a low turf bench. Behind her, roses climb the delicate framework of a trellis, and the full blossoms remind the pious viewer that, just as the rose surpasses all other garden flowers, Mary is superior to all women. The unicorn on her brooch is an emblem of chastity; the pearls set in her golden crown represent purity. In the upper corners of the work, small angels draw back gold-embroidered curtains to reveal the wondrous scene: a comely mother and child in a closed garden, intended to inspire the faithful follower to meditate on the purity and beauty of Mary's protected realm.

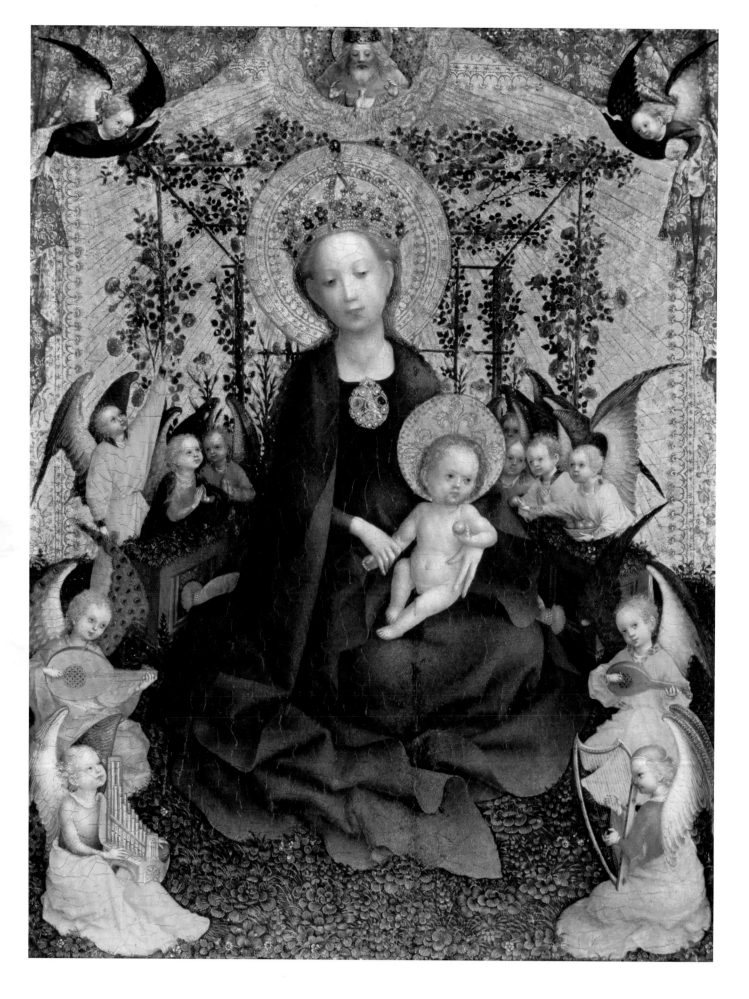

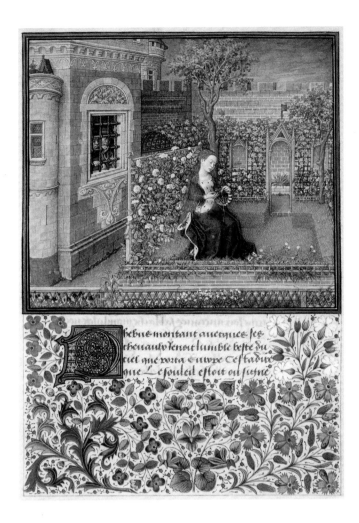

ABOVE

Barthélemy d'Eyck
(*fl.* 1444–69) (attrib.)
Emilia in Her Garden, plate 22,
from *Teseida delle nozze di Emilia*
by Giovanni Boccaccio
(MS 2617)

c. 1468
Vellum
Dimensions unknown
Österreichische Nationalbibliothek, Vienna

In the fifteenth century, on wealthy estates in France and England, a garden tucked behind perimeter walls was designed to refresh the spirit. Planted with sweetly scented flowers and herbs, such gardens were furnished with turf-covered benches, tempting the visitor to linger and enjoy the fragrance and the view. The surrounding walls of stone and brick protected the more delicate features within, including a wooden trellis for climbing roses and a pergola supporting grapevines.

Giovanni Boccaccio's *Teseida delle nozze di Emilia* (*c.* 1340) recounts Theseus's conquest of Thebes, and although the story is set in ancient Greece, this French illumination from the late 1460s depicts all the typical features of a fine fifteenth-century garden. Carnations and pinks grow along the front railing; stock and columbine punctuate the fence at the bottom of the image. Lavender and rosemary scent the air, and a spiky-leafed aloe thrives in a bed of healing plants. Emilia, the hero's sister-in-law, is absorbed in weaving white and red roses from the trellis into a lover's crown. She takes no notice of the men who gaze longingly at her from behind a barred window. They are Theseus's captives – the princes Palemone and Arcita – and, like the garden in which she sits, Emilia is protected from them by sturdy walls.

BELOW

Workshop of Boucicaut Master
(*fl.* 1390–1430)
The Marriage of Adam and Eve,
from *Le Livre des propriétés de choses* (MS 251 f.16r)

c. 1415
Gold leaf, gold ink and tempera
on parchment
Dimensions unknown
The Fitzwilliam Museum, Cambridge

The book of Genesis describes a river that flows out of Eden and divides into four branches – the Pishon, the Gihon, the Tigris and the Euphrates – to irrigate the lands beyond the garden (2:10–14). Although there is no mention of a protective barrier around the garden, both the biblical text and the expulsion of Adam and Eve suggest that Eden existed as a paradise within a larger, less pristine world. This miniature depicts the garden as a small enclosure, ringed by a woven lattice fence, in which plants flourish, animals live in peaceful coexistence, and God presides over the wedding of Adam and Eve.

In contrast to the generalized rendering of the plants and trees, the animals are clearly distinguished by species. There are pigs, cattle, dogs, a sheep, donkeys and deer. In addition to these docile animals, a golden-horned unicorn lowers its head and paws the ground, ready to defend this pure domain. A small dog drinks from a little pond, the source of the river that flows out of Eden through an opening in the fence. Fish swim alongside a swan, which floats on the river, while a chicken and a rooster scratch for food on the nearby riverbank. There is dry ground in the bottom right-hand corner of the image, marking the difference between paradise and mortal terrain.

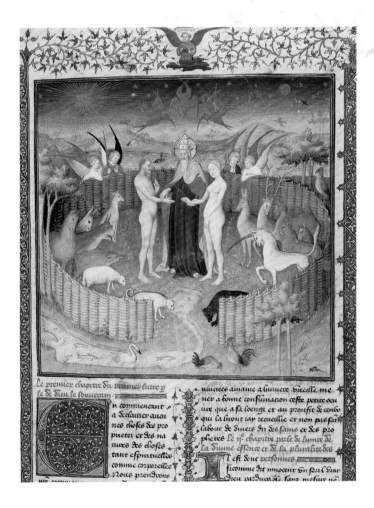

German School
Ladies in a Garden Embroidering,
from *Album Amicorum of
Gervasius Fabricius*
(Add. 17025 f.50)

c. 1603–37
Media and dimensions unknown
The British Library, London

The *album amicorum*, or 'friends' book', has its origins in sixteenth-century German academic circles. A student would invite his instructors and fellow students to inscribe their sentiments – ranging from the erudite to the personal – in a kind of autograph album. As the work of multiple authors, these albums varied in form, and by the end of the sixteenth century it was not uncommon to add illustrations to the text. Gervasius Fabricius, whose career culminated in the office of the Archbishop of Salzburg, likely began to compile his album around 1603, when he was a university student in Würzburg. He continued to add to it until his death in 1637.

This charming miniature offers a view of a formal garden in which elegant women pass the day by doing needlework in the open air. The women in the foreground embroider, stitch wool work and make lace. An elderly woman in black cradles her lapdog; directly opposite, two women entertain by singing and playing a virginal. The garden itself has contemporary features: a fountain, parterres with clipped borders and an arched pergola framed with topiary. Like the owner of the album, the lone man strolling in the garden takes pleasure from the sight of the ladies enjoying their leisure.

Indian School
Two Women in a Bower, possibly
from an illustrated *Ragamala*
manuscript, Bundi-Uniara,
Rajasthan

Late 18th century
Opaque watercolour, gold and silver
on paper
26.5 × 21.6 cm (10⅜ × 8½ in.)
Museum of Fine Arts, Boston

During the reign of the Mughal emperors
(1526–1707), the Hindu princes of
Rajasthan – descendants of Rajput warrior
clans – kept authority over their ancestral
lands through an alliance with the empire.
Cultural exchange led to a flowering of
sophisticated Rajasthani miniature painting,
characterized by a palette of jewel-like
tones, the use of burnished gold and silver
leaf, and a repertoire of themes that suggest
the pleasures of the natural world. This
miniature offers a view of a private garden
in which a splendidly dressed woman
converses with a female attendant while
relaxing in the shade of a vine-covered
pergola. Heavily laden fruit and flowering
trees form a protective screen behind the
pergola; a shimmering river flows past the
little enclave. These natural features define
an exquisite space for secluded pleasure
within the larger confines of a lushly planted
palace garden.

Scholars speculate that this miniature may
have been painted for a *Ragamala* (Garden
of Ragas) manuscript, a compilation of
traditional musical modes illustrated with
visual and poetic counterparts. But the image
may also depict a pleasure garden. The small
scale of the painting affords the viewer a
glimpse of an enclosed world where birds
gather, flowers bloom and a woman enjoys
the sensual atmosphere.

Shih Fu Chuiu Ying
(18th century)
Woman in Garden

n.d.
Ink on silk
Dimensions unknown
The Barnes Foundation, Merion, Pennsylvania

Known as the *Analects*, the teachings of
Confucius (551–479 BC) were collected by
his students and followers during the Han
Dynasty (206 BC – AD 220) in the form of
conversations and aphorisms. Subsequently,
they were adopted as official state policy,
to be used as the basis for a stable society.
A key to social stability was the correct
balance of deference and respect in unequal
relationships, such as those between ruler and
subject, parent and child, husband and wife.
In their daily routines, men and women led
separate lives in their own quarters, and it
would be rare for a man to venture into a
woman's garden. But the genre of 'palace-
style' poetry allowed a man to evoke the
image of an exquisite woman in a garden
setting through analogy and metaphor.

By the eighth century, artists had begun
to paint 'palace beauties' (page 58).[3]
Rather than being specific individuals,
palace beauties were ideal women, dressed
in fabulous garments and paired with
objects of natural beauty that mirrored their
comeliness. A favourite motif of the time
was the lonely lover in her garden, yearning
for a lost or distant love. Here, the woman's
blushing beauty is complemented by the
delicate pink blossoms, which also suggest
that, like a blossom, female beauty is fleeting.

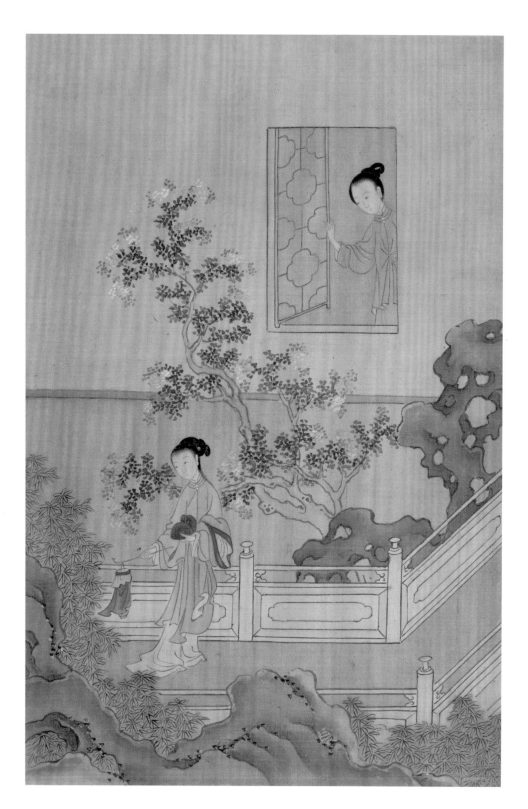

Chinese School
Literati Gathering in Qinglin

16th century
Ink and colour on paper
26 × 83.8 cm (10¼ × 33 in.)
Private collection

Taoism teaches that struggle against natural forces leads to discontent. Chinese literati, or private, gardens embody this principle; as the late Ming Dynasty garden theorist Ji Cheng explains, the ruling aesthetic for all Chinese gardens is to 'look natural, though man-made'. He emphasizes the importance of balancing the size and proportion of such elements as rock formations, water features and pavilions, as well as a careful selection of trees and plants, in order to reflect nature's inherent harmony.[4] Another key feature of literati gardens is an inner garden, secluded and enclosed, where a scholar and his friends could convene to discuss philosophy, nature and art. This inner garden recalls the early Taoist hermits who retreated from society and everyday concerns to live in accord with nature.

The connection between poetry and the literati garden is attributed to the fifth-century Taoist poets Xie Lingyun and Tao Qian, who sought artistic inspiration in their own gardens.[5] By the time of the Ming Dynasty (1368–1644), the *junzi*, a privileged class of highly educated government officials, were building their own private gardens as a refuge from their duties. Like their erudite predecessors, they would withdraw into the inner garden to compose poetry and music, practise their calligraphy and enjoy the company of friends.

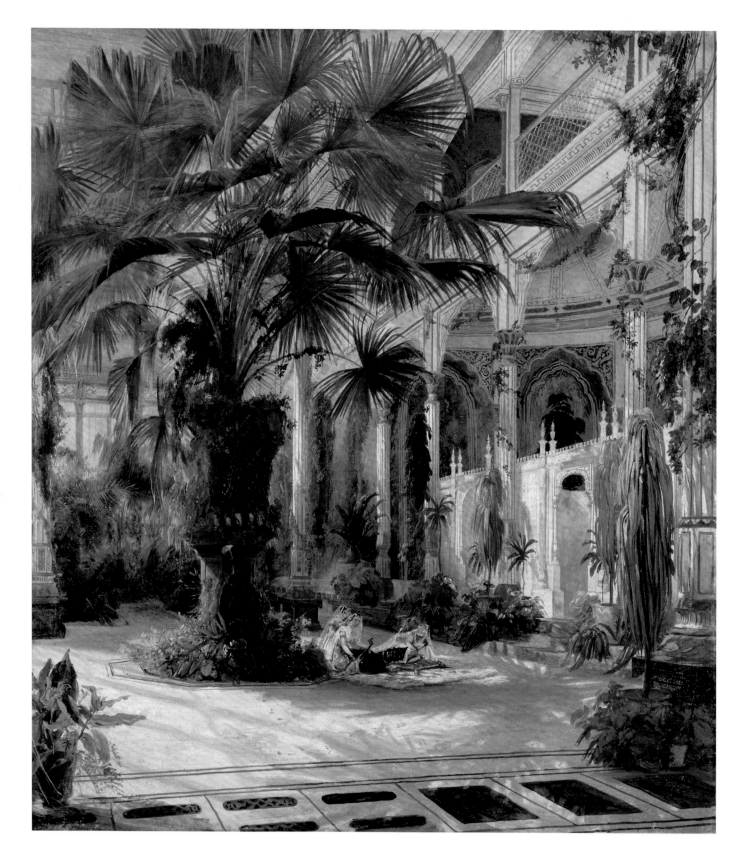

Karl Blechen
(1798–1840)
Interior of the Palm House at Potsdam

1833
Oil on paper on canvas
64 × 56 cm (25¼ × 22 in.)
Hamburger Kunsthalle, Hamburg

In the late eighteenth century the Prussian king Frederick William II acquired an island in the River Havel near Potsdam in north-eastern Germany. His successor, Frederick William III, fascinated by romantic tales of the exploration of the South Seas, developed the island as a personal retreat, building a summer palace, a *ferme ornée* (ornamental farm) and a menagerie. He had the natural forest cultivated to create a wilderness, and named the island Pfaueninsel after the resident peacocks. In 1830 he purchased a collection of tropical plants; architect Karl Friedrich Schinkel (1781–1841) designed a glass-enclosed pavilion, the Palm House, in which to keep it.[6] Once the Palm House had been completed and the plants installed, the king commissioned Karl Blechen to paint two interior views as a gift to his daughter Alexandra Feodorovna, the wife of Tsar Nicholas I.

To be in keeping with the exotic plant collection, Schinkel's Palm House incorporated a number of architectural fragments from an Indian pagoda, which the king had purchased in 1829. Blechen extends the oriental fantasy by depicting brightly dressed odalisques lounging beneath the spreading branches of a massive palm tree. Although the plant collection itself was scientifically significant, and Schinkel's design employed the latest advances in climate-control technology, the appeal of the Palm House lay in the fact that visitors could be transported to a distant realm simply by venturing within its glass walls.

Charles Allston Collins
(1828–1873)
Convent Thoughts

1850–51
Oil on canvas
84 × 59 cm (33⅛ × 23¼ in.)
Ashmolean Museum, Oxford

The young novice in Charles Allston
Collins's *Convent Thoughts* stands in a
cloistered garden holding a prayer book;
the colourful illuminations within, of the
Annunciation and the Crucifixion, indicate
her calling and her sacrifice. She gazes
fixedly at the blossom of a passion flower as
the focus of her meditation. Native to the
tropical forests of South America, the flower
acquired its Latin name – *Passiflora incarnata*
– when the sixteenth-century Jesuit priest
Giovanni Battista Ferrari described its
features as being analogous to the Passion:
the five stamens as Christ's wounds, the
corona as the crown of thorns, the three styles
as the nails of the cross.

Collins set his painting in a real
garden: the quadrangle at the offices of the
Clarendon Press in Oxford (part of Oxford
University Press). But the lush flowers also
serve to illustrate the novice's pious intent
to renounce secular life. The roses and the
Madonna lilies to her right link her with the
Virgin mother, the bleeding hearts to her left
with the sacrificed son. The white water lilies
are a symbol of purity, floating unstained in
a muddy pond. A laurel hedge – with lasting
leaves that never wilt – evokes eternity, and,
like the sturdy brick wall in the background,
it separates this modern *hortus conclusus* from
the outside world.

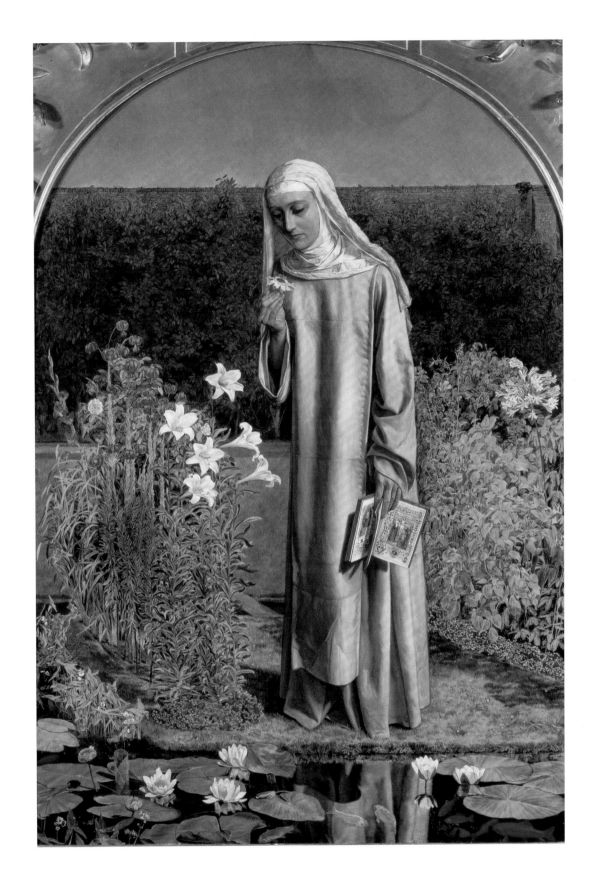

Atkinson Grimshaw
(1836–1893)
*The Rector's Garden, Queen
of the Lilies*

1877
Oil on canvas
82.8 × 122 cm (32⅝ × 48 in.)
Harris Museum and Gallery, Preston, Lancashire, UK

In Atkinson Grimshaw's verdant painting of a rector's garden, an attractive young woman, dressed in summer white, is admiring a tall stand of lilies. The house behind her is as neat and modest as her gown; the ivy that covers the walls of the house suggests the enduring fidelity of those who dwell within. Flowers thrive here, and every bed is well tended, defined by clipped box and separated by smoothly raked paths. Not a single dry blossom or stray leaf disrupts this tidy garden. With roses and lilies in full bloom, it is a fragrant haven, kept safe and secure within a sturdy stone enclosure.

A Victorian viewer would have readily recognized the perfectly cultivated garden as a testimonial to the young woman's virtues. The pink roses, coming into bloom, draw attention to her burgeoning beauty, while the Madonna lilies attest to her character. English author and art critic John Ruskin (1819–1900) voiced the popular Victorian analogy between a flourishing garden and feminine nature in his lecture 'Of Queen's Gardens' (1865), declaring that nothing pleased a man more than seeing his wife 'with every innocent feeling fresh within her', out in the garden among 'the fringes of its guarded flowers' and safe within 'that little rose-covered wall'.[7]

Philip Hermogenes Calderon
(1833–1898)
Broken Vows

1857
Oil on board
29 × 22 cm (11⅜ × 8⅝ in.)
Ashmolean Museum, Oxford

The garden wall can exclude as well as
enclose. The young woman in Philip
Hermogenes Calderon's *Broken Vows* is in
despair. With her right hand clutching the
corner of the ivy-covered wall, she swoons
against the brickwork and presses her left
hand beneath her heart. There is a ring on
her fourth finger, but a broken bangle lies
at her feet. The cause of her distress can
be seen through the broken palings of the
wooden fence. A bright-faced woman raises
her hand to grasp a rosebud from the hand
of a tall, smiling man. These breaks in the
fence expose what the lovers had hoped to
conceal: the pale woman is being betrayed
by her fiancé.

The plants outside the garden wall
have faded. The blossom of the iris in the
foreground has dried on its stalk. A traditional
symbol for a warning, named after the Greek
messenger of the gods, the iris was also
known as the sword lily, and its blade-like
leaves were associated with the pain of
unrequited love. But the ivy on the wall –
an emblem of enduring fidelity – is thriving.
It surrounds the rejected woman, revealing
that the man has made the wrong choice,
abandoning true love for false pleasure.

Frederic Leighton
(1830–1896)
Garden of the Hesperides

c. 1892
Oil on canvas
Diameter: 169 cm (66½ in.)
Lady Lever Art Gallery, Wirral, UK

According to the Greek poet Hesiod
(*c.* eighth century BC), the garden of the
Hesperides was hidden away on an island in
Oceanus, the enormous river believed by the
ancient Greeks to encircle the world. A rare
tree flourished there – given to Zeus's wife,
Hera, by his grandmother, Gaia – and
the golden apples on its branches brought
a golden age of peace and pleasure to the
world. Tended by the daughters of Hesperus,
the god of evening, and guarded by the
serpent-dragon Ladon, the apples thrived,
safe and bountiful, until Heracles invaded the
garden and carried them off to fulfil the
eleventh of his twelve labours.

Frederic Leighton's vision of the story
recalls the description in John Milton's
masque *Comus* (1634) of 'gardens fair'
presided over by the evening god and 'his
daughters three' singing beneath 'the golden
tree'.[8] The shores of Oceanus can be seen
in the distance; roses grow behind the tree
and lilies bloom near its roots. Ladon appears
as a sinuous serpent, coiled around the
languorous body of the woman in the centre,
keeping his vigil while the daughters rest.
The circular canvas, enclosed in an ornate
frame, heightens the sense of isolation in this
mysterious garden at the ends of the Earth.

Dante Gabriel Rossetti
(1828–1882)
Fair Rosamund

1861
Oil on canvas
51.9 × 41.7 cm (20⅜ × 16⅜ in.)
National Museum Wales, Cardiff

Over the centuries, romantic invention has
embellished the liaison between Rosamund
Clifford (before ?1140–1175/76) and Henry II
(1133–1189). According to folklore, Henry
built Rosamund a lodge at the centre of a
maze of such complexity that he could travel
its pathways only by following a crimson
cord. However, Henry's wife, Eleanor of
Aquitaine, soon discovered the arrangement;
she followed the cord and poisoned her rival.

Although 'Fair Rosamund' has her place in
history, there is no documented evidence of
the poisoning. Rosamund is buried in the
choir of Godstow Abbey near Oxford, and
it is now believed that she lived her last days
there, with the nuns.

Dante Gabriel Rossetti celebrates
legend over history in his portrait of Fair
Rosamund. He takes his motif from the
origin of her name – *rosa mundi*, or 'rose of

the world' – painting an ensemble in crimson
hues and rose-shaped ornaments. Her gown
is patterned with blossoms, and she holds a
sprig of rose leaf. A golden rose anchors the
crimson cord to the parapet of her lodge,
where she anxiously awaits her lover. With
her flushed complexion and her abundant
auburn hair adorned with a single blossom,
Rosamund incarnates a flower in a secret
garden cultivated solely for the king's delight.

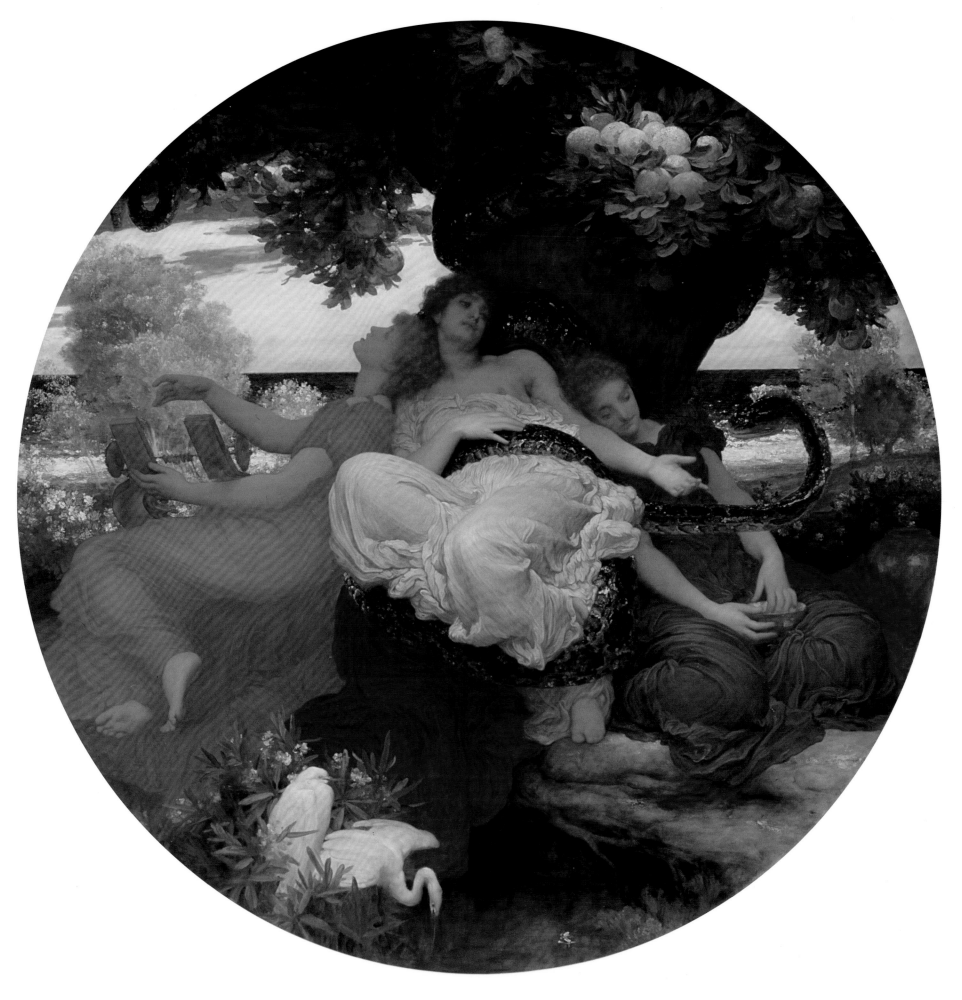

Howard Pyle
(1853–1911)
When All the World Seemed Young, from *Harper's Magazine*

1909
Colour lithograph
Dimensions unknown
Private collection

For more than three decades, Howard Pyle produced illustrations for the American magazine *Harper's Weekly*. Rich in dramatic nuance and carefully observed detail, Pyle's pictures always told a story, with or without their accompanying text. The two young lovers in *When All the World Seemed Young* appear to be at an emotional impasse. There is a palpable sense of tension between them; as the man leans towards the young woman with an imploring gaze, she bows her head and, ever so slightly, pulls back. Their encounter is taking place at a garden gate, and Pyle employs the well-known symbolism of the garden wall to give depth to his narrative.

Popular literature and painting had established the garden wall as an indicator of romantic expectations in tales of courtship. It could serve as a barrier between lovers, or as the location for a tryst. Here, a well-worn path leads from the garden gate to a house in the distance. Will the couple step through the gate and walk the path together, or will they go their separate ways? In Pyle's illustration, the garden wall separates past from future, and like the ardent suitor, the viewer can only guess at what will happen next.

Edward Burne-Jones
(1833–1898)
Pilgrim at the Gate of Idleness

1884
Oil on canvas
97 × 131 cm (38¼ × 51⅝ in.)
Dallas Museum of Art

The Pilgrim's quest for love in the medieval poem *Roman de la Rose* begins in a walled garden. It is May, and as the Pilgrim is wandering in a meadow he is beckoned into a protected enclosure by a lovely woman. She is the personification of idleness, and she invites the Pilgrim to join her in the Garden of Mirth. Once inside the walls of the garden the Pilgrim encounters delightful company, including Mirth, the garden's master; Love; Beauty; Riches; Courtesy; and Youth. He also sees the reflection of a rosebud in the shimmering water of Narcissus's fountain. With Love as his guide, the Pilgrim leaves the garden to seek

his heart's desire, inspired by the vision of the budding rose.

Edward Burne-Jones relied on Chaucer's Middle English translation of the thirteenth-century French allegory of courtly love.[9] Idleness appears as she does in the poem, dressed in a green gown and white gloves with a circlet of roses in her hair. The Pilgrim surrenders to her call, moving towards the opening gate as if in a trance. Like the Pilgrim, the viewer gets only a hint of the wonders within: a tantalizing glimpse of the bright-pink blossoms of a rose bush that clings to the inner wall of the garden.

John Singer Sargent
(1856–1925)
Carnation, Lily, Lily, Rose

1885–86
Oil on canvas
174 × 153.7 cm (68½ × 60½ in.)
Tate Britain, London

On an August evening in 1885, John Singer Sargent observed a magical scene: 'Two little girls in a garden lighting paper lanterns among the flowers.'[10] Over the next few months, posing the daughters of his friend Frederick Barnard in the family's garden in Broadway, Worcestershire, at twilight, he struggled to recapture the image. Sargent's determination to paint a nocturne in natural light limited the time that he could work on his canvas, and, as the season changed, the garden faded. In November he suspended his efforts until the following September, when he successfully completed his fleeting impression of pale flowers and flickering lantern light in the ethereal shadows of dusk.

Despite his insistence on working only when the light was right, Sargent turned to artifice to maintain the beauty of the garden so late in the season. When the rose trees turned into 'black weeds', he purchased a small area of nursery roses.[11] The Aurelian lilies were forced into bloom from bulbs in pots, and he even resorted to tying artificial flowers to dying stalks. But the genuine sparkle of the light – as opalescent on the girls' porcelain-like skin as on the petals of the flowers – caught the exquisite moment when nightfall transformed an ordinary garden into an enchanted realm.

Balthus (Count Balthazar Klossowski de Rola) (1908–2001)
Young Girl at the Window

1955
Oil on canvas
196 × 130.5 (77⅛ × 51⅛ in.)
Private collection

Known for his perplexing and sometimes provocative depictions of girls on the brink of adolescence, Balthus often set his compositions in closed rooms, evoking a claustrophobic atmosphere. Here, however, he has opened a window overlooking a back garden. A girl leans out of the window and looks to her left. With her back to the viewer, her posture suggests that she is a *Rückenfigur*, or proxy figure, placed to entice the viewer to approximate her position and follow her gaze.

Seen through the window, the features of the garden are indistinct. Branches from different trees create a screen of foliage, giving the light that shines through it a green haze. A lawn stretches towards a distant building with a veranda. A gust of wind appears to stir the branches near the window, but otherwise the garden is empty and still. The girl, too, is still, but the firmness of her posture conveys such rapt attention that the viewer cannot help but wonder what it is that she sees. Balthus offers no clues; rather, he uses this ambiguity to compel the viewer to gaze into the garden alongside her.

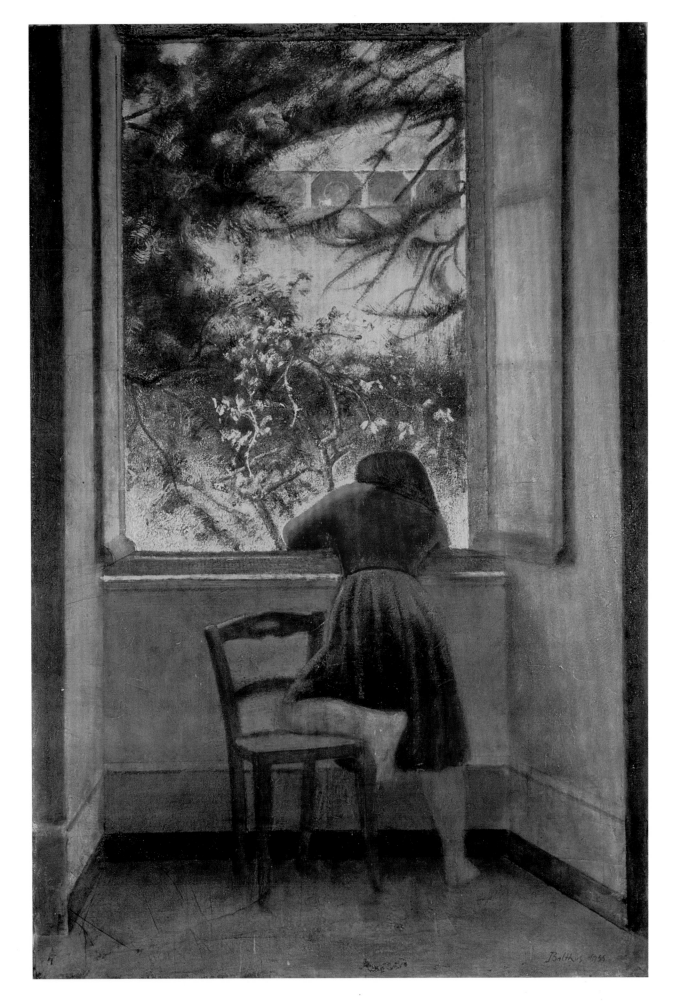

Home and Garden

In *The Lady's Country Companion* (1845), English author Jane Webb Loudon (1807–1858) extolled the benefits of country life for women. Away from the distractions and demands of the city, life in the country was home-centred, and, in addition to providing domestic contentment, 'the ameliorating effects of country pursuits' greatly improved a woman's health; even a woman who was 'delicate in a town' became 'positively robust' in the country. To achieve this desirable balance of health and happiness, Loudon offered a simple recommendation: 'Have a flower-garden laid out as near the house as possible.'[1]

Even before Loudon and her generation decreed that the home was a woman's 'dominion' and the garden a measure of her capacity to nurture, the garden was linked to the home in an intimate and beneficial relationship. In ancient Egypt, palace gardens were enclosed within the walls of the palace to protect them from wind damage, flooding and invaders. Planned around a rectangular pool, such gardens provided the household with sustenance, including fruit, herbs and medicinal plants, as well as the pleasures of scent, shade and beauty (page 148). The magnificent gardens of the Mughal princes featured four water channels intended to represent the four rivers of paradise, honouring the divine impetus that sparked earthly existence (page 150). Across time and cultures, prominent individuals – predominantly male – retreated to their private gardens in search of a restful haven from the demands of public life.

Writing to a friend from his villa in Tuscany, the Roman senator Pliny the Younger noted with pleasure that several of the rooms faced south, and opened on to a formal garden composed of 'box figures' and 'clipped dwarf shrubs', with a meadow in the distance.[2] In ancient Rome, both town houses and villas were planned around gardens, dissolving the boundaries between interior and exterior space. But when the weather was inclement – or the room lacked access to a garden – residents could take pleasure from the painted illusions of grassy expanses, complete with topiary, rose bushes and scattered flowers, that graced the walls (page 149). Over the centuries, inventive artists found striking ways to bring gardens indoors. One of the most enduring of the various patterns used in Persian carpets reflected the design of a paradise garden (page 151), while European tapestries known as verdures transformed solid walls into windows that looked out on to idealized gardens (page 152). The *hyakkazu*, a Japanese pictorial motif featured on portable folding screens, presented flowers of every season, blooming all at once on a background of gold (pages 152–53).

Domestic gardens signalled stability and upward mobility in nineteenth-century European households. A popular motif in painting, particularly among the Impressionist circle, was the family relaxing in the garden (pages 160 and 161). Desirable summer homes featured terraces with lush plantings (page 159), while modern conservatories – incorporating advances in iron and glass technology – allowed affluent households to enjoy elaborate gardens featuring tropical plants all year long (page 156). By the end of the nineteenth century the appeal of a natural garden, whether surrounding an English country cottage (page 158) or Monet's house in northern France (opposite), prevailed over more formal designs. Despite changing tastes and circumstances, the essential relationship between home and garden has continued to thrive.

Claude Monet
(1840–1926)
The Path Through Monet's Garden, Giverny
1902
Oil on canvas
89 × 92 cm (35 × 36¼ in.)
Österreichische Galerie Belvedere, Vienna

When Monet leased his house in Giverny in 1883, the front flower garden had a traditional design. Within a few years, he had replaced the flower beds defined by clipped box borders with freer plantings of iris, oriental poppies and roses, which kept the garden in bloom from early spring until mid-autumn. He preserved one original feature: a gravel pathway flanked by spruce and cypress trees that ran from the front gate to the main door of the house. His second wife, Alice, was fond of their *grande allée*, but Monet complained that the trees cast too much shade on his flowers, and wanted to cut them down.

Monet's painting captures the front garden at the height of summer. Vivid banks of mixed flowers rise on either side of the path, which is bordered by a mosaic of salmon-pink and garnet nasturtiums. The branches of the mature cypress trees form an elegant arc over the path, casting a canopy of shade; it is easy to see why Alice liked the *grande allée*. But in the years that followed, Monet steadily trimmed back the branches to allow more sunlight to reach his flower beds. Eventually, he had the tops of the trees removed, and trained climbing roses around the denuded trunks.

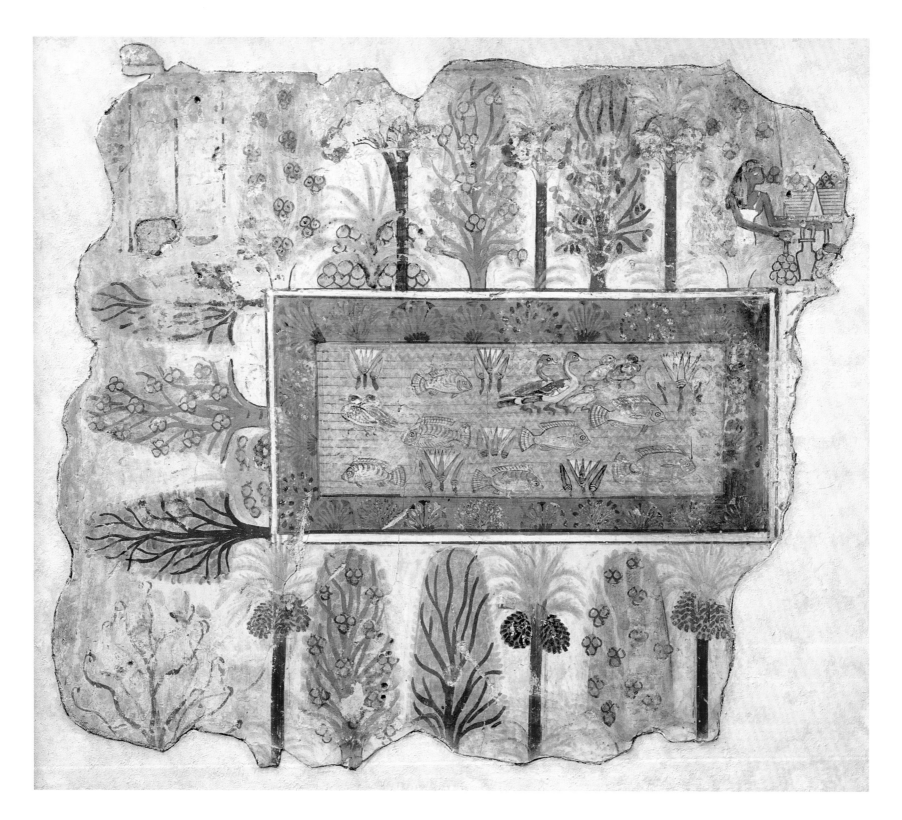

Egyptian School

Garden of a Private Estate with an Ornamental Pool, part of a wall painting from the Tomb of Nebamun, Thebes

c. 1350 BC
Painted plaster
Dimensions unknown
The British Museum, London

Ancient Egyptians identified the eternal spark of life as the *Ka*, and during mortal existence it resided in the physical body. After death, elaborate tombs provided the *Ka* with a facsimile of life's necessities, and this wall painting from the New Kingdom (1550–1086 BC) – part of the tomb complex commissioned by the civil servant Nebamun for himself and his family – reveals that gardens played the same role in the afterlife as they did in day-to-day existence.

Reliefs dating back to the Old Kingdom (third millennium BC) document the enduring design of the Egyptian palace garden. Enclosed within high walls, the garden provided both food and pleasure. One or more rectangular pools anchored the plan; each pool would be surrounded by flower beds and orderly lines of trees. As seen here, sycamore was planted for shade, and date palms, fig and pomegranate for fruit. Such flowering plants and herbs as poppies,

cornflowers, mandrake, marjoram, rosemary and coriander were grown for fragrance, flavour and medicinal purposes. Lotus grew on the water's surface; ducks and fish lived in or beside the pool. Although this wall painting does not record an actual garden, it represents everything that the *Ka* of such a highly placed man as Nebamun, grain accountant to the pharaoh Amenhotep III (1390–1352 BC), would have needed for a comfortable afterlife.

Roman School
Wall painting from the Villa of Livia (detail)

c. 20 BC
Fresco
Height: 200 cm (78¾ in.)
Museo Nazionale Romano, Rome

The villas of prominent citizens in ancient Rome were designed around an open court that housed the garden. The finest rooms of the villa opened out on to the manicured expanse, which was defined by a peristyle and embellished with fountains, topiary in urns, shade and fruit trees, and potted plants. When wall paintings within the villa simulated garden views, the boundary between actual space and artifice disappeared. This wall painting was originally located in the windowless, basement-level dining-room of a suburban villa believed to have been built for Livia (*c.* 58 BC – AD 29), the third wife of Augustus, the first emperor of Rome.

The superb naturalism of the painting permits identification of more than thirty different plants, including fruit-laden pomegranate and orange trees, pine and cypress trees, ox-eye daisies and roses. In the foreground, a low basketwork fence and a low marble wall define a grassy walkway. The birds that perch on the ridge of the wall, and on the branches of the trees behind it, heighten the spatial illusion. Indeed, it seems as though they are about to take flight. Through artful decoration, the household would have been able to dine in a garden setting even in unpleasant weather.

Mughal School
A Nobleman with Attendants in a Garden, from *The Small Clive Album*

c. 1610–15
Opaque watercolour and gold on paper
Dimensions unknown
Victoria and Albert Museum, London

The Mughal Dynasty (1526–1707) marked a golden age of garden design in India. Babur (1483–1530), the first Mughal emperor and the founder of the dynasty, commissioned magnificent gardens in his capitals in Afghanistan and northern India that reflected the Islamic belief that an earthly garden was a microcosm of paradise. Babur's descendants and their noblemen followed his example and enhanced their palaces with exquisite gardens.

This miniature depicts an unnamed nobleman in a walled garden. He sits on a raised platform at the intersection of four water channels. The *chahar bagh*, or 'four-fold garden' – a key feature of Islamic garden design – alludes to the four rivers of paradise. Perfectly trimmed cypress and fruit trees grow in the sunken beds defined by the channels. Ornamental grasses and fragrant blooming plants, typically jasmine, lavender, myrtle and a variety of roses, spangle the beds. The formality of the plan evokes divine order, and the double nature of the plantings – both beautiful and useful – acknowledge divine wisdom and generosity. The miniature is one of sixty-two paintings, including closely observed floral studies, in an album believed to have been presented to Lord Clive by Shuja ud-Daula, the Nawab of Avadh, around 1766.

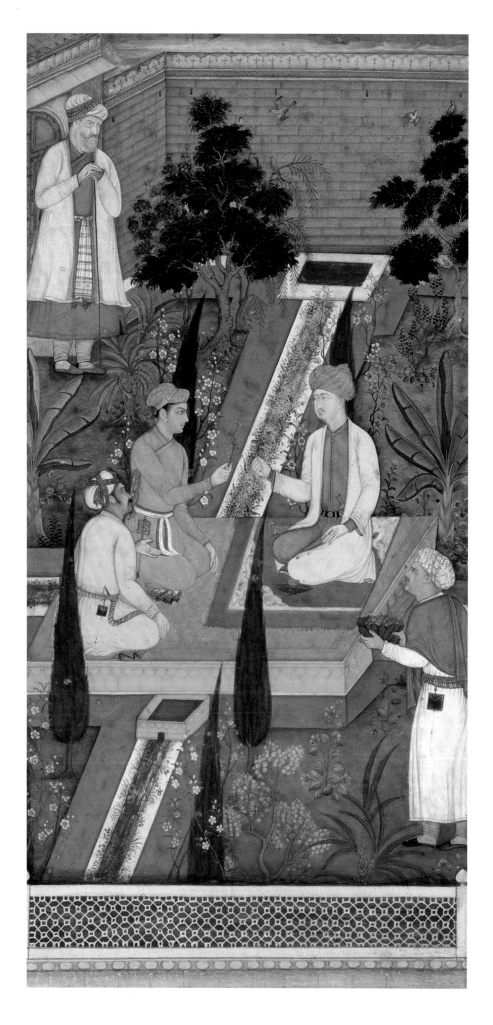

OPPOSITE

Persian School
The Wagner Garden Carpet

17th century
Wool and cotton
530.8 × 431.8 cm (209 × 170 in.)
Burrell Collection, Glasgow

The splendour of traditional Persian carpet design is celebrated by the chronicle writers who documented the seventh-century Arabic incursion into the domain of the Sassanian kings of Persia. The royal palace held magnificent objects unlike anything the invading warriors had seen before, including a spectacular carpet woven out of heavy silk and embellished with silver and gold. Its design simulated that of a royal garden, complete with intersecting water channels, floral borders and plants bearing blossoms and fruit in the form of jewels.[3] Over the centuries, this *chahar bagh* motif has proven to be among the most enduring in carpet design.

The water channels depicted on the Wagner Garden Carpet, woven during the Safavid Dynasty (1501–1732), resemble the letter H, but the overall design can be divided into four identical quadrants. Fish and birds frisk in the flowing water channels and in the pond that forms the central medallion. A menagerie of leopards, peacocks and gazelles can be glimpsed among the dense foliage. Trimmed cypress trees line the water channels, and flowers bloom on the carpet's outer border. Mirroring the plan of the *chahar bagh*, the carpet's design brings into the home the spiritual idea of the garden as a reflection of paradise.

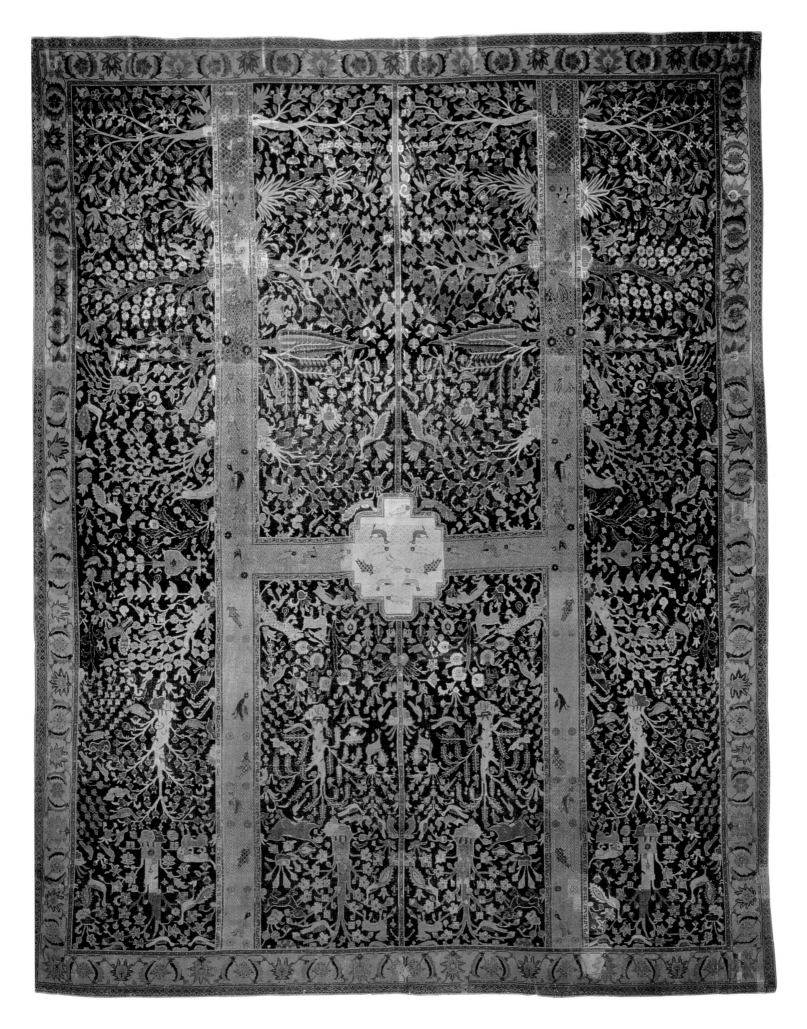

Workshops of Aubusson, France
Verdure with Pear Tree and Rabbit

c. 1650
Wool and silk
Dimensions unknown
Private collection

The word 'verdure', meaning lush green
vegetation, was adopted in the sixteenth
century to describe a type of tapestry. Created
for decorative value rather than warmth,
verdure tapestries feature a splendid display
of luxuriant trees and plants in full flower. In
seventeenth-century France the workshops of
Aubusson produced superior verdures made
of wool and silk. Far from being a centralized
factory, the Aubusson works consisted of
a group of consolidated workshops in the
region between Clermont-Ferrand and
Limoges, allowing the artisans to preserve
some of their traditional independence by
working in their own homes.

The pear trees depicted on this elegant
verdure evoke an estate garden, while the
palm on the left suggests a Mediterranean
location. Magnificent rose bushes bloom in
the foreground; roses are repeated with other
flowers in the decorative border. By the mid-
seventeenth century, when this verdure was
made, landscape and animals were often
incorporated into the design, as shown here
by the inclusion of a placid lake, a cluster of
buildings in the distance and a lively rabbit.
Above all, however, verdures were intended
to celebrate verdant foliage, enabling their
owners to bring the beauty of a sophisticated
garden indoors.

School of Tawaraya Sōtatsu
(fl. 1602 – c. 1640)
Flowers and Butterflies

1730–70
Ink, colour and gold leaf on paper
Six panels, each 131.4 × 52.1 cm
(51¾ × 20½ in.)
Indianapolis Museum of Art

Byōbu, or folding screens, have a long and illustrious history in Japan.[4] Valued for their portability and beauty, screens provided an elegant backdrop for such special activities as honouring a respected guest or celebrating a birthday. The resplendent screens painted by Tawaraya Sōtatsu reflect the sophisticated tastes of the imperial court at Kyoto. Several generations of artists continued in his style, painting naturalistic imagery on lustrous gold backgrounds.

The *hyakkazu* (multitude of flowers) motif of this particular screen features an array of flowers blooming all at once, in defiance of the cycle of the seasons.[5] The beauty of spring is represented by branches of cherry blossom (top right-hand corner) and a purple iris (bottom of the third panel from the left). Full-blown red and white peonies (centre) announce summer; hydrangea and morning glory vines (left-hand panel) evoke the height of the season. Roses (centre, bottom) usher out the summer, while chrysanthemums (far left) and susuki grass (surrounding the morning glory) welcome autumn. Bamboo (third panel from the left), a perennial evergreen, is an auspicious symbol of the waning of one year and the coming of the next. Butterflies flutter over the hydrangea, helping to perpetuate nature's cycle.

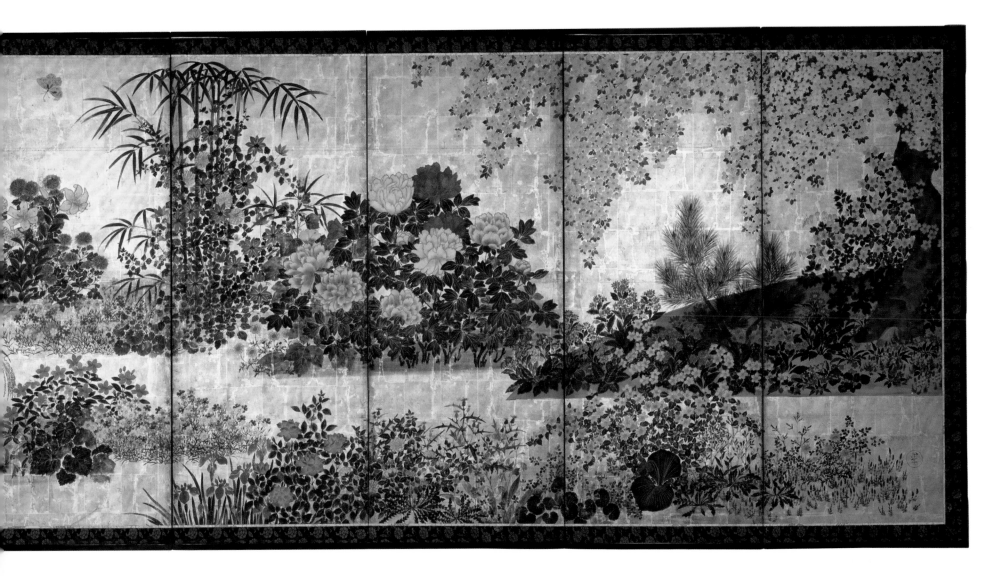

Pieter de Hooch
(1629–1684)
The Soap Bubbles
n.d.
Oil on canvas
Dimensions unknown
Private collection

The seventeenth-century Dutch home reflected the solid values and orderly life that characterized the newly affluent merchant class. In large cities, the family residence housed multiple generations – as well as the family business – in a compact design. Most of the household activities took place in a large ground-level room behind the shop or workshop; the kitchen courtyard was generally adjacent to the family room. Every home had a productive kitchen garden, but wealthier families grew flowers in a second garden tucked away for private enjoyment.

In his youth Pieter de Hooch lived in Rotterdam, Haarlem and Leiden, but he reached the height of his career in about 1660 during an extended stay in Delft. He specialized in modest domestic views, such as this scene of a woman taking a break from her chores to watch a child blow soap bubbles. Both figures stand on a brick walkway near the household's decorative garden; the more functional part of the courtyard can be seen through the open door behind the child. Trained roses climb the railings in the foreground and the trellises anchored to the courtyard wall. But a blanket draped over the railings to air illustrates the fact that, in a practical household, even the most decorative feature of the home could be pressed into use.

ABOVE

Humphry Repton
(1752–1818)
View from My Own Cottage in Essex, from *Fragments on the Theory and Practice of Landscape Gardening*
1816
Coloured lithograph
Dimensions unknown
The British Library, London

By the time Humphry Repton had discovered his talent for landscape gardening – a term he claimed to have coined – he was thirty-six years old, but with energy and innovative practice he quickly rose to prominence. Repton developed a picturesque style that balanced nature and artifice, as well as beauty and practicality. He wrote extensively about his theories of gardening, and delineated his designs in meticulous watercolours, which he bound for clients in red Morocco leather. With the clever use of hinged overlays, Repton's 'Red Books' illustrated his planned enhancements with 'before and after' views.

In 1788, the year he took up his profession, Repton moved his family into a cottage on Hare Street in Romford, Essex, annexing some nearby property to expand the lawn at the front of the house. As can be seen here, he enclosed the lawn with low shrubbery, created a circular path and planted a variety of roses, including rose trees supported by iron stands designed to 'hide the butcher's shop' to the north.[6] The lawn gave the cottage greater presence, but it also demonstrated Repton's belief that a 'garden judiciously stocked with shrubs and flowers' would enfold the household in a genial atmosphere filled with 'happy days and happy nights'.[7]

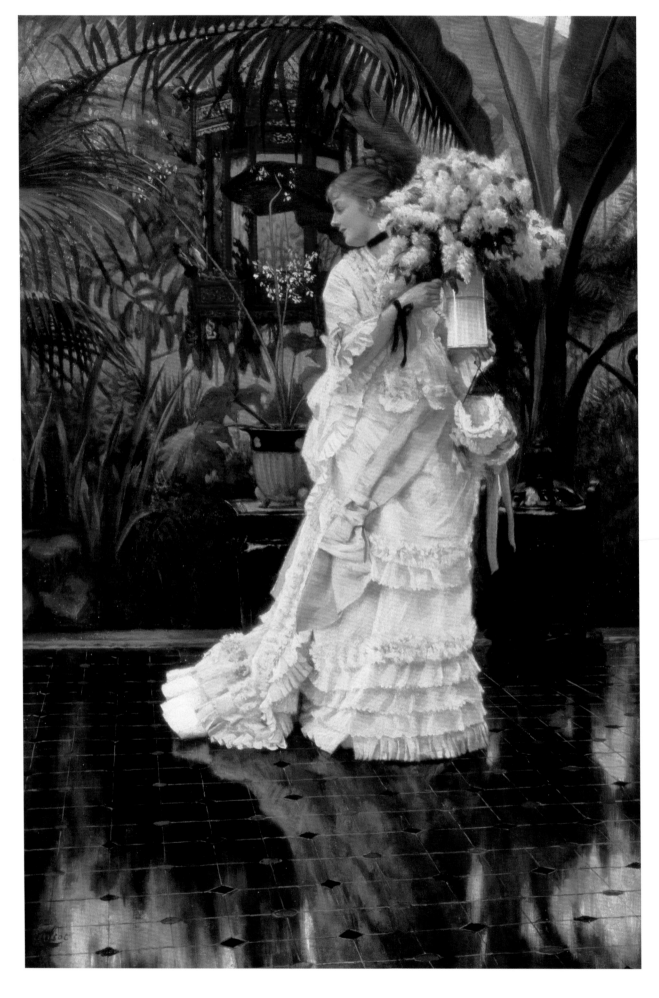

James Tissot
(1836–1902)
The Bunch of Lilacs

c. 1875
Oil on canvas
50.8 × 35.5 cm (20 × 14 in.)
Private collection

By the middle of the nineteenth century, advances in glass and iron technology allowed affluent city dwellers to add a conservatory to their homes. Such prominent horticulturalists as John Claudius Loudon (husband of Jane Webb Loudon; see page 146) and Joseph Paxton endorsed glasshouses for growing rare species, but the new fashion was for the European-style 'winter garden', which combined a controlled climate and a simulated natural landscape of multi-level planting beds beside winding paths. In 1874 James Tissot added a studio-salon with an adjacent conservatory to his house in St John's Wood, north London. A true winter garden, the conservatory opened out behind elegant glass screens, nearly doubling the size of the studio.

Tissot regarded the conservatory as part of the studio. Here, a stylishly dressed woman carrying a vase of lilacs glances over her shoulder towards the conservatory. Like the lilacs, her elegant gown – a stunning spill of pale-blue and white ruffles – marks the season as late spring. Lilacs, however, are not conservatory plants, so perhaps Tissot has cut them from a bush growing outdoors and brought them into the studio. The woman's reflection on the highly polished floor combines her spring attire with the array of palms behind her. No matter what the season outside, it is always summer in the conservatory.

William Morris
(1834–1896)
Trellis wallpaper design

1864
Printed wallpaper
Dimensions unknown
Private collection

When William Morris created his *Trellis* design, two styles of wallpaper dominated the market: 'French' style, featuring florid, hyperrealistic imagery; and 'reformed' style, a decorative aesthetic that echoed the flatness of the wall. Morris offered an alternative, using natural forms in repeatable patterns. He found his motifs in the garden, and the first papers produced by his company, Morris, Marshall, Faulkner & Co., were *Trellis*, *Daisy* and *Pomegranate* (also called *Fruit*). As in the case of all the company's designs, *Trellis* was the product of co-operation between artists and artisans. Morris conceived the idea and sketched the flowers, and architect Philip Webb (1831–1915) drew the birds, but the block carving and printing were contracted out to established craft firms.[8]

In his lectures, Morris urged gardeners to revive such old-fashioned favourites as snowdrops, daisies, primroses and wild roses.[9] He believed that the flat-blossomed wild rose exceeded all modern hybrids in terms of both scent and beauty. In 1862, when Morris made his first sketch for *Trellis*, his own garden at Red House in Bexleyheath, Kent, featured wattle trellises covered with climbing roses. *Trellis* remained one of Morris's favourite patterns, and in 1878, when he moved into Kelmscott House in Hammersmith, west London, he used a version with a blue background to cover the walls of his bedroom.

Helen Allingham
(1848–1926)
A Surrey Cottage

n.d.
Watercolour on paper
Dimensions unknown
Private collection

In 1881, after spending two pleasant summers in Surrey, Helen Allingham and her family moved from their Chelsea home to the village of Sandhills near Witley. The picturesque environment inspired her to develop her signature depictions of rural England, and even though her husband's failing health required the family to return to London in 1888, Allingham continued to explore the countryside in order to paint cottages and their gardens. From the towering sunflowers and gladioli to the moss and lichen on the thatched roof and the traditional garments worn by the girl, this undated watercolour attests to Allingham's keen observation. It also shows how she often enhanced her imagery with charming details, such as the perching doves and the kitten cradled in the girl's arms.

The wide appeal of Allingham's cottage gardens was part of a larger nostalgia for England's agricultural past in an age of industrial growth. Although cottages still functioned as country residences – from the poor labourer's shack to the substantial house of an affluent landowner – the simple cottage garden acquired a romantic significance. Free from imposed formal garden design, and featuring native plants bearing the 'home-bred English names that one has known from childhood', the cottage garden was seen as an icon of authentic English life.[10]

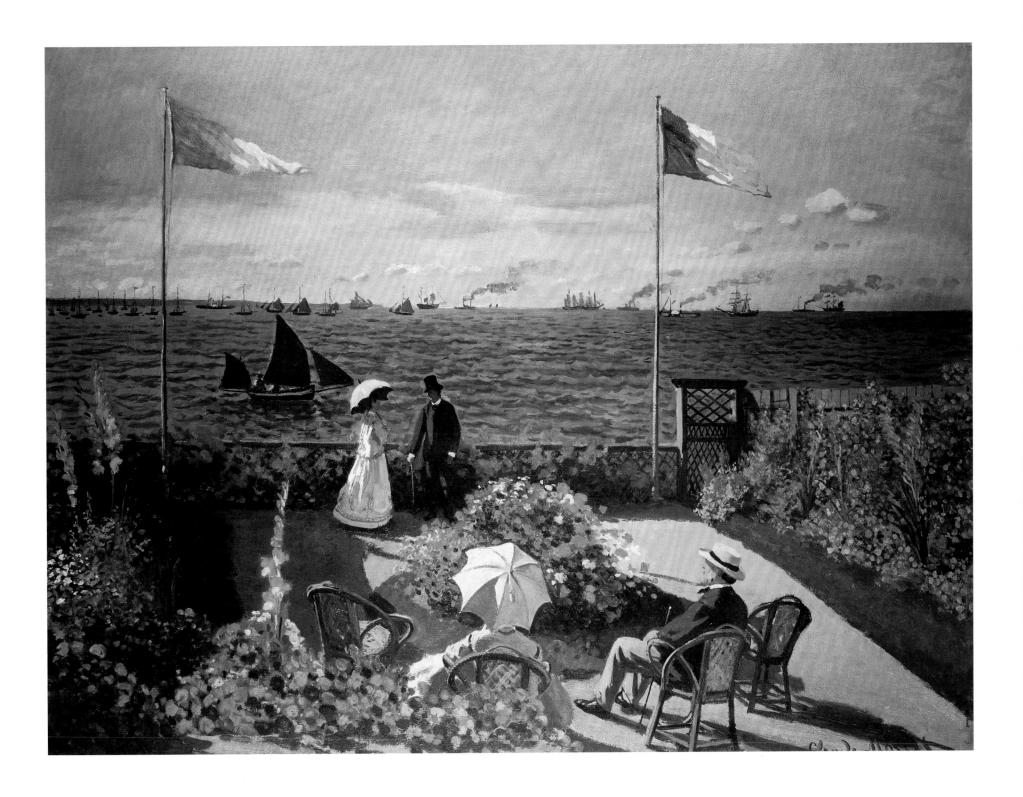

Claude Monet
(1840—1926)
Garden at Sainte-Adresse

1867
Oil on canvas
98.1 × 129.9 cm (38⅝ × 51⅛ in.)
The Metropolitan Museum of Art, New York

Monet's aunt Jeanne-Marguerite Lecadre spent her summers in a villa on the Channel coast. In 1867 Monet joined her at Sainte-Adresse, a fashionable suburban resort roughly 3 kilometres (2 miles) to the north of Le Havre, the port city that had been his childhood home. Monet had always had a passion for the sea, and he kept busy that summer, painting outdoors on the rocky

shore. This view of family members relaxing on the terrace of their villa – Monet's aunt and father, Adolphe, are seated in the foreground – was likely painted indoors, from the vantage point of an upper-storey window.

Channel steamers and pleasure boats punctuate the horizon. A sailing boat close to the shore bobs along on the choppy blue-green waters, and regatta flags flutter in the

wind. The terrace is as neatly planted as an estate garden: tall gladioli rise over clusters of nasturtiums in manicured beds, and red and white geraniums, pruned into a spreading dome, flourish on a grassy *massif*. A terrace was a desirable amenity in a coastal villa, providing not only a small, private garden but also the perfect viewpoint from which to watch the passing boats.

Berthe Morisot
(1841–1895)
Eugène Manet with His Daughter at Bougival

c. 1881
Oil on canvas
73 × 92 cm (28¾ × 36¼ in.)
Musée Marmottan Monet, Paris

Writing in 1934, the French art critic Louis Vauxcelles (1870–1945) observed that, in the nineteenth century, French painters had taken a new approach to the garden. Although the eighteenth century had produced such outstanding garden painters as Jean-Honoré Fragonard (pages 16 and 95), in the nineteenth century artists had forged a more intimate relationship with the subject. He noted that 'nearly all of them at a given point in their careers painted *their* garden'.[11] Part of this shift was due to the upwardly mobile, middle-class backgrounds of many painters after the 1850s. Berthe Morisot, for example, grew up in an upper-middle-class household in the fashionable Paris neighbourhood of Passy. She and her sister, Edma, enjoyed a private family garden, and by the time they had married and set up their own homes, a garden was an essential feature of family life.

Morisot often posed family members in her sister's garden at Maurecourt near Auvers-sur-Oise, and when she and her husband, Eugène Manet, moved into their own home in Passy, he took great pride in designing the garden. Here, Morisot depicts Manet and their daughter, Julie, in the back garden of a house they had rented in Bougival, a commune in the western suburbs of Paris. Morisot's opalescent palette and deft brushstrokes capture the casual yet ephemeral spirit of her subject: a father and daughter relaxing in a garden on a perfect summer's day.

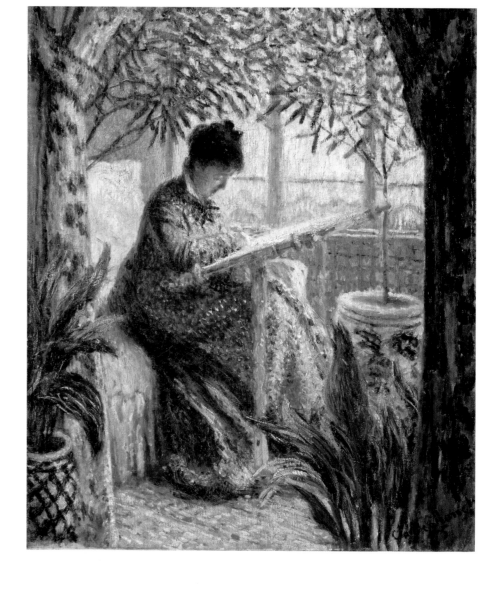

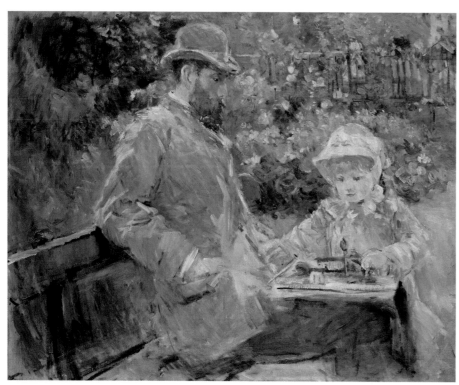

Claude Monet
(1840–1926)
Madame Monet Embroidering

1875
Oil on canvas
65 × 55 cm (25 ⅝ × 21 ⅝ in.)
The Barnes Foundation, Merion, Pennsylvania

Monet's earliest known gardens were attached to rented houses in Argenteuil, a middle-class commune in the north-western suburbs of Paris. He moved there with his first wife, Camille, and their son Jean in 1872, and they lived in a comfortable house close to the Seine until 1874. Monet's paintings were not selling, and when he became unable to pay the rent, he moved the family to a bungalow not far from the railway station. There was a garden at the rear of the property, which allowed Monet not only to pursue his developing passion for cultivating flowers but also to continue to paint and entertain his family and friends in his own garden.

One of Monet's favourite features of the house was a veranda that opened on to the garden. Blurring the boundary between interior and exterior space, Monet furnished it with small trees and potted palms planted in large blue-and-white ceramic urns, which he had purchased in The Netherlands in 1871. On a sunny day, the veranda would be beautifully illuminated with natural light, as seen here in Monet's portrait of Camille sitting at her embroidery frame. The family lived in the house for four years until their straitened economic circumstances forced them to move even further away from Paris, to Vétheuil.

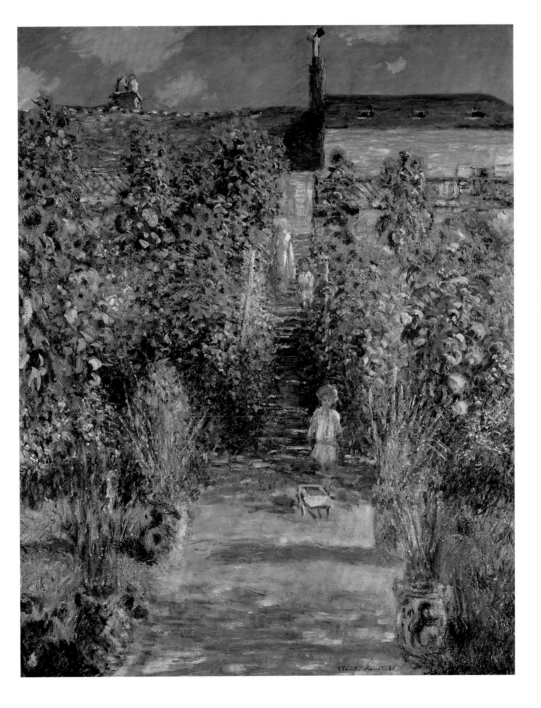

Claude Monet
(1840–1926)
The Artist's Garden at Vétheuil

1880
Oil on canvas
150 × 120 cm (59 × 47 ¼ in.)
National Gallery of Art, Washington, D.C.

In June 1880 the journalist Émile Taboureux paid a visit to Monet at his house in Vétheuil, a market town roughly 64 kilometres (40 miles) to the north-west of Paris. Taboureux described the house as 'completely modern', noting that the location – overlooking the Seine – appealed to the painter's passion for boating. In the journalist's eyes, however, the most striking feature was the thriving garden. Taboureux remarked on the abundance of 'wildflowers … impressionist ones, of course!'[12]

Two years earlier, when Monet had leased the house, he had requested that the terraces running down to the river be landscaped, and every summer he planted them with flowers. Following Taboureux's visit Monet painted four versions of the towering sunflowers that flanked the path and steps leading up to the house. The blue-and-white urns in the foreground of this version can be seen in earlier canvases painted at his rented house in Argenteuil (opposite, right), and also in later works painted at his home in Giverny; indeed, wherever he lived, he would fill the urns with plants and place them in either the garden or the house. Monet's stay in Vétheuil was brief: by the end of 1881 he had moved his family to Poissy on the industrial outskirts of Paris. The rent was low, but he lamented the lack of a garden.

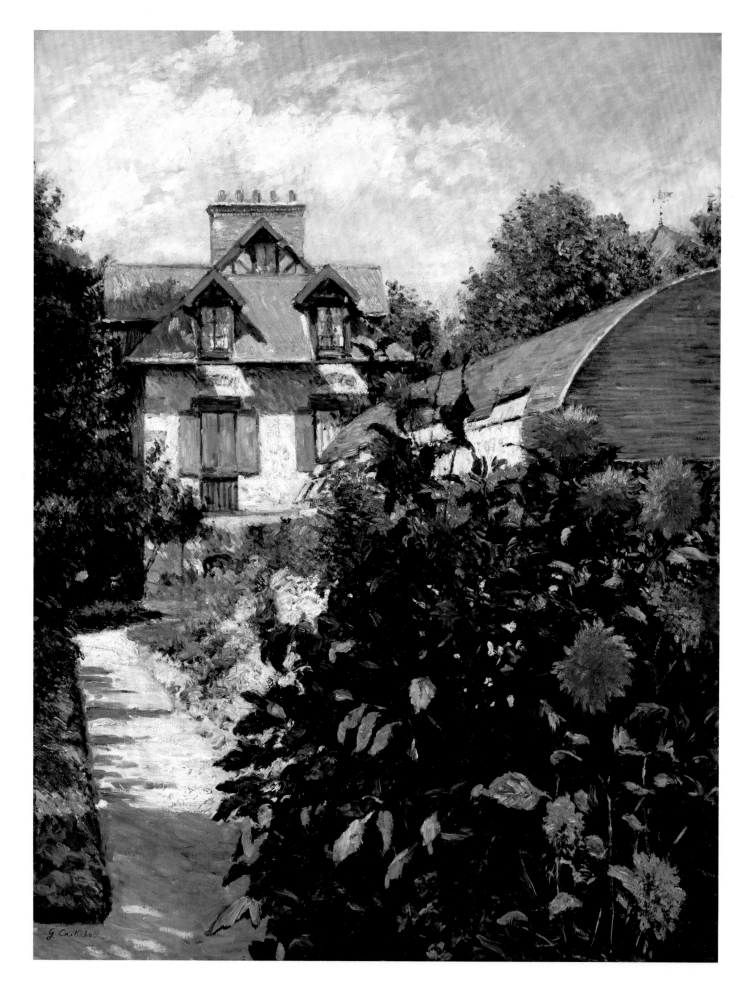

Gustave Caillebotte
(1848–1894)
The Dahlias, Garden at Petit-Gennevilliers

1893
Oil on canvas
116 × 90 cm (45⅝ × 35⅜ in.)
Private collection

In 1881 Gustave Caillebotte and his brother bought a property on the banks of the Seine at Petit-Gennevilliers, roughly 19 kilometres (12 miles) to the north-west of Paris. The modern house had comfortable, old-fashioned proportions, and was built of rough-textured stone and roofed with red tiles. The land behind the house led down to the river, so Caillebotte created his garden at the front. Over the next few years, as he devoted more of his time to boating and gardening, he stopped exhibiting his paintings. By 1888 he had given up his residence in Paris, and had purchased his brother's share of the Petit-Gennevilliers property, adding a hen house, a new studio and a large greenhouse fitted with the latest technological features.

From that point onwards Caillebotte's garden became the central subject of his art. He cut flowers for still-life compositions, and painted his stunning orchids in their greenhouse setting. But his favourite views reveal the seamless unity that he had created between his house and his garden. This painting evokes the experience enjoyed by guests as they passed the magnificent stand of coral and gold fimbriated dahlias, walked along the shaded path beside the greenhouse and were welcomed into the intimate environment of the painter's home.

Max Agostini
(1914–1997)
Monet's Home at Giverny

n.d.

Oil on canvas

65 × 81 cm (25⅝ × 31⅜ in.)

Galerie Martin-Caille Matignon, Paris

In the spring of 1883 Monet boarded a train in Paris and travelled north-west through the Seine valley. Looking to move out of the city and into the countryside, he found a house to lease on the southern outskirts of Giverny, a picturesque hamlet in Haute-Normandie. The village suited Monet's needs: although small and untouched by industrial development, it offered convenient rail access to Paris. But it was the modest two-storey house that convinced him that he had found his home. The exterior walls were covered in pale-pink stucco – added by a previous tenant who had lived in Guadeloupe – and it sat on 1 hectare (2½ acres) of fertile land. Within days of moving in that June, Monet had planted some of his favourite flowers, including poppies, sunflowers and Christmas roses, close to the front of the house.

As a self-styled 'Contemporary Impressionist', Max Agostini worked in the open air to capture the elusive effects of colour and light. He travelled throughout France in search of his subjects, and was drawn to Giverny both by its natural beauty and by its associations with Monet. Agostini paid tribute to his predecessor in this view of Monet's house, in which the building's low profile and pale but luminous walls blend easily into a vista of dazzlingly brilliant flowers, described by a critic in Monet's day as 'floral fireworks'.[13] Monet himself never expressed a desire to repaint the house, but he did change the colour of the shutters from grey to green, to enhance the harmonious relationship between his modest home and magnificent garden.

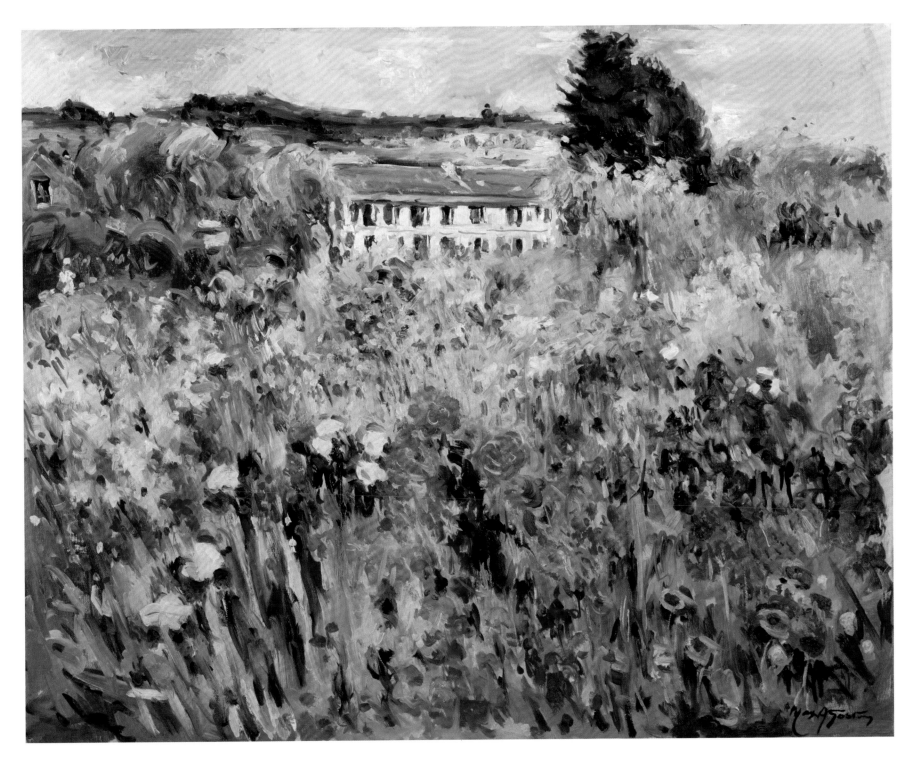

Public Gardens

Writing in 1851, horticulturalist Andrew Jackson Downing (1815–1852) argued that municipalities should create green spaces and gardens for public recreation: 'Plant spacious parks in your cities, and unloose the gates.'[1] Downing had a particular project in mind – a public park for New York City – and his emphasis on welcoming people from every walk of life voiced a populist point of view. Within a decade the construction of Central Park was well under way, but the egalitarian philosophy that shaped its design was not exclusively American. Throughout the major capitals of Europe, royal domains and private parklands were being opened for public use; access to previously restricted land was rapidly becoming an aspect of modern urban life.

In common with middle-class culture and urban development, public parks and gardens enjoyed unparalleled growth during the middle of the nineteenth century. But the process of transformation had started in the previous century when aristocratic landowners had begun to grant the public restricted access to their land. By the end of the eighteenth century, such privately maintained grounds as the Jardins des Tuileries in Paris were providing limited public amenities, including cafes and toilet facilities. Commercial venues, such as London's Vauxhall Gardens, also emerged (opposite), and in Japan, shrine sites added tea houses and garden displays to satisfy the demands of tourists (page 169). And as public parks and gardens became a feature of modern life, they also became a featured motif in contemporary art.

Nowhere is this more evident than in the work of those artists who launched their careers during France's Second Empire (1852–70). In Paris, the ambitious urban renewal plan sponsored by the government of Napoleon III and supervised by Georges Eugène Haussmann converted vast tracts of royal land into public gardens and parks; between 1848 and 1870 the amount of land set aside for public recreation rocketed from a mere 19 hectares (47 acres) to more than 1800 hectares (4500 acres).[2] Pursuing subjects of modern life, artists joined their fellow Parisians in the new public spaces. Edouard Manet, for example, depicted the lively crowd at an open-air concert (page 172). John Singer Sargent portrayed fashionable strollers, eager to be seen in an elegant setting (page 173). Together with day trippers from every level of society, Monet and Renoir rode the new railway lines out of the city for a few pleasant hours of boating, bathing or picnicking under the summer sun (pages 176, 177 and 179). As seen in the work of Edouard Vuillard, the parks brought families out of their homes and into the open air (page 174); travel writer Karl Baedeker noted that the Jardins des Tuileries were 'the especial paradise of nursemaids and children'.[3]

Towards the end of the nineteenth century Camille Pissarro rented a flat overlooking the Tuileries. One of the last of the royal enclaves to be fully opened to the public, the Tuileries still preserved their aristocratic origins in the strict geometry of André Le Nôtre's formal plan: smooth gravel paths, manicured parterres and reflecting pools. From his window high above the rue de Rivoli, Pissarro surveyed the view conceived for royal residents and their privileged guests. Now that the 'gates' had been 'unloosed', he painted the gardens as part of the public landscape (page 178).

Canaletto
(Giovanni Antonio Canal)
(1697–1768)
Vauxhall Gardens: The Grand Walk

c. 1751
Oil on canvas
50.8 × 76.8 cm (20 × 30¼ in.)
Private collection

When London-based entrepreneur Jonathan Tyers (1702–1767) became the proprietor of the New Spring Gardens on the south bank of the River Thames in 1732, he embarked on an extensive renovation project. For nearly seventy-five years the gardens had had a rural aspect, but Tyers cleared away some of the old trees and shrubs, and divided the 5-hectare (12-acre) plot into nine sections traversed by broad gravel avenues and ornamented with architectural follies. By presenting the favourite features of private landscape gardens in a public venue, Tyers created a highly successful attraction that drew pleasure-seekers from every walk of London life. In 1785 the old name was dropped in favour of its enduring popular name, Vauxhall Gardens.[4]

The whimsical pavilions seen in Canaletto's vista housed a small group of musicians and provided refreshments. Visitors gathered to listen or dance to the music, and at night lanterns illuminated the tree-lined *allées*. The vast grounds that surrounded the orchestra clearing were intersected by wide walkways; Tyers had the old-fashioned topiary and walls replaced with ornamental groves. Fanciful temples, archways and sculptures provided diversions along the wooded pathways, mirroring the new trends in landscape design for elite estate gardens. Hidden from view, the ornamental structures were often favoured for romantic – or illicit – encounters.

Thomas W. Lascelles
(fl. c. 1885–1914)
The Old Physic Garden of the
Apothecaries at Chelsea, 1790,
after Henry Gillard Glindoni
(1852–1913)

1890
Engraving
Dimensions unknown
Private collection

The origins of the Chelsea Physic Garden in London can be traced to 1673, when the Society of Apothecaries developed a small plot of land for the purpose of training apprentices in the cultivation and use of medicinal plants. It operated without a university affiliation, and in 1722 Dr Hans Sloane offered the society 1½ hectares (4 acres) of his freehold estate on the Chelsea Embankment. He granted the society a perpetual lease for only £5 a year and an annual donation of fifty plant specimens to develop a study collection for the Royal College of Physicians.[5] The river location offered many advantages, including good drainage, a congenial microclimate and ready transportation.

As can be seen in Thomas Lascelles's engraving of an illustration by Henry Gillard Glindoni, the garden was simple and serviceable. Michael Rysbrack's statue of Dr Sloane (1733) appears in the middle distance as the presiding spirit of the enterprise.[6] A small glass cloche can be seen in the bottom left-hand corner, protecting a rare plant. Glindoni set this lively gathering of members of the society in 1790; just over a century later, in 1899, the society handed over the running of the garden to the City Parochial Foundation. The garden did not open to the general public until 1983. Since then, however, with interest in ecology and ethno-botany on the rise, it has once again become the site of enthusiastic activity.

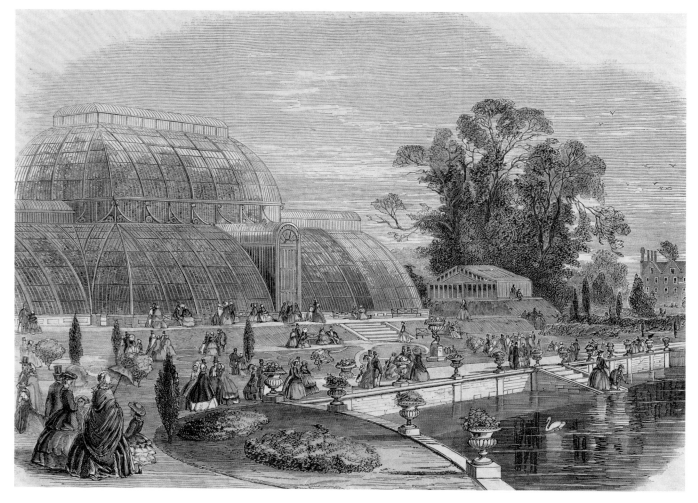

Unknown artist
Kew Gardens: Palm House

n.d.
Coloured engraving
Dimensions unknown
Royal Botanic Gardens, Kew, London

When Sir Joseph Banks's death in 1820 brought about the end of his tenure as director of the Royal Botanic Gardens at Kew, south-west London, their reputation declined. One problem was limited access. Restricted visits had been allowed since George III had come to the throne in 1760, but there was no public transport to Kew from central London. And, as one visitor remembered, 'You entered unwelcome, you rambled about suspected, and you were let out with manifest gladness.'[7]

All that changed in 1841, when the gardens became the property of the state. Under Sir William Hooker (director from 1841 to 1864), an ambitious programme of rebuilding and development was launched with the objective of serving the public. Architect and garden designer Decimus Burton (1800–1881) created a new entrance, which led visitors along a broad walkway in an open landscape ornamented with fountain pools and beds of flowers. The path led directly to Burton's grand Palm House, the jewel of the new public garden. With its soaring height and vast span, the Palm House accommodated botanical wonders from every corner of the Empire, including the colossal *Bactris gasipaes* (peach palm). By the time the Palm House opened in 1848, the London and South Western Railway had reached Richmond, and the gardens quickly became a favourite destination for a day trip out of the city.

Utagawa Hiroshige
(1797–1858)
The Bridge with Wisteria (Kameido Tenjin Shrine), from *One Hundred Famous Views of Edo*

1856–58
Colour woodblock print
35.9 × 23.3 cm (14⅛ × 9⅛ in.)
Cincinnati Art Museum, Ohio

Kameido, a district in the north-eastern part of Tokyo, was developed in the aftermath of the Great Meireki Fire (1657), which destroyed much of the city (at that time known as Edo). Its central feature was a shrine dedicated in 1662 to the ninth-century scholar Sugawara no Michizane, who had been venerated as Tenjin, the patron of learning and calligraphy. Over the years, however, the district became popular as a tourist destination thanks to its distinctive *taikobashi*, or 'drum bridges', and the annual flowering of magnificent wisteria.

Here, Utagawa Hiroshige highlights the attractions favoured by the public during the nineteenth century. The steeper of the pair of drum bridges at the shrine can be seen in the centre; small figures of elegant women delicately traverse the precipitous span. A tea house decorated with red lanterns looks out over the water, but Hiroshige gives prominence to the wisteria vines, gracefully draping them over an overhead trellis in the foreground. This particular impression derives some of its beauty from a printing error: note how the rich blue ink used for the water appears in the area of sky beneath the arch of the bridge. By Hiroshige's day, making a day trip to Kameido in late April or early May for the *Fuji Matsuri* (Wisteria Festival) had become almost as popular as viewing cherry blossom in early spring.

John Bachman
(*fl.* 1850–77)
*Central Park, Summer,
Looking South*

1865
Colour lithograph
Dimensions unknown
Museum of the City of New York

In 1858 the eleven-member board of the
New York City Parks Commission selected
the Greensward plan as the winning entry
in a competition to design a new municipal
park. Submitted by Frederick Law Olmsted
(1822–1903) and Calvert Vaux (1824–1895),
the plan reflected its name, proposing the
creation of sweeping spans of lawn among
existing water features and groves of
trees. The designated site in the centre of
Manhattan, as well as its mandate to serve
all the people of the city, prompted the
commissioners to set aside the name of the
plan and call their new public green space
Central Park.

This bird's-eye view illustrates the open
aesthetic of the Greensward plan. Just three
years earlier the commissioners had stressed
their desire for natural beauty over imposed
formal design, stating that 'Vegetation should
hold the first place of distinction.'[8] The
inclusion of paths throughout the plan
encouraged visitors to stroll at their leisure,
but in the early years the lawn known as the
Sheep Meadow was off limits to pedestrian
traffic. Explaining that blades of grass 'can be
enjoyed without pressing them underfoot', the
commissioners endorsed the Sheep Meadow
as a place for 'mental refreshment', as well as
grazing grounds for a flock of pedigree sheep.[9]

Claude Monet
(1840–1926)
Garden of the Princess, Louvre

1867
Oil on canvas
91.8 × 61.9 cm (36⅛ × 24⅜ in.)
Allen Memorial Art Museum, Oberlin College, Ohio

To capture a panoramic view of Paris in the
spring, Monet applied for official permission
to set up his easel on an upper-floor balcony
on the east side of the Louvre. The former
palace remained a royal property, but Monet's
vista reveals the permeable nature of the
boundary between private domain and
public access during the Second Empire.
A vast urban renewal project – sanctioned
by Napoleon III and directed by Georges
Eugène Haussmann – transformed Paris
into a modern city with broad avenues, new
buildings and open parklands (see page 166).
Many of the royal gardens, such as the fenced
lawn of the Garden of the Princess, were
opened to the public when the imperial
family was not in residence.

The silver-violet silhouettes of the domes
of the Panthéon (centre) and the church of
the Val-de-Grâce (right) loom in the misty
distance, on the left bank of the Seine.
Newly planted chestnut trees line the Quai
du Louvre. The street teems with activity
as pedestrians make their way through the
carriage traffic. But within the borders of the
garden, the space is open and the pace slows
to a stroll, with visitors circulating on raked
gravel paths beside the orderly plantings that
ring the manicured lawn.

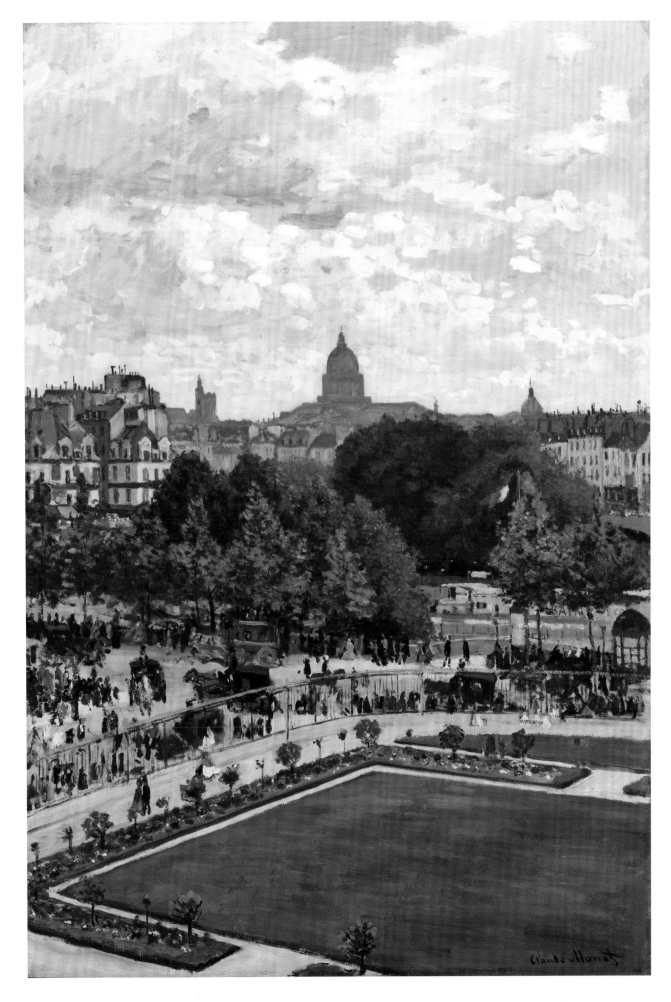

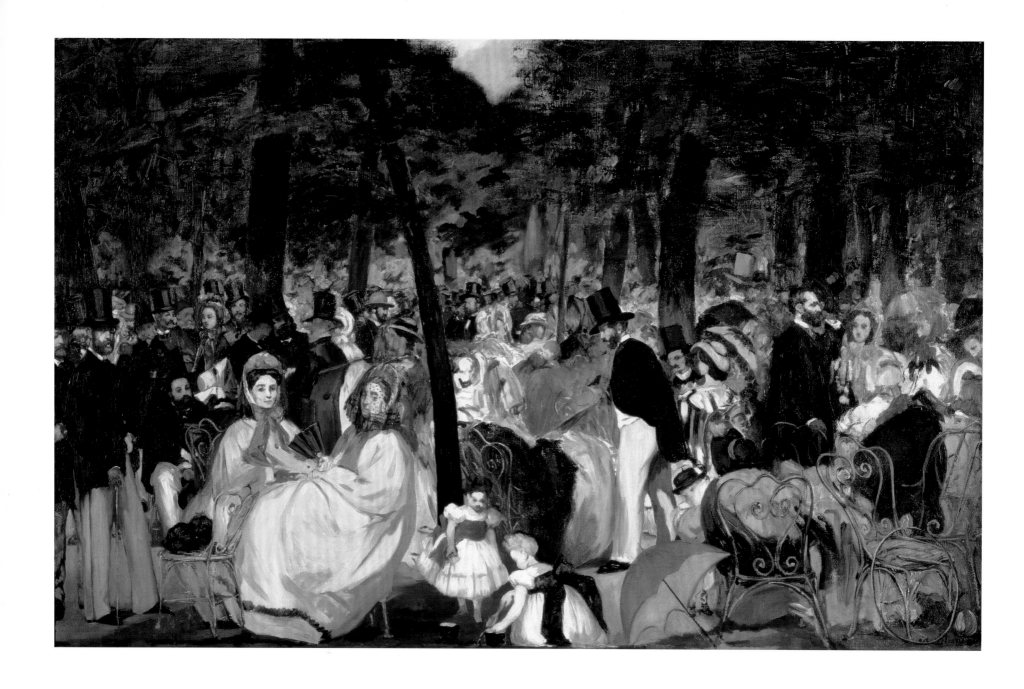

Edouard Manet
(1832–1883)
Music in the Tuileries Gardens

1862
Oil on canvas
76.2 × 118.1 cm (30 × 46½ in.)
The National Gallery, London

The Jardins des Tuileries take their name from a tile works that occupied the site during the thirteenth century. Early in the sixteenth century the site was acquired by François I; later, his daughter-in-law Catherine de Médicis had the grounds landscaped in the Italian style. In 1664 André Le Nôtre, landscape gardener to Louis XIV, reconfigured the gardens along a grand, tree-lined avenue featuring ornamental pools and flanked by formal parterres. In the late eighteenth century the Tuileries became one of the first royal parks in Europe to admit members of the public. Although access was limited to designated areas during specific hours of selected days, such amenities as cafes and public toilets were provided to assure the visitors' comfort.[10]

By the time Edouard Manet painted his view of a Sunday-afternoon concert, much of the gardens had been opened for public use as part of Georges Eugène Haussmann's urban renovation plan. With its old growth of chestnut trees, wide gravel paths and cooling ponds, the Tuileries attracted crowds of upwardly mobile Parisians, who enjoyed the freedom to stroll, picnic or listen to music on once-restricted grounds. For Manet, however, it was the crowd – fashionably dressed and eager to take in the events, as well as the gossip, of the day – rather than the park's features, that made the Tuileries modern.

John Singer Sargent
(1856–1925)
Luxembourg Gardens at Twilight

1879
Oil on canvas
73.7 × 92.7 cm (29 × 36½ in.)
Minneapolis Institute of Arts

Marie de Médicis became the Queen Regent of France when her husband, Henri IV, was assassinated in 1610. Shortly afterwards, she commissioned a spacious palace and gardens just south of the Paris city walls. The original plan for the Jardin du Luxembourg is attributed to Jacques Boyceau de la Baraudière (*fl.* 1602 – *c.* 1633), and the elegant design – dominated by an octagonal pond at the centre of four square formal beds – reflected the ornamental traditions of the queen's Italian homeland. In 1791, shortly after the beginning of the French Revolution, the palace became the property of the state, and the gardens were opened to the public.

In John Singer Sargent's day, the gravel parterre that surrounds the pond attracted sophisticated left-bank strollers, as well as artists from the nearby École des Beaux-Arts. Here, two fashionable figures – a dashing man carrying a straw boater and a slender woman in rose – saunter across the buff-grey gravel. At twilight in the height of summer, the verdant trees behind the balustrade that separates the pond from the elevated beds are engulfed in shadow. The silver-violet tones of the early evening sky transform the popular public park into an intimate setting, recalling the luxury of the garden's original purpose as an elegant royal retreat outside the city's walls.

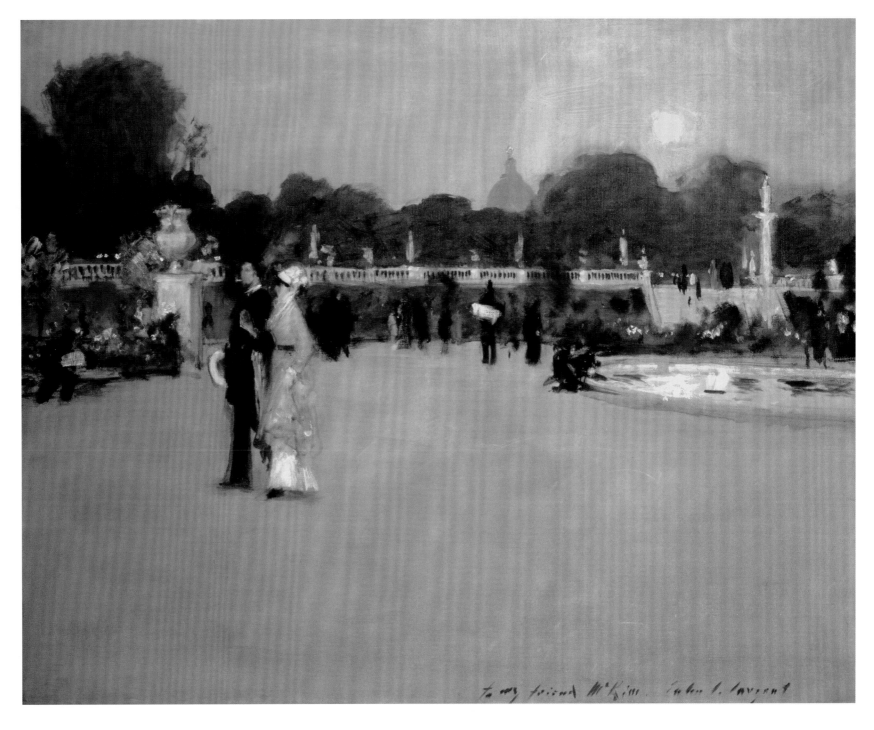

Edouard Vuillard
(1868–1940)
Public Gardens: Girls Playing, the Interrogation

1894
Distemper on canvas
Left panel: 215 × 88 cm (84⅝ × 34⅝ in.);
right panel: 215 × 92 cm (84⅝ × 36¼ in.)
Musée d'Orsay, Paris

Edouard Vuillard's nine-panel ensemble *Public Gardens* was commissioned by Alexandre Natanson for the combined salon and dining-room of his apartment on the rue du Bois de Boulogne in Paris. Each panel depicts children playing in a public garden, accompanied by their friends, mothers or nannies. Vuillard had explored the theme in earlier paintings, but for this ambitious undertaking he gathered ideas by observing children and their carers in the favourite parks of upper-middle-class families: the Jardins des Tuileries and the Bois de Boulogne. Although his settings are evocative rather than specific, the wide sand-and-gravel walkways framed by groves of trees suggest that these two panels were inspired by the features of the spacious Bois de Boulogne.

Located on the western edge of Paris, outside the old city walls, the Bois de Boulogne spreads over more than 800 hectares (2000 acres). In Vuillard's day, as now, the park featured a wonderful variety of trees, including beech, hornbeam, chestnut and cedar, as well as the remnants of an ancient oak forest. Originally a royal domain, it had been turned into a public park by Napoleon III in 1852; the landscaping, which introduced open lawns and the walkways, was financed by the sale of plots of land on the perimeter of the forest for residential development, including Natanson's home.

Edouard Manet
(1832–1883)
The Garden of Père Lathuille

1879
Oil on canvas
92 × 112 cm (36¼ × 44⅛ in.)
Musée des Beaux-Arts, Tournai, Belgium

The Parisian cafe attained new prominence and prosperity in the bourgeois climate of the Second Empire. The rising middle class had more money to spend and more time in which to relax, and the cafe provided a brief respite from the grind of daily life. The city's new central boulevards, built as part of Georges Eugène Haussmann's urban renovation plan, were flanked by wide, tree-lined pavements, and in good weather cafe proprietors were able to move their tables outside. Other establishments, such as Père Lathuille's cafe-restaurant in the Batignolles district, created garden spaces in courtyards or on terraces, where patrons could eat a meal, dally over coffee or meet to arrange a rendezvous.

Edouard Manet used Père Lathuille's garden terrace as the setting for this staged vignette. The woman has been dining alone, and at the end of her meal a man approaches her in a seductive, flirtatious manner. The other patrons have left, and an exasperated waiter looks on, wondering how long the pair will occupy the table. Broad-leafed tropical plants and palms can be seen through the glass partition behind the table. An old tree with spreading branches and a line of bushes create a natural boundary between the public space and the semi-private garden.

Auguste Renoir
(1841–1919)
La Grenouillère

1869
Oil on canvas
66.5 × 81 cm (26⅛ × 31⅞ in.)
Nationalmuseum, Stockholm

The expansion of the French railway network brought a surprising advantage to the working-class citizens of Paris. With a cheap return ticket and a short journey, it was possible to escape the crowds of the city for a day's holiday. A favourite destination was Croissy-sur-Seine, located to the west of the city near the fashionable suburb of Bougival. It took just twenty minutes to get there from the Gare Saint-Lazare in central Paris. In the summer, visitors could rent boats or bathing cabanas, or swim in the Seine for free. The rowdy crowds were catered to by floating cafes, the most popular of which was La Grenouillère.

To paint this lively scene, Renoir set up his easel on the banks of the Seine close to the establishment's moorings. One of the two barges used for dancing and dining can be seen on the right. The artificial island in the centre – no more than an anchored raft, decorated with a potted tree and connected to the shore by a narrow footbridge – was known as 'the Flowerpot' or 'the Camembert' for its shape. Such makeshift attractions created the atmosphere of a pleasure garden, in which Renoir discovered a modern-day counterpart to the eighteenth-century *fête galante*.

Auguste Renoir
(1841–1919)
Two Sisters (On the Terrace)

1881
Oil on canvas
100.5 × 81 cm (39⅝ × 31⅞ in.)
The Art Institute of Chicago

Renoir described Chatou as 'the prettiest
of all the suburbs in Paris', but most visitors
made the short journey from the city centre –
just 14½ kilometres (9 miles) in a westerly
direction – to row on the Seine.[11] In Renoir's
day, the Île de Chatou had become
a centre for the sport, and the setting for this
double portrait features a popular gathering-
place for athletes and aficionados alike. The
cafe terrace of the Hôtel Fournaise overlooked
the Seine, and rowers can be seen training
on the river in the distance. However, by
emphasizing the flowering bushes, the
budding trees with light spring foliage, and
the cut flowers ornamenting the garments of
the sitters, Renoir has presented the rowers'
cafe as a riverside garden.

Although the painting was long called
Two Sisters, there is no evidence that the
models were siblings. The young woman has
been identified as Jeanne Darlaud; she wears
a dark-blue flannel dress of the type that
women favoured for boating. The girl's name
is not known. But the comments made by
Renoir as he began the work suggest that he
was seeking to capture a sense of time and
place, rather than portray specific individuals:
'The weather is fine and I have my models.'[12]
His subject was simply the pleasure of sitting
by the river to enjoy fair weather, abundant
sunshine and spring flowers.

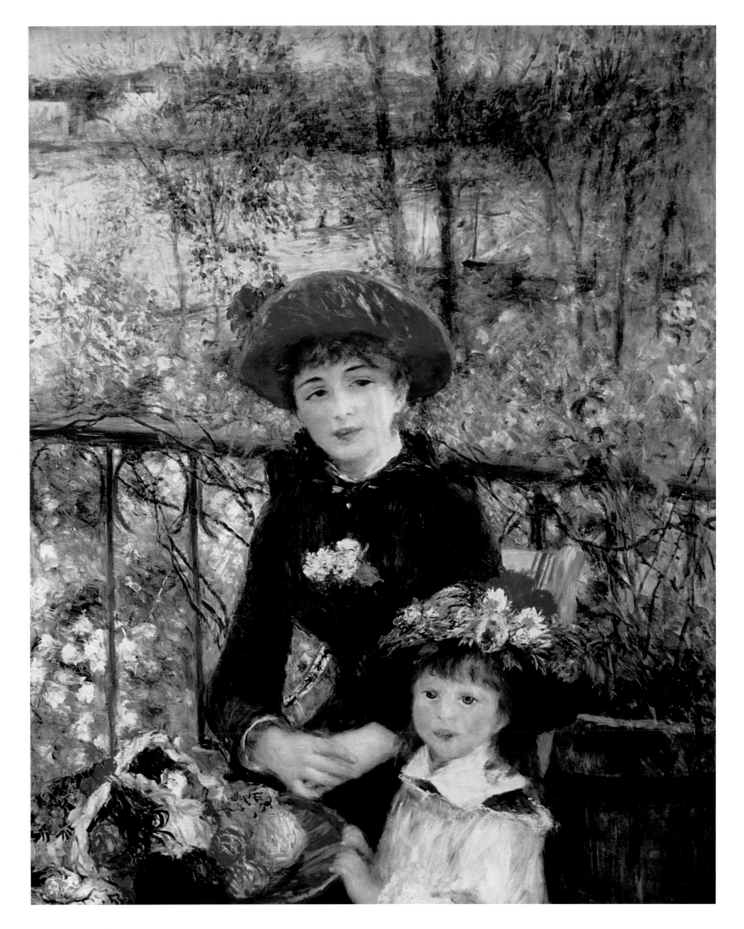

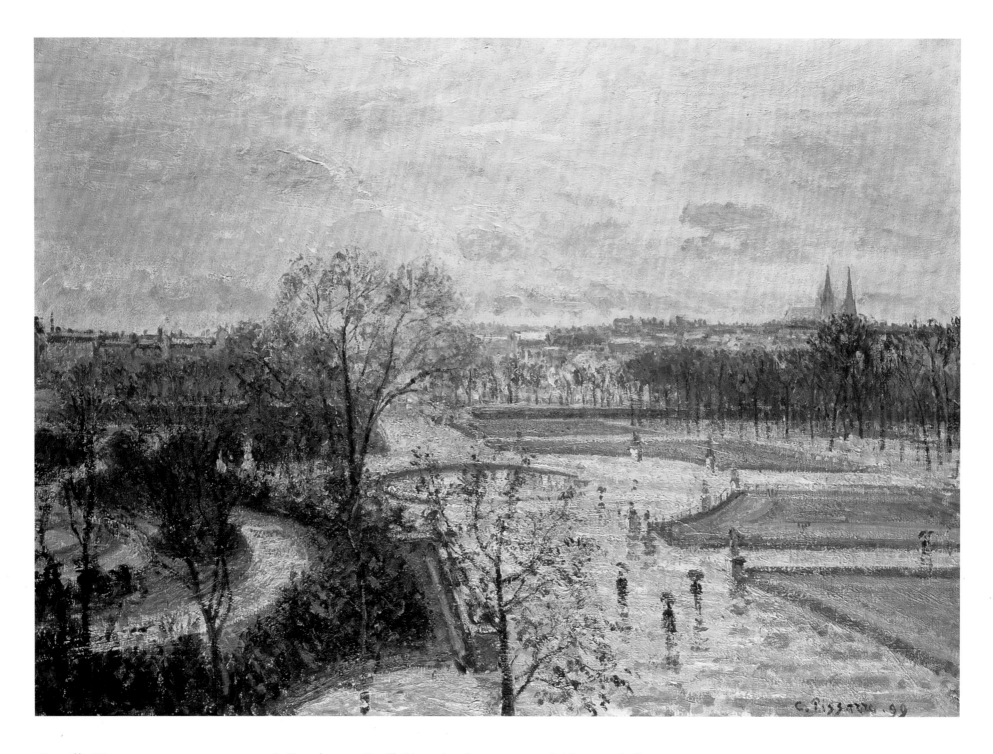

Camille Pissarro
(1830–1903)
The Garden of the Tuileries in Rainy Weather

1899
Oil on canvas
65 × 92 cm (25⅝ × 36¼ in.)
Ashmolean Museum, Oxford

In December 1898 Camille Pissarro leased an upper-storey flat on the rue de Rivoli in Paris. His windows faced south, towards the Seine, affording him a panoramic view of the vast grounds of the Jardins des Tuileries. The rue de Rivoli defined the northern boundary of the gardens, the Louvre marked the eastern extent, and the Place de la Concorde and the Arc de Triomphe lay to the west. With his easel set up at the window, Pissarro painted sixteen views of the gardens. In this one, painted in January 1899, he captures the chilly sensation of damp air and the opalescent beauty of winter's low light. The people in the garden hurry along the

avenues, holding up umbrellas to protect themselves from the rain.

Pissarro also portrays some of the features that had survived from André Le Nôtre's mid-seventeenth-century design. The wide gravel avenues that bisect the grounds establish the clear axial plan. Circular paths and plantings, as well as the round pools, counter the rigid geometry. Given the season, the parterres are bare, but the broad lawns remain green. The chestnut trees are young: two decades earlier, during the civic insurrections that preceded the brief regime of the Paris Commune (March–May 1871), the old copses had been burnt.

Claude Monet
(1840–1926)
Sketch for Le Déjeuner sur l'herbe

1865–66
Oil on canvas
130 × 181 cm (51⅛ × 71¼ in.)
The Pushkin State Museum of Fine Arts, Moscow

By the middle of the nineteenth century, the former royal domain of the forest of Fontainebleau had become a popular destination for a day trip from Paris. In 1849 a new railway line made the 56-kilometre (35-mile) journey brief and convenient, and in 1862 Napoleon III designated part of the forest as a nature reserve. Using his friends as models, Monet staged this picnic on the edge of the forest near the village of Chailly. He had planned the work as a large-scale tribute to modern leisure – the original canvas was nearly 6 metres (20 feet) wide – but he abandoned the project and, in 1884, cut the canvas into three fragments.

This is a highly finished studio sketch from the time of his initial endeavour.[13]

Monet's painting conveys the experience of young urbanites enjoying a day in the country. The women are dressed in summer garments, and one man relaxes in his vest and shirtsleeves. The lavish picnic was likely provided by one of the new excursion services based in Chailly; a delivery man, wearing a driver's hat and cloak, waits near a hamper in the shadows of the birch tree on the right-hand side of the canvas. By incorporating such real-life details, Monet transformed the iconic motif of outdoor pleasure into a genuine reflection of modern life.

A harassed school teacher from Hayes
Took her children to Hampton Court Maze,
They got thoroughly lost
At a moderate cost
And then had a wonderful time admiring
the Great Vine and imagining Henry VIII
serving double faults on the Tennis Court.
It was easy to get there, too — Green Line
Coaches 716, 716A, 718 and 725 run to the gates.

Frédéric Henri Kay Henrion (1914–1990)
Advertisement for Green Line coach trips to Hampton Court Palace

1956
Colour lithograph
101 × 63.5 cm (39¾ × 25 in.)
Victoria and Albert Museum, London

In Jerome K. Jerome's novel *Three Men in a Boat* (1889), the hapless travelling companions visit Hampton Court Palace to take a quick spin through the famous maze. They have a strategy: if they turn only right, they can 'walk round for ten minutes' and then be off to lunch. Two hours later, after repeatedly finding themselves back at the centre, they call the keeper to rescue them.[14] Frédéric Henri Kay Henrion's poster presents an alternative version of this scenario, portraying 'A harassed school teacher from Hayes' taking refuge at the centre of the maze while her pupils scream for help.

The hedge maze at Hampton Court Palace, the earliest known example of such a maze in England, was added to the palace gardens in the late seventeenth century; the planting appears to have been completed by 1689. Designed by George London and Henry Wise, it was originally planted with hornbeam hedge; over the years, however, the hornbeam has mostly been replaced by yew. Contrary to the circular form depicted in the poster, the maze has a trapezoidal plan. Moreover, it is a puzzle maze – as distinct from the more common unicursal maze, a single path winding to the centre – consisting of irregular blocks of densely planted trees, or islands, enclosing the core. The design confounds the popular solutions of turning in only one direction or moving through with one hand on the hedge wall; either technique will always lead the visitor back to the centre.

Henri Rousseau ('Le Douanier') (1844–1910)
Exotic Landscape

1910
Oil on canvas
130 × 162 cm (51⅛ × 63¾ in.)
Norton Simon Museum, Pasadena, California

Critics and friends alike attributed Rousseau's jungle motifs to his deployment in Mexico in the army of Napoleon III. But in 1910 the French art critic Arsène Alexandre interviewed the painter and revealed that he had never 'traveled further than the glass houses of the Jardin des Plantes'.[15] In fact, Rousseau had never left France. Like his jungle paintings, the tales he spun of his experiences as a young soldier were vivid

inventions inspired by Paris's great collection of plants and animals from distant lands.

The Jardin des Plantes was founded in 1626. In 1792 the royal menagerie was moved there from Versailles and opened to the public. But the inhabitants of Rousseau's jungles were likely sketched from specimens at the gardens' Zoology Gallery, which had opened in 1889 and featured stuffed animals in lifelike positions. Rousseau particularly

liked the glasshouses (1835–41), where he spent hours drawing individual leaves and flowers from the wide array of tropical specimens on display. As he explained to Alexandre: 'When I go into the glasshouses and see the strange plants of exotic lands, it seems to me that I enter into a dream.'[16] Back in his studio, he would arrange the images he had collected on his canvases into the souvenirs of his imaginative travels.

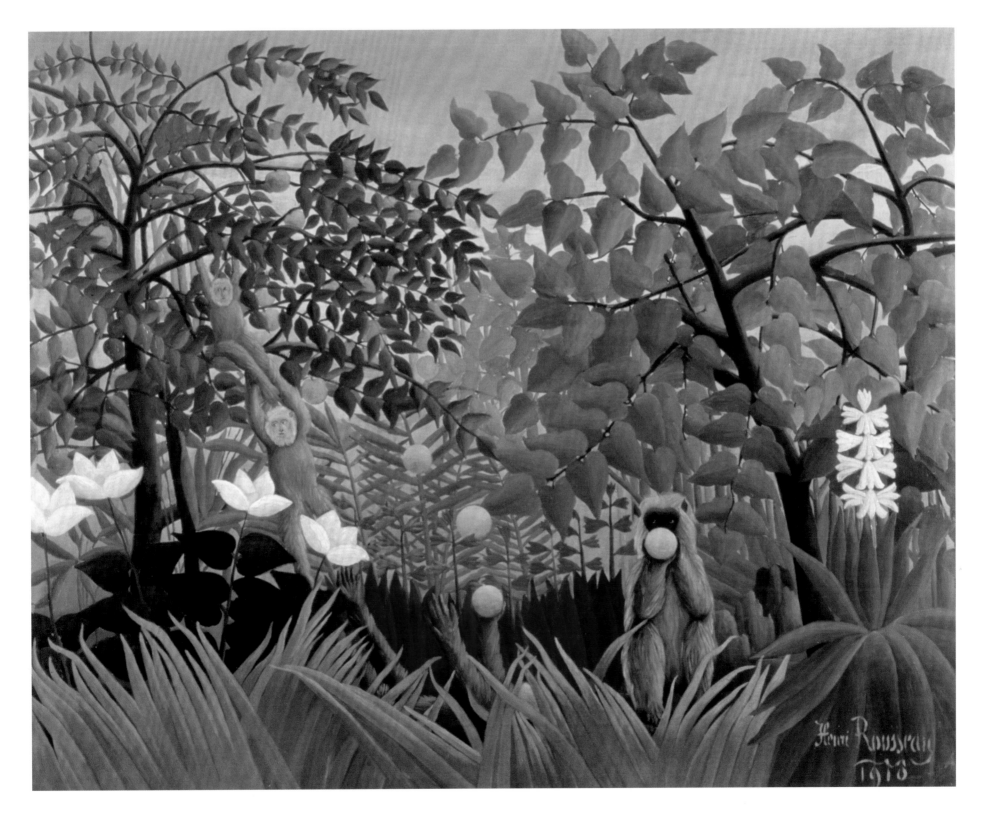

John Singer Sargent
(1856–1925)
Boboli Gardens

c. 1907
Transparent and opaque watercolour over
graphite on paper
25.4 × 35.6 cm (10 × 14 in.)
Brooklyn Museum, New York

In 1549 Eleanor of Toledo, the wife of
Cosimo I de' Medici, purchased the
unfinished Palazzo Pitti on the south bank of
the River Arno in Florence. Although her
new palace remained unfinished at her death
in 1562, the construction of the gardens,
initially planned by Niccolò Tribolo, was
well under way. The original design reflected
both Eleanor's interest in medicinal plants
and her husband's passion for unusual
trees, but in the seventeenth century their
descendants built formal terraces up the steep
hillside and added an amphitheatre. The
gardens were opened to the general public by
Pietro Leopoldo di Lorena when he became

the Grand Duke of Tuscany in 1766. More
than a century later, Edith Wharton deemed
them 'the most important, if not the most
pleasing, of Tuscan pleasure gardens'.[17]

Although Wharton found the Boboli
Gardens 'merely forlorn',[18] John Singer
Sargent lent them a spirit of romantic
melancholy, painting several watercolour
views of the Piazzale dell'Isolotto in the
late afternoon. Designed by Giulio Parigi in
1618 and completed by his son Alfonso in
1637, this little island in a small lake at the
northern edge of the gardens features an oval
basin ringed with statues and a fragrant
lemon garden.

August Macke
(1887–1914)
Zoological Garden I

1912
Oil on canvas
58.5 × 98 cm (23 × 38½ in.)
Städtische Galerie im Lenbachhaus, Munich

At first glance, it seems as if Auguste Macke has presented the Cologne Zoological Garden as a modern peaceable kingdom. The wrought-iron fences meant to separate the human visitors from the animal residents disappear in the bright array of colour and pattern, where men in suits and bowler hats mingle freely with parrots, cockatiels and deer. But rather than seeking a new manifestation of Eden in the popular public garden, Macke chose his subject for its pictorial potential, in which colour and rhythm convey the energy of contemporary life.

Macke was a founding member of Der Blaue Reiter (The Blue Rider), an association of avante-garde painters that included Franz Marc (1880–1916) and Wassily Kandinsky (1866–1944). In 1912 Marc and Macke travelled to Paris, where they met Robert Delaunay (1885–1941), whose chromatic interpretation of cubism – called Orphism – inspired Macke to experiment with colour and pattern. Macke had often sketched as he strolled in the Cologne Zoological Garden (founded in 1860), and in this painting he used colour to express the myriad visual sensations of that experience, as seen in the vivid plumage of the exotic birds, the muted fabrics of the men's suits and the tonal patterns created by strong sunlight filtered through the canopy of trees arching over the paths.

Artists' Gardens

At the turn of the twentieth century, devotees of modern art shared a single desire: to be invited into Claude Monet's garden in Giverny. In 1907 the novelist Marcel Proust (1871–1922) described his own anticipation to the readers of the newspaper *Le Figaro*. He mused that the painter envisioned his garden as a palette 'artfully made up with harmonious tones', explaining that Monet designed his gardens as a 'first and living sketch' for his 'sublime canvases'. But they were not merely models for painting; rather, the gardens represented a genuine 'transposition of art', in which nature 'comes to life through the eyes of a great painter'.[1]

Few artists have been as closely associated with their gardens as Monet, but he was not alone in forging a reciprocal bond between his art and his garden. His own interest can be traced to his early years in Paris, where, with like-minded young artists, he set up his easel outdoors in public gardens to capture a timely image of urban life in the modern world. As the artists of the Impressionist circle established their reputations, as well as their households, they created private gardens in which they could pose their friends and families and paint the beauty of nature under natural light. The most avid gardeners – Monet and Gustave Caillebotte – exchanged tips, seeds and cuttings, and discussed their gardens with the same passion that fuelled their art.

The pleasures that inspire artists to plant gardens reflect those of all gardeners: a love of nature, an enjoyment of outdoor work and a delight in cultivating one's own intimate corner of the world. But artists also regard their gardens as an extension of their artistic practice. At the height of their popular acclaim, Atkinson Grimshaw and James Tissot added lavish gardens to their homes. They used them to entertain and impress potential clients, but both painters thought of their gardens as natural studios, where they could pose their models in settings of their own design (opposite, top, and page 195). Artists' gardens also provide a creative gathering-place, a refuge from convention; the Pre-Raphaelites enjoyed William Morris's garden at Red House in Kent (page 191), while the Bloomsbury group migrated from London to Charleston in East Sussex. Furthermore, a garden can offer a place for restorative contemplation, for, as Vanessa Bell said of her garden, 'One can sit out all day if one likes' (page 201).[2]

More than just providing a setting, a garden can give form to emotions or abstract ideas. John Constable expressed his deep attachment to his boyhood home simply by looking out of a window at his father's house and painting the garden and its surroundings (page 189). Vincent van Gogh turned to gardens to affirm his belief that the human spirit finds consolation in nature (pages 196 and 197). For Emil Nolde, flowers embodied life's essential spirit (page 202), while Stanley Spencer saw magic in the most ordinary of gardens (page 203). In a garden, an artist can erase the boundaries between life and work, and between nature and art, as seen in Gertrude Jekyll's garden at Munstead Wood in Surrey (page 200), where flowers themselves are transformed into pigment artfully arrayed on the canvas of nature.

OPPOSITE, TOP
Atkinson Grimshaw
(1836–1893)
In the Pleasaunce

1875
Oil on canvas
44.7 × 76.2 cm (17⅝ × 30 in.)
Private collection

In his youth, Atkinson Grimshaw lived in Leeds, where new industry and trade fuelled the local economy. As a young man, he clerked for the Great Northern Railway, but he also attracted notice as a self-taught painter; by 1861, art had become his sole profession. Within a decade Grimshaw had won popular, as well as critical, acclaim for his 'moonlight' pictures, and to celebrate his success he purchased Knostrop Old Hall, a Jacobean mansion on the eastern outskirts of Leeds.

When Grimshaw moved into his grand new residence, in 1870, the grounds were overgrown and the gardens neglected. Undeterred, he embarked on an ambitious programme of renovation, adding an ornate wing in a faux-Jacobean style, a conservatory and a large formal garden, which he dubbed 'the Plesaunce'. The name referred to a late medieval garden design, an enclosed space featuring walkways; plantings of beautiful flowers, fragrant grasses and herbs; and ornamental trees. For his pleasaunce, Grimshaw borrowed elements from all periods of garden history, fashioning a luxurious display rather than an authentic re-creation – further evidence of his status as an affluent and self-made man.

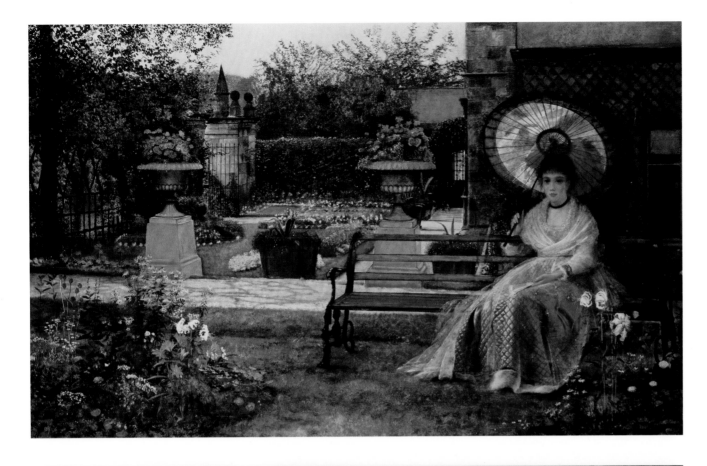

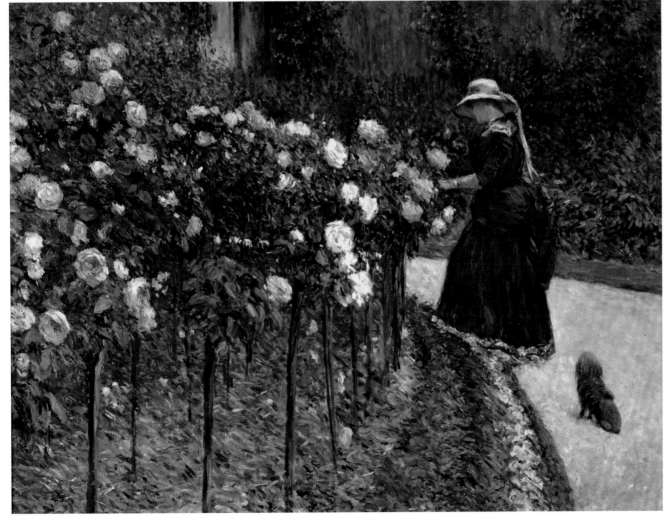

LEFT, BOTTOM
Gustave Caillebotte
(1848–1894)
*Roses in the Garden at
Petit-Gennevilliers*
1886
Oil on canvas
89 × 116 cm (35 × 45¾ in.)
Private collection

Nothing remains of Gustave Caillebotte's
residence in Petit-Gennevilliers (page 162),
but the painter's canvases, as well as his
brother's photographs, give us a glimpse of
the beauty and variety of the garden. Known
for his methodical approach to planting –
he liked to group his flowers in rectangular
beds – Caillebotte cultivated a glorious
ornamental garden, featuring dahlias, lilacs
and magnificent stands of roses. With its
lushly planted *massifs* and gently curving
paths, edged with nasturtium and bordered
by lime trees, the garden provided Caillebotte
with the perfect setting in which to observe
the effects of light on natural colour.

The resplendent rose beds recall the
elegant garden park at Yerres, where a young
Caillebotte summered with his parents and
brother. Here, the flowers are in full bloom
at the height of summer, and, using deft
brush strokes, Caillebotte portrays the range
of colours on display, from waxy white to
a deep blush-pink, set off by verdant green
leaves. The woman in the fashionable
dark-blue dress – identified as Caillebotte's
mistress, Charlotte Berthier – tilts her head
towards a bright bloom, the flush of her skin
in the heat mirroring its rosy hue. Working
quickly in the open air, Caillebotte caught
every subtle shift of colour under the
shimmering sun.

Peter Paul Rubens
(1577–1640)
Rubens and Isabella Brant in the Honeysuckle Bower

1609–10
Oil on canvas
178 × 136.5 cm (70⅛ × 53¾ in.)
Alte Pinakothek, Munich

Rubens returned to his native Antwerp
in 1608 after launching his career in Italy.
He had planned only a brief stay in Belgium,
but his reputation brought him prestigious
commissions, and in 1609 he married
Isabella Brant, the daughter of a wealthy
and cultured civic secretary. After the
wedding the couple lived with Isabella's
father; within a year Rubens had bought a
large house with a handsome garden just off
the Meir, one of Antwerp's most fashionable
streets. He improved the garden by adding
features in the formal Italian style, including
patterned beds defined by trimmed hedges,
ornamental trees grown in pots and a garden
pavilion embellished with sculpture.

This self-portrait with Isabella celebrates
the couple's marriage; she rests her right hand
on his. They sit within the fragrant shelter of
a honeysuckle bower, but rather than being a
feature of their own garden, it is a symbol of
their loving union. The association may be
traced to the tale of Daphnis and Chloe. The
young lovers lived far apart, and during one
rare reunion Chloe's mother allowed them to
linger in a bower as long as the honeysuckle
bloomed. When Aphrodite aided the lovers
by making the blossoms last, the honeysuckle
became a symbol of enduring love.

John Constable
(1776–1837)
*Golding Constable's Vegetable
Garden*

1815
Oil on canvas
33 × 50.8 cm (13 × 20 in.)
Wolsey Art Gallery, Christchurch Mansion, Ipswich

John Constable painted this panorama of the verdant countryside of the lower Stour Valley from the upper windows of his father's house in East Bergholt, Suffolk. His father, Golding, was a mill owner, with holdings in nearby Flatford and Dedham, and the large, abundant garden reflects the comfortable wealth of the household. A hired man can be seen raking in the foreground; on the right, beyond the fenced grazing green, a neighbour's plentiful garden seems small in comparison. The low, rolling countryside – with a broad field of grain in the middle distance and a windmill on the horizon – presents the vista that Constable had known since childhood.

Writing to a friend, Constable once declared, 'I should paint my own places best.' He explained that the act of painting views associated with his 'careless boyhood' was a matter of 'feeling' rather than of craft.[3] During the summer of 1815, the year before his father died, he also produced a highly finished drawing of the family's kitchen garden and a painting of the flower garden. He identified these gardens as his father's, but through deep attachment, close observation and loving depiction, he had made them his own.

Berthe Morisot
(1841–1895)
The Garden at Bougival

1884
Oil on canvas
73 × 92 cm (28¾ × 36¼ in.)
Musée Marmottan, Paris

When Berthe Morisot and her husband, Eugène Manet (Edouard Manet's brother), moved into their new home in Paris's chic Passy neighbourhood, Eugène took pleasure in cultivating a flower garden. But while the house was under construction (from 1881 to 1883) the family lived in a rented house in Bougival, a suburb located in a picturesque bend of the Seine about 14 kilometres (9 miles) to the west of central Paris. The region had an elegant past, with handsome seventeenth- and eighteenth-century chateaux dotted along the banks of the river. One contemporary writer compared the region to a sophisticated garden, with trees in 'the most agreeable pattern', and luxurious lawns that were 'fresh and gentle to the feet'.[4]

The Morisot/Manet family stayed in a house on the rue de la Princesse, and the comfortable design accommodated Morisot's dual role as artist and mother. The house featured a large veranda overlooking a lawn, and a garden with rose trellises. With her easel set up on the veranda, Morisot could watch her daughter, Julie, at play while painting under natural light. In this view of the brilliant roses in full bloom, the high summer sun glazes the house and its surroundings with dazzling light.

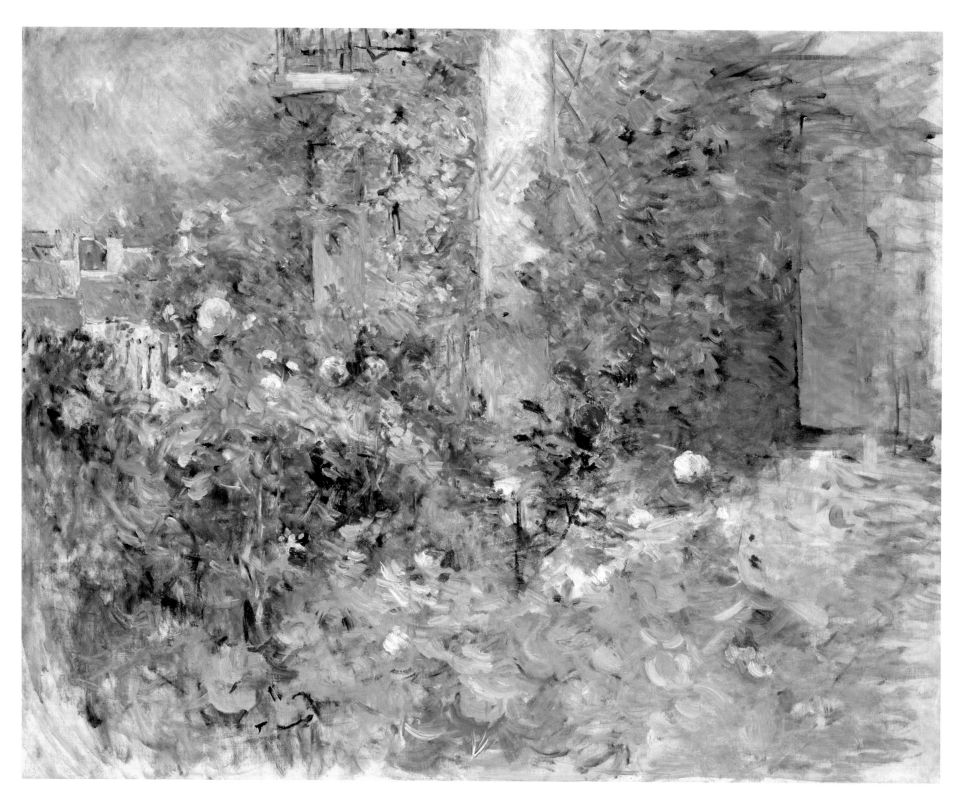

Walter Crane
(1845–1915)
Tea at Red House

1907
Watercolour on paper
17.8 × 28 cm (7 × 11 in.)
Private collection

In 1859 William Morris purchased a
1-hectare (2-acre) site in Bexleyheath, Kent,
and commissioned his friend Philip Webb,
an architect, to build a two-storey house after
his own design. He called it the Red House,
in reference to the tone of the local brick,
and its medieval-cottage aesthetic erased any
sense that it was newly built. The effect of
age was enhanced by the site, an abandoned
orchard. Webb's survey of the property
listed eighty trees, including apple, cherry,
pear, holly, hazel and yew. The garden was
integrated into the design of the house;
Morris desired that every window should
have a garden view.

At the front of the house a square
garden divided into four smaller squares
was surrounded by a wattle fence overgrown
with climbing roses. The enclave behind the
house, as seen in Walter Crane's watercolour,
featured a broad lawn shaded by old trees.
Flowering creepers and rose trellises covered
the walls of the well court, masking any signs
of 'raw newness'.[5] Although Morris was
knowledgeable about plants and gardening
practices, his contemporaries could not recall
ever seeing him with 'a spade in his hands'.[6]
Morris's stay at the Red House was brief –
from 1860 to 1865 – but the garden's influence
on his designs (page 157) lasted a lifetime.

Samuel Palmer
(1805–1881)
In a Shoreham Garden

1829
Ink and watercolour on paper
27.9 × 22.2 cm (11 × 8¾ in.)
Victoria and Albert Museum, London

The abundance of nature always sparked Samuel Palmer's visionary creativity. His son recalled that when he encountered 'foliage, blossom, or fruit' in 'prodigal profusion', his 'delight took his imagination by the hand and led it far away from beaten tracks'.[7] This painting of an apple tree reveals how he was able to transform a lovely yet relatively mundane subject. Palmer moved to the Kentish village of Shoreham with his father in 1826; there, he was visited by his friends, a circle of like-minded young artists that included John Linnell (1792–1882) and Edward Calvert (1799–1883). Influenced by the intuitive art of William Blake, they called themselves 'the Ancients', adopting the credo of 'poetry and sentiment'. A family inheritance allowed Palmer to stay on in the village long after his friends had departed, and in 1828 his father rented Water House near the River Darent.

The trees and shrubs that Palmer portrays transcend the bounty of any imaginable springtime. The luminous blossoms seem even brighter against the leaden sky, while the enigmatic figure in red adds to the sense of mystery. Palmer's exact location when he created the work is still subject to debate; he may have been painting in his father's garden at Water House.[8] But for Palmer, the location was merely a point of departure; a garden's true beauty was revealed to him through the vision it inspired.

Auguste Renoir
(1841–1919)
Flowers in a Greenhouse

1864
Oil on canvas
130 × 98.4 cm (51½ × 38¾ in.)
Hamburger Kunsthalle, Hamburg

Renoir built his dream home late in life. In
1907 he purchased land in Cagnes-sur-Mer
on the Côte d'Azur, and by 1908 he was
settled in his spacious new house surrounded
by an olive grove. Throughout his career he
preferred to paint outdoors, but as an aspiring
young artist he often lacked the means to pay
for rent and food, let alone design a garden.
Like his friend Monet, he set up his easel in
Parisian public parks, such as the Jardins des
Tuileries and the Jardin du Luxembourg,
and in the grounds of former royal estates,
including those at Saint-Cloud and Chailly,
near Fontainebleau.

Renoir also painted still life, arranging
plants as if a gardener were getting ready
to do his springtime bedding. Here, Renoir
groups a tall arum lily with an overblown
parrot tulip and a pale-blue crocus; they
are still in their pots, waiting to be planted.
The composition also includes a blooming
white lilac, a star-flower cineraria and, in the
foreground, a wooden tray of zinnias with a
bunch of grass draped over one corner. This
odd assortment would never bloom at the
same time under natural conditions, revealing
that Renoir constructed his model using
hothouse plants.

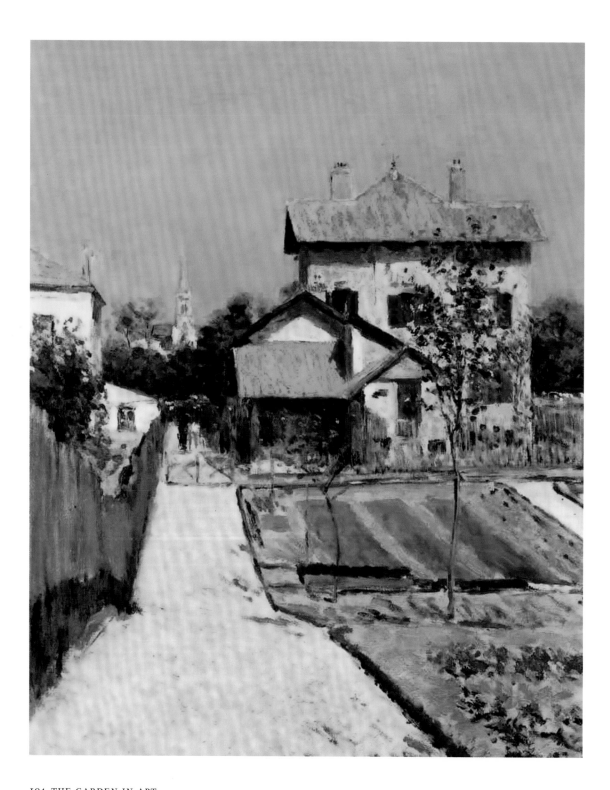

Gustave Caillebotte
(1848–1894)
The Artist's House at Petit-Gennevilliers

c. 1882
Oil on canvas
65 × 54 cm (25 ⅝ × 21 ¼ in.)
Private collection

A mutual passion for boating led Gustave
Caillebotte and his brother, Martial, to buy
a property on the Seine at Petit-Gennevilliers
in 1881 (see page 162), and the long, narrow
parcel of land proved to be an ideal location
in which the painter could create a garden.
Martial married in 1887 and moved out, and
in the following year Gustave made the house
his main residence. Although the house
was modern, he renovated and refurbished
it to suit his own needs, and improved the
outbuilding that served as his studio. He also
built a greenhouse, where he successfully
cultivated rare species of orchid. Monet lived
in nearby Argenteuil, and the two artists
traded gardening tips, as well as catalogues,
seeds and cuttings.

The young trees in this painting indicate
that the garden is at an early stage of
development, but Caillebotte's preference
for orderly beds and segregated plantings
is already evident. Over the years, he grew
chrysanthemums, poppies, daisies, dahlias
and lilacs, as well as flowering fruit trees;
his friend and fellow gardener Gustave
Geoffroy recalled that everything was
'pampered' and 'labeled' in Caillebotte's
'little vegetal world'.[9] Caillebotte's garden
inspired him to paint floral still lifes, and he
decorated door panels for his dining-room
with images of his favourite blooms.
Photographs taken by Martial in the early
1890s portray the garden in its full glory,
and document the painter lovingly tending
his beds.

James Tissot
(1836–1902)
The Garden of the Artist's House
n.d.
Oil on canvas
Dimensions unknown
Private collection

In 1871 the French-born painter James Tissot moved from Paris to London to escape the chaotic aftermath of the Franco-Prussian War. His witty paintings of fashionable society found a welcoming audience, and within two years he was able to purchase a large detached villa in then-suburban St John's Wood. Shortly after moving into the house at 17 Grove End Road, Tissot added a studio-salon with a conservatory and a stepped terrace, which led directly from the studio into the villa's spacious garden.

Tissot upgraded the garden by installing a large ornamental fishpond in the sweeping lawn behind the house. A wrought-iron colonnade – a copy of the marble colonnade in Paris's Parc Monceau with Ionic rather than Corinthian columns – was designed to enclose the pond, and within a few years fast-growing vines were draping the entablature and trailing around the capitals. In mild weather, Tissot enjoyed entertaining his guests in the garden, but he also used it all year round as an outdoor studio. In the warmer months he would pose his elegant female models, dressed in their lightweight frocks, in hammocks shaded by the mature chestnut trees; at other times of the year he would sit them on the ornamental benches, wrapping them in furs and shawls to keep out the chill.

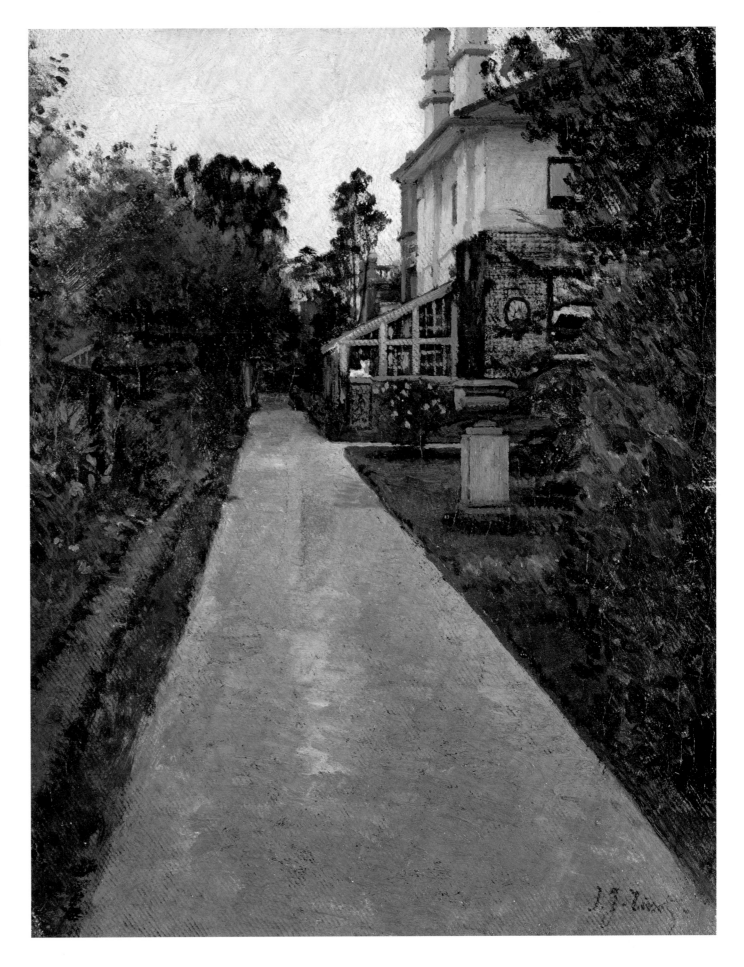

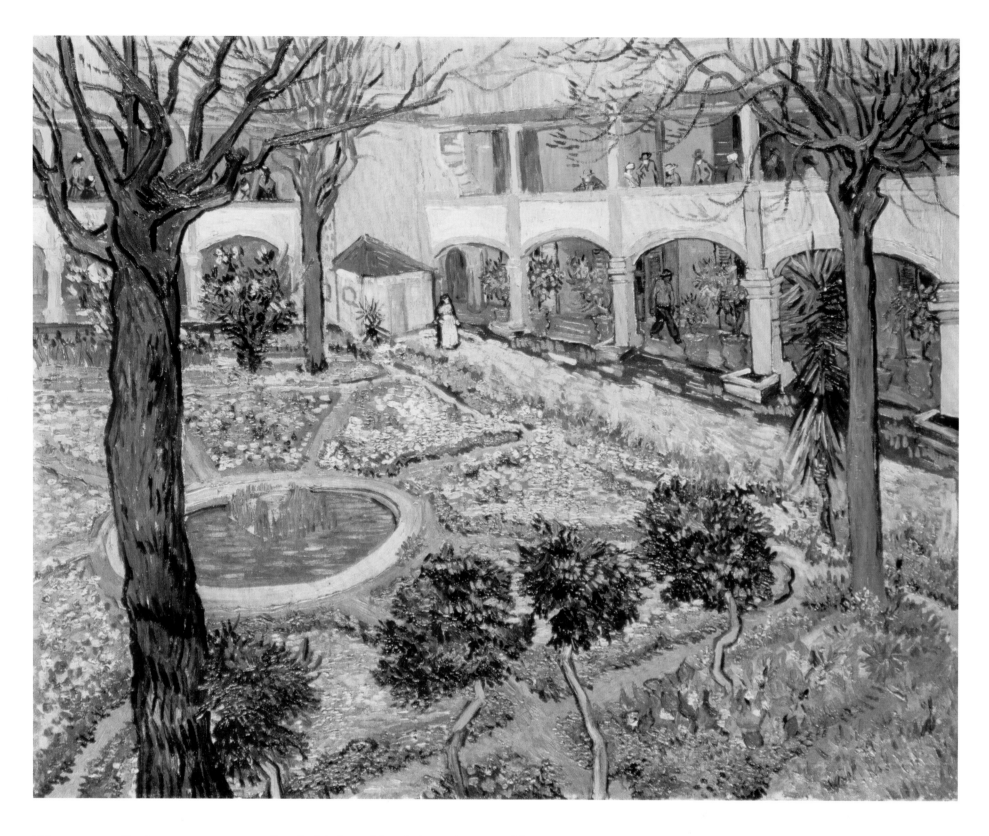

Vincent van Gogh
(1853–1890)
*The Courtyard of the Hospital
at Arles*

1889
Oil on canvas
73 × 92 cm (28¾ × 36¼ in.)
Sammlung Oskar Reinhart, Winterthur, Switzerland

Van Gogh had moved from Paris to Arles in the early part of 1888, seeking to paint 'nature under a bright sky'.[10] He worked relentlessly throughout the year, but late in December, with his emotional stability shattered, he slashed his own ear in what he wryly described to his brother Theo as 'simply an artist's fit'.[11] He recovered from his physical wound, but in the early months of 1889 he suffered from intermittent delusions, and complaints about his erratic behaviour prompted the local authorities to recommend that he be confined to a hospital.

Van Gogh painted several canvases during his month-long confinement, including this one of the hospital courtyard garden, complete with its formal, wedge-shaped flower beds surrounding a fountain. The view depicts the garden as a respite from the tedium of life on the wards, and Van Gogh included his fellow inmates looking out from the upper-floor balconies. Although never an active gardener himself, Van Gogh believed that a troubled soul could find tranquillity and consolation in a garden setting. In the summer of 1890, just weeks before his death, he wrote to his mother: 'For one's health … it is very necessary to work in the garden and see the flowers growing.'[12]

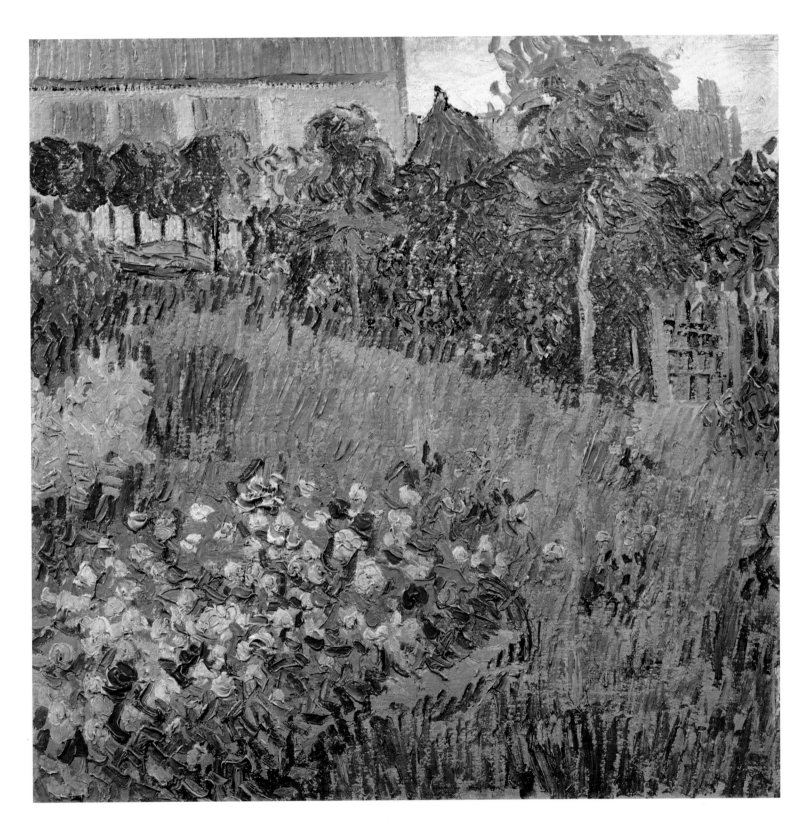

Vincent van Gogh
(1853–1890)
Daubigny's Garden

1890
Oil on canvas
50.7 × 50.7 cm (20 × 20 in.)
Van Gogh Museum, Amsterdam

In 1860 the artist Charles-François Daubigny (1817–1878) moved to the village of Auvers-sur-Oise. An early advocate of *plein-air* painting, Daubigny worked outdoors, and over the years like-minded artists, including Paul Cézanne and Camille Pissarro, followed his example and travelled to Auvers – roughly 32 kilometres (20 miles) to the north-west of Paris – to set up their easels in the surrounding countryside. Van Gogh made the journey towards the end of May 1890, to live under the compassionate care of another Auvers resident, Dr Paul Gachet. Although Daubigny had died more than a decade earlier, his widow still lived in the couple's house, and to honour the late painter Van Gogh decided to paint their garden.

For this view, Van Gogh placed his easel near the rose beds, already blossoming under the late spring sun. He sent a sketch of the vista to his brother, with a letter describing the wonderful array of colours on show; in the painting, these can be seen in the green grasses, the pink flowers, the yellow lindens and, in the background, the blue-grey tiles of the house's roof. In the centre, between the lindens, purple irises are still in bloom. With clear tones and controlled brushstrokes, Van Gogh fulfilled the most important objective of *plein-air* painting: to capture glorious colour lit by natural light.

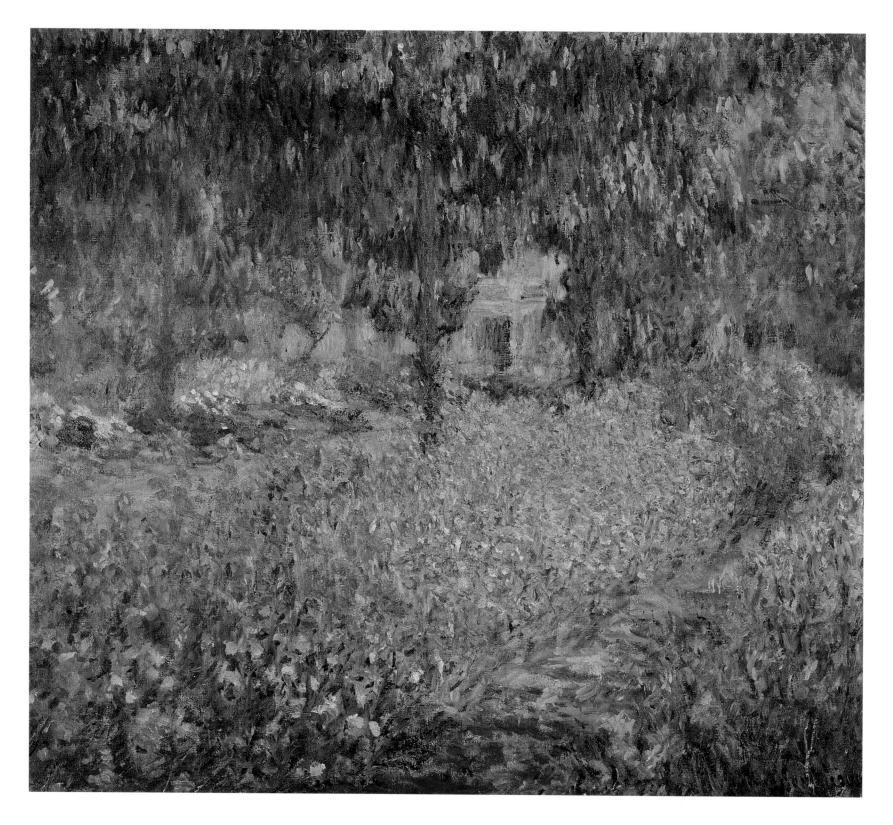

Claude Monet
(1840–1926)
The Artist's Garden at Giverny

1900
Oil on canvas
81.6 × 92.6 cm (32⅛ × 36½ in.)
Musée d'Orsay, Paris

In June 1883 Monet wrote to his dealer Paul Durand-Ruel from his house in Giverny, explaining that he was very busy gardening in order 'to have some flowers to paint when the weather's bad'.[13] By the time he purchased the house in November 1890 (he had been renting it since 1883), he had come to regard the garden as an extension of his palette, arranging colours so that he could observe their intermingling under natural light. From mid-spring to early summer – his favourite time of year – blue and violet hues dominated his plantings. This work displays the astonishing variety of tones he achieved by combining several varieties of iris with aubrieta, sweet rocket and mauve honesty.

After observing the Giverny garden over the course of a year, gardening expert Georges Truffaut marvelled at the beauty of Monet's uni-chrome planting, especially in early June, when thousands of *Iris germanica* (a bearded iris) bloomed in long beds more than 1 metre (3 feet) wide. In an article published in the journal *Jardinage*, Truffaut declared that, although Monet was a superb painter, it was his opinion that Monet's 'most beautiful work ... is his garden'.[14] Monet himself, however, made no such distinction, explaining to art critic François Thibault-Sisson that they were one and the same: 'I owe it to flowers for having become a painter.'[15]

Claude Monet
(1840–1926)
Waterlilies

1903
Oil on canvas
81.3 × 101.6 cm (32 × 40 in.)
The Dayton Art Institute, Ohio

The plot of land that Monet purchased across the road from his house in Giverny in 1893 (see page 83) was barely half a hectare (1 acre) in size. However, it contained a feature that was essential to his plan to build a water garden: a small pond fed by a stream called the Ru. The pond had once been a watering hole for farm animals, and in order to provide a healthy environment for water lilies, Monet knew that he had to find a means of keeping the water fresh. He secured permission from the local prefect to have the stream bed reconfigured into a loop that would flow into and out of the pond, thereby preventing it from stagnating. He then hired workmen to soften its perimeter with undulating curves, and to intersperse the surrounding old growth of poplar and aspen with new plantings of reeds, bamboo and weeping willow. By the following summer the pond was in full flower, ringed by hydrangeas, rhododendrons and azaleas, and adorned with pale-pink and pale-yellow water lilies.

Monet's initial studies of the pond date from 1897, but in 1903 he began a project that would engross him for the next six years. He conceived each canvas of his *Nymphéas* series as a boundless plane of shimmering water enlivened by the play of reflected light. The lilies on his pond seemed to glide with the whim of the water, giving Monet endless variations to paint.

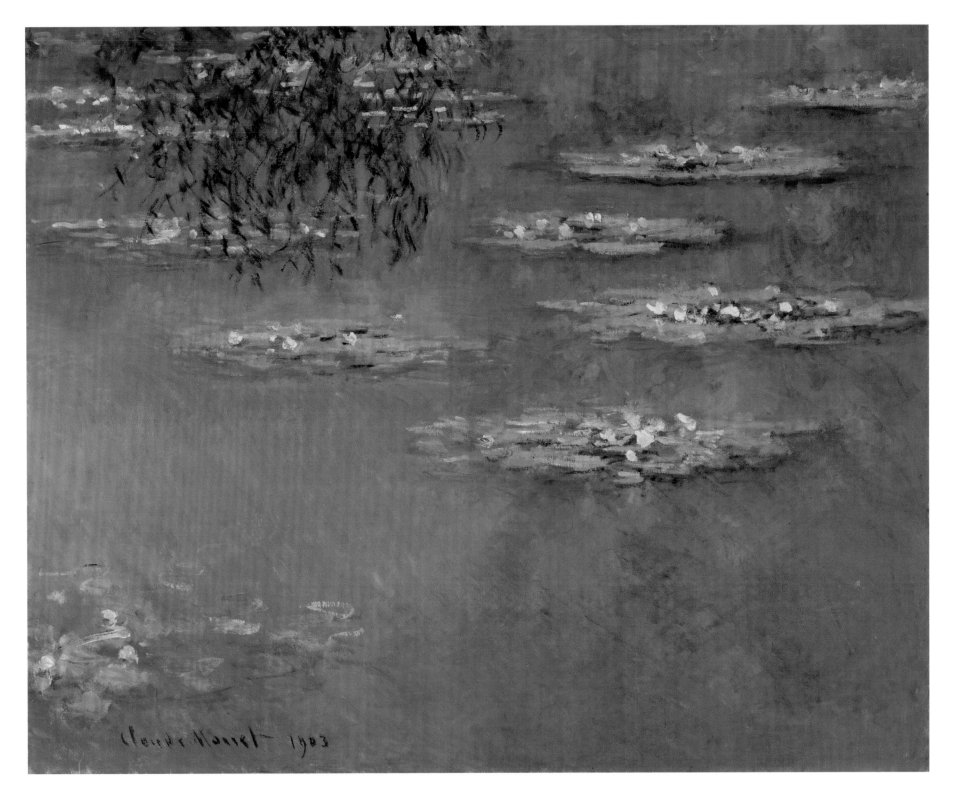

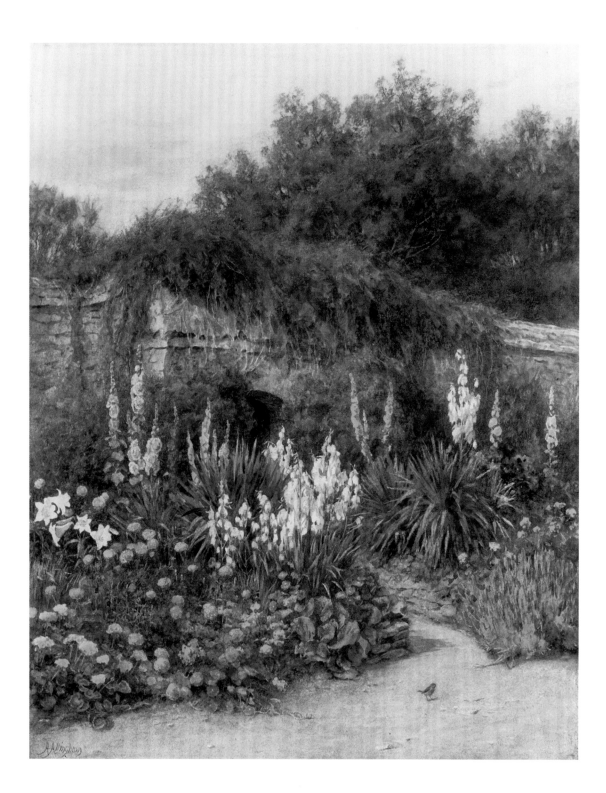

Helen Allingham
(1848–1926)
In Munstead Wood Garden, Gertrude Jekyll's Garden, Godalming, Surrey

c. 1903
Pencil and watercolour on paper
40.6 × 29 cm (16 × 11⅜ in.)
Private collection

As an eighteen-year-old student enrolled at the South Kensington Schools of Art (now the Royal College of Art) in London, master gardener Gertrude Jekyll (1843–1932) discovered a passion for colour that would inspire her most innovative contribution to garden design. Later in her career, she conceived the hardy flower border as a living equivalent to a painting, with densely planted blossoms and foliage simulating broad swathes of colour brushed across a canvas. She arranged her colours in progressive tonal harmonies – cool to vivid to cool – so that 'each portion ... becomes a picture in itself'.[16]

The flower border at Jekyll's home in Surrey ran the length of a 60-metre (200-foot) sandstone wall separating her spring garden from her summer cutting garden. Helen Allingham, a friend of Jekyll since 1889, painted several views of the border around 1900, concentrating here on the drifts of cool lavender, pale-yellow hollyhocks, white lilies and grey-green foliage that flank the archway over a path through the wall. Jekyll enhanced the natural appearance of her border by bedding her plants in free-form plots with intermingled boundaries. While she likened her approach to that of a painter, there was one significant difference: her palette was revealed only when the garden came into full bloom.[17]

Vanessa Bell
(1879–1961)
Garden at Charleston

c. 1930s
Oil on canvas
45.8 × 36 cm (18 × 14⅛ in.)
Private collection

In 1916, when Vanessa Bell and her partner, Duncan Grant (1885–1978), moved into a modest eighteenth-century farmhouse in East Sussex, the walled garden behind the house contained the remnants of a potager, with fruit trees and potato plants. Over the course of their long residence at Charleston, Bell and Grant transformed the walled garden into a stunningly colourful and decidedly unorthodox ensemble of discrete areas of planting, fragrant trees and a witty placement of sculpture and ornamental mosaics. Grant's studio looked out on to the garden, as did the dining-room, and both artists painted garden views and still lifes from cut flowers.

Here, Bell presents a glimpse of the sun-washed north-east corner of the walled enclosure. The area was later named 'the Piazza', for its terrace made by Bell's son Quentin in 1946, and although this view predates the terrace, the Mediterranean aesthetic is already in evidence. Bell adored red flowers – 'every kind of red from red lead to black' – and she cultivated an array of poppies, as well as roses, foxglove and red-hot pokers.[18] Both she and Grant enjoyed gardening, but they also employed a gardener; he can be seen tending the fig and damson trees near the back wall.

Emil Nolde
(1867–1956)
Blumengarten

1922
Oil on burlap
74 × 89.9 cm (29⅛ × 35⅜ in.)
Private collection

Emil Nolde recognized an apt metaphor for mortality in the ephemeral beauty of flowers. Their 'fate' fascinated him. Each stage of a flower's life – 'shooting up, blooming, growing, decaying, and thrown away in a pit' – offered a counterpart to those of human existence. He acknowledged that 'Our own life is not always so logical and beautiful', but noted that humanity and plants share an inevitable conclusion, ending 'in the fire or the grave'.[19] Despite his grim perspective, Nolde adored garden flowers, and nothing pleased him more than having a garden attached to his home.

The location of this garden is uncertain; Nolde changed his address repeatedly between 1917 and 1927, when he purchased a farm in Seebüll, northern Germany, near his boyhood home. Here, with brilliant, pure pigment and thick impasto, he conveys nature's life force at its height. The blooms – red roses, scarlet poppies, deep-blue hyacinths – are magnificent in size as well as hue. While Nolde infused the flowers with a mystical potency, the garden reveals quotidian traces, such as neatly tended circular beds and a white picket fence in the distance, suggesting that he used an actual garden as his model.

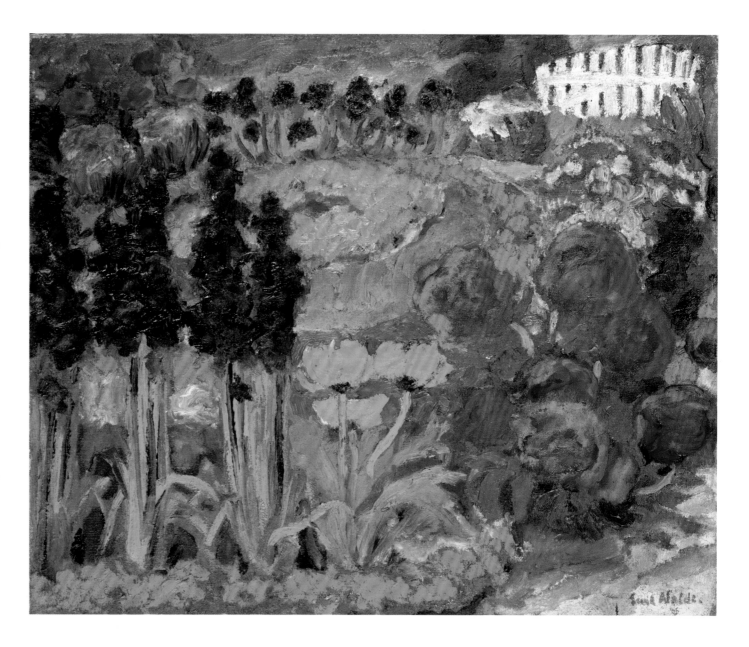

Stanley Spencer
(1891–1959)
Gardens in the Pound, Cookham

c. 1936
Oil on canvas
91.4 × 76.2 cm (36 × 30 in.)
Leeds Art Gallery

In 1932 Stanley Spencer moved back to his birthplace of Cookham, Berkshire. With his dealer's encouragement, he turned to painting landscapes. Spencer had occasionally painted landscape scenes since 1914; however, he regarded them as a minor theme in his work, and it perplexed him that patrons seemed to prefer them. By returning to Cookham, he learned to see familiar surroundings with new eyes, and he portrayed his native village with such frankness that he easily achieved his objective of exposing the 'unique and special meaning' in an ordinary environment.[20]

The brick terraced houses that line the Pound, a narrow street leading to the railway station, have small front gardens defined by iron fences and a set of iron railings that run parallel to the pavement. Although every owner has planted red salvia, each garden has a distinctive character. One garden bed is surrounded by feathery grasses, another by an orderly terracotta border set in gravel. The garden in the foreground, just in front of the spot where Spencer placed his easel, is full of life, the plants nearly filling the compact space. Spencer marvelled at the beauty to be found in humble environments, comparing his experience to Moses's encounter with the divine: 'I saw many burning bushes in Cookham.'[21]

Garden Favourites

When William Morris considered the question of how to improve the modern, middle-class dwelling in a pragmatically titled lecture 'Making the Best of It' (1880), he suggested that the place to begin was the garden. He recommended that home gardeners resist the allure of floral novelties, and select old-fashioned flowers instead. In gardens, as in his designs, Morris valued authenticity over showy display; the new hybrids and 'double-flowers' could not match the satisfying simplicity of cabbage roses, columbine and 'that wonder of beauty, a single snowdrop'.[1] And Morris followed his own advice: his gardens featured wild roses, daisies, marigolds and columbine (page 191). The natural beauty of these old-fashioned flowers inspired the best of his textile and wallpaper designs (page 157).

What makes a particular flower a garden favourite? Many of us share Morris's view, finding beauty in the familiarity of flowers with long-standing associations. Some of these are native plants, but many old, familiar favourites have distant origins: hollyhocks (page 221), for example, were brought to Europe from Palestine, lilacs (page 212) came from Persia, and sunflowers (page 219) travelled to Europe from the Americas. Even Gertrude Jekyll, as staunch as Morris in her advocacy of native plants, comfortably mixed flowers of diverse origins, in order to include 'things I like best, whether new friends or old'.[2] Throughout history, floral lore has linked individual blossoms with emblematic meanings – daisies with innocence, pansies with thought, for example – prompting both artists and gardeners to include them in their designs (pages 209 and 215). Close observation can transform common plants into natural wonders, as seen in the precise watercolours featuring primroses, cornflowers and even moss by William Henry Hunt (opposite) and Andrew Nicholl (page 211).

Whether imported or indigenous, certain flowers at certain points in time have attained a cult-like status. The 'tulipomania' that swept The Netherlands in the seventeenth century (page 208) led flower fanatics to squander their life savings on a single bulb of a rare variety, only to find that the stunning red streaks of the white 'Semper augustus' disappeared after the first blooming (the streaks having been caused by a virus rather than being an inherent characteristic of the breed). In the East, the yearly blossoming of the marsh iris drew crowds to Horikiri, making the tiny farming village a popular destination among the sophisticated tourists of Edo-era Japan. This particular iris was introduced into the West in 1852, but it was the depictions of the regal purple bloom by such artists as Utagawa Hiroshige that made it a favourite in European and American gardens (page 216).

Since the late nineteenth century, striking hybrids, including colourful chrysanthemums and new varieties of rose, have enjoyed waves of popularity, moving quickly from being promoted as a novelty to becoming a garden mainstay (pages 218 and 220). Claude Monet's neighbours in the farms around Giverny feared that his water lilies would poison the local streams, but now the paintings of these same flowers are celebrated as a testament to the artist's deep attachment not only to his garden but also to the region (page 222). No single factor explains why a particular flower attracts attention, and the depiction of countless varieties, ranging from glamorous exotics to humble wild flowers, reveals that any flower can become a garden favourite.

William Henry Hunt
(1790–1864)
Primroses and Bird's Nest with Three Blue Eggs
n.d.
Watercolour on paper
27.9 × 22.6 cm (11 × 8⅞ in.)
Harris Museum and Art Gallery, Preston, Lancashire, UK

The English primrose (*Primula vulgaris*) blooms early in the spring. The first part of its Latin name, *Primula*, means 'first one', an idea reflected in the Latin origin of its common name, *prima rosa*, or 'first rose'. But it is not a rose; rather, it is a herbaceous perennial that grows wild as ground cover in shaded woods and at the base of hedgerows. William Henry Hunt's minutely rendered watercolour reveals the delightful surprises to be found hidden away beneath such hedgerows: delicate mosses, a bird's nest containing three tiny blue eggs, and two pale-yellow primrose plants in full bloom.

As a young boy, Hunt trained with the painter John Varley (1778–1842), who taught him to draw directly from nature. By the 1830s Hunt had become famous for his exquisite still lifes of objects taken from the natural world; his signature practice of including a bird's nest won him the nickname 'Bird's Nest' Hunt. True to his training, Hunt always insisted on painting from observation rather than memory, but, owing to a disability, he could not crouch down in the hedgerows to observe his subject. Instead, he collected plants and nests in order to paint them in his studio, arranging his chosen items on crumpled paper covered with earth and moss in a re-creation of his garden's mossy undergrowth.

Jean-Léon Gérôme
(1824–1904)
The Tulip Folly

1882
Oil on canvas
65.4 × 110 cm (25¼ × 39⅜ in.)
The Walters Art Museum, Baltimore

Native to the Middle East, tulips were introduced into Europe in 1554, when Ogier Ghiselin de Busbecq, the Austrian ambassador to the court of Constantinople, brought a gift of bulbs from Suleiman the Magnificent to Ferdinand I. In 1593 Carolus Clusius, the supervisor of the new botanical garden at the University of Leiden, planted the first known tulips in The Netherlands. Within two decades, affluent Dutch speculators were buying up bulbs, and prices sometimes tripled in the course of a single day. Most prized was the 'Semper augustus', a white tulip with red flame breaks; at the height of the demand, a

single bulb cost as much as 10,000 florins.[3] The market crashed in 1637, putting an end to 'tulipomania'.

In Jean-Léon Gérôme's *The Tulip Folly*, soldiers trample beds of conventional tulips in the district of Sint-Bavokerk in Haarlem. They are under the orders of an armed nobleman, who stands guard over a single potted flower, a 'Semper augustus' that has yet to bloom, but which is worth more than all the others combined. Many buyers were disappointed in the precious cultivar; the breaking colour turned out to be the result of a virus, and over the life of the bulb, blossoms lost their red flames.

French School

Miniature of Pierre Sala Dropping His Heart in a Marguerite, from *Petit livre d'amour* by Pierre Sala (Stowe 955 f.6r)

c. 1500
Parchment codex
13 × 9.5 cm (5⅛ × 3¾ in.)
The British Library, London

In full bloom, the ox-eye daisy – its radiating white petals encircling a broad disc floret – resembles a long-lashed eye; its buds, however, look like little pearls. In medieval France, this resemblance gave rise to the popular name 'marguerite', from the Latin *margarita*, or 'pearl'. According to troubadour lore, a knight who enjoyed the requited love of his chosen lady included a marguerite in his coat of arms. The little perennial flower also inspired a traditional test of love, in which the petals are plucked one by one to the chant of 'She loves me; she loves me not.'

Pierre Sala (before 1457–1529), a French poet attached to the court of Charles VII, wrote a set of quatrains, had them inscribed on purple-stained parchment in gold, and bound them with illuminations into a book to present to Marguerite Builloud, the wife of the king's treasurer. Here, and in the accompanying dedication not shown, Sala boldly declares his love. Standing alone in a garden of fantastic blue-and-white flowers, he places his heart into the willing blossom of the sole marguerite. The lavish love token clearly won Marguerite's heart: after the death of her husband in 1506, she became Sala's wife.

Martin Johnson Heade
(1819–1904)
Apple Blossoms and a Hummingbird

1875
Oil on board
30.5 × 37.5 cm (12 × 14¾ in.)
Private collection

In May 1870 painter Frederic Edwin Church
(1826–1900) wrote to his friend and fellow
artist Martin Johnson Heade to tell him that
springtime in his orchard had been glorious:
'I had more apple blossoms on my farm this
season than you ever painted.'⁴ This gentle
boast referred to Heade's small, exquisite
paintings of branches of apple blossom. He
had first used the motif in 1865, as a perch
for a pair of ruby-throated hummingbirds
guarding their nest; indeed, at that time, his
real interest lay in the hummingbirds, rather
than the blossom. Fascinated by the tiny,
hovering birds since childhood, Heade had
made several expeditions to study them in
South and Central America. However,

when he paired his birds with apple blossom,
he chose the ruby-throat – the single species
native to eastern North America – over more
exotic varieties.

Heade portrayed a number of different
types of apple blossom in various still-life
compositions, but generally paired Japanese
flowering crab apple with hummingbirds.
The bright-red buds produce pale-pink
flowers from mid-March to May. The
blossoms, which fade to a glossy white
when fully opened, are highly fragrant and
known to attract hummingbirds with their
sweet nectar. As here, Heade always set
the ensemble against an open sky, as if he
were observing a tree in a garden.

Andrew Nicholl
(1804–1866)
Poppies and Wild Flowers on the Northern Irish Coastline

n.d.
Watercolour on paper
36 × 53.5 cm (14⅛ × 21 in.)
The Whitworth Art Gallery, The University of Manchester, UK

From 1862 to 1866, in his post at the Royal Botanic Society's gardens at Regent's Park in London, the Irish gardener William Robinson (1838–1935) specialized in British wild flowers. In 1870 he published *The Wild Garden*, the book that launched the popularity of wild-flower gardens in Britain. Robinson advocated the cultivation of hardy plants – whether native to the region or not – in neglected areas of the garden, and encouraged his readers to compose their naturalistic gardens from 'flowers selected from wild places in various parts of the British isles'.[5]

During the 1830s Andrew Nicholl, a Belfast-born landscape artist, produced a series of watercolours that established the wild flower as his signature motif. Using a small format and the precision of botanical illustration, Nicholl painted clusters of the wild flowers that grew along the Antrim coast of Northern Ireland. Although this particular work is not dated, it illustrates the appeal of the series: a profusion of delicately delineated flowers blooming in the foreground, with the basalt cliffs of the coastline in the distance. The wild poppies, daisies and cornflowers were native to the region, and appear in many of Nicholl's views. Like Robinson, the artist found that nature's model provided a 'charming little hardy garden'.[6]

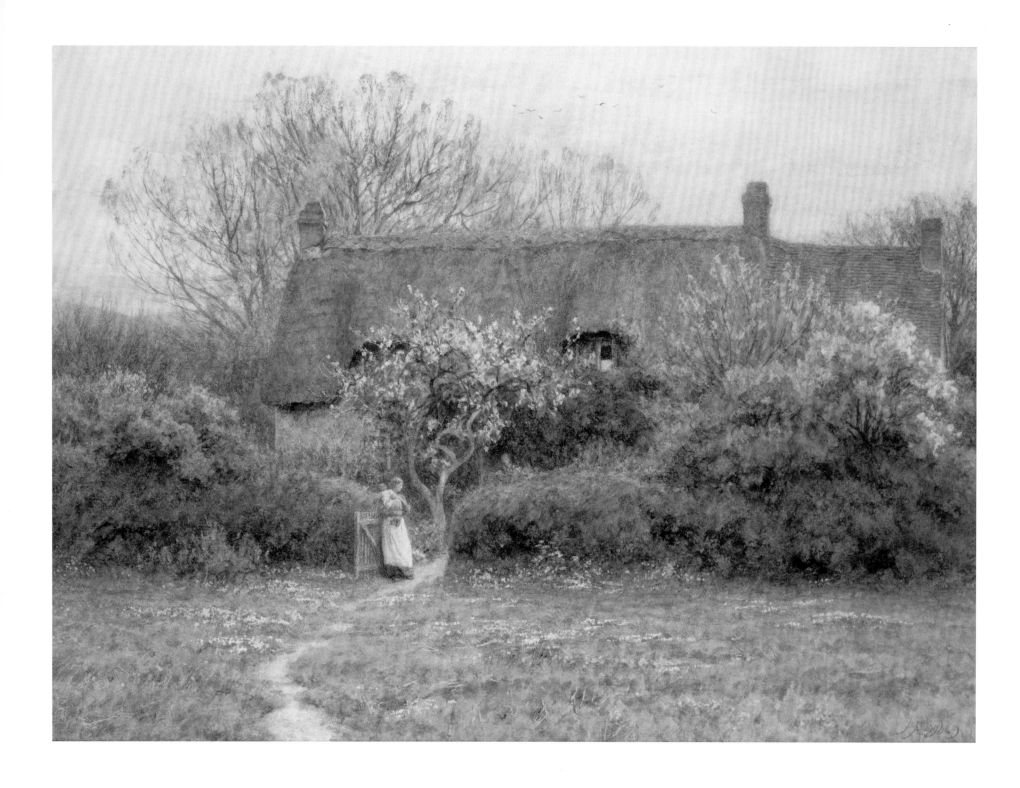

Helen Allingham
(1848–1926)
Cottage, Freshwater, Isle of Wight

n.d.
Watercolour
Dimensions unknown
Private collection

Native to south-eastern Europe and Asia, lilacs were introduced into western Europe during the first half of the sixteenth century. Pierre Belon, a naturalist who was also an envoy of the French king Francis I to the court of Suleiman the Magnificent in Constantinople, reported seeing an extraordinary plant with a 'fox's tail' of fragrant blossoms; the first European-grown fox-tail lilac tree (*Syringa vulgaris*) was recorded in 1562 in Vienna.[7] Proving to be hardy in most climates, the lilac quickly shed its exotic aura. By the nineteenth century it was flourishing in gardens – from grand to humble – all across the continent.

Helen Allingham painted this scene in Freshwater, a large village at the western end of the Isle of Wight. During her sketching tours of the region – after 1890 she went there nearly every spring for a decade to portray the home of Alfred Tennyson, Freshwater's most prominent resident until his death in 1892 – she captured the charm of the local cottages and their picturesque gardens. Massive lilac bushes were a typical feature in early summer; they were long-lived, required little attention and flowered annually when not pruned. Unlike the many practical plants associated with cottage gardens, lilacs were grown simply for their beauty and fragrance.

Winslow Homer
(1836–1910)
The Four-Leaf Clover

1873
Oil on canvas
36.2 × 51.8 cm (14¼ × 20⅜ in.)
Detroit Institute of Arts

White clover, an invasive ground-cover plant that thrives in grassy meadows, can have any number of leaves, but the most common form is the three-leaf *Trifolium repens*. The four-leaf clover is an uncommon variant, and its rare occurrence – one in approximately 10,000 – has earned the little lobe-leaved plant a history of symbolic associations. Long-standing European traditions link the individual leaves with faith, hope, love and luck. But luck has overshadowed all the other meanings, and in many Western nations, finding a four-leaf clover is always regarded as a harbinger of good fortune.

Winslow Homer painted *The Four-Leaf Clover* at a crucial point in his career. He spent the summer of 1873 in Gloucester, Massachusetts, experimenting with watercolour under natural light. Although this work is in oil, his sensitive rendering of modulated light reveals that he was able to transpose his new-found skills from one medium to the other. The little girl and her lucky find seem merely incidental. Homer painted many vignettes of children enjoying leisure activities that summer, but his central motif was the effects of natural light that he observed when painting outdoors. Here, he integrates the girl's form through colour: the geranium-red of her stockings and the grass-green of the clover she holds in her right hand.

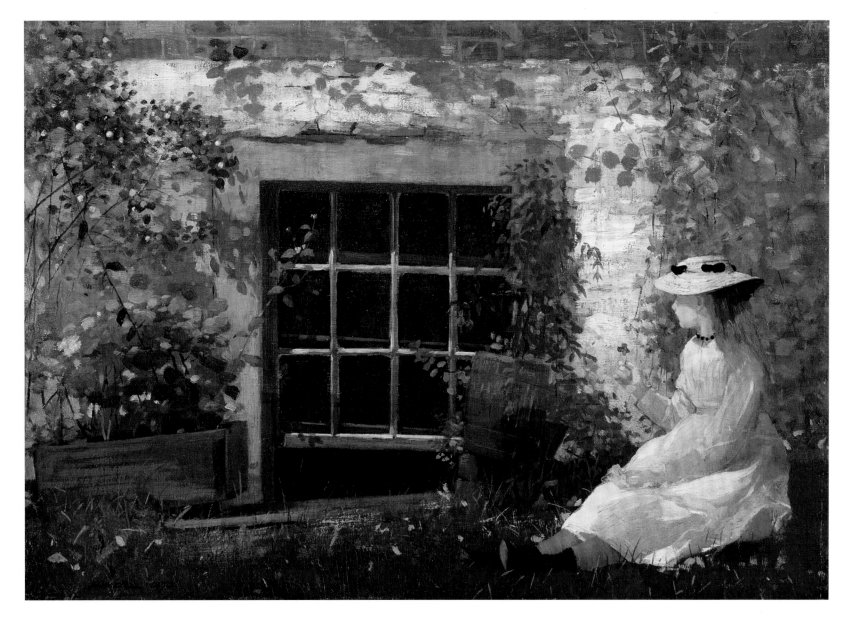

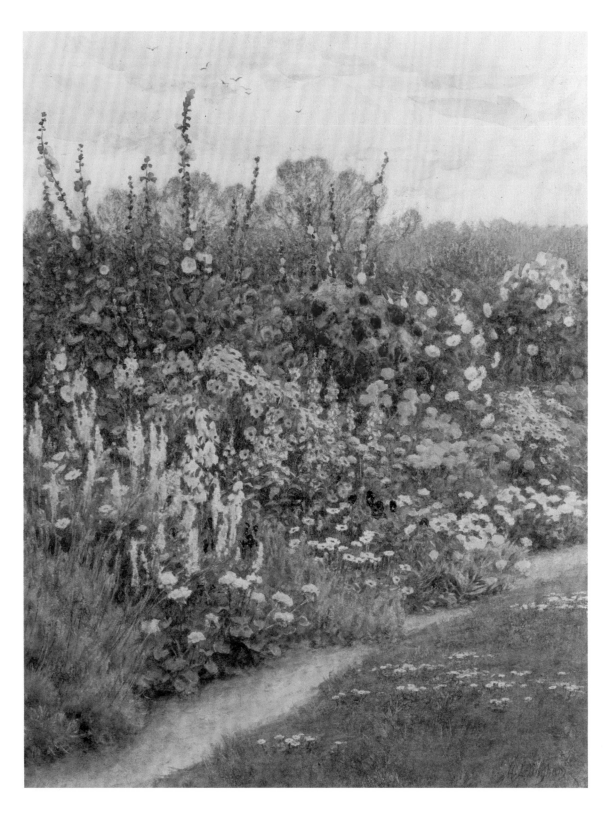

Helen Allingham
(1848–1926)
A Herbaceous Border in Miss Jekyll's Garden, Munstead Wood, Godalming

n.d.
Watercolour and gouache on paper
30.8 × 23.8 cm (12⅛ × 9⅜ in.)
Private collection

With its massed plantings – an unaffected configuration of colour and height – the herbaceous border has been a favourite feature of English gardens since the late Victorian era. Its mix of hardy flowers, shrubs and grasses seems traditional, but its best-known form developed out of garden-design theories devised in the nineteenth century. Writing in 1824, the botanist John Claudius Loudon advocated mingled but balanced plantings to avoid 'a wild, confused, crowded or natural-like appearance'.[8] Regularity reigned until the 1870s, when William Robinson promoted the revival of old-fashioned flowers; not long after that, the innovative informality of Gertrude Jekyll's designs transformed the aesthetic of the herbaceous border.

Inspired by the natural vitality of cottage gardens, Jekyll combined densely planted flowers and foliage in seemingly random arrangements. But she achieved this artless appearance through artful planning, positioning her plants to create drifts of colour, like paint strokes on a canvas. Her plantings produced natural progressions of colour: from cool blues and grey greens at either end, pure tones built up to such intense hues as red and yellow in the centre. Jekyll favoured English plants – lupins, hollyhocks and double daisies – but included such exotics as dahlias to achieve desired effects, explaining that 'All flowers are welcome … where a brave show is wanted.'[9]

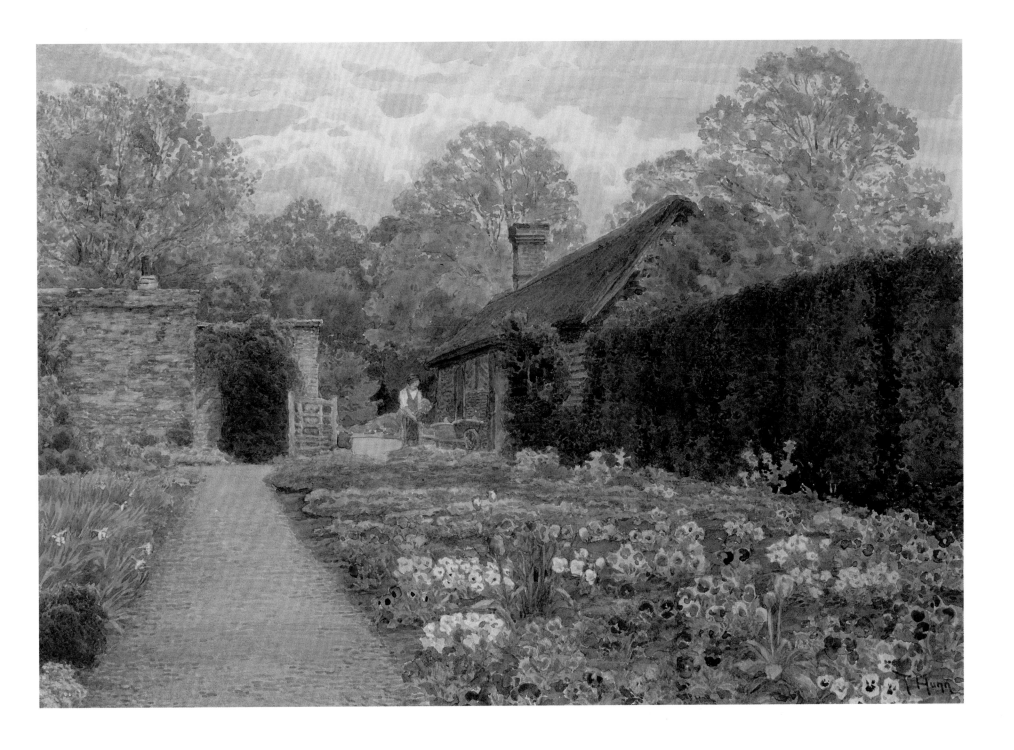

Thomas H. Hunn
(1857–1928)
The Pansy Garden, Munstead Wood, Surrey, Home of Gertrude Jekyll
n.d.
Watercolour
25 × 35 cm (9⅞ × 13¾ in.)
Private collection

Shortly after designing a garden for her mother's house near Godalming in Surrey, Gertrude Jekyll began the decades-long development of Munstead Wood, her own home, on the triangular plot of land just across the road. Even before the completion of the house – designed by her friend and collaborator Edwin Lutyens – in 1897, she had started to lay out her gardens. To preserve the character of the region, she cultivated and augmented the natural woodland on the property; in the area immediately surrounding the house, however, Jekyll experimented with formal designs and speciality gardens.

Thomas H. Hunn's watercolour illustrates how Jekyll liked to mingle varieties of a single type of flower in the same plot. This colourful array consists mostly of pansies. In the early decades of the nineteenth century, horticulturalists began to cross-breed varieties of viola. *Viola × wittrockiana* cultivars, or common pansies – distinguished by rounded, overlapping petals and a so-called 'face' – were first bred by the gardener William Thompson in 1813. By the final years of the nineteenth century, pansies were available in a wide range of colours, but the most popular variety featured the now-familiar blocks of purple and yellow, a legacy of its origins in the wild *Viola tricolor*. Jekyll has grouped different types of pansy in loosely formed patches of colour, so that one hue seems to drift into another. A closer look at the painting reveals that a few tulip bulbs have found their way into the mix.

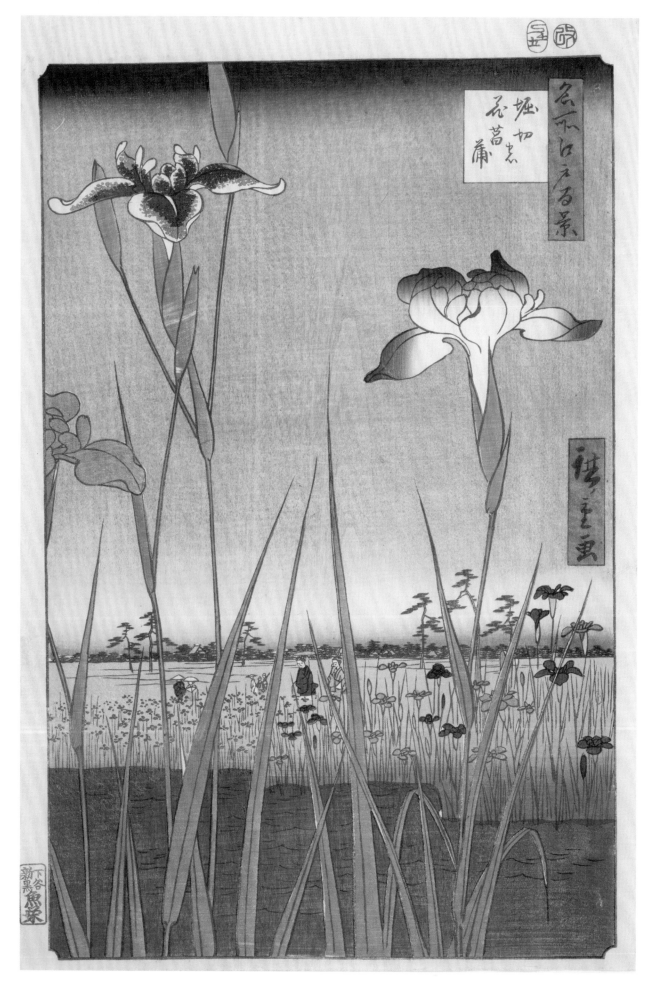

Utagawa Hiroshige
(1797–1858)
Horikiri Iris Garden, from *One Hundred Famous Views of Edo*

1856–58
Colour woodblock print
36.1 × 23.6 cm (14¼ × 9¼ in.)
The Fitzwilliam Museum, Cambridge

Throughout the Edo period (1603–1868), the farming village of Horikiri supplied flowers to Edo (present-day Tokyo), the capital of the Tokugawa Shogunate. Irises were first cultivated in Horikiri in the 1660s, and by the nineteenth century the village's lovely iris garden was attracting throngs of visitors each spring. Known as *hanashōbu*, the irises grown in Horikiri were well suited to the swampy soil of the region. The name means flowering *shōbu*, referring to an unrelated plant with similar sword-like leaves, the sweet flag, which was used to disperse noxious spirits during the annual Boys' Festival each May.[10]

Although other flowers grown in Horikiri attracted large seasonal crowds, Utagawa Hiroshige featured the iris in bloom to represent the village's flower farms in his collection of 'must-see' views around Edo. His exacting observation of the three tall stalks in the foreground conveys the subtle variations of colour and petal shape prized by the flower's admirers. Beyond a fast-flowing body of water, tourists walk among the reeds and blossoms; Hiroshige claimed that it was hard to distinguish between the flowers and the many beautiful women who came to the garden.[11] Horticulturalist Philipp Franz von Siebold introduced the *hanashōbu* into Europe in 1852, and the importation of Hiroshige's album of famous views advanced its popularity in both Europe and the United States.

Kokei Kobayashi
(1883–1957)
Poppies

1921
Pigment and ink on silk
Dimensions unknown
Tokyo National Museum

Kokei Kobayashi studied the traditional arts of Japan from an early age. He was among a new generation of painters intent on preserving and revitalizing established aesthetics and practices to counter the rising influence of the Western style, or *Yōga*. Following the example of illustrious masters of the past, *Nihonga* (Japanese-style) painters rejected the rising popularity of oil on stretched canvas in favour of such venerable mediums as mineral pigments and ink on silk, and such time-honoured formats as screens and hanging scrolls. Kobayashi's deep admiration for the work of the Rimpa school, a circle of seventeenth- and early eighteenth-century artists in Kyoto who produced exquisitely expressive and richly decorative works featuring natural forms, can be seen in this depiction of poppies on a hanging scroll.

Although it is believed that the first poppies to be seen in Japan were imported from China during the Muromachi Era (1333–1573), the creation of the poppy motif is attributed to the Rimpa artists of the early seventeenth century.[12] Two different forms of cultivated blossom appeared in Japanese art: first, the *hinageshi*, with its delicate petals; and secondly, the *keshi*, with its peony-like bloom. Here, Kobayashi portrays *keshi* in red and white, a colour combination that had long been regarded as auspicious.

Charles Courtney Curran
(1861–1942)
Chrysanthemums

1890
Oil on canvas
22.9 × 30.5 cm (9 × 12 in.)
Private collection

Here, Charles Courtney Curran depicts a mother and child looking at pots of blooming chrysanthemums in a greenhouse. Peering intently at the full-blown blossoms, the mother appears to be instructing her daughter in how to choose a healthy plant. Curran had spent the previous year in Paris, studying at the Académie Julian, and absorbing a new, naturalistic approach to depicting the subjects of modern life. He then achieved fame with his attractive images of the 'new woman', an up-to-date figure fully engaged in contemporary activities. In this work, the hats and warm coats worn by the mother and daughter indicate that they are at a public display – a flower show, perhaps, or a commercial greenhouse – rather than in the conservatory of a private house.

The theme of modernity extends to the chrysanthemums; the bright colours mark them as new hybrids. The hardy flowering perennial was first cultivated in ancient China, and the first part of the Greek origin of its name, chosen by the botanist Carolus Linnaeus in the eighteenth century, cites its yellow or yellow-white colour: *chrysous*, meaning 'golden'. By the late nineteenth century hybridization had produced an array of hues, ranging from violet red to pale pink, as well as new forms, such as the giants and the double-blossom pompons seen here.

Gustave Caillebotte
(1848–1894)
Sunflowers in the Garden at Petit-Gennevilliers

1885
Oil on canvas
131 × 105 cm (51½ × 41⅜ in.)
Private collection

The sunflower entered European gardens as an import from the New World in the early sixteenth century, together with such other exotic plants from the Americas as peppers, tomatoes and maize. Within decades of the first recorded cultivation in Madrid's Royal Botanical Garden in 1510, the sunflower was commanding a special place in ornamental gardens throughout Europe. But the hardiness that matched its lofty height and vivid colour made the sunflower easy to grow, and by the nineteenth century an anonymous garden writer in *Ladies' Horticulture* was able to observe, rather tartly, that despite its magnificence, the sunflower was regarded as common and 'often excluded from the parterre'.[13]

By the second half of the nineteenth century, however, the sunflower had found new favour among the gardeners in the Impressionist circle; Edouard Manet, Claude Monet and Gustave Caillebotte all cultivated *Helianthus annuus* in their gardens. Caillebotte planted his sunflowers in a dense grouping in the garden of his house and studio at Petit-Gennevilliers, painting them at the peak of their late summer glory. The radiant hue of the bright, ragged blooms – nodding on towering stalks fringed with deep-green foliage – conveys the sensation of heat on a sultry summer's afternoon under a cloudless sky.

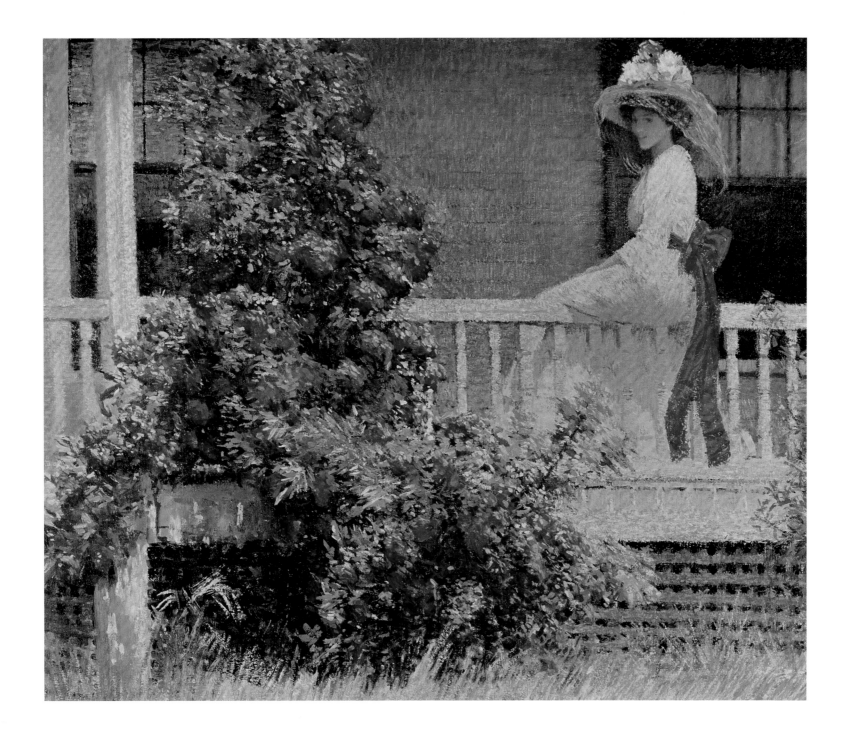

Philip Leslie Hale
(1865–1931)
The Crimson Rambler

c. 1908
Oil on canvas
64.1 × 76.7 cm (25¼ × 30¼ in.)
Pennsylvania Academy of the Fine Arts, Philadelphia

In an inventive twist on the traditional analogy between female beauty and blooming roses, Philip Leslie Hale pairs a young woman in a white summer dress with an abundant Crimson Rambler. Although her hat is crowned with full-blown white and red blossoms, it is the scarlet sash, encircling her waist and trailing over the side of the porch railing, that echoes the bush in full flower. The hardy climber, distinguished by its clusters of pure-red flowers, enjoyed wide popularity in the United States in the first decade of the twentieth century, but it came from Asia, by way of England.

In China, this multiflora hybrid was known as *Shi Tz-mei,* or 'Ten Sisters', for its clustered blooms. At some unspecified time it was exported to Japan. In 1878, twenty years after Japan had begun trading with the West, a Scottish professor of engineering at the University of Tokyo sent a sample to Thomas Jenner in England, who marketed it as 'the Engineer' with little success. In 1892 Arthur Turner rebranded it 'Turner's Crimson Rambler'.[14] Three years later it was exported to the United States, but, owing to its small blossoms and lack of scent, its popularity there was short-lived.

Frederick Frieseke
(1874–1939)
Hollyhocks

n.d.
Oil on canvas
64.7 × 81.2 cm (25½ × 32 in.)
National Academy Museum, New York

The pollen found in soil samples taken during the excavation of Neanderthal burial sites at Shanidar Cave in the Zagros Mountains of northern Iraq revealed that one individual was buried with twenty-eight varieties of flowering plants, including hollyhocks.[15] Part of the mallow family, the hollyhock was introduced into Europe from the Middle East in the late Middle Ages, when the belief that returning crusaders had brought the plant back with them gave rise to its common name, a combination of 'holly' (holy) and 'hoc' (mallow). By the middle of the nineteenth century, hollyhocks ranked among the most popular garden plants, valued for their height, hardiness and colour. Thomas James claimed that, when painting gardens, artists always included hollyhocks – whether or not they could actually be seen – because nothing was more picturesque than a 'long avenue of these floral giants'.[16]

Frederick Frieseke painted these hollyhocks in the garden of Le Hameau, a house in Giverny. The house was leased by the American artist Mary C. Wheeler, and it is believed that Frieseke and his wife, Sarah, lived there at some point during their regular summer visits to Giverny between 1906 and 1919. Wherever they stayed, Frieseke took his inspiration from the colour combinations in his host's garden. The towering flower stalks seen here were not an artistic flourish; the vibrant line of colour paired nicely with the bright-green shutters of the house.

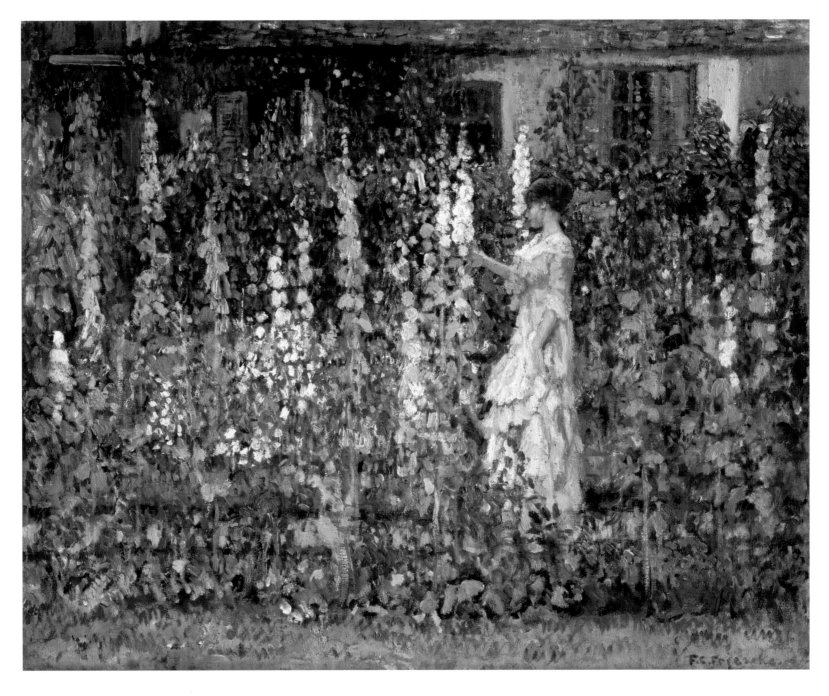

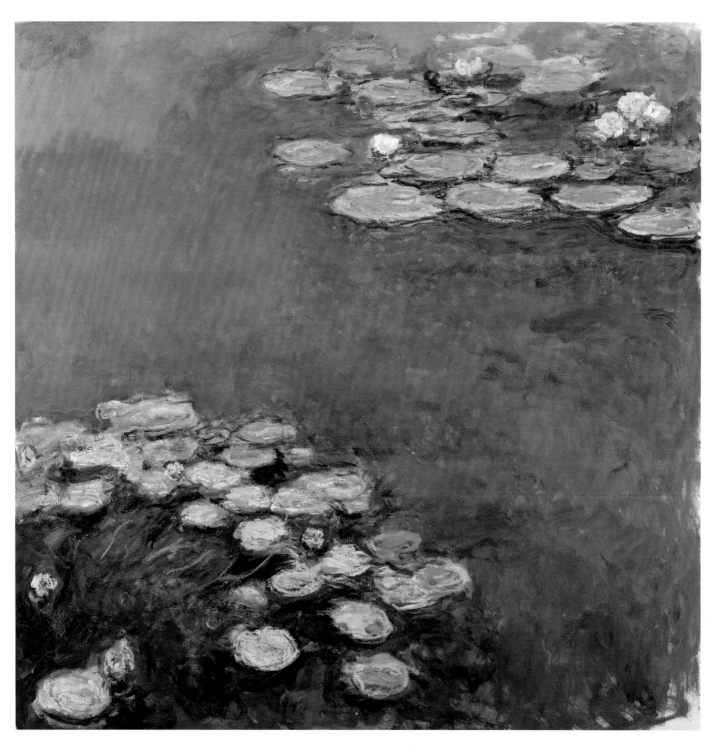

Claude Monet
(1840–1926)
Waterlilies, Harmony in Blue

1914–17
Oil on canvas
200 × 200 cm (78 ¼ × 78 ¼ in.)
Musée Marmottan Monet, Paris

Although art critics waxed poetic about the
exquisite rarity of the *Nymphaea* in Monet's
water garden, he generally chose well-known
hybrids, selected for hardiness as well as
colour. He often quipped that he ordered
them with little forethought from a catalogue.
There may be a grain of truth in this
assertion. In 1893, the year in which he
began constructing the water garden, he also
subscribed to *Revue Horticole*, which featured
articles by Joseph Bory Latour-Marliac,
founder of the Latour-Marliac nursery, who
had successfully created aquatic hybrids that
resembled tropical species but thrived in a
northern climate.[17] Monet rarely kept
detailed records of the plants he purchased,
but his name does appear in a Latour-
Marliac customer inventory from 1904.[18]

The water garden required constant
attention, and Monet's head gardener,
Félix Breuil, oversaw the daily regimen of
deadheading the plants, rinsing their leaves
and skimming off the algae. In the morning,
if Monet planned to paint that day, one of
the gardeners would gently group the water
lilies into clusters, their flowers still closed;
by midday, with the pads now moving
on the water in random formations, the
flowers would be open. As seen here, Monet
concentrated on the ephemeral effects of
light and colour – pink and yellow blossoms,
blue water, green reflections – rather than
individual plants.

Claude Monet
(1840–1926)
Wisteria

c. 1919–20
Oil on canvas
149.8 × 200.5 cm (59 × 78⅞ in.)
Allen Memorial Art Museum, Oberlin College, Ohio

Wisteria combines exquisite beauty with tenacious strength. Its racemes of fragrant blossoms dangle like pendants from a woody vine, which will twine around any support and climb to great heights. In 1901 Monet added a trellis superstructure for climbing plants to the simple arched bridge that spanned his water garden at Giverny; a decade later he trained Asian wisteria to cover the trellis, creating a magnificent floral canopy of mauve topped with white.

At the end of the First World War, French prime minister Georges Clemenceau came to Giverny to see the colossal paintings of water lilies that Monet had promised to donate to the nation as an armistice gift (pages 82–83). When Monet encircled Clemenceau with the paintings to demonstrate his planned installation, the premier pointed out a flaw in the design: an entrance door would break the effect of a panorama of floating flowers. As a solution to the problem, Monet painted frieze-like canvases of wisteria that could be installed over the doorway to unify the murals. In October 1920 he began to consult with the architect Louis Bonnier about housing the *Grandes Décorations* in a custom-built pavilion on the grounds of the Hôtel Biron in Paris. In a cost-cutting measure, however, Paul Léon, the Minister of Fine Arts, suggested using a pre-existing building, and in April 1921 Monet agreed to the Musée de l'Orangerie, with its curved walls, as an acceptable alternative. By then, he had already painted nine views of heavily laden wisteria branches set against a bright-blue sky.

Gustav Klimt

(1862–1918)

Orchard with Roses

1911–12
Oil on canvas
110 × 110 cm (43¼ × 43¼ in.)
Private collection

From the late 1890s, Gustav Klimt and
his partner, Emilie Flöge, enjoyed a yearly
Sommerfrische (an extended summer holiday)
at the Attersee in Austria, first in a chateau
on the shores of the lake (with Emilie's
family), and then, from 1900 to 1907, in the
guest wing of a brewery near Litzlberg. He
regarded these holidays as an opportunity to
restore his creative energy, and although he
indulged in such leisure activities as reading,
swimming and boating, he kept to a rigorous
painting schedule, rising before breakfast to
work outdoors. He painted landscapes for his
own pleasure, employing a variety of devices,
including binoculars and opera glasses, to
experiment with perspective. When the
weather was inclement, Klimt stayed indoors,
but set his easel near a window so that he
could continue to paint.

Between 1908 and 1912 Klimt and Flöge
spent their summers at the Villa Oleander
in Kammer, a resort at the northern end
of the Attersee. The exact location of this
rose garden is unknown, but in Klimt's
mature style, the visual experience of a view
transcends its location. Drawing on influences
as diverse as Byzantine mosaics, Egyptian and
Minoan frescoes, and Japanese Rimpa-school
painting (page 217), Klimt treated each
brushstroke like a tessera in a decorative
mosaic to convey the sheer sensuous beauty
of a rose garden at the height of summer.

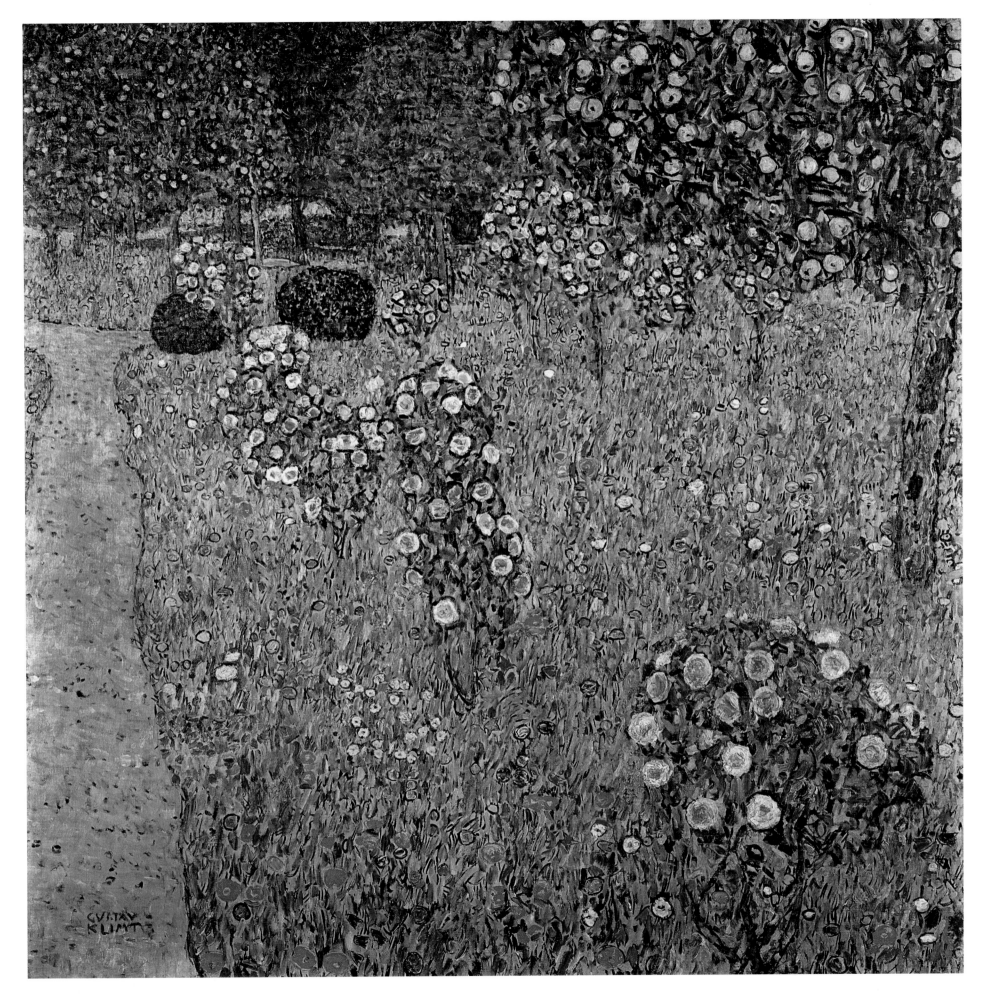

NOTES

INTRODUCTION

1 Emil Nolde, quoted in *Emil Nolde*, exhib. cat. by Peter Selz, New York, San Francisco and Pasedena, 1963, p. 49.

2 This book does not attempt to provide a history of gardening. For books on garden history, please see the 'History and Theory' section of the select bibliography (page 233).

3 Ji Cheng, *Yuan Ye: The Craft of Gardens* (1634), quoted in Joseph Cho Wang, *The Chinese Garden*, Oxford (Oxford University Press) 1998, p. 17. Although Laozi is often identified as a contemporary of Confucius (551–479 BC), his life dates are unknown, and some scholars question whether he even existed. Similarly, no firm date can be assigned to the *Dao De Jing*. For a discussion of the principles of Taoism, see Kristofer Schipper, 'Taoism: The Story of the Way', in *Taoism and the Arts of China*, exhib. cat., ed. Stephen Little, Art Institute of Chicago, November 2000 – January 2001; Asian Art Museum of San Francisco, February–May 2001, pp. 33–55.

4 See 'Paradeisos', in Patrick Taylor, ed., *The Oxford Companion to the Garden*, Oxford (Oxford University Press) 2006, p. 362. See also Tom Turner, *Garden History: Philosophy and Design, 2000 BC – 2000 AD*, London and New York (Spon Press) 2005, p. 82.

5 All references to the Bible are to the following edition: *The New Oxford Annotated Bible*, ed. Herbert G. May and Bruce M. Metzger, New York (Oxford University Press) 1973.

6 Ælfric of Eynsham, quoted in Bridget Ann Henisch, *The Medieval Calendar Year*, University Park, Pa. (Pennsylvania State University Press) 2002, p. 52.

7 Daini no Sanemasa (*c*. 1018–1093), tr. Fumiko E. Cranston, quoted in *Beyond Golden Clouds: Japanese Screens from the Art Institute of Chicago and the Saint Louis Art Museum*, exhib. cat., ed. Janice Katz, Art Institute of Chicago, June–September 2009; Saint Louis Art Museum, October 2009 – January 2010, p. 49.

8 See Henry D. Smith II and Amy G. Poster, *Hiroshige: One Hundred Famous Views of Edo*, New York (George Braziller) 1986, pl. 35.

9 Jean de La Fontaine, *Les Amours de Psyché et de Cupidon* (1669), quoted in Stéphane Pincas, *Versailles: The History of the Gardens and Their Sculpture*, London (Thames & Hudson) 1996, p. 32.

10 Between 1848 and 1870 the quantity of land designated for public use expanded from 19 to 1820 hectares (47 to 4500 acres). See Robert L. Herbert, *Impressionism: Art, Leisure, and Parisian Society*, New Haven, Conn., and London (Yale University Press) 1988, pp. 141–42.

11 Thomas Meehan, in *The Gardener's Monthly* (June 1878), quoted in Beverly Seaton, *The Language of Flowers: A History*, Charlottesville, Va., and London (University Press of Virginia) 1995, p. 5.

12 Gertrude Jekyll, *Colour in the Flower Garden*, London (Country Life) 1908, pp. 51–52.

THROUGH THE SEASONS

1 Henry David Thoreau, journal entry, 26 October 1857, in H.G.O. Blake, ed., *Autumn: From the Journal of Henry David Thoreau*, Boston (Houghton Mifflin) 1892, p. 157.

2 *Ibid.*, p. 158.

3 Ovid, *Metamorphoses*, tr. A.D. Melville, Oxford (Oxford University Press) 1986, p. 345.

4 Hattori Ransetsu, quoted in Rachel E. Carr, *Japanese Floral Art: Symbolism, Cult, and Practice*, Princeton, NJ (D. Van Nostrand) 1961, p. 137. For New Year's symbolism, see *ibid.*, p. 71.

5 Quoted in Henry D. Smith II and Amy G. Poster, *Hiroshige: One Hundred Famous Views of Edo*, New York (George Braziller) 1986, pl. 30.

6 Vincent van Gogh, letter to Émile Bernard, June 1888, in *The Complete Letters of Vincent van Gogh*, 3 vols, New York (New York Graphic Society) 1958, vol. 3, p. 491.

7 This description is based on a fourteenth-century poem: 'A promise was made / When the first fall colors came / To the maple leaves: / When they scatter, the showers / Of early winter will begin.' Attributed to the Tonsured Prince of the Second Rank Shōson (1303–1370), tr. Fumiko E. Cranston, quoted in *Beyond Golden Clouds: Japanese Screens from the Art Institute of Chicago and the Saint Louis Art Museum*, exhib. cat., ed. Janice Katz, Art Institute of Chicago, June–September 2009; Saint Louis Art Museum, October 2009 – January 2010, p. 52.

8 See Smith and Poster, *Hiroshige*, pl. 88, 94.

9 Quoted in Katz, *Beyond Golden Clouds*, p. 55.

10 Samuel Palmer, letter to John Linnell, 21 December 1828, quoted in A.H. Palmer, *The Life and Letters of Samuel Palmer, Painter and Etcher*, London (Eric and Joan Stevens) 1972, p. 176.

11 Alfred Herbert Palmer, in *ibid.*, pp. 46–47.

12 John Evelyn, *Kalendarium Hortense* (1664), quoted in May Woods and Arete Swartz Warren, *Glass Houses: A History of Greenhouses, Orangeries and Conservatories*, New York (Rizzoli) 1988, p. 31.

THE GARDEN AS METAPHOR

1 Tom Turner, *Garden History: Philosophy and Design, 2000 BC – 2000 AD*, London and New York (Spon Press) 2005, p. 82.

2 St Barbara, patron saint of soldiers, is usually identified by a tower or a chalice. One legend, however, provides an account of how her bones were used to return water to dried-up rivers and wells. The parched, bare ground that surrounds the well in this painting is as deliberately observed as every other natural feature in the garden, suggesting an iconographic meaning, and therefore that the woman sitting by the well might be St Barbara. For a version of this legend, see 'Master of the Paradise Garden', *History of Art*, all-art.org/gothic_era/08.html (accessed March 2011). The life-giving properties of the water associated with her miraculous bones further argue for allying the saint with the well of living water.

3 Philipp Otto Runge, letter to Ludwig Tieck, 1802, in Charles Harrison *et al.*, eds, *Art in Theory, 1648–1815: An Anthology of Changing Ideas*, Oxford (Blackwell) 2000, p. 987.

4 Edward Burne-Jones, quoted in Georgiana Burne-Jones, *Memorials of Edward Burne-Jones*, 2 vols, London (Macmillan) 1904, vol. 2, p. 145.

5 William Morris, 'For the Briar Rose', in *Poems by the Way*, London (Longmans, Green and Co.) 1910, p. 150. Morris wrote the poem in 1890, in response to Burne-Jones's paintings.

6 Edward Burne-Jones, quoted in Burne-Jones, *Memorials*, vol. 2, p. 195. The other paintings in the series are *The Briar Wood* (see page 56), *The Council Chamber* and *The Garden Court*. For a complete account of Burne-Jones's decades-long engagement with this tale, see Debra N. Mancoff, 'A Chamber of Dreams: Burne-Jones and the Saloon in Buscot Park', *Style 1900*, 13, Spring/Summer 2000, pp. 72–78.

7 See Ellen Johnston Laing, 'Chinese Palace-Style Poetry and the Depiction of a Palace Beauty', *The Art Bulletin*, 72, June 1990, pp. 284–95.

8 During the Tang Dynasty, especially pious women began to use their own hair to embellish devotional images of the Buddha.

9 Elisa Valtonen, 'The History, Art and Architecture of Tampere Cathedral', Department of Translation Studies, University of Tampere, Finland, uta.fi/FAST/FIN/REL/ev-cathe.html (accessed March 2011).

10 John McCrae, *In Flanders Fields and Other Poems*, New York and London (G.P. Putnam's Sons) 1919, p. 3.

11 Alfred Tennyson, *Maud: A Monodrama* (1855), Part 1, Stanza XXII, line 882, in *The Poetical Works of Tennyson*, ed. G. Robert Stange, Boston (Houghton Mifflin) 1974, p. 211.

12 Felix Klee, quoted in *In Paul Klee's Enchanted Garden*, exhib. cat. by Michael Baumgartner *et al.*, Bern, Oslo and Bergen, 2008, p. 16.

13 Hermann Bahr, 'Address on Klimt' (1901), quoted in *Gustav Klimt: In Search of the 'Total Artwork'*, exhib. cat., ed. Jane Kallir, Seoul, Hangaram Art Musuem, February–May 2009, p. 36.

FAMOUS GARDENS

1 Louis XIV, *Manière de montrer les jardins de Versailles*, quoted in Michel Baridon, *A History of the Gardens of Versailles*, tr. Adrienne Mason, Philadelphia (University of Pennsylvania Press) 2008, p. 2. The French king wrote six versions of this tour between 1689 and 1704.

2 Most notable is the resemblance of the main vista to Claude Lorrain's *Landscape with Aeneas at Delos* (1672), which is currently in the collection of the National Gallery in London.

3 The height is generally cited as approximately 23 metres (75 feet). See David Joyce, ed., *Garden Styles: An Illustrated History of Design and Tradition*, London (Pyramid) 1989, p. 11. For other controversies, see Stephanie Dalley, 'Ancient Mesopotamian Gardens and the Identification of the Hanging Gardens of Babylon Resolved', *Garden History*, 21, Summer 1993, pp. 1–13. Some scholars claim that the gardens were sunk into the ground, or that ancient sources are actually referring to gardens in Nineveh built by the Assyrian king Sennacherib (died 681 BC).

4 The others were the Great Pyramid of Giza; the statue of Zeus at Olympia; the Temple of Artemus at Ephesus; the Mausoleum of Maussollos at Halicarnassus; the Colossus of Rhodes; and the Lighthouse of Alexandria. Of the seven, only the pyramid has survived into the modern era.

5 The lake was created after the establishment of the garden by redirecting the waters of the nearby Yuquan Springs to collect at the foot of the hill. Qianlong also demolished a Ming-era temple on the crest of the hill, which he renamed Wanshou (Longevity Hill) to honour his mother. See Cheng Liyao, *Imperial Gardens: Ancient Chinese Architecture*, tr. Zhang Long, Vienna and New York (Springer) 1998, pp. 140–41.

6 Empress Cixi also undertook extensive renovations after the Anglo-French invasion, at which time she chose the new name.

7 Babur, quoted in Christopher Thacker, *The History of Gardens*, Berkeley, Calif. (University of California Press) 1992, p. 31.

8 Babur, quoted in Penelope Hobhouse, *Gardening Through the Ages: An Illustrated History of Plants and Their Influence on Garden Styles – From Ancient Egypt to the Present Day*, New York (Simon & Schuster) 1992, p. 64.

9 François Bernier, quoted in Thacker, *The History of Gardens*, p. 32.

10 See Wayne E. Begley, 'The Myth of the Taj Mahal and a New Theory of Its Symbolic Meaning', *The Art Bulletin*, 61, March 1979, pp. 7–34. Based on inscriptions on the mausoleum, as well as the political history of Shah Jahan's reign, Begley proposes that the complex was a monument to power and piety, and speculates that the emperor intended it to be his own tomb.

11 Samuel Palmer, letter to John Linnell, 13 November 1838, quoted in Colin Harrison, *Samuel Palmer*, Oxford (Ashmolean Museum) 2004, p. 54.

12 Hannah Palmer, quoted in *ibid.*, p. 54.

13 The gardens continued to deteriorate until 1851, when Gustav von Hohenlohe undertook the first of a series of restoration projects that have returned the gardens and the waterworks to their original magnificence.

14 Samuel Palmer, letter to Miss Wilkinson, May 1858, quoted in A.H. Palmer, *The Life and Letters of Samuel Palmer, Painter and Etcher*, London (Eric and Joan Stevens) 1972, p. 218.

15 Lewis Carroll (Charles Lutwidge Dodgson), *Alice's Adventures in Wonderland* (1865), in *Alice's Adventures in Wonderland & Through the Looking-Glass*, New York (Bantam) 1981, pp. 58–61.

16 Claude Monet, quoted by Roger Marx in a review for *Gazette des Beaux-Arts*, June 1909. See Charles F. Stuckey, ed., *Monet: A Retrospective*, New York (Park Lane) 1986, p. 267.

17 Maurice Guillemot, in *La Revue Illustrée*, 15 March 1898, quoted in Stuckey, *Monet*, p. 200.

PLEASURE GARDENS

1 Albertus Magnus, quoted in John Harvey, *Mediaeval Gardens*, London (Batsford) 1981, p. 6.

2 See Marilyn Stokstad *et al.*, *Art History*, 2 vols, New York (Harry N. Abrams) 1995, vol. 2, pp. 725–26, and Charles D. Cuttler, *Northern Painting from Pucelle to Bruegel: Fourteenth, Fifteenth, and Sixteenth Centuries*, New York (Holt, Rinehart and Winston) 1968, p. 209.

3 Such outer gardens were often cultivated for profitable production. See Penelope Hobhouse, *Gardening Through the Ages: An Illustrated History of Plants and Their Influence on Garden Styles – From Ancient Egypt to the Present Day*, New York (Simon & Schuster) 1992, p. 91.

4 For the practice of individual viewing and shared listening, see Robert Irwin, *Islamic Art in Context*, New York (Harry N. Abrams) 1997, p. 167.

5 Kahren Hellerstedt defines *buitenpartijen* as an outdoor party consisting of 'elegant members of the upper class dallying on garden terraces, in formal gardens, or in secluded groves while teasing, taunting, and tempting one another'.

See *Gardens of Earthly Delight: Sixteenth and Seventeenth-Century Netherlandish Gardens*, exhib. cat. by Kahren Hellerstedt, Pittsburgh, Frick Art & Historical Center, April–May 1986, p. 44.

6 Charles Collé, quoted in Donald Posner, 'The Swinging Women of Watteau and Fragonard', *Art Bulletin*, 64, March 1982, pp. 82–83.

7 See Leonard Roberts, *Arthur Hughes: His Life and Works*, Woodbridge (Antique Collectors' Club) 1997, p. 126.

8 The section written by Guillaume de Lorris is a fragment of 4058 lines. The poem was subsequently completed by Jean de Meun in the early fourteenth century. Meun subverts the theme of the poem and turns it into a critique of courtly society.

9 Chaucer's translation, *The Romaunt of the Rose*, dates from the early phase of his career (*c.* 1360–72), when he was most receptive to French influences. It is based on all of Lorris's section of the poem and a brief portion of Meun's addition, although scholars disagree over how much of the extant work can be attributed to Chaucer.

WORKING GARDENS

1 Thomas Jefferson, letter to Charles Willson Peale, 20 August 1811, in Edwin Morris Betts, ed., *Thomas Jefferson's Garden Book*, Chapel Hill, NC (University of North Carolina Press) 2002, p. 461. An American painter and naturalist, Peale founded the Philadelphia Museum in 1786, and co-founded the Pennsylvania Academy of the Fine Arts in 1805. In 1810 he retired to his farm in Bellfield, Pennsylvania, where he continued to paint as well as garden.

2 *Ibid.*

3 Wendell Berry, *The Unsettling of America: Culture and Agriculture*, San Francisco (Sierra Club Books) 1997, p. 139.

4 Hany Farid and Samir Farid, 'Unfolding Sennedjem's Tomb', *KMT: A Journal of Ancient Egypt*, Spring 2001, p. 1.

5 Julian of Norwich, quoted in Bridget Ann Henisch, *The Medieval Calendar Year*, University Park, Pa. (Pennsylvania State University Press) 2002, p. 53.

6 See also Add. 19766 folios 52b, 64b, 66b, 75a, 77a and 79b. British Library Online Catalogue, India Office Select Materials, bl.uk/catalogues/indiaofficeselect/welcome.asp (accessed March 2011).

7 Andrews's gun licence notes that he is a freeholder with an annual income of at least £100. Michael Rosenthal, *The Art of Thomas

Gainsborough: 'A Little Business for the Eye', New Haven, Conn., and London (Yale University Press) 1999, p. 17.

8 Humphry Repton, quoted in J.C. Loudon, ed., *The Landscape Gardening and Landscape Architecture of the Late Humphry Repton, Esq.*, London (Longman & Co.) 1840, p. 366.

9 This coloured engraving is based on the original black-and-white illustration in Humphry Repton, *Fragments on the Theory and Practice of Landscape Gardening*, London (T. Bensley and Son) 1816, fig. 228. The caption identifies the work as 'View of the proposed forcing-garden at Woburn Abbey during winter'.

10 Humphry Repton, quoted in Loudon, *Landscape Gardening*, p. 367.

11 John Evelyn, *Acetaria* [1699], Charleston, SC (BiblioBazaar) 2008, p. 19.

12 William Robinson, *The English Flower Garden*, London (John Murray) 1889, p. 8.

13 Mary Beauchamp Russell, *The April Baby's Book of Tunes, With the Story of How They Came to Be Written, By the Author of 'Elizabeth and Her German Garden'*, London (Macmillan) 1900, p. 31.

BEHIND THE GARDEN WALL

1 Frances Hodgson Burnett, *The Secret Garden* [1911], Cambridge, Mass. (Candlewick Press) 2008, p. 79.

2 Quoted in Penelope Hobhouse, *Gardening Through the Ages: An Illustrated History of Plants and Their Influence on Garden Styles – From Ancient Egypt to the Present Day*, New York (Simon & Schuster) 1992, p. 77.

3 See Ellen Johnston Laing, 'Chinese Palace-Style Poetry and the Depiction of a Palace Beauty', *Art Bulletin*, 72, June 1990, p. 285.

4 Ji Cheng, *Yuan Ye: The Craft of Gardens* (1634), quoted in Joseph Cho Wang, *The Chinese Garden*, Oxford (Oxford University Press) 1998, p. 17.

5 Maggie Keswick, *The Chinese Garden*, London (Frances Lincoln) 2003, pp. 90–91. Tao Qian was also known as Tao Yuanming.

6 The Foulchiron Collection came from Paris, and was purchased by the king on the recommendation of the naturalist and explorer Alexander von Humboldt. The Palm House was completed in 1830, but burnt to the ground in 1880.

7 John Ruskin, 'Of Queen's Gardens' [1865], in *Sesame and Lilies (Lectures)*, Rockville, Md (Arc Manor) 2008, p. 79.

8 John Milton, 'A Masque Presented at Ludlow Castle, 1634 [*Comus*]', in *The Complete Poetry and Essential Prose of John Milton*, ed. William

Kerrigan *et al.*, New York (Random House) 2007, p. 97.

9 See 'Pleasure Gardens', notes 8 and 9, above.

10 John Singer Sargent, letter to Edwin Austen Abbey, August 1885, quoted in *John Singer Sargent*, exhib. cat., ed. Elaine Kilmurray and Richard Ormond, London, Washington and Boston, 1998–99, p. 114.

11 John Singer Sargent, letter to Robert Louis Stevenson, undated, quoted in *ibid.*

HOME AND GARDEN

1 Mrs Loudon (Jane Webb Loudon), *The Lady's Country Companion: or, How to Enjoy a Country Life Rationally* [1845], London (Longman, Brown, Green and Longmans) 1852, pp. 154–55.

2 Pliny the Younger, 'My Garden in Tuscany' (first century AD), quoted in Scott J. Tilden, ed., *The Glory of Gardens: 2000 Years of Writings on Garden Design*, New York (Harry N. Abrams) 2006, pp. 155–56.

3 Tom Turner, *Garden History: Philosophy and Design, 2000 BC – 2000 AD*, London and New York (Spon Press) 2005, p. 90.

4 For the history and use of screens, see *Beyond Golden Clouds: Japanese Screens from the Art Institute of Chicago and the Saint Louis Art Museum*, exhib. cat., ed. Janice Katz, Art Institute of Chicago, June–September 2009; Saint Louis Art Museum, October 2009 – January 2010, pp. 13–20.

5 *Ibid.*, p. 112. Katz attributes the popularity of the motif to a rising interest in botany among the shoguns and regional warlords. It is associated with the circle of Sōtatsu's followers.

6 Humphry Repton, *Fragments on the Theory and Practice of Landscape Gardening* (1816), quoted in Dorothy Stroud, *Humphry Repton*, London (Country Life) 1962, p. 162.

7 Humphry Repton, 'Memoirs', quoted in George Carter, 'Humphry Repton at Hare Street, Essex', *Garden History*, 12, Autumn 1984, p. 126.

8 The pear-wood printing blocks were carved at Barrett's on Bethnal Green Road, London, while the paper was printed by Jeffrey & Co. in Whitechapel, London. Both were long-established firms using traditional methods. See Lesley Hoskins, 'Wallpaper', in *William Morris*, exhib. cat., ed. Linda Parry, London, Victoria and Albert Museum, May–September 1996, pp. 198–200.

9 William Morris, 'Making the Best of It', in *William Morris on Art and Design*, ed. Christine Poulson, Sheffield (Sheffield Academic Press) 1996, pp. 95–96.

10 L.G. Seguin, *Rural England: Loitering Along the Lands, the Common-Sides and the Meadow-Paths*

with Peeps into the Halls, Farms and Gardens, London (Strahan and Co.) 1881, p. 19.

11 Louis Vauxcelles, 'Introduction', *Jardins d'hier et d'aujourd'hui* (1934), quoted in *A Day in the Country: Impressionism and the French Landscape*, exhib. cat. by Richard Brettell *et al.*, Los Angeles, Chicago and Paris, 1984–85, p. 211. Emphasis in original.

12 Émile Taboureux, 'Claude Monet', *La Vie moderne*, 12 June 1880, quoted in Charles F. Stuckey, ed., *Monet: A Retrospective*, New York (Park Lane) 1986, pp. 91, 92.

13 Arsène Alexandre, in *Le Figaro*, 9 August 1901, quoted in Stuckey, *Monet*, p. 220.

PUBLIC GARDENS

1 Andrew Jackson Downing, 'The New-York Park', *Horticultural Magazine*, August 1851, quoted in Sara Cedar Miller, *Central Park: An American Masterpiece*, New York (Harry N. Abrams) 2003, p. 18.

2 In some cases this expansion was funded by the sale of royal land to private developers. See Robert L. Herbert, *Impressionism: Art, Leisure, and Parisian Society*, New Haven, Conn., and London (Yale University Press) 1988, pp. 141–42.

3 Karl Baedeker, *Paris and Its Environs, with Routes from London to Paris: Handbook for Travellers*, Leipzig (K. Baedeker) 1891, p. 151.

4 Prior to 1785 there was no admission charge. Vauxhall Gardens closed briefly in 1839. It was resold two years later, and remained open until its final closure in 1859, after which the attractions were demolished and the land developed.

5 The original agreement was to build a collection of 2000 specimens; by 1795 it contained 3700 plants. The collection eventually went to the British Museum, and was later transferred to the Natural History Museum.

6 The current statue in the garden is a replica. The original, damaged by pollution, is held by the British Museum.

7 *Gardners' Chronicle*, 24 July 1847, quoted in Ray Desmond, *Kew: The History of the Royal Botanic Gardens*, London (Harvill Press) 1995, p. 167.

8 The Board of Commissioners of Central Park (1862), quoted in Miller, *Central Park*, p. 56.

9 The Board of Commissioners of Central Park (1863), quoted in *ibid.*, p. 113. A flock of sheep (first Southdown and then Dorset) was maintained in the Sheep Meadow from 1864 to 1934. In addition to serving as a picturesque presence, the grazing sheep helped to maintain and fertilize the grass.

10 The garden was fully opened to the public in 1848, during the brief rule of the Second Republic (1848–51). During the subsequent Second Empire, the precincts closest to the old Tuileries Palace remained restricted.

11 Auguste Renoir (1880), quoted in *Renoir's Portraits: Impressions of an Age*, exhib. cat. by Colin B. Bailey, Ottawa, Chicago and Fort Worth, 1997–98, p. 186.

12 Auguste Renoir, letter to James McNeill Whistler, April 1881, quoted in *ibid.*

13 Monet discovered that it was impossible to work on such a large canvas outdoors, and was dissatisfied with the results of working from on-site sketches in the studio. The two surviving fragments are held by the Musée d'Orsay, Paris.

14 Jerome K. Jerome, *Three Men in a Boat* [1889], Lawrence, Kan. (Digireads.com) 2005, p. 31.

15 Arsène Alexandre, quoted in *Henri Rousseau: Jungles in Paris*, exhib. cat., ed. Frances Morris and Christopher Green, London, Paris and Washington, D.C., 2005–2006, p. 30.

16 Arsène Alexandre, quoted in *ibid.*, p. 41.

17 Edith Wharton, *Italian Villas and Their Gardens*, New York (The Century Club) 1904, p. 25.

18 *Ibid.*, p. 29.

ARTISTS' GARDENS

1 Marcel Proust, in *Le Figaro*, 15 June 1907, quoted in Charles F. Stuckey, ed., *Monet: A Retrospective*, New York (Park Lane) 1986, p. 250.

2 Vanessa Bell, quoted in Quentin Bell and Virginia Nicholson, *Charleston: A Bloomsbury House and Garden*, London (Frances Lincoln) 1997, p. 129.

3 John Constable, letter to John Fisher, 1821, quoted in Charles Harrison *et al.*, eds, *Art in Theory, 1815–1900: An Anthology of Changing Ideas*, Oxford (Blackwell) 1998, pp. 118–19.

4 G.B., 'Les Environs de Paris, Bougival', *L'Illustration*, 53, 24 April 1869, p. 267.

5 Georgiana Burne-Jones, *Memorials of Edward Burne-Jones*, 2 vols, London (Macmillan) 1904, vol. 1, p. 212.

6 J.W. Mackail, *The Life of William Morris*, 2 vols, London (Longmans, Green and Company) 1899, vol. 1, p. 143.

7 A.H. Palmer, *The Life and Letters of Samuel Palmer, Painter and Etcher*, London (Eric and Joan Stevens) 1972, p. 48.

8 See *Samuel Palmer 1805–1881: Vision and Landscape*, exhib. cat. by William Vaughan *et al.*, London, The British Museum, October 2005 – January 2006; New York, The Metropolitan Museum of Art, March–May 2006, p. 139.

9 Gustave Geoffroy, 'Notre Temps, Gustave Caillebotte', *La Justice*, 13 June 1894, quoted in *Gustave Caillebotte: Urban Impressionist*, exhib. cat. by Anne Distel *et al.*, Paris, Galeries Nationales du Grand Palais, September 1994 – May 1995; Los Angeles County Museum of Art, June–September 1995, p. 270.

10 Letter 605, *The Complete Letters of Vincent van Gogh*, 3 vols, Boston (Little, Brown and Company) 2000, vol. 3, p. 208.

11 Letter 569, *ibid.*, p. 114.

12 Letter 650, *ibid.*, p. 296.

13 Claude Monet, letter to Paul Durand-Ruel, 5 June 1883, quoted in Richard Kendall, ed., *Monet by Himself: Paintings, Drawings, Pastels, Letters*, London (Macdonald Orbis) 1989, p. 107.

14 Georges Truffaut, 'The Garden of a Great Painter', *Jardinage*, November 1924, quoted in Stuckey, *Monet*, pp. 316, 317.

15 Claude Monet, quoted in Paul Hayes Tucker, *Claude Monet: Life and Art*, New Haven, Conn., and London (Yale University Press) 1995, p. 178.

16 Gertrude Jekyll, *Colour Schemes for the Flower Garden*, London (Country Life) 1908, pp. 51–52.

17 Gertrude Jekyll, *Some English Gardens*, London, New York and Bombay (Longmans, Green and Company) 1904, p. 122.

18 Vanessa Bell, letter to Roger Fry, summer 1930, quoted in Bell and Nicholson, *Charleston*, p. 134.

19 Emil Nolde, *Jahre der Kämpfe*, Berlin (Rembrandt-Verlag) 1934, p. 40; author's translation.

20 Stanley Spencer, quoted in *Stanley Spencer*, exhib. cat., ed. Timothy Hayman and Patrick Wright, London, Ontario and Ulster, 2001–2002, p. 136.

21 Stanley Spencer, in *Sermons by Artists*, London (Golden Cockerel Press) 1934, p. 50.

GARDEN FAVOURITES

1 William Morris, 'Making the Best of It', in *William Morris on Art and Design*, ed. Christine Poulson, Sheffield (Sheffield Academic Press) 1996, pp. 95–96. Morris presented the lecture to the Trades Guild of Learning and the Birmingham Society of Artists in 1880.

2 Gertrude Jekyll, *Wood and Garden, Notes and Thoughts, Practical and Critical, of a Working Amateur*, London (Longmans, Green and Company) 1899, p. 101.

3 Details of the amounts paid vary, but the real escalation occurred between 1623, when a high price of 1000 florins for a single bulb was recorded, and 1637, when the price topped out at 10,000 florins. See Anna Pavord, *The Tulip*, London (Bloomsbury) 1999, p. 133, and Patrick Taylor, ed., *The Oxford Companion to the Garden*, Oxford (Oxford University Press) 2006, p. 478. The latter states that 10,000 florins equalled the earning power of a 'skilled artisan' over the course of twenty-four years.

4 Frederic Edwin Church, letter to Martin Johnson Heade, May 1870, quoted in Theodore E. Stebbins, *The Life and Work of Martin Johnson Heade: A Critical Analysis and Catalogue Raisonné*, New Haven, Conn., and London (Yale University Press) 2000, p. 128.

5 William Robinson, *The Wild Garden: or, Our Groves and Shrubberies Made Beautiful by the Naturalization of Hardy Exotic Plants*, London (John Murray) 1870, p. 157.

6 *Ibid.*

7 Diana Wells, *100 Flowers and How They Got Their Names*, Chapel Hill, NC (Algonquin Books) 1997, pp. 121–22.

8 John Claudius Loudon, *An Encyclopedia of Gardening*, 2nd edn, London (Longman, Hurst, Rees, Orme, Brown and Green) 1824, p. 799.

9 Gertrude Jekyll, quoted in Judith B. Tankard and Martin A. Wood, *Gertrude Jekyll at Munstead Wood: Writing, Horticulture, Photography, Homebuilding*, Stroud (Sutton Publishing) 1996, p. 224.

10 See Henry D. Smith II and Amy G. Poster, *Hiroshige: One Hundred Famous Views of Edo*, New York (George Braziller) 1986, pl. 64.

11 Utagawa Hiroshige, in *Ehon Edo Miyage* (Souvenirs of Edo; 1850–67), quoted in *ibid.*

12 See Janice Katz, 'Collecting and Patronage of Art in Seventeenth-Century Japan: The Maeda Daimyo', PhD diss., Princeton University, 2004, pp. 200–202.

13 Quoted in J.J. Grandville, *The Court of Flora: Les Fleurs Animées – The Engraved Illustrations of J.J. Grandville*, intro. by Peter A. Wick, New York (George Braziller) 1981, unpaginated.

14 See Charles Quest-Ritson, *Climbing Roses of the World*, Portland, Ore. (Timber Press) 2003, p. 130.

15 See Arlette Leroi-Gourhan, 'The Flowers Found with Shanidar IV, a Neanderthal Burial in Iraq', *Science*, 190, 7 November 1975, pp. 562–64.

16 Thomas James, *The Flower Garden: With an Essay on the Poetry of Gardening*, London (John Murray) 1852, p. 57.

17 See Vivian Russell, *Monet's Water Lilies: The Inspiration of a Floating World*, London (Frances Lincoln) 1998, p. 42. For Latour-Marliac's hybrids, see *ibid.*, pp. 31–41.

18 See Vivian Russell, *Monet's Garden: Through the Seasons at Giverny*, London (Frances Lincoln) 1995, p. 135.

TIMELINE

c. 3000 BC
An Old Kingdom relief sculpture depicts waterways and a palm in an enclosure. The sculpture is believed to be the oldest known representation of Egyptian domestic garden design.

c. 2000 BC
In Egypt, a wooden model of an enclosed garden – roughly the size of a doll's house, and featuring representations of a pool and sycomore trees (*Ficus sycomorus*) – is included in the tomb of Meketre, chancellor to the pharaohs Mentuhotep II and Mentuhotep III.

c. 1400 BC
The Akkadian Epic of Gilgamesh describes the Garden of the Gods, in which bushes grow precious stones and trees bear carnelian fruit and lapis lazuli leaves.

c. 1400 BC
Wall paintings of elaborate gardens, showing pools, shade trees and geometric plantings, embellish Egyptian Eighteenth Dynasty tombs.

c. 1000 BC
In the book of Genesis, the earliest known version of the Creation story describes the Garden of Eden.

c. 800 BC
Greek poet Homer describes different types of cultivated outdoor space – courts, gardens and groves – in his epic poems the *Iliad* and the *Odyssey.*

c. 600 BC
According to legend, New Babylonian emperor Nebuchadnezzar creates the Hanging Gardens of Babylon.

After 479 BC
One of the world's oldest surviving gardens is created near the Sishui River in China's Shantung province to surround the tomb of the philosopher Confucius.

c. 372–286 BC
Greek philosopher Theophrastus – the 'Father of Botany', who tended his own garden in Athens for nearly sixty years – writes *Historia Plantarum* (Enquiry into Plants) and *De Causis Plantarum* (About the Growth of Plants).

c. 300 BC
In the Song of Solomon, a bridegroom describes the chaste beauty of his bride as an enclosed garden that contains a fountain of living water.

c. 235 BC
Hieron II, king of Syracuse, builds an elaborate garden on board his pleasure boat.

c. 40–20 BC
Garden imagery becomes a popular motif in the decoration of the dining-rooms of Roman villas.

c. 27 BC
Marcus Vitruvius Pollio describes tree-lined colonnades in his ten-volume architectural treatise, *De Architectura* (On Architecture).

c. AD 8
Ovid includes the myth of Vertumnus – god of the changing seasons, who courted and won Pomona, the goddess of orchards and gardens – in *Metamorphoses* (Book IV).

Before 79
Pliny the Elder compiles information on botany, kitchen gardens and the medicinal and cosmetic uses of flowers for his *Historia Naturalis.*

c. 100
Pliny the Younger writes extensive descriptions of the gardens of his villas in Tuscany and the Upper Tiber Valley.

353
Chinese calligrapher Wang Xizhi invites poet-scholars to attend a Spring Purification Festival at the Lanting (Orchid Pavilion) near Lanzhu Mountain.

637
Following a visit to the palace of the Sassanian kings, Western travellers in Persia describe seeing woven silk carpets depicting royal gardens.

c. 794
In Heian-period Japan, the viewing of blooming *sakura* (cherry trees) becomes an annual event for the imperial court at Kyoto.

c. 800
In the *Capitulare de Villis*, Charlemagne decrees that each of his estates should have a garden planted with a variety of herbs and fruit and nut trees.

c. 1030
The physician Ibn Butlan of Baghdad writes *Taqwim al-Sihhah* (Maintenance of Health), a treatise that stresses the benefits of eating vegetables and working in the garden.

c. 1050
The Japanese gardening manual *Sakuteiki* (Notes on Garden-Making), attributed to Tachibana no Toshitsuna, instructs gardeners to respond to the spirit of nature and emulate its forms.

c. 1240
Guillaume de Lorris writes the first part of the *Roman de la Rose*, a tale of courtly love featuring an allegorical walled garden. The poem is completed in the early fourteenth century by Jean de Meun.

c. 1260
In his treatise on the natural sciences, *De Vegetabilibus et Plantis*, Albertus Magnus gives instructions on creating grass lawns, turf benches and fragrant herb and flower beds for refreshing the senses.

1305
Written by Italian nobleman Pietro Crescenzi, the gardening treatise *Liber Ruralium Commodorum* is published in Bologna.

1339
The landscape style of Chinese Song Dynasty painting inspires Musō Soseki's design for a garden pond for the shogun Ashikaga Takauji at Tenryu-ji in Kyoto.

c. 1370
Geoffrey Chaucer translates the *Roman de la Rose* into English, creating *The Romaunt of the Rose*. How much of the extant translation can be attributed to Chaucer remains a matter of debate.

1411–16
The Limbourg brothers are commissioned to illuminate *Les Trés Riches Heures du duc de Berry*, setting the Labours of the Months on the duke's estates in France.

1452
Leon Battista Alberti completes his architectural treatise, *De Re Aedificatoria*, in which he recommends adding such Classical garden ornaments as topiary and plants in urns to the gardens of villas.

c. 1466
A temple scroll, attributed to the priest Zoen, provides the text for the Japanese garden manual *Senzui narabi ni yagyo no zu* (Illustrations for Designing Mountain, Water and Hillside Field Landscapes).

c. 1470
Leonardo da Vinci begins to make studies of plants and flowers in order to explore both their scientific properties and their artistic potential.

c. 1482
Sandro Botticelli paints *Primavera*, the celebrated allegory of spring.

c. 1500–1505
In *The Garden of Earthly Delights*, Hieronymus Bosch depicts a site of irresistible carnal indulgence flanked by the Garden of Eden and the fires of Hell.

c. 1508
The Mughal emperor Babur begins to create the Bagh-i Vafa (Garden of Fidelity) on his lands near Kabul. It is the first – and remained the favourite – of his renowned gardens.

1510
Imported from the Americas, the first sunflower in Europe is cultivated at Madrid's Royal Botanical Garden.

1529
Ownership of Hampton Court Palace passes from Cardinal Thomas Wolsey to Henry VIII, who adorns the gardens with family emblems and a Tudor green-and-white colour scheme.

1550
Cardinal Ippolito d'Este acquires a former Benedictine monastery on a hilltop in Tivoli, and begins work on a new villa and spectacular gardens. The Villa d'Este's water features inspire a new direction in Italian garden design.

1554
The earliest known tulip bulbs in Europe are brought from the court of Suleiman the Magnificent in Constantinople to the court of Ferdinand I, Holy Roman Emperor, in Vienna.

1565

Pieter Bruegel the Elder designs four images of seasonal work. Published five years later by Hieronymus Cock, they are widely replicated by other artists as examples of contemporary gardening practices.

1574

The Ottoman sultan Selim II orders the Sheriff of Aziz to send him 50,000 tulip bulbs for his gardens in Constantinople.

1585

English artist and explorer John White makes sketches of the native peoples of Roanoke Island (present-day North Carolina), including images of community gardens.

1590

The *hortus botanicus* of the University of Leiden in The Netherlands is created on the site of a former monastery kitchen garden.

1599–1602

Ferdinand I de' Medici, Grand Duke of Tuscany, commissions highly detailed bird's-eye-view paintings of famous estate gardens in the Tuscan countryside.

1626

The Jardin des Plantes is founded in Paris.

1632–62

Shah Jahan creates the gardens and mausoleum known as the Taj Mahal (Crown of the Palace) to honour the death of his wife Mumtaz Mahal, who had died in childbirth.

1634

In China, Ji Cheng's three-volume treatise on garden design, *Yuan Ye: The Craft of Gardens*, inspires a resurgence in garden construction among both scholars and the newly affluent.

1636

Chinese court official Qi Biaojia takes leave from his post to create a retirement garden at his home in Shanyin, a district in the Zhejiang province; his memoir, *Footnotes to Allegory Mountain*, records his experience.

1637

Dutch 'tulipomania' comes to an end when the tulip market collapses.

1660s

The purple-blossomed sword-leaved iris (*hanashōbu*) is first cultivated in the Japanese farming village of Horikiri.

1661

Louis XIV commissions architect Louis Le Vau and landscape designer André Le Nôtre to transform the chateau and grounds of Versailles.

1664

André Le Nôtre imposes a formal, axial design on the gardens of the Tuileries Palace in Paris.

1675–80

Maria Sibylla Merian publishes her three-volume *New Book of Flowers* in Nuremberg, Germany. To suggest a natural setting without compromising botanical accuracy, she includes insects and butterflies in her renderings.

1684

William III acquires Het Loo, a medieval castle in Apeldoorn in The Netherlands, and transforms the grounds into modern formal gardens to rival those at Versailles.

1689

The planting of the hornbeam maze at Hampton Court Palace, designed by George London and Henry Wise, is completed.

1689–1704

Louis XIV authors tours of his gardens at Versailles for his honoured guests.

1717

In Paris, the Royal Academy of Painting and Sculpture creates a new subject category, *fête galante*, to classify the garden paintings of Antoine Watteau.

1722

The Society of Apothecaries in London relocates the Chelsea Physic Garden – a medicinal garden created for the purpose of training apprentices – to its present location on the north bank of the Thames.

1728

Batty Langley's *New Principles of Gardening* promotes a new, naturalistic approach to landscape gardening over the prevailing formal style.

1732

Entrepreneur Jonathan Tyers purchases the New Spring Gardens in London, and transforms them into a modern landscaped pleasure garden popularly known as Vauxhall Gardens.

1737

Swedish botanist Carolus Linnaeus publishes his landmark taxonomy *Genera Plantarum*, establishing binomial nomenclature and the classification of plants according to sexual structure.

1741

Landowner and banker Henry Hoare II redesigns the grounds of Stourhead, his family's estate in Wiltshire, to resemble the ideal vistas pictured in landscape paintings of Italy.

1749

Entrepreneurial brothel owners in Edo initiate a cherry-blossom festival on the Nakano-chō, the main avenue in the pleasure district of Yoshiwara, to attract more customers.

1750

The Qianlong Emperor of China renovates the gardens of the Summer Palace and renames the site Qingyiyuan (Garden of Clear Ripples).

1758–62

William Chambers designs some of the best-known garden follies at Kew Gardens, including the Pagoda.

1759

François Marie Arouet, otherwise known as Voltaire, writes *Candide, ou l'Optimisme*, in which a young man wanders the globe only to discover that 'we should cultivate our gardens'.

1761

George Washington inherits the Mount Vernon estate in Virginia following the death of Anne Fairfax, his sister-in-law.

1764

Lancelot 'Capability' Brown is appointed master gardener at Hampton Court Palace. At nearby Kew Gardens, he demolishes the buildings designed for Queen Caroline by William Kent, and imposes a more neutral landscape on the grounds.

1766

The Boboli Gardens in Florence are opened to the public.

1772–81

William Mason, English poet and gardener, explains his theories on gardening in a multi-volume poem, *The English Garden*.

1778

A tomb for Jean Jacques Rousseau is built on an island in the park at Ermenonville, northern France, where he spent his last days. Sixteen years later, his remains were moved to the Panthéon in Paris.

1783

Marie Antoinette commissions French architect Richard Mique to build a faux Norman village, including a mill and a dairy, on the grounds of the Petit Trianon, her private retreat at Versailles.

1787

William Curtis founds *The Botanical Magazine* in order to promote exotic plants and educate readers about their cultivation.

1788

Humphry Repton takes up landscape gardening and develops his distinctive 'Red Books', which provide his clients with 'before and after' views of the planned work through the use of overlays.

1791

The Jardin du Luxembourg in Paris becomes state property under the revolutionary government.

1792

The animals of the royal menagerie at Versailles are moved to a new public zoological garden in the Jardin des Plantes in Paris.

1805

In Japan, a tea house opens near the Tenjin Shrine in Kameido to cater to the tourists who come to see the flowering of cherry blossom and wisteria in the spring.

1809

Thomas Jefferson leaves the White House and retires to his Virginian estate, Monticello, where he gardens all year round, keeping careful records of his plantings.

1813
Gardener William Thompson crosses various species of viola and produces *Viola × wittrockiana* cultivars, known as common pansies.

1815
John Constable depicts the kitchen and flower gardens at his father's house in East Bergholt, Suffolk.

1817–21
Pierre Joseph Redouté publishes his illustrated three-volume study *Les Roses*.

1830
Nathaniel Bagshaw Ward invents the 'Wardian case', a small terrarium designed to protect exotic specimens during travel.

1835–41
New glasshouses are built for the Jardin des Plantes in Paris.

1838
John Claudius Loudon publishes *Arboretum et Fruticetum Britannicum*, a comprehensive study of British trees and shrubs illustrated with plates drawn from living specimens.

1840–49
Having gained success as an early pioneer of science fiction, Jane Webb Loudon publishes a series of gardening books for female readers.

1841
Kew Gardens in London becomes the property of the state, and is opened to the general public.

1841
American artist John G. Rand invents a portable metal paint tube, which enables artists to take a selection of pigments out of the studio and paint in the open air.

1845
In England, the repeal of the glass tax makes large sheets of glass more affordable, leading to a boom in the construction of public and domestic conservatories.

1851
With the help of Calvert Vaux, Andrew Jackson Downing lays out the grounds of the White House, the Capitol building and the Smithsonian Institution in Washington, D.C.

1852
Horticulturalist Philipp Franz von Siebold introduces the Japanese sword-leaved iris into Europe.

1853
Civic planner Georges Eugène Haussmann is appointed prefect of the Seine by Napoleon III, and begins to supervise the transformation of the city of Paris.

1858
The Greensward plan, submitted by Frederick Law Olmsted and Calvert Vaux, is chosen as the design for New York's Central Park.

1862
William Morris begins to produce wallpaper designs based on the flowers in his garden at Red House in Bexleyheath, Kent.

1862
In France, parts of the forest of Fontainebleau are designated as a nature reserve.

1870
William Robinson publishes *The Wild Garden*, sparking an interest in wild flowers in Victorian England.

1871
During an insurgency in Paris, members of the radical Commune set fire to the Tuileries Palace and its copses of old chestnut trees. The remains of the palace are destroyed in 1883.

1872
Claude Monet moves his family to Argenteuil in the north-western suburbs of Paris, where he paints – and tends – his own garden.

1874
French painter James Tissot extends the studio at his home in St John's Wood, north London, by adding a studio-salon with an adjacent commodious conservatory.

1874–90
Edward Burne-Jones paints his multi-panel series *The Briar Rose*, which tells the story of a knight who encounters a castle and its court, all of whom are held under a spell of sleep within an overgrown garden of briar-rose vines.

1875
Émile Zola writes *The Sin of Father Mouret*, in which a timid priest posted to a provincial parish succumbs to the devastating charms of a free-spirited young woman in the garden of a derelict chateau, where 'living flowers opened like naked flesh'.

1878
Gertrude Jekyll's mother moves into Munstead House near Godalming in Surrey; nineteen years later, Jekyll moves into Munstead Wood across the road, where she designs a garden that incorporates the character of the surrounding land.

1880
In a lecture titled 'Making the Best of It', William Morris advises gardeners to avoid 'florist flowers' and cultivate such old-fashioned native species as snowdrops and columbine.

1881
Helen Allingham moves to the Surrey village of Sandhills and begins to paint her signature subject, the cottage garden.

1883
Berthe Morisot and her family move into a new house in the Paris neighbourhood of Passy. Morisot's husband, Eugène Manet, designs the garden.

1886
In Egypt, the excavation of the tomb of Sennedjem, a skilled artisan of the Nineteenth Dynasty, reveals detailed and naturalistic images of farming and gardens.

1887
The introduction in the United Kingdom of the Allotment Act of 1887 requires local authorities to provide community gardening plots for their constituency.

1888
In China, the Empress Dowager Cixi rebuilds the Summer Palace complex – destroyed twenty-eight years earlier in an Anglo-French invasion – and renames it Yiheyuan (Garden of the Preservation of Harmony).

1888
Gustave Caillebotte gives up his residence in Paris to paint and garden all year round at his home in Petit-Gennevilliers on the Seine.

1890
Claude Monet purchases the house and property in Giverny that he has leased for seven years.

1890
Vincent van Gogh moves to Auvers-sur-Oise and, with the permission of the artist's widow, paints in Charles-François Daubigny's garden.

1893
Claude Monet purchases a marshy plot of land across the road from his home in Giverny to create a pond for water lilies.

1899
The hapless tourists in Jerome K. Jerome's comic novel *Three Men in a Boat* get trapped in the maze at Hampton Court Palace.

1904
Featuring illustrations by Maxfield Parrish, Edith Wharton's travel guide *Italian Villas and Their Gardens* is published.

1908
Gertrude Jekyll explains her painterly approach to planting in *Colour Schemes for the Flower Garden*, published by Country Life.

1909
Daniel Burnham and Edward H. Bennett publish the *Plan of Chicago*. Illustrated with plates by Jules Guérin, the plan proposed to transform the Chicago lakefront into continuous parkland.

1910
The famous 'Sleeping Dragon' plum tree, celebrated in Utagawa Hiroshige's print *Plum Estate, Kameido* (1857), perishes in a devastating flood.

1911
Rudyard Kipling uses the garden as a metaphor to encourage his fellow countrymen to support the British Empire in the poem 'The Glory of the Garden'.

1915
The Canadian army surgeon Lieutenant Colonel John McCrae writes 'In Flanders Fields', a tribute to the soldiers who had lost their lives in the First World War.

1916
Vanessa Bell and Duncan Grant move into Charleston, an eighteenth-century farmhouse in East Sussex.

1924
Botanist Georges Truffaut visits Monet in his garden at Giverny and writes in the journal *Jardinage* that the painter's greatest work of art is his garden.

1930
Vita Sackville-West and Harold Nicolson purchase Sissinghurst Castle in Kent. Inspired by Gertrude Jekyll's theories about colour, Sackville-West creates one of the world's most famous private gardens.

1932
Stanley Spencer returns to his boyhood village of Cookham in Berkshire. There, he paints the modest local gardens.

1941
The British government launches the 'Dig for Victory' initiative, encouraging citizens to plant 'victory gardens' in order to reduce dependency on imported food during wartime.

1956
Sculptor Isamu Noguchi collaborates with architect Marcel Breuer to create a two-level, Japanese-inspired rock garden for the UNESCO headquarters in Paris.

1967
Poet Ian Hamilton Finlay begins work on Little Sparta, the garden at his home near Edinburgh, placing poems carved in stone among the plants.

1969
Artist Hans Haacke creates *Grass Grows* – a mound of earth seeded with rye grass – as part of the *Earth Art* exhibition at the Andrew Dickson White Museum of Art at Cornell University.

1970
Sculptor Robert Smithson proposes the project *Floating Island to Travel Around Manhattan Island*, a garden on a barge pulled by a tugboat. Never realized in the artist's lifetime, the project was produced in 2005 by Minetta Brook and the Whitney Museum of American Art, New York.

1975
In New York, Alan Sonfist plants *Time Landscape* – a re-creation of the natural landscape as it existed prior to the seventeenth-century European colonization of the eastern United States – on the north-east corner of LaGuardia Place and West Houston Street.

1977
Topiary animals in the garden of the Outlook Hotel in Colorado come to life and terrorize a family in Stephen King's horror novel *The Shining*.

1981
PepsiCo hires landscape architect Russell Page to develop the grounds of its corporate headquarters in Purchase, New York. The resulting Donald M. Kendall Sculpture Gardens feature more than forty large-scale works, including Claes Oldenburg's *Giant Trowel II*.

1982–87
At the invitation of the *documenta 7* exhibition, Joseph Beuys creates *7000 Oaks*, a piece of land art in Kassel, Germany, consisting of 7000 newly planted oak trees.

1985
The Noguchi Museum opens in Long Island City, New York. Isamu Noguchi designed the museum's sculpture garden around a 75-year-old *Ailanthus altissima* (Tree of Heaven), which died in 2008.

1992
Artist Jeff Koons creates *Puppy*, an enormous West Highland White Terrier-shaped topiary sculpture covered with 70,000 flowers, for an exhibition in Bad Arolsen, Germany.

1992
Anya Gallaccio assembles a carpet of 10,000 English tea roses on a bed of thorns for the installation *Red and Green*. The exhibition included the withering of the roses.

2000
Marc Quinn's *Garden*, created for the Fondazione Prada in Milan, uses cryogenic technology to preserve flowers in a sealed tank.

2000
Performance artist Yang Zhichao has grass implanted into his own back for a piece called *Planting Grass*.

2001
The Eden Project – a series of large geodesic-dome greenhouses in Cornwall – opens to the public. Conceived by co-founder Tim Smit and designed by architect Nicholas Grimshaw, the greenhouses contain plant species from around the world.

2004
Chicago's Lurie Garden opens in Millennium Park. A collection of plants native to the American Midwest, the garden is designed to embody the city's motto, *Urbs in Horto* (City in a Garden).

2004
Japanese artist Yayoi Kusama groups floating mirror balls in Central Park's Conservatory Water in a reinvention of her 1966 Venice Biennale installation *Narcissus Garden*.

2007
Seattle's Olympic Sculpture Park, built by the Seattle Art Museum, opens on the site of a reclaimed petroleum facility. The park features works of sculpture by Claes Oldenburg, Richard Serra, Louise Bourgeois and Mark Dion, as well as four native gardens.

2008
Using rows of stacked jute bags filled with seeds, Mona Hatoum creates *Hanging Garden* on the streets of Berlin, a military-style barricade that sprouts grass and weeds.

2008
The Shirley Sherwood Gallery of Botanical Art is built in the grounds of the Royal Botanic Gardens at Kew to showcase Kew's extensive collection of botanical illustrations. It is the first public gallery in the world to be dedicated to botanical art.

2009
United States First Lady Michelle Obama plants a kitchen garden at the White House in Washington, D.C.

2009
As part of the exhibition *The Sky Within My House* – sixteen site-specific installations on sixteen patios in Cordoba, Spain – Chinese artist Cai Guo-Qiang attaches plants to the backs of turtles and releases them in a courtyard.

2010
At the São Paulo Biennale, conceptual artist Ai Weiwei installs *Zodiac Heads/Circle of Animals*, oversized replicas of the twelve bronze animals of the Chinese zodiac. The originals were looted during the destruction of the Summer Palace in Beijing in 1860.

SELECT BIBLIOGRAPHY

HISTORY AND THEORY

William Howard Adams, *Gardens Through History: Nature Perfected*, New York (Abbeville Press) 1991

Julia S. Berrall, *The Garden: An Illustrated History*, Harmondsworth (Penguin) 1978

Jan Birksted, ed., *Landscapes of Memory and Experience*, London (Spon Press) 2000

Nils Büttner, *The History of Gardens in Painting*, tr. Russell Stockman, New York (Abbeville Press) 2008

Peter Coates, *Nature: Western Attitudes Since Ancient Times*, Berkeley, Calif. (University of California Press) 1998

F.R. Cowell, *The Garden as a Fine Art: From Antiquity to Modern Times*, London (Weidenfeld and Nicolson) 1978

Enclosed and Enchanted, exhib. cat. by Kerry Brougher and Michael Tarantino, Modern Art Oxford, July–October 2000

Mark Francis and Randolph T. Hester Jr, eds, *The Meaning of Gardens: Idea, Place, and Action*, Cambridge, Mass. (MIT Press) 1995

Robert Pogue Harrison, *Gardens: An Essay on the Human Condition*, Chicago and London (University of Chicago Press) 2008

Penelope Hobhouse, *Gardening Through the Ages: An Illustrated History of Plants and Their Influence on Garden Styles – From Ancient Egypt to the Present Day*, New York (Simon & Schuster) 1992

———, *In Search of Paradise: Great Gardens of the World*, London (Francis Lincoln) 2006

Lucia Impelluso, *Gardens in Art*, tr. Stephen Sartarelli, Los Angeles (The J. Paul Getty Museum) 2007

Geoffrey Jellicoe and Susan Jellicoe, *The Landscape of Man: Shaping the Environment from Prehistory to the Present Day*, London (Thames & Hudson) 1987

David Joyce, ed., *Garden Styles: An Illustrated History of Design and Tradition*, London (Pyramid) 1989

Alain Le Toquin and Jacques Bosser, *Gardens in Time*, New York (Harry N. Abrams) 2006

Marina Schinz and Susan Littlefield, *Visions of Paradise: Themes and Variations on the Garden*, London (Thames & Hudson) 1985

Patrick Taylor, ed., *The Oxford Companion to the Garden*, Oxford (Oxford University Press) 2006

Christopher Thacker, *The History of Gardens*, Berkeley, Calif. (University of California Press) 1992

Scott J. Tilden, ed., *The Glory of Gardens: 2000 Years of Writings on Garden Design*, New York (Harry N. Abrams) 2006

Tom Turner, *Garden History: Philosophy and Design, 2000 BC – 2000 AD*, London and New York (Spon Press) 2005

Matteo Vercelloni and Virgilio Vercelloni, *The Invention of the Western Garden: The History of an Idea*, New Lanark (Waverley) 2010

May Woods and Arete Swartz Warren, *Glass Houses: A History of Greenhouses, Orangeries and Conservatories*, New York (Rizzoli) 1988

REGIONAL AND HISTORICAL STUDIES

Art of the Garden: The Garden in British Art, 1800 to the Present Day, exhib. cat., ed. Nicholas Alfrey *et al.*, London, Belfast and Manchester, June 2004 – May 2005

Wendell Berry, *The Unsettling of America: Culture and Agriculture*, San Francisco (Sierra Club Books) 1997

Edwin Morris Betts, ed., *Thomas Jefferson's Garden Book*, Chapel Hill, NC (University of North Carolina Press) 2002

Marjorie Blamey and Christopher Grey-Wilson, *The Illustrated Flora of Britain and Northern Europe*, London (Hodder and Stoughton) 1989

Tom Carter, *The Victorian Garden*, London (Bell and Hyman) 1984

Cheng Liyao, *Imperial Gardens: Ancient Chinese Architecture*, tr. Zhang Long, Vienna and New York (Springer) 1998

———, *Private Gardens: Ancient Chinese Architecture*, tr. Zhang Long, Vienna and New York (Springer) 1999

Michel Conan, ed., *Bourgeois and Aristocratic Cultural Encounters in Garden Art,*

1550–1850, Washington, D.C. (Dumbarton Oaks Research Library and Collection) 2002

Stephen Daniels, *Humphry Repton: Landscape Gardening and the Geography of Georgian England*, New Haven, Conn., and London (Yale University Press for the Paul Mellon Centre for Studies in British Art) 1999

Eleanor P. DeLorme, *Garden Pavilions and the 18th Century French Court*, Woodbridge (Antique Collectors' Club) 1996

Sarah Jane Downing, *The English Pleasure Garden: 1660–1860*, Oxford (Shire) 2009

Fang Xiaofeng, *The Great Gardens of China: History, Concepts, Techniques*, New York (Monacelli Press) 2010

Gardens of Earthly Delight: Sixteenth and Seventeenth-Century Netherlandish Gardens, exhib. cat. by Kahren Hellerstedt, Pittsburgh, Frick Art & Historical Center, April–May 1986

John Harvey, *Mediaeval Gardens*, London (Batsford) 1981

Anne Helmreich, *The English Garden and National Identity: The Competing Styles of Garden Design, 1870–1914*, Cambridge (Cambridge University Press) 2002

Bridget Ann Henisch, *The Medieval Calendar Year*, University Park, Pa. (Pennsylvania State University Press) 2002

Robert L. Herbert, *Impressionism: Art, Leisure, and Parisian Society*, New Haven, Conn., and London (Yale University Press) 1988

Elizabeth Hyde, *Cultivated Power: Flowers, Culture, and Politics in the Reign of Louis XIV*, Philadelphia (University of Pennsylvania Press) 2005

Michael Kammen, *A Time to Every Purpose: The Four Seasons in American Culture*, Chapel Hill, NC (University of North Carolina Press) 2004

Maggie Keswick, *The Chinese Garden*, London (Frances Lincoln) 2003

Mrs Loudon (Jane Webb Loudon), *Gardening for Ladies*, London (John Murray) 1846

———, *The Ladies' Flower-Garden of Ornamental Annuals*, London (W.S. Orr) 1849

John Claudius Loudon, *Arboretum et Fruticetum Britannicum* [1838], London (Longman, Brown, Green and Longmans) 1844

A Medieval Flower Garden, San Francisco (Chronicle Books) 1994

Millard Meiss, *Les Très Riches Heures: The Medieval Seasons*, New York (George Braziller) 1995

Nickianne Moody, 'Gardening in Print: Profession, Instruction, and Reform', *Nineteenth-Century Gender Studies*, 5, Summer 2009, pp. 1–36

Tim Richardson, *The Arcadian Friends: Inventing the English Landscape Garden*, London (Bantam) 2007

Elizabeth Barlow Rogers *et al.*, *Romantic Gardens: Nature, Art, and Landscape Design*, Boston (David R. Godine) 2010

Vivian Russell, *Edith Wharton's Italian Gardens*, London (Frances Lincoln) 1997

Rahoul B. Singh, *Gardens of Delight: Indian Gardens Through the Ages*, London (Pavilion) 2008

Roy Strong, *The Artist and the Garden*, New Haven, Conn., and London (Yale University Press for the Paul Mellon Centre for Studies in British Art) 2000

———, *The Renaissance Garden in England*, London (Thames & Hudson) 1998

Tom Turner, *European Gardens: History, Philosophy and Design*, London (Routledge) 2010

Joseph Cho Wang, *The Chinese Garden*, Oxford (Oxford University Press) 1998

Twigs Way, *Allotments*, Oxford (Shire) 2008

Carl Woodring, *Nature into Art: Cultural Transformations in Nineteenth-Century Britain*, Cambridge, Mass. (Harvard University Press) 1989

Michiko Young, *The Art of the Japanese Garden*, Boston (Tuttle) 2005

LEGEND, LANGUAGE, LORE

Rachel E. Carr, *Japanese Floral Art: Symbolism, Cult, and Practice*, Princeton, NJ (D. Van Nostrand) 1961

Alice M. Coates, *Flowers and Their Histories*, New York (McGraw-Hill) 1968

J.J. Grandville, *The Court of Flora: Les Fleurs Animées – The Engraved Illustrations of J.J. Grandville*, intro. by Peter A. Wick, New York (George Braziller) 1981

Geoffrey Grigson, *A Dictionary of English Plant Names*, London (Allen Lane) 1974

Marina Heilmeyer, *The Language of Flowers: Symbols and Myths*, Munich, London and New York (Prestel) 2001

John Ingram, *Flora Symbolica: or, The Language and Sentiment of Flowers*, London (Frederick Warne and Company) 1869

Thomas James, *The Flower Garden: With an Essay on the Poetry of Gardening*, London (John Murray) 1852

Vincenzina Krymow, *Mary's Flowers: Gardens, Legends, and Meditations*, Cincinnati, Oh. (St Anthony Messenger Press) 1999

Debra N. Mancoff, *Flora Symbolica: Flowers in Pre-Raphaelite Art*, Munich, London and New York (Prestel) 2003

———, *Sunflowers*, London (Thames & Hudson) 2001

Anna Pavord, *The Tulip*, London (Bloomsbury) 1999

Beverly Seaton, *The Language of Flowers: A History*, Charlottesville, Va., and London (University Press of Virginia) 1995

Harold P. Stern, *Birds, Beasts, Blossoms, and Bugs: The Nature of Japan*, New York (Harry N. Abrams) 1976

J.E. Taylor, *Flowers: Their Origin, Shapes, Perfumes and Colours*, London (Hardwicke and Bogue) 1879

Robert Tyas, *The Language of Flowers: or, Floral Emblems of Thoughts, Feelings, and Sentiments*, London and New York (George Routledge and Sons) 1869

Bobby J. Ward, *A Contemplation upon Flowers: Garden Plants in Myth and Literature*, Portland, Ore. (Timber Press) 1999

Diana Wells, *100 Flowers and How They Got Their Names*, Chapel Hill, NC (Algonquin Books) 1997

ARTISTS' GARDENS

Quentin Bell and Virginia Nicholson, *Charleston: A Bloomsbury House and Garden*, London (Frances Lincoln) 1997

'Bird's Nest' Hunt and His Followers, exhib. cat. by Martha Parrish, New York, Hirschl & Adler Galleries, December 1986 – January 1987

Judith Bumpus, *Impressionist Gardens*, London (Phaidon) 1990

Valerie Easton and David Laskin, *Artists in Their Gardens*, Seattle (Sasquatch Books) 2001

Susan Foister, *Dürer and the Virgin in the Garden*, London (The National Gallery) 2004

Jill, Duchess of Hamilton *et al.*, *The Gardens of William Morris*, London (Frances Lincoln) 1998

Henri Rousseau: Jungles in Paris, exhib. cat., ed. Frances Morris and Christopher Green, London, Paris and Washington, D.C., 2005–2006

In Paul Klee's Enchanted Garden, exhib. cat. by Michael Baumgartner *et al.*, Bern, Oslo and Bergen, 2008

Gertrude Jekyll, *Wood and Garden, Notes and Thoughts, Practical and Critical, of a Working Amateur*, London (Longmans, Green and Company) 1899

Katharine Lochnan, ed., *Seductive Surfaces: The Art of Tissot*, New Haven, Conn., and London (Yale University Press) 1999

Debra N. Mancoff, *Monet's Garden in Art*, London (Frances Lincoln) 2001

———, *Van Gogh's Flowers*, London (Frances Lincoln) 1999

Thierry Mariage, *The World of André Le Nôtre*, tr. Graham Larkin, Philadelphia (University of Pennsylvania Press) 1999

The Marley Collection of Watercolours by Helen Allingham, sales cat., London, Christie, Manson & Woods, September 1991

Mrs Delany and Her Circle, exhib. cat., ed. Mark Laird and Alicia Weisberg-Roberts, New Haven, Conn., Yale Center for British Art, September 2009 –

January 2010; London, Sir John Soane's Museum, February–May 2010

André Rogger, *Landscapes of Taste: The Art of Humphry Repton's Red Books*, London (Routledge) 2007

Vivian Russell, *Monet's Garden: Through the Seasons at Giverny*, London (Frances Lincoln) 1995

Samuel Palmer 1805–1881: Vision and Landscape, exhib. cat. by William Vaughan *et al.*, London, The British Museum, October 2005 – January 2006; New York, The Metropolitan Museum of Art, March–May 2006

Henry D. Smith II and Amy G. Poster, *Hiroshige: One Hundred Famous Views of Edo*, New York (George Braziller) 1986

Judith B. Tankard and Martin A. Wood, *Gertrude Jekyll at Munstead Wood: Writing, Horticulture, Photography, Homebuilding*, Stroud (Sutton Publishing) 1996

Pamela Todd, *The Impressionists at Home*, London (Thames & Hudson) 2005

———, *The Impressionists at Leisure*, London (Thames & Hudson) 2007

———, *The Pre-Raphaelites at Home*, London (Pavilion) 2001

Christopher White, *Rubens and His World*, New York (Viking) 1968

Clare A.P. Willsdon, *Impressionist Gardens*, London (Thames & Hudson) 2010

———, *In the Gardens of Impressionism*, London (Thames & Hudson) 2004

Pierre Wittmer, *Caillebotte and His Garden at Yerres*, New York (Harry N. Abrams) 1991

Martin Wood, ed., *The Unknown Gertrude Jekyll*, London (Frances Lincoln) 2006

ON SPECIFIC GARDENS

Michel Baridon, *A History of the Gardens of Versailles*, tr. Adrienne Mason, Philadelphia (University of Pennsylvania Press) 2008

Mavis Batey and Jan Woudstra, *The Story of the Privy Garden at Hampton Court*, London (Barn Elms) 1995

Wayne E. Begley, 'The Myth of the Taj Mahal and a New Theory of Its Symbolic Meaning', *The Art Bulletin*, 61, March 1979, pp. 7–34

Stephanie Dalley, 'Ancient Mesopotamian Gardens and the Identification of the Hanging Gardens of Babylon Resolved', *Garden History*, 21, Summer 1993, pp. 1–13

Ray Desmond, *Kew: The History of the Royal Botanic Gardens*, London (Harvill Press) 1995

Christian Duvernois, *Marie-Antoinette and the Last Garden at Versailles*, New York (Rizzoli) 2008

Hany Farid and Samir Farid, 'Unfolding Sennedjem's Tomb', *KMT: A Journal of Ancient Egypt*, Spring 2001, pp. 1–8

Susanne Groom and Lee Prosser, *Kew Palace: The Official Illustrated History*, London and New York (Merrell) 2006

Gustave Caillebotte: Urban Impressionist, exhib. cat. by Anne Distel *et al.*, Paris, Galeries Nationales du Grand Palais, September 1994 – May 1995; Los Angeles County Museum of Art, June–September 1995

Morrison H. Heckscher, *Creating Central Park*, New Haven, Conn., and London (Yale University Press) 2008

Pierre-André Lablaude, *The Gardens of Versailles*, Paris (Éditions Scala) 2005

Sara Cedar Miller, *Central Park: An American Masterpiece*, New York (Harry N. Abrams) 2003

Gregory Nosan, 'Pavilions, Palaces, and Patriotism: Garden Architecture at Vauxhall', in Michel Conan, ed., *Bourgeois and Aristocratic Cultural Encounters in Garden Art, 1550–1850*, Washington, D.C. (Dumbarton Oaks Research Library and Collection) 2002, pp. 101–21

Stéphane Pincas, *Versailles: The History of the Gardens and Their Sculpture*, London (Thames & Hudson) 1996

GARDENS TO VISIT

CHINA

Lanting (Orchid Pavilion), Lanzhu Mountain, Shaoxing
shaoxing.gov.cn/en/Shaoxingscenery/Shaoxingscenery.htm

Summer Palace, Beijing
ebeijing.gov.cn/Travel/Sightseeing/Summer_Palace

FRANCE

Bois de Boulogne, Paris
en.parisinfo.com/museum-monuments/1338/bois-de-boulogne?1

Château de Fontainebleau
musee-chateau-fontainebleau.fr

Château de Versailles
en.chateauversailles.fr/gardens-and-park-of-the-chateau-

Jardin des Plantes, Paris
www.mnhn.fr/museum/foffice/transverse/transverse/accueil.xsp?cl=en

Jardin du Luxembourg, Paris
en.parisinfo.com/museum-monuments/1241/jardin-du-luxembourg-

Jardins des Tuileries, Paris
louvre.fr/llv/musee/jardins_tuileries.jsp

Monet's garden, Giverny
giverny.org/gardens/fcm/visitgb.htm

Parc Zoologique de Paris
www.mnhn.fr/museum/foffice/transverse/transverse/accueil.xsp?cl=en

Restaurant Fournaise, Chatou
restaurant-fournaise.fr/Page_welcome.htm

GERMANY

Cologne Zoological Garden
koelnerzoo.de

Garden Kingdom of Dessau-Wörlitz
gartenreich.com/en/index.html

ITALY

Boboli Gardens, Florence
firenzemusei.it/00_english/boboli/index.html

Villa d'Este, Tivoli
villadestetivoli.info/storiae.htm

THE NETHERLANDS

Paleis Het Loo, Apeldoorn
paleishetloo.nl/frontpage/0/2/Home.html

UNITED KINGDOM

Charleston, Lewes, East Sussex
charleston.org.uk

Chelsea Physic Garden, London
chelseaphysicgarden.co.uk

Hampton Court Palace, Surrey
hrp.org.uk/hamptoncourtpalace

Munstead Wood, Godalming, Surrey
www.gardenvisit.com/garden/munstead_wood_garden

Red House, Bexleyheath, Kent
nationaltrust.org.uk/redhouse

Stourhead, Wiltshire
nationaltrust.org.uk/stourhead

UNITED STATES

Central Park, New York
centralparknyc.org

Monticello, Charlottesville, Virginia
monticello.org/gardens/index.html

Mount Vernon, Virginia
mountvernon.org

PICTURE CREDITS

Allans of Duke Street, London, UK/The Bridgeman Art Library: 58; Allen Memorial Art Museum, Oberlin College, Ohio, USA/R.T. Miller Jr Fund/The Bridgeman Art Library: 171, 223; Alte Pinakothek, Munich, Germany/Giraudon/The Bridgeman Art Library: 188; Art Gallery and Museum, Kelvingrove, Glasgow, Scotland/© Culture and Sport Glasgow (Museums)/The Bridgeman Art Library: 119; The Art Institute of Chicago, USA/The Bridgeman Art Library: back jacket bl, 177; Ashmolean Museum, University of Oxford, UK/The Bridgeman Art Library: 13, 135, 137, 178; The Barnes Foundation, Merion, Pennsylvania, USA/The Bridgeman Art Library: 132, 160t; Biblioteca Estense, Modena, Italy/The Bridgeman Art Library: 74; Bibliothèque de l'Arsenal, Paris, France/Giraudon/The Bridgeman Art Library: 89t; Bibliothèque des Arts Decoratifs, Paris, France/Archives Charmet/The Bridgeman Art Library: 113; Bibliothèque Nationale, Paris, France/The Bridgeman Art Library: 47, 67; © Birmingham Museums and Art Gallery/The Bridgeman Art Library: 99; The British Library, London, UK/The Bridgeman Art Library: 29b; The British Library, London, UK/© British Library Board. All rights reserved/The Bridgeman Art Library: 11, 12b, 37t, 52r, 112, 130, 155, 209; The British Museum, London, UK/The Bridgeman Art Library: 148; The British Museum, London, UK/Giraudon/The Bridgeman Art Library: 17; Brooklyn Museum of Art, New York, USA/The Bridgeman Art Library: 55; Brooklyn Museum of Art, New York, USA/Gift of the Estate of Charles A. Brandon, by exchange/The Bridgeman Art Library: 96–97; Brooklyn Museum of Art, New York, USA/Purchased by special subscription/The Bridgeman Art Library: 182; Burrell Collection, Glasgow, Scotland/© Culture and Sport Glasgow (Museums)/The Bridgeman Art Library: 151; © Butler Institute of American Art, Youngstown, Ohio, USA/Museum Purchase 1919/The Bridgeman Art Library: 60; Château de Versailles, France/Giraudon/The Bridgeman Art Library: 15, 71, 72; © Christie's Images/The Bridgeman Art Library: 10; Cincinnati Art Museum, Ohio, USA/Gift of Charles Elam in memory of Mabel McNenny Elam/The Bridgeman Art Library: 169; Dallas Museum of Art, USA/The Bridgeman Art Library: 141; The Dayton Art Institute, Ohio, USA/Gift of Mr Joseph Rubin/The Bridgeman Art Library: 199; Deir el-Medina, Thebes, Egypt/The Bridgeman Art Library: 107; Detroit Institute of Arts, USA/Bequest of Robert H. Tannahill/The Bridgeman Art Library: 213; Detroit Institute of Arts, USA/The Bridgeman Art Library: 21r; Detroit Institute of Arts, USA/Purchased with the Lizzie Merrill Palmer Fund/The Bridgeman Art Library: 34; Egyptian National Museum, Cairo, Egypt/The Bridgeman Art Library: 7; Faringdon Collection,

Buscot, Oxfordshire, UK/The Bridgeman Art Library: 56, 57; The Fitzwilliam Museum, University of Cambridge, UK/The Bridgeman Art Library: 46, 129b, 216; Galerie Janette Ostier, Paris, France/Giraudon/The Bridgeman Art Library: 28; Galerie Martin-Caille Matignon, Paris, France/© 2011 ADAGP, Paris, and DACS, London/The Bridgeman Art Library: 163; Galleria degli Uffizi, Florence, Italy/The Bridgeman Art Library: 30–31, 50–51; Gemäldegalerie Alte Meister, Kassel, Germany/© Museumslandschaft Hessen Kassel/Ute Brunzel/The Bridgeman Art Library: 110; Germanisches Nationalmuseum, Nuremberg, Germany/The Bridgeman Art Library: 89b; Guggenheim Collection, Venice, Italy/The Bridgeman Art Library: 62; Hamburger Kunsthalle, Hamburg, Germany/The Bridgeman Art Library: 54, 101, 134, 193; Harris Museum and Art Gallery, Preston, Lancashire, UK/The Bridgeman Art Library: 98, 136, 207; Indianapolis Museum of Art, USA/Mr and Mrs Richard Crane Fund/The Bridgeman Art Library: 96; Indianapolis Museum of Art, USA/Mr and Mrs William R. Spurlock Fund/The Bridgeman Art Library: 152–53; Institute of Oriental Studies, St Petersburg, Russia/Giraudon/The Bridgeman Art Library: 90; © Ipswich Borough Council Museums and Galleries, Suffolk, UK/The Bridgeman Art Library: 189; J. Paul Getty Museum, Los Angeles, USA/The Bridgeman Art Library: back jacket br, 32; © Lady Lever Art Gallery, National Museums Liverpool/The Bridgeman Art Library: 139; Leeds Museums and Galleries (City Art Gallery) UK/© 2011 The Estate of Stanley Spencer. All rights reserved DACS/The Bridgeman Art Library: 185, 203; Lobkowicz Collections, Nelahozeves Castle, Czech Republic/The Bridgeman Art Library: 93; Manchester Art Gallery, UK/The Bridgeman Art Library: 102; The Metropolitan Museum of Art, New York, USA/Giraudon/The Bridgeman Art Library: 92, 159; Minneapolis Institute of Arts, USA/The Bridgeman Art Library: 173; Musée Cognacq-Jay, Paris, France/Giraudon/The Bridgeman Art Library: 94; Musée Condé, Chantilly, France/Giraudon/The Bridgeman Art Library: 29t; Musée de la Ville de Paris, Musée Carnavalet, Paris, France/Giraudon/The Bridgeman Art Library: 73; Musée de la Ville de Paris, Musée du Petit Palais, France/The Bridgeman Art Library: 39; Musée de l'Hôtel Sandelin, Saint-Omer, France/Giraudon/The Bridgeman Art Library: 27; Musée des Beaux-Arts, Lille, France/Giraudon/The Bridgeman Art Library: back jacket tr, 105, 109; Musée des Beaux-Arts, Nantes, France/Giraudon/The Bridgeman Art Library: 65, 82–83; Musée des Beaux-Arts, Tournai, Belgium/Giraudon/The Bridgeman Art Library: 175; Musée d'Orsay, Paris, France/Giraudon/The Bridgeman Art Library: back jacket tl, 20, 25, 35, 83, 174, 198; Musée Guimet, Paris, France/Giraudon/The Bridgeman Art Library: 91;

Musée Marmottan Monet, Paris, France/Giraudon/The Bridgeman Art Library: 160b, 190, 222; Musée National du Moyen Age et des Thermes de Cluny, Paris/The Bridgeman Art Library: 88; Musée Rodin, Paris, France/Flammarion/The Bridgeman Art Library: 33; Museo Nacional del Prado, Madrid, Spain/The Bridgeman Art Library: 87; Museo Nazionale Romano, Rome, Italy/The Bridgeman Art Library: 149; Museum of Fine Arts, Boston, USA/Gift of John Goelet/The Bridgeman Art Library: 131; Museum of Finnish Art, Ateneum, Helsinki, Finland/Giraudon/The Bridgeman Art Library: 45, 59; © Museum of the City of New York, USA/The Bridgeman Art Library: 170; National Academy Museum, New York, USA/The Bridgeman Art Library: 221; The National Gallery, London, UK/The Bridgeman Art Library: 114–15, 172; National Gallery of Art, Washington, D.C., USA/Giraudon/The Bridgeman Art Library: 161; © National Gallery of Scotland, Edinburgh/The Bridgeman Art Library: 118; © National Museum Wales/The Bridgeman Art Library: 36, 138; © Nationalmuseum, Stockholm, Sweden/The Bridgeman Art Library: 176, 21l; Norton Simon Collection, Pasadena, California, USA/The Bridgeman Art Library: 181; Oskar Reinhart Collection, Winterthur, Switzerland/The Bridgeman Art Library: 196; Österreichische Galerie Belvedere, Vienna, Austria/The Bridgeman Art Library: 63, 147; Österreichische Nationalbibliothek, Vienna, Austria/Alinari/The Bridgeman Art Library: 108; Österreichische Nationalbibliothek, Vienna, Austria/The Stapleton Collection/The Bridgeman Art Library: 125, 129t; © Peabody Essex Museum, Salem, Massachusetts, USA/The Bridgeman Art Library: 70; Pennsylvania Academy of the Fine Arts, USA/The Bridgeman Art Library: 220; Private collection/© 2011 ADAGP, Paris, and DACS, London/The Bridgeman Art Library: 143; Private collection/Archives Charmet/The Bridgeman Art Library: 66, 77; Private collection/© Linda Benton/The Bridgeman Art Library: 123; Private collection/Joanna Booth/The Bridgeman Art Library: 152; Private collection/The Bridgeman Art Library: 2, 18, 37l, 52l, 76, 78, 81, 117, 120t, 120b, 140, 145, 157, 158, 162, 167, 187b, 194, 212, 219, 225; Private collection/© Christie's Images/The Bridgeman Art Library: 53, 187t; Private collection/Courtesy of Julian Hartnoll/The Bridgeman Art Library: front jacket, 61; Private collection/© The Estate of Vanessa Bell, courtesy of Henrietta Garnett/Photo © Peter Nahum at The Leicester Galleries, London/The Bridgeman Art Library: 201; Private collection/© Mallett Gallery, London, UK/The Bridgeman Art Library: 200, 214, 215; Private collection/© Nolde Stiftung Seebüll/The Bridgeman Art Library: 6; Private collection/© Nolde Stiftung Seebüll/Photo © Christie's Images/The Bridgeman Art Library:

202; Private collection/Roger Perrin/The Bridgeman Art Library/© Raoul Vion: 122; Private collection/Photo © Agnew's, London, UK/The Bridgeman Art Library: 195; Private collection/Photo © Christie's Images/The Bridgeman Art Library: 8, 19, 116, 121, 132–33, 154, 156, 210, 218; Private collection/Photo © The Fine Art Society, London, UK/The Bridgeman Art Library: 191; Private collection/Photo © Lefevre Fine Art Ltd, London/The Bridgeman Art Library: 41; Private collection/Photo © The Maas Gallery, London/The Bridgeman Art Library: 127; Private collection/The Stapleton Collection/The Bridgeman Art Library: 14, 42, 75, 115, 168t; The Pushkin State Museum of Fine Arts, Moscow, Russia/The Bridgeman Art Library: 100, 179; Roy Miles Fine Paintings/The Bridgeman Art Library: 103; Royal Botanic Gardens, Kew, London, UK/The Bridgeman Art Library: 168b; St Martin, Colmar, France/Giraudon/The Bridgeman Art Library: 49; © Samuel Courtauld Trust, The Courtauld Gallery, London, UK/The Bridgeman Art Library: 9; Service Historique de la Marine, Vincennes, France/Lauros/Giraudon/The Bridgeman Art Library: 111; Städelsches Kunstinstitut, Frankfurt-am-Main, Germany/The Bridgeman Art Library: 48; Städtische Galerie im Lenbachhaus, Munich, Germany/The Bridgeman Art Library: 165, 183; The State Hermitage Museum, St Petersburg, Russia/The Bridgeman Art Library: 22; © Tate/Tate Images: 142; Tokyo National Museum, Japan/The Bridgeman Art Library/© Kokei Kobayashi: 205, 217; © The Trustees of the Chester Beatty Library, Dublin/The Bridgeman Art Library: 12t; © Trustees of the Royal Watercolour Society, London, UK/The Bridgeman Art Library: 23; UCL Art Collections, University College London, UK/The Bridgeman Art Library: 43; Van Gogh Museum, Amsterdam, The Netherlands/Giraudon/The Bridgeman Art Library: 197; Victoria and Albert Museum, London, UK/The Bridgeman Art Library: 38, 68, 69, 80, 192; Victoria and Albert Museum, London, UK/© F.H.K Henrion/The Bridgeman Art Library: 180; Victoria and Albert Museum, London, UK/The Stapleton Collection/The Bridgeman Art Library: 150; © The Wallace Collection, London, UK/The Bridgeman Art Library: 16, 85, 95; Wallraf-Richartz-Museum, Cologne, Germany/Giraudon/The Bridgeman Art Library: 128; © The Walters Art Museum, Baltimore, USA/The Bridgeman Art Library: 208; The Whitworth Art Gallery, The University of Manchester, UK/The Bridgeman Art Library: 211; Yale Center for British Art, Paul Mellon Collection, USA/The Bridgeman Art Library: 40, 79.

INDEX

Page numbers in *italic* refer to the illustrations.

Dedicated to the memory of my father and his garden

ACKNOWLEDGEMENTS

I should like to thank Claire Chandler and Hugh Merrell at Merrell Publishers for giving me the opportunity to explore this topic, and for their generous support while doing so. My thanks also go to Merrell staff members Mark Ralph, for his thoughtful handling of the manuscript; Nick Wheldon, for his help with image selection; and Nicola Bailey, for producing the book's beautiful design. I am indebted to my able research assistants, Elissa Papendick, Jeannette L. Tremblay, Rachel M. Wolff and Vrinda Agrawal. For their research support, I am grateful to Kristan Hanson, Holly Stec Dankert and the staff of the Flaxman Library at the School of the Art Institute of Chicago; for their invaluable insight, I thank my colleagues Janice Katz, at the Art Institute of Chicago, and Anne Helmreich, at the Getty Foundation. A special nod of gratitude goes to Geoffrey Hamerlinck, Administrative Assistant in the Department of Art History, Theory and Criticism at the School of the Art Institute of Chicago. Finally, I wish to acknowledge my friends Donald L. Hoffman and Paul B. Jaskot, for always listening to my ideas; and my dear parents, Elinor R. Mancoff and Philip Mancoff, who taught me that there are many ways to cultivate a garden.

First published 2011 by

Merrell Publishers Limited
81 Southwark Street
London SE1 0HX

merrellpublishers.com

Text, design and layout copyright © 2011 Merrell Publishers Limited
Illustrations copyright © 2011 the copyright holders; see page 236

British Library Cataloguing-in-Publication Data:
Mancoff, Debra N., 1950–
The garden in art.
1. Gardens in art.
I. Title
758.9'635-dc22

ISBN 978-1-8589-4522-4

Produced by Merrell Publishers Limited
Designed by Nicola Bailey
Project-managed by Mark Ralph
Indexed by Vicki Robinson

Printed and bound in China

JACKET FRONT
Detail of John William Waterhouse, *The Soul of the Rose*, 1908 (see page 61)

JACKET BACK, CLOCKWISE FROM TOP LEFT
Detail of Claude Monet, *Waterlily Pond: Pink Harmony*, 1900 (see page 83); detail of Jacob Grimmer, *Spring*, n.d. (see page 109); detail of Vincent van Gogh, *Irises*, 1889 (see page 32); detail of Auguste Renoir, *Two Sisters (On the Terrace)*, 1881 (see page 177)

PAGE 2
Detail of Gustav Klimt, *Orchard with Roses*, 1911–12 (see page 225)

PAGE 25
Detail of Claude Monet, *The Luncheon: Monet's Garden at Argenteuil*, c. 1873 (see page 35)

PAGE 45
Detail of Hugo Simberg, *The Garden of Death*, 1896 (see page 59)

PAGE 65
Detail of Claude Monet, *Waterlilies at Giverny*, 1917 (see pages 82–83)

PAGE 85
Detail of Jean-Honoré Fragonard, *The Swing*, 1767 (see page 95)

PAGE 105
Detail of Jacob Grimmer, *Spring*, n.d. (see page 109)

PAGE 125
Detail of Barthélemy d'Eyck (attrib.), 'Emilia in Her Garden', c. 1468 (see page 129)

PAGE 145
Detail of Gustave Caillebotte, *The Dahlias, Garden at Petit-Gennevilliers*, 1893 (see page 162)

PAGE 165
Detail of August Macke, *Zoological Garden I*, 1912 (see page 183)

PAGE 185
Detail of Stanley Spencer, *Gardens in the Pound, Cookham*, c. 1936 (see page 203)

PAGE 205
Detail of Kokei Kobayashi, *Poppies*, 1921 (see page 217)